The Lost Worlds of John Ford

Cinema and Society series
General Editor: Jeffrey Richards

The Lost Worlds of John Ford
Beyond the Western

Jeffrey Richards

BLOOMSBURY ACADEMIC
LONDON • NEW YORK • OXFORD • NEW DELHI • SYDNEY

BLOOMSBURY ACADEMIC
Bloomsbury Publishing Plc
50 Bedford Square, London, WC1B 3DP, UK
1385 Broadway, New York, NY 10018, USA
29 Earlsfort Terrace, Dublin 2, Ireland

BLOOMSBURY, BLOOMSBURY ACADEMIC and the Diana logo are trademarks of
Bloomsbury Publishing Plc

First published in Great Britain 2020
This paperback edition published in 2021

Copyright © Jeffrey Richards, 2020

Jeffrey Richards has asserted his right under the Copyright, Designs and Patents Act,
1988, to be identified as Author of this work.

For legal purposes the Acknowledgments on pp. x–xi constitute an extension of this
copyright page.

Cover design: Charlotte Daniels

Dan Dailey and John Wayne in *The Wings of Eagles* (1957)
© Courtesy Everett Collection / Mary Evans

Bloomsbury Publishing Plc does not have any control over, or responsibility for, any
third-party websites referred to or in this book. All internet addresses given in this
book were correct at the time of going to press. The author and publisher regret
any inconvenience caused if addresses have changed or sites have ceased to
exist, but can accept no responsibility for any such changes.

A catalogue record for this book is available from the British Library.

A catalog record for this book is available from the Library of Congress.

ISBN: HB: 978-1-3501-1470-8
 PB: 978-1-3501-9496-0
 ePDF: 978-1-3501-1468-5
 eBook: 978-1-3501-1469-2

Series: Cinema and Society

Typeset by RefineCatch Limited, Bungay, Suffolk

To find out more about our authors and books visit www.bloomsbury.com and sign up for
our newsletters

For
Robert Gitt
and
Anthony Slide

Contents

List of Illustrations

Introduction and Acknowledgments

"My name is John Ford. I make Westerns" has been one of the most celebrated pronouncements of the golden age of Hollywood. It occurred at the height of the McCarthyite purge on October 22, 1950 at an emergency meeting of the Screen Directors Guild, of which Ford was a founder member. It was called by Cecil B. de Mille and a right wing cabal on the board of directors of the Guild with the aim of ousting the liberal Guild president Joseph L. Mankiewicz who was opposing the introduction of a compulsory loyalty oath and a black list of those refusing to take it. Ford denounced the proposed black list, called for the resignation of the board of directors and a vote of confidence in Mankiewicz. He carried the day. It is a measure of the respect with which Ford was held in the industry that he triumphed over the forces of reaction. Ford was admired not only by the giants of the American film industry (Orson Welles, Frank Capra, Howard Hawks, Alfred Hitchcock, Samuel Fuller, Martin Scorsese, Anthony Mann and Steven Spielberg) but also by the titans of world cinema (Satyajit Ray, Jean Renoir, Mark Donskoi, François Truffaut, Federico Fellini, Ingmar Bergman and Akira Kurosawa). Sergei Eisenstein wrote that the American film he most wished he had made was John Ford's *Young Mr. Lincoln*. Ford was chosen in 1973 as the first recipient of the American Film Institute's Life Achievement Award and he became the first American film-maker to receive the country's highest civilian award, the Medal of Freedom. He certainly directed some of the greatest Westerns ever made (*Stagecoach*, *My Darling Clementine*, *The Searchers*, *Fort Apache*, *Rio Grande*, *She Wore a Yellow Ribbon*, *The Horse Soldiers*). But he was much more than a maker of Westerns. He received four best director Oscars but none of them was for a Western. In fact he made no Westerns between 1929 and 1939. When he was honored in 1972 by a Screen Directors Guild "Salute", the film he chose to accompany the ceremony was his Welsh family saga *How Green Was My Valley* and not one of his celebrated Westerns.

The literature on Ford is extensive, but there has been an overconcentration on the Westerns to the neglect of the non-Western films. While he was

undoubtedly devoted to the world of the American West and the values it embodied, he had other current preoccupations, and he explored them in a series of films that deserve to be better known. His other cinematic worlds included Ireland, the Family, Catholicism, War, and the Sea, which share with the Westerns the recurrent themes of memory and loss, the plight of outsiders and the tragedy of family break-up. The principal object of this book is to analyze these other worlds. It is not a biography though inevitably elements of his life and beliefs will feature in the analysis. There are three outstanding biographies of Ford by Tag Gallagher (*John Ford: the Man and his Films*, 1986), Scott Eyman (*Print the Legend: the Life and Times of John Ford*, 1999) and Joseph McBride (*Searching for John Ford*, 2001). This study will engage with these writers and with other influential Ford scholars such as Lindsay Anderson, Peter Bogdanovich, Andrew Sinclair, Andrew Sarris and J. A. Place in what will be a revisionist account, challenging many judgments on individual films and seeking to re-evaluate titles frequently dismissed as failures or marginal works, among them such neglected masterworks as *Mary of Scotland*, *The Fugitive*, *The Hurricane*, *Wee Willie Winkie* and *Gideon's Day*. It is intended to follow up this book with a second volume, *John Ford's American Worlds* which will re-examine not only his films set in the West but also those films set in the South and in New England and in America's historical past.

This book has been many years in the making and during that time I have incurred many debts of gratitude for help and advice of various kinds. I wish to thank in particular John Birchall, James Chapman, Stephen Constantine, Michael Coyne, Estel Eforgan, Allen Eyles, Sir Christopher Frayling, Philip French, Mark Glancy, Tom Hamilton, Kevin Harty, Joel Hockey, Corinna Peniston-Bird, Sara Bryant, and Linda Persson. I am grateful to Robert Gitt and Anthony Slide for making available unpublished interviews with Frank Baker, Eileen Crowe and Mary Ford. This book is dedicated to them in recognition of many years of valued friendship. Stills are from the author's collection. Thanks are due to Caroline Maxwell for compiling the index.

1

John Ford: The Enigmatic Genius

Ford the Man

John Ford, arguably the greatest of all American film directors, was born John
Martin Feeney on February 1, 1894 in the state of Maine. He was the youngest
surviving of the eleven children of Irish immigrants John A. Feeney and
Barbara Curran Feeney. Having failed the entrance examination for the US
Naval Academy at Annapolis, he joined his elder brother Frank in Hollywood
in 1914. Frank, who had rechristened himself Francis Ford, had arrived in
1907 and established himself as a director and star in the fledgling movie
industry. Known henceforth as Jack Ford, the young John Feeney became a
props man, a stunt man and an extra in his brother's films. None of Frank's
films have survived. But Ford told Peter Bogdanovich that Frank had been his
greatest influence:

> He was a great cameraman—there's nothing they're doing today . . . that he
> hadn't done; he was a good artist, a wonderful musician, a hell of a good
> actor, a good director . . . he just couldn't concentrate on one thing too long.

He also acknowledged the influence of Griffith ("D. W. Griffith influenced us
all").[1] But as Frank's career declined due to alcoholism and poor business
decisions, Jack's took off. Ford would later employ his brother as a character
actor, often playing drunken old derelicts, which some have seen as payback
for Frank's patronizing treatment of the young Jack.

Ford began directing two-reelers in 1917 and soon graduated to features
with *Straight Shooting*. Teamed with cowboy star Harry Carey, he directed 22
films at Universal between 1917 and 1921. The stories were devised by Ford

[1] Peter Bogdanovich, *John Ford*, Berkeley: University of California Press, 1978, p. 40.

and Carey and featured a continuing character, a good-bad man called Cheyenne Harry. Ford recalled of these Westerns: "They weren't shoot-em-ups, they were character stories. Carey was a great actor".[2]

Anxious to strike out on his own and establish a solo reputation, and jealous of Carey's greater earnings (Carey was being paid $2,250 a week to Ford's $300), Ford moved from Universal to Fox where in 1923 he changed his billing from Jack to John Ford and achieved a great hit with his Western epic *The Iron Horse* (1924). He successfully weathered the change from silent to sound films and made no Westerns between 1926 and 1939. Instead he worked in a variety of genres mainly at Fox (later 20th Century-Fox) and RKO Radio Pictures, winning his first Oscar for his Irish melodrama *The Informer* in 1935.

He established a productive relationship with screenwriter Dudley Nichols and they were to work on fourteen films together. As Stephen O. Lesser writes:

> The Ford–Nichols relationship was critical in the developing careers of both men, although Nichols' contribution to Ford's style has become a matter of dispute. In recent times, the weight of opinion has swung against Nichols, claiming that Ford only revealed himself as a poet of the cinema once free from the schematic bonds of Nichols's screenplays. On the other hand, it was only after Ford had discovered Nichols that Ford achieved the critical success needed to fuel his career and establish his reputation. It is safe to say that the two men shared similar outlooks and worked well together, each bringing out tendencies in the other that resulted in a symbolic, atmospheric style of filmmaking.[3]

Another key relationship in Ford's career was with Darryl F. Zanuck, head of 20th Century-Fox. Zanuck told his biographer Mel Gussow in 1968:

> In reviewing all the work of the many directors I have finally come to the conclusion that John Ford is the best director in the history of motion pictures . . . Ford had that enormous sense of the visual. He makes the camera act . . . He was an artist. He painted a picture—in movement, in action, in still shots . . . He was a great great pictorial artist.[4]

[2] Bogdanovich, *John Ford*, p. 39.
[3] Robert E. Morsberger, Stephen O. Lesser and Randall Clark, eds., *Dictionary of Literary Biography vol. 26: American Screenwriters*, Detroit, MI: Gale Research Co., 1984, p. 229.
[4] Mel Gussow, *Zanuck: Don't Say Yes Until I Finish Talking*, London: W. H. Allen, 1971, pp. 163–4.

Ford returned the compliment:

> Darryl's a genius—and I don't use the word lightly ... he is head and shoulders above all producers ... We had an ideal relationship.[5]

This is remarkable coming from Ford who detested most producers and resented any tampering with his films. Zanuck had absolute control of 20th Century-Fox, choosing the properties, assigning scripts to writers, deciding the casts, supervising the final edit. With Ford who cut in the camera as he was filming, Zanuck's main effect was to reduce the running time of Ford's films by editing out what he considered extraneous scenes slowing down the trajectory of the story. The studio's fondness for Americana allowed Ford to make his easy-going Will Rogers trilogy and three masterpieces, *Young Mr. Lincoln* (1939), *Drums Along the Mohawk* (1939) and *The Grapes of Wrath* (1940) which brought Ford his second best director Oscar. A third followed for *How Green Was My Valley* (1941) before the war interrupted his career. He set up the Field Photo Unit which became the cinematic branch of the Office of Strategic Service (OSS) and was employed throughout the war making training films and documenting the progress of hostilities. Two of Ford's documentaries won Oscars, *Battle of Midway* (1942) and *December 7th* (1943), although they were not specifically awarded to the director. Much against his will, Ford was seconded from the unit to MGM in 1945 to make a tribute to the PT (Patrol Torpedo) boats, *They Were Expendable*, which turned out to be another masterpiece.

Anxious to avoid being tied to a studio, he set up after the war an independent company, Argosy, with Merian C. Cooper. Their first production, the Catholic allegory *The Fugitive*, was a box office disaster and Ford produced his celebrated cavalry trilogy, *Fort Apache* (1948), *She Wore a Yellow Ribbon* (1949) and *Rio Grande* (1950), to recoup the company's fortunes. He also established a new partnership with the journalist Frank Nugent who was to script eleven films for Ford, including *The Quiet Man* (1952), his long-cherished Irish romance which brought him his fourth best director Oscar.

During the 1950s Ford became increasingly disenchanted with American society and his vision darkened. During the 1920s and 1930s he can be seen

[5] Gussow, *Zanuck*, pp. 162–3.

actively subscribing to an optimistic populist view of American history and society. In his films, the move is always westward: from Europe to America (*Mother Machree, Four Sons, Flesh, The Informer, How Green Was My Valley*), the dream of the immigrant; and in America from East to West, the aim of the pioneer (*The Iron Horse, 3 Bad Men, Drums Along the Mohawk, Wagon Master*). His films reached an optimistic peak with *Wagon Master* (1950) which tells of a Mormon trek across the desert in search of the Promised Land.

But with the development of the Cold War, anti-Communist paranoia fueling the McCarthyite purges and the beginning of civil rights agitation, Ford turned from the optimistic age of frontier America and the dream of an ideal society to be created there and began to eulogize settled traditional societies with what is basically paternalist government, sustained by simple Christian faith, good neighborliness and time-honored rituals; hence his affectionate depictions of Old Ireland (*The Quiet Man*), the Old South (*The Sun Shines Bright*) and the South Seas (*Donovan's Reef*).

However, he depicts a bitterly divided United States in films about the Civil War (*The Horse Soldiers, How the West Was Won*), and he begins to explore the impact of racism on American society in *The Searchers* (1956), regarded by many as his greatest film, *Sergeant Rutledge* (1960), *Two Rode Together* (1961) and *Cheyenne Autumn* (1964). He celebrates an old-style political machine in *The Last Hurrah* (1958) and provides a melancholy elegy for the Old West in *The Man Who Shot Liberty Valance* (1962). His box office appeal began to wane as two personal projects *The Rising of the Moon* (1957) and *Gideon's Day/Gideon of Scotland Yard* (1958) failed badly at the box office. The balance of power between him and his favorite star John Wayne shifted. Increasingly Ford could only get his projects off the ground if Wayne agreed to star. His health began to fail and longtime associates noticed his energy levels falling and his increasing preference for shooting in the studio and avoiding the rigors of location filming. In a 1959 interview he lamented, "The old enthusiasm has gone maybe. But don't quote that. Oh, hell, you can quote it."[6] A lifetime of alcoholism caught up with him and he had to withdraw from *Young Cassidy* (1965) as he had from *Mister Roberts* (1955). When his final film *7 Women* (1966) was both

[6] Joseph McBride, *Searching for John Ford*, London: Faber and Faber, 2003, p. 600.

a critical and box office failure, MGM canceled his next project and thereafter he could not raise finance for any of his projects. As he lamented to French critic Claudine Tavernier, repeating it over and over again, "They won't let me make any more films".[7]

In the 1930s he had described himself as "a definite Socialistic democrat"[8] and still defined himself as a Democrat in the 1960s.[9] But after World War Two he moved steadily to the right though never as far right as his friends John Wayne and Ward Bond. With his strong commitment to the military, he supported the unpopular Korean and Vietnam Wars. However, his disillusionment proceeded apace in the 1960s. As he told British interviewer Philip Jenkinson in 1970:

> I'm worried about these riots, these students. I'm worried about this anti-racism. It doesn't mean the Negroes are doing it. They are being influenced by outside. Some other country. They are agents, the people who are doing things, that are being arrested . . . and the poor Negroes are getting the blame. That's why I think our ancestors would be . . . bloody ashamed of us if they saw us now.[10]

In 1971 Ford was diagnosed with terminal cancer. He lived long enough to receive the first American Film Institute Life Achievement Award and the Presidential Medal of Freedom, the highest civilian award in the United States, before he died on August 31, 1973.

Ford was a nightmare for interviewers. He said: "I hate pictures—well, I like making them, but it's no use asking me to talk about them."[11] When he was not answering in monosyllables, he would make things up, embellish or deny the truth, contradict previous statements. He hated analyzing his films. His attitude was akin to that of the similarly uncommunicative Rudyard Kipling who would answer questions about his life and work with the statement "It's all in the books". For Ford his films spoke for themselves and said everything he wanted to say.

His films were the world as he wanted it to be and it overlapped with reality to the extent that he twice made feature films about real-life friends, John

[7] Gerald Peary, ed., *John Ford Interviews*, Jackson: University Press of Mississippi, 2001, p. 103.
[8] McBride, *Searching for John Ford,* p. 193.
[9] Peary, *John Ford Interviews*, pp. 48, 107.
[10] Peary, *John Ford Interviews*, p. 140.
[11] Louis Marcorelles, "Ford of the Movies", *Cahiers du Cinéma 86* (1958), p. 32.

Bulkeley (*They Were Expendable*) and Frank "Spig" Wead (*The Wings of Eagles*); three if you count Wyatt Earp whom he claimed to have known in the 1920s and who described to him the gunfight at the O.K. Corral, the subject of *My Darling Clementine*. He also made a documentary tribute, *Chesty*, to another old friend, General Lewis "Chesty" Puller and tried and failed to make a biopic of his wartime commander, "Wild Bill" Donovan, who was to have been played by John Wayne. Ford even portrayed himself in one of these films, choosing one of his closest friends Ward Bond to play him under the name John Dodge in *The Wings of Eagles*. It is an embodiment of the mythic Ford. Bond, equipped with Ford's hat, pipe and Oscars, projects the image of the irascible but good-hearted professional, an anti-intellectual who claims to have played Robert E. Lee in *The Odyssey*, and who signs "Spig" Wead as a scriptwriter with the instruction to write about "People! Navy people!"

John Ford the man was deeply insecure, haunted by demons, riven by contradictions, "an unquiet man" as his grandson Dan Ford called him.[12] Although he was extremely well-read, he posed as an illiterate. He dismissed descriptions of himself as a poet and an artist as "horseshit", claiming just to be a hard-nosed run-of-the mill professional doing a job of work.[13] On the contrary, it is clear from his admiration for F. W. Murnau and his close study of the German Expressionist classics that he consciously sought to produce works of art but would never admit it lest he come across as an intellectual, an aesthete or as a pretentious sissy. He also had an acknowledged mission to film the works of Irish and Irish American writers. A measure of his desire to be taken seriously as an artist is his move away from Westerns to more general film fare, his change of studio (from Universal to Fox) and his change of name (from Jack Ford to John Ford). He was socially insecure. As an Irish American Catholic from an immigrant family in a Protestant-dominated country, as someone married to a socially superior Protestant blueblood, and as a college dropout, he proudly proclaimed himself a peasant and a rebel. But he sought advancement in the Navy as an officer and a gentlemen and sought to amass medals and decorations as recognition of his service. He found acceptance in the studio system where, unlike another famous rebel and maverick, he was

[12] Dan Ford, *The Unquiet Man*, London: William Kimber, 1979.
[13] Peary, *John Ford Interviews*, p. 159.

able to work. Orson Welles, working mainly outside the system, managed to complete a dozen films between 1941 and 1985; Ford made over 130 between 1917 and 1965.

Ford was also sexually insecure, a trait detected by many who knew him best. His work was a means by which he sought to reconcile his personal dilemmas. For someone who celebrated the family in his films, he was an unsatisfactory husband and father. For a man proud of the United States, he was torn between the two sides in the matter of the Civil War. Revering Abraham Lincoln and coming from the Northern state of Maine, he was intellectually a Unionist. But as a romantic and an admirer of the chivalric code, he was temperamentally a Confederate. This is confirmed in a 1949 article by Frank Nugent.[14] The fact that he re-read *The Three Musketeers* once a year and spent several years trying to set up a production of Sir Arthur Conan Doyle's *The White Company* underlines his commitment to chivalry.[15] It is no wonder that he claimed that he had an uncle who had fought on both sides in the Civil War and he used the cavalry trilogy to show the two sides being reconciled by service in the US cavalry.

Harry Carey Jr., who appeared in nine Ford features and one television film, commented on Ford's attitude to his actors:

> Jack was a man for all seasons, but not a man for all actors. He was kind to the tough and cruel to the fainthearted, paternal and gentle to the girls. They *loved* him, but he was afraid of them.[16]

It is interesting that he should have detected a fear of women, for Michael Wayne, John's eldest son, sensed the same thing: "Ford had respect for women but he also had a fear of women".[17] Women recognized the sensitivity in him. Mary Astor, who worked with him in *The Hurricane*, found him "Terse, pithy, to the point. Very Irish, a dark personality, a sensitivity which he did everything to conceal".[18]

[14] Gaylyn Studlar and Matthew Bernstein, eds., *John Ford Made Westerns*, Bloomington, IN: Indiana University Press, 2001, p. 264.
[15] Peary, *John Ford Interviews*, pp. 98–99; Tag Gallagher, *John Ford: The Man and his Films,* Berkeley: University of California Press, 1986, p. 545.
[16] Harry Carey Jr., *Company of Heroes*, Metuchen, NJ and London: The Scarecrow Press, 1994, p. 59.
[17] Scott Eyman, *Print the Legend: The Life and Times of John Ford*, New York: Simon and Schuster, 1999, p. 401.
[18] Mary Astor, *A Life on Film*, New York: Delacorte Press, 1971, p. 134.

Katharine Hepburn found him "enormously, truly sensitive".[19] Myrna Loy, whom he directed in *Black Watch* and *Arrowsmith*, recalled "John Ford had tremendous sensitivity, but we seldom see the gentle things he did".[20] Anna Lee wrote: "He could be absolutely hideous to people, very nasty and unpleasant. On the other hand he had a very loving heart. He was always kind to me."[21] In part, this stemmed from the fact that during the shooting of her first Ford film, *How Green Was My Valley*, she suffered a miscarriage. Ford was devastated, closed down the film for a day and thereafter took a particular interest in her well-being. Australian actor Frank Baker recalled: "He had a strange, old-world quality with women. He was always very nice to women, always very courteous to them. You would never hear bad language on a John Ford set ... God! If you used bad language in front of women, he'd throw you right off the set."[22] But it is no coincidence that when he created the Field Photo Farm after the war, it was an all-male enclave, with a prominent sign reading "No women allowed". For he was happiest and most comfortable in all-male company. Dudley Nichols offered Lindsay Anderson an acute insight into Ford. He said Ford had "one blind spot—his inability to deal with the man–woman relationship with feeling and insight, no matter how clearly it is written in the script ... Ford's weakness ... is that he cannot create in his actors the normal man–woman passions, either of love or the hate that is the dark side of impassioned love. I should guess he does not know it, does not understand it."[23] Harry Carey Jr. revealed that it became a standing joke that Ford hated to direct love scenes and usually left them to the end of the shooting.[24]

The dark side of his sensitivity was his reaction to criticism. He knew exactly how he wanted to make his films and when he was satisfied with a scene that was it. If ever an actor asked for another take to improve his performance, Ford might reshoot it with no film in the camera or shoot it and then hand the piece of film to the actor if indeed he agreed to reshoot it at all. He would accept no suggestions from the cast about his shooting of the film. When Katharine

[19] McBride, *Searching for John Ford*, p. 114.
[20] James Kotsilibas-Davis and Myrna Loy, *Myrna Loy: Being and Becoming*, London: Bloomsbury, 1987, pp. 57–58.
[21] Anna Lee and Barbara Roisman Cooper, *Anna Lee*, Jefferson, NC and London, 2007, p. 138.
[22] Frank Baker, unpublished interview with Robert Gitt and Anthony Slide, July 30, 1977.
[23] Lindsay Anderson, *About John Ford*, London: Plexus, 1981, p. 241.
[24] Carey, *Company of Heroes*, p. 119; McBride, *Searching for John Ford*, p. 231.

Hepburn and Will Rogers made a suggestion about shooting a scene, he stalked off and told them to shoot it themselves. Hepburn did.[25] When Helen Hayes complained about his changes to the script he barked "Get on that set and stick to your acting—such as it is."[26] He could not take criticism. When a preview showing of *The Informer* went down badly, he was physically sick and when audiences laughed at the love scenes in *Black Watch* he went on one of his alcoholic benders. His habit of chewing on a handkerchief all the time he was shooting bespeaks someone who is intensely nervous.

Coupled with the sensitivity was the fact that he was extremely sentimental and wept easily. In order not to reveal this to the world, he developed an alternative personality. This process was observed by Frank Baker who worked with him for forty years and also encountered the extreme reaction to criticism. When in *Hearts of Oak* (1924) Ford criticized his acting in characteristically extreme terms ("You're the worst actor I've ever seen in my life"), Baker snapped back "You are the worst director I have ever worked for". Ford replied: "As long as you work for me you're not going to get a screen credit". Baker worked for him on twenty-seven films until 1963 and Ford remained true to his word. Baker never did get a screen credit. Over the years Baker was able to view Ford at close quarters and concluded:

> He was two completely different people, one is the real John Ford. And the real John Ford is so much different from the John Ford we know, the tough, ruthless, sarcastic individual. He's so very different to the real John Ford, who's a very kind individual. But he was afraid of that. And the John Ford we know is a legend, a living legend who was created by John Ford to protect the other John Ford, the sympathetic, sentimental, soft John Ford. I am quite assured now that John Ford was perhaps suffering tremendously from a very great inferiority complex, and sitting right at the fountain of that inferiority complex was his brother Francis. He knew that this was where it all came from, and he took it out on Frank for the rest of his life ... Everything that John Ford did, I could see the reflection of Frank. Camera angles and different touches. He'd say "How do you like that?" and I'd say "I've seen that before" and he'd go as cold as anything. He had an amazing admiration of his brother ... but he was completely jealous of him.[27]

[25] The films involved were *Doctor Bull* (Will Rogers) and *Mary of Scotland* (Katharine Hepburn).
[26] The film was *Arrowsmith*. Helen Hayes, *On Reflection*, New York: M. Evans and Co. Inc., 1968, p. 189.
[27] Frank Baker interview.

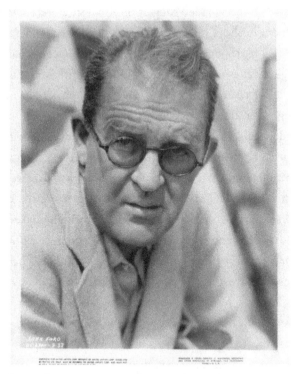

Figure 1.1 John Ford—1930s portrait photograph

If one source of Ford's insecurity was comparison with his brother, another was his concern about his masculinity. His shyness with women and his preference for male company led associates to speculate about his sexuality. Garry Wills argues:

> Ford, especially in the 1920s, favored brawny types, like George O'Brien, a weightlifter who posed for muscular nude shots. Ford often stripped O'Brien's shirt away at the climax of the action. The fight that ends *The Iron Horse* is a good example. He also took off the young Victor McLaglen's shirt (*The Black Watch*, *The Lost Patrol*) ... Harry Carey (Senior) and Joe Harris, who had worked with Ford in his silent days, speculated about the "crushes" he formed for various beefcakes.[28]

In an article for an Italian film magazine in 1951 Ford described his feelings for John Wayne, of whom he says "he is, has always been and always will be my pal". It sounds like love at first sight.

[28] Garry Wills, *John Wayne: The Politics of Celebrity*, London: Faber and Faber, 1997, p. 47.

I have liked Duke's style since the first time I saw him in 1928 when I went to USC to recruit a bunch of athletes to play in a football game in *Salute* ... Duke was not as strong or as developed as the other young men I saw ... However I was struck by his self-assured manner. I also liked his smile—easy and natural.

He had "tremendous energy", "displayed that masculine ease which is the secret of success on the silver screen" and conveyed to the audience what it was to be a "real man." "When acting in a dramatic role, he behaves in the same way as he would in real life. It is this kind of acting that makes a film both beautiful and believable".[29] Ford took him up as prop man, stunt man and extra. But more important he admitted him to his social circle. However once Marion "Duke" Morrison was spotted by Raoul Walsh and given a new name (John Wayne) and the star role in his epic Western *The Big Trail* (1929), Ford did not speak to him for three years. Wayne never understood why. But it stands out a mile. Ford was jealous. His protégé had been stolen from him. But once the film failed at the box office and Wayne retreated to cheap B picture Westerns to hone his craft, Ford readmitted him to his circle but did not cast him until *Stagecoach* in 1939. Ford was furious with Wayne for avoiding military service in World War Two but eventually forgave this—another measure of his affection. Wayne repaid him with absolute and unquestioning devotion throughout his career.

Another means Ford employed to conceal his soft side and assert his control of the set was observed by Frank Baker:

He always picked somebody at the beginning of a picture and he'd let them have it. You couldn't do anything right. And he just sat there with that flat voice and he would attack you; he would humiliate you. He'd make you grovel. I could never understand why he'd do that, and he'd do it right through the picture.[30]

It could be established players he would pick on (Victor McLaglen in *The Informer*, Thomas Mitchell in *Stagecoach*, Walter Brennan in *My Darling Clementine*, Eddie Albert in *7 Women*, J. Carrol Naish in *The Fugitive*, John Carradine in *Mary of Scotland*, Donald Sinden in *Mogambo*, O. Z. Whitehead

[29] Studlar and Bernstein, *John Ford Made Westerns*, pp. 272–3.
[30] Frank Baker interview.

in *The Grapes of Wrath*). One of his targets was stage actors. But more often than not it was good-looking, inexperienced young actors (Humphrey Bogart in *Up the River*, Norman Foster in *Pilgrimage*, Harry Carey Jr. in *3 Godfathers*, John Agar in *Fort Apache*, Robert Wagner in *What Price Glory*) and there must be a suspicion that he behaved like this to disguise a certain *tendresse*.

Another manifestation of his sensitivity to criticism and exercise of autocratic caprice was his tendency to banish people who offended him. Actor George O'Brien abandoned him when he was in a drunken stupor on their Far Eastern tour in 1931. Ford banished him until 1948 when he was recalled for *Fort Apache*. When Victor McLaglen turned down a part in *The Long Voyage Home* (1940) because the salary was too small, Ford banished him also until 1948 and *Fort Apache*. Andy Devine was playing the driver in *Stagecoach* (1939) when Ford got angry with him and said "I don't know why the hell I'm using you in this picture" and Devine replied "Because Ward Bond can't drive six horses". Ford did not speak to him for six years and did not employ him again until 1961. Ben Johnson was banished for 13 years after Ford overheard him say at dinner during the filming of *Rio Grande* (1950): "there was a lot of shootin' goin' on today, but not too many Indians bit the dust". This despite the fact that Johnson was under contract to Argosy Pictures and being groomed for stardom.

In her autobiography, Maureen O'Hara, Ford's favorite leading lady, explicitly asserts that Ford was gay and at one time had designs on her good-looking brother James Lilburn, whose acting career he later ruined out of spite. This revelation, says O'Hara, made sense of several facts about the Ford marriage, "the separate bedrooms, his insulting her, the periodic drinking, and the lack of outward affection they showed each other." She concludes:

> I now believe there was a conflict within Ford and that it caused him great pain and turmoil. These kinds of desires were something John Ford could readily accept in others, but never in himself. He saw himself as a man's man . . . he was also too immersed in the teachings of Catholicism. He would have seen it as a terrible sin.[31]

This conflict was her explanation for the punishing drinking bouts.

[31] Maureen O'Hara with John Nicoletti, *'Tis Herself*, London: Simon and Schuster, 2004, pp. 190–191.

The person Ford most resembles, unlikely as it may sound, is Alfred Hitchcock. Like Ford, Hitchcock was a Catholic and an exile (in his case from England). They were the products of lower middle-class families (Ford's father, a saloonkeeper, Hitchcock's, a green-grocer). Hitchcock's wife Alma Reville converted to Catholicism on marriage as did Ford's wife Mary McBryde Smith. Both men had sexual hangups and a streak of sadism. Both initially sought artistic respectability (Hitchcock by filming plays by John Galsworthy, Noel Coward and Sean O'Casey; Ford by filming plays by Eugene O'Neill, Maxwell Anderson and Sean O'Casey). Eventually they settled for mastery of a particular genre (Hitchcock the thriller, Ford the Western). But both believed that silent films were the purest form of cinema.

As Frank Nugent observed in a 1949 profile of the director:

> Ford never has formally surrendered to the talkies. His writers are under standing orders to keep dialog to an "irreducible minimum". Ford usually manages to trim the "irreducible" still more.[32]

Ford himself said: "I. . .am a silent picture man. Pictures, not words, should tell the story".[33]

One of the best known stories about Ford, repeated again at the American Film Institute Life Achievement Award dinner, is that on one film a producer turned up on set to complain that Ford was behind schedule. He promptly tore a dozen pages from the script and said "Now we're back on schedule". The problem with this story is that it is attached to a dozen different films. So either it is mythical or he did it regularly as a stunt—and he was a man with a penchant for practical jokes. Either way it underlines his preference for visuals over dialog.

Donald Sinden described his method of directing on *Mogambo* in which he starred with Grace Kelly:

> On the bank of a river a landing stage had been built and at it was moored a river steamer. The film crew and the camera were positioned on the bank and without a single word from Ford, Grace and I were bundled on to the boat which set off upstream. With us came the second assistant who

[32] Studlar and Bernstein, *John Ford Made Westerns*, p. 268.
[33] Peary, *John Ford Interviews*, p. 64.

established walkie-talkie communication with the unit. Round the bend of the river the boat stopped and turned about. We waited. No one had been given any instructions. We had no rehearsal; the script merely indicated: "The boat arrives and the scientist and his wife get off." Over the walkie-talkie we heard, "Roll 'em. Action", and the boat started to chug forward. Suddenly Ford's voice screamed over a loud-hailer: "Grace—Donald—get below. OK. Donald—come on deck. Look around at the scenery. Call Grace. Put your arm around her. Point out a giraffe over on your right. Get your camera out—quickly. Photograph it—the giraffe. Smile at him, Grace. Grace—you're scared. OK. You're coming into the pier. Look around. What's in store for you? Natives are running down to meet you. OK. OK. Cut. Print it." And that was our baptism of being directed by Ford: exactly what he had done in the days of silent films.[34]

Ford the Artist

Ford's films always had a distinctive look and feel, hence the adjective "Fordian". A Ford film was Fordian in its tendency to opt for an anecdotal structure rich in "business", comic interludes, gesture and incidental detail. An instinctive commitment to composition within the frame, the avoidance of camera movement, the sparing use of close-ups, a love of ritual and a fondness for improvisation were also characteristically Fordian. The regular use of the same actors and actresses, the so-called stock company, gave an enduring sense of family and continuity to his films.

Ford revealed his basic film-making philosophy to Jean Mitry in 1955 saying that the secret was to turn out films that pleased the public but also revealed the personality of the director. "Directing is a craft. If a director's films do not make money, he cannot expect to retain the confidence and goodwill of the men who put up the wherewithal". He went on to describe his involvement in the film-making process. "The *cutting*: I do it myself. And I plan the film. When a subject interests me, I also take part in the scripting. If the subject

[34] Donald Sinden, *A Touch of the Memoirs*, London: Hodder and Stoughton, 1982, p. 175.

doesn't interest me, I am satisfied to do my job to everybody's best interest. When I work with a scriptwriter, he outlines the situations, develops the continuity, writes the dialog. The shooting arrangements and the cutting, I do myself. We have numerous conferences with the cameraman, the set designer, and sometimes the actors. Each one knows what he has to do and understands the picture before starting to work on it. A well-prepared film is shot quickly."[35]

In 1967, Ford elaborated on his involvement in the scriptwriting of his films. "There's no such thing as a good script really. Scripts are dialog and I don't like all that *talk*. I've always tried to get things done visually. I don't like to do books or plays. I prefer to take a short story and expand it, rather than take a novel and try and condense it." He went on to describe precisely how he worked with the writer: "I spend the afternoon with him and work out a sequence: we talk and argue back and forth—he suggests something, I suggest something. That night or next morning, he knocks it out on his typewriter, blocks it out and we see whether we were right or wrong".[36] It is clear from this that the scriptwriter did literally provide the words but that the ideas, incidents, shape and structure, emerged from the discussion sessions. Here the groundwork was done, the blueprint prepared for the architect director to start building in the studio.

Rarely did Ford's name appear on the script credits but he admits to having actively rewritten several of the scripts he filmed bearing the names of other writers, to having provided original screen stories for some of his films and to having worked closely with particular writers for long periods. He wrote many of the early Universal Westerns together with the star Harry Carey, the credited scriptwriter often being just the man who wrote down the ideas. He also recalled completely rewriting (with William Collier Sr.) Maurine Watkins' script for *Up the River* and (with Dudley Nichols) rewriting in the space of eight days a highly unsatisfactory script for *The Lost Patrol*, presumably by Garrett Fort, who received a script credit. He worked closely on *Young Mr. Lincoln* with Lamar Trotti, without receiving credit and he injected original material into the scripts of several of his Fox assignments in order to liven them up. But more significant perhaps than this is the longstanding and richly

[35] Andrew Sarris, *Interviews with Film Directors*, New York: Avon Books, 1969, pp. 197–8.
[36] Bogdanovich, *John Ford*, p. 107.

productive relationships he had with two successive scriptwriters: Dudley Nichols and Frank Nugent. These relationships signify the two distinct periods of his career in sound films, pre-war and post-war.

Ford's Style

Ford's strengths both in his own words and according to the testimony of his collaborators were the directing of actors, an eye for composition, the ability to infuse life and spontaneity into scripts by means of "business", gesture and detail, a feeling for ritual and folk music. It is these strengths which dictate Ford's narrative style, a style summed up by his own predilection for the short story which could be expanded, and which suggested a central narrative framework that is constructed loosely enough to permit the maximum leeway for the elaboration of a comic incident, the extemporization of a dance or a fight, the improvisation of a dialogue exchange. What a close study of Ford's silent films reveals is the wealth of anecdotal detail, the development of character, atmosphere and business, at the expense of the central narrative line, which is sometimes lost sight of completely. This must be seen as Ford's style, and it is a style to which talkies must have seemed at first sight inimical. The introduction of dialogue, the increased importance of stage-trained actors and scenarists, were factors Ford would have to come to terms with.

He came to terms with them, thanks to Dudley Nichols, the first of his long-term writing collaborators. Critics have accused Nichols of being a pernicious influence on Ford. His influence was undoubtedly very strong but it did not lead to the results that some have suggested. He did not seduce Ford into stylization, symbolism or theatricality. These were second nature to Ford and can be seen in many of his pre-Nichols silent films. He did not inveigle Ford into filming prestige literary properties—for *The Fugitive*, *The Informer*, *The Plough and the Stars*, *The Long Voyage Home* were all films that Ford himself passionately wanted to make. What he did do was to impose on Ford's films a tight and controlled structure. When Nichols first came to Hollywood in 1929 and was assigned by Fox to work with Ford, he confessed that he had no idea how to write a film script. Ford told him to write a play in 50 or 60 scenes and Ford would turn it into a shooting script. This advice is the key to Nichols'

influence. His Ford scripts are essentially plays—organized, precise, tightly structured, carefully introducing and developing characters by dialogue and interplay, building up logically to a climax. This is aided by the fact that several of them were originally plays (*The Plough and the Stars, Mary of Scotland, The Long Voyage Home*). Even when they were not plays but novels to begin with (*The Lost Patrol, The Informer, The Hurricane, The Fugitive*), they are turned into structures similar to the plays. The notable exception to this is *Stagecoach*, which despite its careful narrative structure (the journey framework, the handful of strongly characterized people thrown together, the hallmarks of the Nichols scripts), is developed from a short story and allows Ford the greatest scope for digression in all the Nichols scripts. Thus perhaps the most characteristic feature of the Nichols scripts with the possible exception of *Stagecoach* is that their structure did not allow for the sorts of interpolation Ford loved. He himself was later to acknowledge this when telling Bogdanovich that *The Informer* was not one of his favorite films—"It lacks humor which is my forte".[37]

One might conclude that Ford was in awe of Nichols, playwright and intellectual (when he turned director, Nichols' own *magnum opus* was a marathon version of Eugene O'Neill's *Mourning Becomes Electra* which predictably failed at the box office), for his influence on Ford was never equaled by anyone else. Both before the Nichols period during the silent days, during the Nichols period when working with other writers, and subsequently, Ford's style is the familiar anecdotal one. The Will Rogers trilogy (*Doctor Bull, Judge Priest* and *Steamboat Round the Bend*) and the Americana classics *Drums Along the Mohawk* and *Young Mr. Lincoln* are all rich in comedy, business, anecdote, the creation of atmosphere at the expense of strict narrative development. On all except *Doctor Bull*, Ford's chief script collaborator seems to have been Lamar Trotti. After the war when Nichols turned director himself and Ford left 20th Century-Fox to found his own production company Argosy, Ford inaugurated a new relationship—with critic and writer Frank Nugent and in this relationship Ford seems to have been the stronger personality. The films they made together (the cavalry trilogy, *Wagon Master, The Searchers, The Quiet Man, The Last Hurrah*) brought to perfection the anecdotal style. In all

[37] Bogdanovich, *John Ford*, p. 59.

the films Nugent worked on and indeed all of Ford's later films this is the predominant style. Probably the only exceptions are *Mogambo* and *7 Women*. In *Mogambo* he manifestly was not interested. "I don't know a thing about it" he said in 1955, "I haven't even seen it. But why should I have deprived myself of a trip to Africa and the chance to make one more film? One does one's job. The film of really personal interest is an exception".[38] The 1966 film *7 Women* is an unexpected reversal to the Thirties, and Nichols' structure and approach. The subordination of narrative line to anecdote is something which enraged traditionally narrative-orientated critics. Ford was habitually accused of self-indulgence, disregard for plot development, dramatic naïveté. What he had in fact done was to bring his own style to perfection. Asked what sort of stories he liked, Ford replied: "Anything with interesting characters—and some humor".[39] These are the aspects that his style of film-making particularly favored. Nugent described to Lindsay Anderson the process of working with Ford:

> Usually a script is written scene by scene, gone over, discussed, rewritten maybe, then okayed—and you don't go back over it again...With Jack, once the scene is okayed, you can put it behind you.[40]

Winston Miller, who co-wrote *My Darling Clementine*, confirmed this, saying Ford thought in terms of scenes and not of strict narrative progression.[41] Ford introduced Nugent to the habit of writing potted biographies of the main characters ("Where born, educated, politics, drinking habits (if any), quirks"), something he continued in his writing career. But he makes it clear that "the finished picture is always Ford's, never the writer's". This is because Ford would add and improvise and cut dialogue he considered excessive. Nugent recalled that *The Quiet Man* was filmed with "remarkably few changes". But *Wagon Master* and *She Wore a Yellow Ribbon* faced script cuts which he considered "rather harsh".[42]

Someone who entirely rejected the idea of Ford making creative input to the scripts was Nunnally Johnson, who scripted *The Prisoner of Shark Island*,

[38] Sarris, *Interviews*, p. 199.
[39] Bruce Beresford, "John Ford: Decline of a Master", *Film* 56 (Autumn 1969), p. 6; Peary, *John Ford Interviews*, p. 62.
[40] Anderson, *About John Ford*, p. 244.
[41] Ronald L. Davis, *John Ford: Hollywood's Old Master*, Norman and London: University of Oklahoma Press, 1995, p. 183.
[42] Anderson, *About John Ford*, pp. 424–4.

The Grapes of Wrath and *Tobacco Road*. Believing that the writer's role in the collaborative process of film-making was persistently underrated and the director's role overemphasized, he told Lindsay Anderson:

> I wrote the scripts without thought of the director to do them and they were offered to him by Zanuck, who selected all the directors for my pictures in those days. All were accepted in the form offered, and though I have worked with directors who made suggestions and contributed ideas, I can't remember that John ever said anything one way or the other about them. Nor can I remember his ever altering or rewriting any of the scripts on the set. It was on the set, I might add, that John made all his contributions to the picture. These were in the staging of the scenes, the shaping of the characters and his wonderful use of the camera. In any case, the pictures he did for me, for good or bad, were completely faithful to the text of the script.[43]

Business and Gesture

Ford's distinctive talent lay not in any one particular photographic style but in the exposition of character, the flair for detail, the evocation of atmosphere and most importantly the orchestration of these effects into a coherent totality. A small but perfect example of this genius can be seen in a little scene in *The Prisoner of Shark Island*. Colonel Dyer, old Southern veteran and father-in-law of Dr. Mudd, decides to sell his sword to raise money to help get his son-in-law out of prison. He stumps over to a trunk, muttering to himself, flings things out, reverently taking out a bottle and putting it on one side, and then he pulls out the sword which Stonewall Jackson gave him and, declaring he'll sell it and run through anyone who offers him less than $150, he strides out. The camera is stationary throughout this scene, which is filmed in medium shot. It is a small vignette with comic intent but is irresistibly touching. The colonel's uniform— Confederate great coat and plumed hat—lend him dignity and a cavalier presence. The use of *Dixie* on the soundtrack, beginning quietly and rising to a triumphant crescendo, stresses the patriotism and sacrifice of the old man. His reverence for the bottle and the sword tells us volumes about his character, while he remains for much of the scene with his back to the camera muttering

[43] Anderson, *About John Ford*, p. 247.

to himself. The coordination of costume, music, movement and gesture create precisely the effect Ford was seeking—a mingling of comedy and pathos.

Ford admitted that he allowed himself to improvise but strictly within the predetermined framework. "You don't 'compose' a film on the set; you put a predesigned composition on film. It is wrong to liken a director to an author. He is more like an architect, if he is creative."[44] In this regard, Ford's approach is similar to Hitchcock's and it explains why he frequently completed his films in a matter of weeks. Ford recalled improvising the entire Slim Summerville part in *Air Mail*, much of the trial sequence in *The Informer* and bits of business in the Will Rogers trilogy. The actors who worked on *Stagecoach* were kept on the set when they were not actually shooting so that they could be on hand if Ford came up with extra bits of business or lines of dialogue.[45] Ford himself told Bogdanovich that he liked to keep the writer on the set to create new lines to cover situations that arose during shooting and that Nichols in particular was always on set.[46] Bogdanovich's own account of a visit to the locations where Ford was shooting *Cheyenne Autumn* provides a revealing demonstration of the improvisatory Ford, devising lines and action as he goes and which the script girl frantically writes down trying to keep up with him.[47]

It is worth pointing to the contrast with Cecil B. DeMille here, a director who like Ford worked with a stock company, habitually came up with scenes and lines from his old films when scripting the new ones, and some of whose films superficially recall some of Ford's (*cf. Union Pacific* and *The Iron Horse*, *Unconquered* and *Drums Along the Mohawk*, *The Story of Dr. Wassell* and *Arrowsmith*). He too took the architectural concept of cinema as his longtime scriptwriter Jesse Lasky Jr. testified:

> A DeMille script was something very different than most other scripts were or are because DeMille made his film on paper. He actually laid out every scene, every cut, every piece of business. There was very little creation done on the set. His scripts were enormous. The detail in them was tremendous. You not only wrote the dialogue but you timed the dialogue with the business of the character. So that every step was actually worked out with floor plans

44 Sarris, *Interviews*, p. 198.
45 Bob Thomas, ed., *Directors in Action*, Indianapolis: Bobbs-Merrill Company Inc., p. 164.
46 Bogdanovich, *John Ford*, p. 107.
47 Bogdanovich, *John Ford*, pp. 6–19.

of the set and with the art department and he planned the whole movement. When you went on the set, it was just about as it had been on paper. He hated to change, to improvise.[48]

Unlike Ford, DeMille's early training had been in the theater. He had written plays in the Belasco tradition and his view of the cinema was shaped by this early training. Reams of dialogue, complex and ramified narratives in which telling the story predominated, one-dimensional characters, a fondness for shooting in the studio, these are the hallmarks of the DeMille film. He had no time for the improvisatory flash of imagination and he paid no attention to the actors. Despite his huge casts, and the regularity with which he used the same players (Victor Varconi, Julia Faye, Francis MacDonald, Ian Keith, etc.), they never had a quarter of the individuality that Ford gave his one-scene bit players like Mae Marsh, Jack Pennick or Hank Worden.

What one misses most of all in DeMille and in many much greater directors—such as Henry King and Raoul Walsh, favorites of Ford, men of similar outlook and tastes, excellent directors with a feeling for visuals, pace and atmosphere—is that whole extra dimension of gesture and incident which enriches the bare bones of a plot and creates the feeling of an entire universe recreated on celluloid and not just a story from beginning to end, a universe which will continue when the film is finished, and in Ford's case does continue from film to film.

The gesture or piece of business is used not just for its own sake but to encapsulate character, convey mood, demonstrate emotion. Ford's most characteristic gestures and bits of business are developed from film to film, linking his work together and deepening in resonance with each successive use. Sometimes he uses a line of dialogue for this purpose. "A slug of gin, if you please"—the shabby genteel comic-pathetic line of the would-be respectable lady turns up in *The Long Voyage Home* (Mildred Natwick), *Gideon's Day* (Maureen Potter), and *Donovan's Reef* (Dorothy Lamour) for instance. Similarly he sometimes uses catchphrases whose repetition conveys more than speech after speech of dialogue: John Wayne's defiant "That'll be the day" in *The Searchers*; the professional's litany "That's what I get paid for" which links Wyatt Earp in *My Darling Clementine* to Nathan Brittles in *She Wore a Yellow Ribbon*;

[48] Jesse Lasky Jr., *Whatever Happened to Hollywood?*, London: W. H. Allen, 1973, p. 258.

John Wayne's "Never apologize, mister, it's a sign of weakness"; and Ben Johnson's "That ain't in my department" in *She Wore a Yellow Ribbon*.

But more often than dialogue, there is the gesture. Probably the most famous gesture in all Ford is in *The Searchers* when Ward Bond as Captain the Reverend Samuel Clayton, the Ranger leader, deliberately looks away when he sees Martha Edwards stroking the folded coat of her brother-in-law Ethan, revealing her deep unspoken love for him. No commentator, however, has noted it is in fact a combination of two previous gestures in Ford's work—Lincoln looks away as the childhood sweethearts in *The Iron Horse* kiss, just as later Nathan Brittles looks away while Mac Allshard and his wife kiss in *She Wore a Yellow Ribbon*, allowing a private gesture the privacy it deserves, while in *Rio Grande* Maureen O'Hara strokes John Wayne's greatcoat before handing it to him, a confession of the survival of her love for him. This is a pattern of repetition which can often be found in Ford. The gesture often sums up a state of mind and attitude for which visual expression is far subtler than verbal.

Many films are constructed of a rich texture of such gestures. In *Wagon Master*, character is encapsulated again and again in this way: in the cavalier hat-doffing of Harry Carey Jr. (developed from Carey's similar gesture in *3 Godfathers*), in the mincing walk of Dr. A. Locksley Hall (recalling exactly the similar gait of Otis Harlan in *3 Bad Men*), the involuntary cussing of Ward Bond in moments of stress and Russell Simpson's reproving stare, the huffing and puffing on the bullhorn of Jane Darwell.

Comedy

Beyond the individual gesture and something of an elaboration of it is the development of the comedy sequence. Ford uses his comedy in different ways: to enliven films he didn't like and didn't want to do, to lighten the tone of his tragedies, to enrich narrative and character in films he did like and did want to do. He has described himself in fact as a director of comedies who makes sad films. Very often this comedy was improvised and is one of the reasons for the freshness and spontaneity of his films.

Repeatedly in the Bogdanovich interview Ford stresses the improvisatory nature of his comedy: on *Kentucky Pride* ("we went to Kentucky to do a little story about horse-racing and we put a lot of comedy into it"), *Submarine Patrol*

("Of course all the comedy in it wasn't in the script; we put it in as we went along"), *How Green Was My Valley* ("Phil Dunne wrote the script and we stuck pretty close to it. There may have been a few things added but that's what a director's for. You can't just have people stand up and say their lines—there has to be a little movement, a little action, little bits of business and things"), and *The Quiet Man* ("We had a lot of preparation on the script, laid out the story pretty carefully but in such a way that if any chance for comedy came along, we could put it in").[49]

This talent came in most useful when Ford was working on projects he didn't like. *The World Moves On* was a film which Ford "fought like hell against doing". So in the middle of it he introduced Stepin Fetchit (real name: Lincoln Theodore Monroe Andrew Perry) as a French legionnaire and gave him some comic-cowardly antics in the trenches and bits of business involving his ignorance of the language. *Born Reckless* was another film he didn't want to do – part war film, part gangster film, part comedy – so he inserted a baseball game into the war episode to liven it up and it is the highlight of the film.

On a second level, Ford uses comedy to lighten the serious and tragic stories. In *Air Mail*, he created from nothing a part for Slim Summerville as an engineer on the air base and developed some memorable comedy for him. It includes him being ordered to destroy some forbidden whiskey and proceeding to drink it, a bit of business developed for the cavalry sergeants in *Fort Apache* years later. Most notably there is an entirely silent sequence in which Ford's genius for the use of gesture and expression is fully displayed.

But mainly the comedy is used to illustrate character and illuminate relationships. One only has to think of the priceless sequences of the floating waxworks and the final steamboat race in *Steamboat Round the Bend*, of the political convention in *Liberty Valance*, of the recruit-selection and recruit-drilling in *Drums Along the Mohawk* and of the courtroom comedy of *Young Mr. Lincoln*, *Sergeant Rutledge* and *The Sun Shines Bright*, to demonstrate his mastery of comedy. It is in fact precisely this fondness for the self-contained episode which has made Ford's films so easy to cut. Few directors have seen their films so consistently reduced in length by the studios. The anecdotal style lends itself to this without any difficulty. Episodes, comic or otherwise, were

49 Bogdanovich, *John Ford*, pp. 46, 69, 80, 90.

cut from Ford films sometimes removing entire characters—*Steamboat Round the Bend*, *The Horse Soldiers*, *How Green Was My Valley* (removing Dennis Hoey), *They Were Expendable* (removing Wallace Ford), *Cheyenne Autumn* (removing John Qualen), *The Last Hurrah* (removing Edmund Lowe), *Mr. Roberts*, *Young Mr. Lincoln*, *The Sun Shines Bright* and there are probably other examples. Fully half an hour was cut from *My Darling Clementine* and *The Last Hurrah*.

Ritual and Music

Another important aspect of Ford bearing on his narrative style is his love of ritual, the staging of an occasion that would allow for a regular pattern of people and action, a rhythm of formal movement and positioning, which is at once aesthetically precise, reflective of an ordered world view and dramatically self-contained. Ford rarely missed a chance to introduce such an occasion into his films and such occasions give his films a unique pattern which is also at odds with conventional narrative development. In the words of Joseph McBride and Michael Wilmington, the fabric of Ford's films consists of "dances, marches, births, deaths, drinking parties, brawls, courtships, funerals, wakes, weddings, church meetings, elections, speeches, trials, operations, dinners, riding contests, ceremonies of war and peace, arrivals, departures, more arrivals, more departures".[50]

The funeral is perhaps the most common of all these rituals in Ford and whether it involves military order or family grief or communal religious sentiment, it constitutes an affirmation of identity, communal feeling and a sense of the order and fitness of things. There are funerals, burials, wakes formal and informal, in *The Iron Horse*, *Lightnin'*, *3 Bad Men*, *Hangman's House*, *Seas Beneath*, *The Lost Patrol*, *The Informer*, *The Plough and the Stars*, *Wee Willie Winkie*, *The Grapes of Wrath*, *The Long Voyage Home*, *They Were Expendable*, *She Wore a Yellow Ribbon*, *The Searchers*, *The Last Hurrah*, *Cheyenne Autumn*, *3 Godfathers*. To this one might add executions, formally conducted in *The Plough and the Stars*, *The Prisoner of Shark Island*, *The*

[50] Joseph McBride and Michael Wilmington, *John Ford*, London: Secker and Warburg, 1974, p. 28.

Fugitive, Four Men and a Prayer and *Mary of Scotland*. Even the business of birth and death itself is given a ritual flavor in Ford with the death of General Herkimer in *Drums Along the Mohawk* being rapidly followed by the birth of the Martins' child, the death of Ivor in *How Green Was My Valley* by the birth of his son Gareth, the death of Private Dunker by the birth of a black child in *The Horse Soldiers*—and on each occasion characters comment on the process.

The dance in Ford is generally a joyous celebration of community spirit, often given an added dimension by the arrival of an outsider during the course of the merrymaking. The outsider, after a brief awkwardness, either integrates into the group (Earp in *My Darling Clementine* and Gruffyd in *How Green Was My Valley*) or remains outside it (Lincoln in *Young Mr. Lincoln*, Thursday in *Fort Apache*, the Cleggs in *Wagon Master*). Particularly impressive as demonstrations of community feeling are the Grand Marches in *Fort Apache* and *The Sun Shines Bright*, and the hoedowns and barn dances in *Drums Along the Mohawk*, *The Grapes of Wrath*, *My Darling Clementine* and *Wagon Master*. It is symptomatic of Ford's failing faith in the values he had once hymned that the last dances to appear in his work—the settlers' hoedown and the cavalry dance in *Two Rode Together*—are meaningless, desultory affairs, completely lacking the splendor and spirit of the earlier dances. Dances noticeably decline in prominence in the last ten years of his career.

The fight, which with other directors is a violent free-for-all, is conducted in Ford according to strict rules, within an enclosing circle of spectators and is often stopped by some senior character who insists on a restart according to the Queensberry rules; thus the fights in *Wee Willie Winkie*, *How Green Was My Valley*, *Rio Grande*, *The Quiet Man*, *The Searchers*, *What Price Glory*, *Donovan's Reef* and *Two Rode Together*.

Some Ford films are almost entirely composed of rituals and it is this which dictates their narrative structure. This is particularly true of the cavalry trilogy, a ritual pattern of ceremonial and ordered movement, with a succession and an interweaving of parades, drills, processions, funerals, flag-raisings, charges, retreats, dances, dinner parties, serenades, within which the story lines are conducted rather than vice versa.

Closely related to ritual is Ford's use of music. His devotion to folk melody is unquestionably part of the overall style and his films echo to the haunting melodies of lilting Irish tunes and the stirring strains of American marching

songs. Sometimes a particular song is associated with a particular film—"Red River Valley" in *Grapes of Wrath*, "My Darling Clementine" in *Clementine*, "The Rising of the Moon" in *Rising of the Moon*, "Streets of Laredo" in *3 Godfathers*, "Captain Buffalo" in *Sergeant Rutledge*, "The Monkeys Have No Tails in Zamboanga" in the naval pictures. But more often there is a wealth of melody. The score for *Stagecoach* incorporated nineteen 19th-century Western songs. *The Informer* and *The Quiet Man* between them included "Those Endearing Young Charms", "Rose of Tralee", "Wearing of the Green", "The Minstrel Boy", "Mush, Mush, Mush", "Galway Bay", "The Wild Colonial Boy", "The Humour is On Me Now", "The Kerry Dance", "The Young May Moon", "The Isle of Innisfree". The cavalry films echoed with "Beautiful Dreamer", "Home Sweet Home", "Goodnight, Ladies", "The Girl I left Behind Me", "Yellow Ribbon", "Garry Owen", "You're In The Army Now", "15 Miles on the Erie Canal", "Aha, San Antone", "Dixie", "I Left My Love", "Johnny Comes Marching Home", "The Bonnie Blue Flag", "Battle Hymn of the Republic". Even when Ford had new songs written for his films, notably by Stan Jones for *Rio Grande*, *Wagon Master* and *The Searchers*, they were written in the style and idiom of the classic Western songs.[51] Surprisingly his silent films notably incorporate musical references with the lyrics communicated by intertitles. In *Bucking Broadway* (1917) the cowboys gather round the piano to sing "Home Sweet Home". In *Hell Bent* (1918) Cheyenne Harry and Cimarron Bill sing "Sweet Adeline", and *The Iron Horse* features "Drill, Ye Terriers, Drill" as navvies construct the intercontinental railway. In the films with synchronized music and sound effects, "Little Mother" is sung in *Four Sons,* and the title song in *Mother Machree.*

Stock Company

Ford's affection for "interesting characters" called for a pool of talented actors and Ford developed what critics called "The Stock Company", the actors and actresses for whom the bits of business in which he excelled were devised. Like the repeated use of Monument Valley, the repeated use of the same actors gave

51 On Ford's use of music in his Westerns, see Kathryn Kalinak, *How the West Was Sung*, Berkeley: University of California Press, 2007.

Ford's films a unity, a Dickensian richness and depth, and a uniqueness, all of which stamp his films as "Ford Films". Ford, who was referred to as "Pappy", "Coach", "Boss" and "the old man", demanded unquestioning obedience from the stock company. In the recurrent use of the same personnel both before and behind the camera there is the feeling of a team, or a family. One of the reasons Ford gave for making films was the chance to work with old friends. These old friends grow old together in his films and their presence gives an added warmth, a sense of continuity and of time passing and reflects that family feeling which Ford sees as the cement of society.

Loyalty to his "people" was one of Ford's hallmarks. It is not just that he used the same stars repeatedly: Harry Carey Sr. 26 times, John Wayne 24, Hoot Gibson 13, Henry Fonda 8, George O'Brien 12, Victor McLaglen 12. He used the same extras, stuntmen and bit players for even longer. He frequently assigned small speaking roles to stuntmen such as Fred Kennedy, Chuck Roberson, Fred Graham, Chuck Hayward and Cliff Lyons. The longest serving was Jack Pennick, one of Ford's oldest friends and for years a member of his equipage. He was almost always around in some capacity or another. He functioned as Ford's aide throughout the war. He is actually credited as assistant director on *The Fugitive* and *Fort Apache* though to the Ford aficionado, he will be remembered as the perennial sergeant or bartender in some 45 films between 1928 and 1962. Only death ended his association with Ford. Harry Tenbrook can be traced in 28 films between 1918 and 1958 but was probably in more—in parts so minute that they have escaped detection. Danny Borzage, brother of director Frank Borzage, the man who played mood music on the sets of Ford films on his accordion, had roles in at least 16 films between 1924 and 1964 and undoubtedly more besides. Francis Ford, Ford's elder brother, played the main lovable drunken wrecks in 31 films between 1921 and 1953 when he died, the parts actually getting bigger in later years and being much more those of supporting actor than bit player. But Mae Marsh, star of Griffith's *Birth of a Nation*, was a regular one-scene bit part player, appearing in 17 films between 1939 and 1963.

The stock company itself not only seemed like a family, it was in a very real sense a family or rather a constellation of close family groups which by the end of Ford's career had reached its second generation of participants in the Ford equipage. We have already noted the appearance of Francis Ford, Ford's older

brother, in 31 films. Francis's son Philip appeared in *The Blue Eagle*. Ford's son-in-law Ken Curtis also appeared in 13 films, often as an amiable country bumpkin. Behind the camera Ford's son Patrick functioned in many capacities: co-author of *Wagon Master*, second unit director on *The Quiet Man*, associate producer of *The Searchers*, co-producer of *Sergeant Rutledge* and unofficial assistant on many others. But relations between them were always strained and there was a major estrangement on *Cheyenne Autumn* when Patrick, who had researched the subject, was passed over for the job of scriptwriter in favor of James R. Webb. In the end, Ford cut Patrick out of his will. His daughter Barbara, who later married Ken Curtis, was assistant editor on 5 films. Another brother of Ford's, Eddie (who called himself Edward O'Fearna), and Ford's brother-in-law Wingate Smith were assistant directors on his films from the 1920s to the 1960s.

Ford's career began with Harry Carey. Together they made 25 films, collaborating on the scripts and working closely together. With the coming of sound, Carey made the transition from star to character actor. He made only one such appearance for Ford, in the important role of the Commandant in *The Prisoner of Shark Island*. He remained close to Ford, however, and when he died in 1948 *3 Godfathers* was dedicated to his memory. Appropriately the film saw the official debut of Carey's son, Harry Carey Jr. who became a stock company regular, appearing in 10 productions. Carey's widow, Olive, played a tough frontierswoman in *The Searchers* and *Two Rode Together*. John Wayne, who was the next-longest-serving Ford star, was discovered by Ford and worked as a bit player in *Hangman's House*, *Salute* and *Men Without Women*. Wayne's son Pat made his debut as a boy in *Rio Grande* and subsequently played in 9 more Ford films and Wayne's other children Michael, Antonia and Melissa also appeared in *The Quiet Man*. Victor McLaglen, who was both a star and later character actor for Ford, appeared in 11 films, his brother Cyril in 4 and his own son Andrew began his career as an assistant director on *The Quiet Man* and subsequently made several films with Wayne and took over part of the stock company when Ford retired. Maureen O'Hara, the archetypal Ford heroine though she appeared in only 5 Ford films, introduced both of her brothers James Lilburn and Charles Fitzsimons to film acting via Ford; each of them played in 3 Ford films. Barry Fitzgerald played in 5 Ford films, and would probably have played in more if he had not become a star in his own right with

Paramount Pictures after his success in *Going My Way*. His brother Arthur Shields played in 6 films. Dorothy Jordan, the wife of Ford's Argosy co-producer Merian C. Cooper, had roles in 3 Ford films, notably that of Martha in *The Searchers*. Anna Lee played in 9 films and her sons John and Tim Stafford appeared in *Donovan's Reef*. Jack Holt appeared in *They Were Expendable* and his son Tim in *Stagecoach* and *My Darling Clementine*.

People talk glibly about "The Stock Company" without appreciating that there were in fact three distinct stock companies with some overlapping. The first and least known was the silent stock company which included Harry Carey Sr. (25 films), Hoot Gibson (12), Molly Malone (10), Duke Lee (16), Vester Pegg (22) and J. Farrell MacDonald. MacDonald was the favored prototype Irishman, lachrymose, devious and two-fisted, of the sort Victor McLaglen later portrayed. He appeared in 26 films, mainly during the silent and early sound periods 1919–1931 but he did make the occasional reappearance, memorably playing Mac the bartender in *My Darling Clementine* a few years before his death. Duke Lee and Vester Pegg, regulars in his silent Westerns, were recalled by Ford for his first talkie Western *Stagecoach* in 1939.

Then there is the pre-war sound stock company 1929–1941, headed by Ward Bond (13) and John Carradine (8) as well as the ubiquitous Francis Ford (18), and including Lionel Pape (7), Berton Churchill (5), Brandon Hurst (5), Pat Somerset (8), J. M. Kerrigan (5), Roger Imhof (4), Spencer Charters (4), Stepin Fetchit (4), Donald Meek (4), Charley Grapewin (4). Wallace Ford (no relation) played in 3 films. Of these only Bond, Carradine and Francis Ford carried on directly into the post-war period and Ward Bond is the continuity figure *par excellence*, playing in 28 films between 1929 and 1960. Russell Simpson appeared in 10 films between 1934 and 1959.

Finally there is the post-war stock company, built up in the late Forties essentially and including Harry Carey Jr. (10), Willis Bouchey (12), Ken Curtis (13), Hank Worden (9), Jane Darwell (7), Carleton Young (7), Charles Seel (4). There was even a junior stock company, as Robert Parrish recalled:

> Whenever he needed kids, he called the Watson family (seven children of assorted sexes, sizes and ages), the Johnson family (six), or the Parrish family (four). This way he could fill a schoolroom scene, and still only have to contend with three "movie mothers" ... Our three families became more or

less Ford's kid stock company. He depended on us to give him no trouble and we depended on him for work during the hard times of the Depression.[52]

As Anna Lee recalled: "When anyone became a member of the Ford stock company, they became family and he looked after each one".[53] But it was part of his autocratic approach to film-making that he rarely forgave anyone who turned down a part. Anna Lee said: "I found that the way to keep working in John Ford films was never to refuse one. We rarely got to see a script. We were told that we had a part but never knew if it was going to be a leading role or just a line or two, which often happened to me. You didn't say 'no' to John Ford".[54] Anna Lee who had starred in British films in the 1930s and in American films in the early 1940s appeared in 8 Ford films in roles ranging from an uncredited bit part in *The Man Who Shot Liberty Valance* to a full star role in *7 Women*.

As early as 1936 Ford's films were notable for their casts. When Howard Sharpe interviewed Ford for *Photoplay* in that year, he said "Casting was first, and of supreme importance". Ford told him: "With the exception of the stars who are signed for parts by the studio in advance, I insist on choosing names for myself. And I spend more time on that than any other". Sharpe commented: "the strongest forte of Ford is his selection of bit players" and noted that he employed a lot of former silent stars in small roles. Ford agreed and said that "these ex-stars will, after all, give a better performance even in the smallest part than any casual extra would" but also conceded that sentiment played a part: "when I was starting in this town those people were kind to me. I want to repay a little of that if it's in my power". Sharpe concluded: "On Ford's private lists are one hundred names … from which he picks his cast for every picture he directs. Always the same people, always the same results; they know his technique and his wishes, they are capable and hard-working. To my knowledge it's the only list of its kind in the movie colony."[55] Even in the 1950s, he was recalling long-forgotten silent stars to play character parts (James Kirkwood in *The Sun Shines Bright*, Antonio Moreno in *The Searchers*, Stuart Holmes in *Wings of Eagles*).

[52] Robert Parrish, *Growing Up in Hollywood*, New York: Harcourt Brace Jovanovich, 1976, p. 179. On the Stock Company in general, see Bill Levy, *Lest We Forget: The John Ford Stock Company*, Albany, GA: Bear Manor Media, 2013.
[53] Lee and Cooper, *Anna Lee*, p. 229.
[54] Lee and Cooper, *Anna Lee*, p. 138.
[55] Peary, *John Ford Interviews*, pp. 16–17.

But what gives the films a strange, almost mystical circularity is that at the end of his career Ford regularly returns to the actors who had figured in his earlier years. That this was not purely accidental can be shown by the wholesale reunion of old friends that was *The Last Hurrah.* For this film he gathered together actors who had not worked with him for 20 years and more. This 1958 film reunited him with Spencer Tracy (*Up the River*—1930), Pat O'Brien (*Air Mail*—1932), Ricardo Cortez (*Flesh*—1932), Edward Brophy (*Flesh*—1932, *The Whole Town's Talking*—1935), Frank Albertson (*Salute*—1929, *Men Without Women, Born Reckless, Air Mail*— 1932), Wallace Ford (*The Lost Patrol, The Informer, The Whole Town's Talking*—1935), Edmund Lowe (*Born Reckless*—1930, his part was cut from *The Last Hurrah*), John Carradine (*Grapes of Wrath*—1940), O. Z. Whitehead (*Grapes of Wrath*). These appear in addition to the more recent regulars such as Ken Curtis, Donald Crisp, Jane Darwell, Anna Lee etc. Even Basil Rathbone who had turned down the part of Eugene DeLaage in *The Hurricane* appears. It is surely the most remarkable reunion of old friends ever put on celluloid.

But *The Last Hurrah* is only the most extreme case. Increasingly from the late Forties on, Ford revived actors and actresses who had worked for him many years before, so that we see within the scope of his work actors beginning or at the peak of their careers and actors at the end of their careers. Entire lifetimes pass before our eyes. Perhaps the most notable cases are those of Hoot Gibson, star of 12 silent Westerns for Ford, who returns in 1959 after 38 years to play a sergeant in *The Horse Soldiers* and George O'Brien, star of 7 films for Ford between 1924 and 1931, who returns 17 years later to play character parts in *Fort Apache* and *She Wore a Yellow Ribbon*, and 15 years on, long after he had retired from the screen, he returns again to appear in *Cheyenne Autumn*. But there are many more:

Irene Rich *Desperate Trails* (1921) returns in *Fort Apache* (1948).
Noble Johnson *The Wallop* (1921) returns in *She Wore a Yellow Ribbon* (1949).
Grant Withers *Upstream* (1927) returns in *My Darling Clementine* (1946), *Fort Apache* (1948), *Rio Grande* (1950), *The Sun Shines Bright* (1953).
Victor McLaglen, star of 8 films 1925–1937: *The Fighting Heart* (1925), *Mother Machree* (1926), *Hangman's House* (1928), *Strong Boy* (1929),

The Black Watch (1929), *The Lost Patrol* (1934), *The Informer* (1935), *Wee Willie Winkie* (1937) returns as a character actor in 4: 1948–1952 *Fort Apache* (1948), *She Wore a Yellow Ribbon* (1949), *Rio Grande* (1950), *The Quiet Man* (1952).

Andy Devine in 2 films: *Doctor Bull* (1933), *Stagecoach* (1939) returns for *Two Rode Together* (1961), *The Man Who Shot Liberty Valance* (1962), *How the West Was Won* (1962).

Erin O'Brien-Moore *The Plough and the Stars* (1936) returns for *The Long Gray Line* (1955).

Denis O'Dea *The Plough and the Stars* (1936) returns for *Mogambo* (1953) and *The Rising of the Moon* (1957).

Edward G. Robinson *The Whole Town's Talking* (1935) returns in *Cheyenne Autumn* (1964).

Ben Johnson in 4 films 1948–1950: *3 Godfathers* (1948), *She Wore a Yellow Ribbon* (1949), *Wagon Master* (1950), *Rio Grande* (1950) also returns in *Cheyenne Autumn* (1964).

Stepin Fetchit in 4 films 1929–1935: *Salute* (1929), *The World Moves On* (1934), *Judge Priest* (1934), *Steamboat Round the Bend* (1935) returns for *The Sun Shines Bright* (1953).

Milburn Stone *Young Mr. Lincoln* (1939) returns for *The Sun Shines Bright* (1953).

Arleen Whelan *Young Mr. Lincoln* (1939) returns for *The Sun Shines Bright* (1953).

Cesar Romero *Wee Willie Winkie* (1937) returns for *Donovan's Reef* (1963).

Dorothy Lamour *The Hurricane* (1937) also returns for *Donovan's Reef* (1963).

Dick Foran *Fort Apache* (1948) similarly returns for *Donovan's Reef* (1963).

John Loder *How Green Was My Valley* (1941) returns for *Gideon's Day* (1958).

Dolores del Rio *The Fugitive* (1947) returns for *Cheyenne Autumn* (1964).

Donald Crisp *Mary of Scotland* (1936) and *How Green Was My Valley* (1941) returns for *The Long Gray Line* (1955) and *The Last Hurrah* (1958).

Even his long-forgotten silent stars Gertrude Astor (*Cheyenne's Pal* (1917)) and Helen Gibson (*The Rustlers* (1919)) are extras in *Liberty Valance*. Certainly

no other director who used a stock company—and Capra and DeMille are probably the most notable—achieved this circularity.

Interestingly Ford retained the habit common in silent picture days of casting non-actors who had something that the camera loved and who displayed a naturalness which he did not see in stage-trained actors. Some of these non-actors went on to stellar careers. Ward Bond and John Wayne were ex-college football players when Ford assigned them small roles in *Salute*. George O'Brien was a boxer, assistant cameraman, prop man and stunt man when given the lead role in *The Iron Horse*. Woody Strode was a decathlon champion and football star when given the title role in *Sergeant Rutledge*. Tennis star Althea Gibson played a supporting role in *The Horse Soldiers*. The balladeer Stan Jones played General Ulysses S. Grant in the same film. Rodeo champion Ben Johnson had no acting experience when Argosy signed him, planning to groom him for stardom until, after playing key roles in *Wagon Master*, *She Wore a Yellow Ribbon* and *Rio Grande*, he fell out with Ford and was banished.

John Baxter argues:

> Characters in Ford work under a strong disadvantage; deprived of individuality in favour of embodying the virtues of a society, they are types rather than people and ... their personalities remain frozen in time.[56]

But this argument is effectively refuted by Stuart M. Kaminsky:

> Enduring popular literature is based on universal character types, the recognition that certain kinds of people reflect both a basic meaning for their own time and a meaning which is, at the same time, universal. The inability of some critics to recognize the late John Ford's handling of type in this manner, and to confuse it with stereotyping, has—in part—kept much of Ford's best work ... from being appreciated.[57]

So Ford's characters are not stereotypes but archetypes, he suggests, like characters in Chaucer, Shakespeare, Dickens and Mark Twain. In Ford they are given three-dimensional life by character actors who become as Ford's career unfolds old friends. His gallery of archetypes include the hard-drinking Irish

[56] John Baxter, *The Cinema of John Ford*, London: Zwemmer, 1971, p. 19.
[57] Stuart M. Kaminsky, *American Film Genres*, New York: Dell Publishing, 1972, p. 252.

NCO (Victor McLaglen), the philosophical drunken doctor (Thomas Mitchell), the mournful Swedish immigrant (John Qualen), the faithful black retainer (Stepin Fetchit). His perennial female archetypes are the idealized mother (Jane Darwell, Sara Allgood, Alice Brady) and the redeemed whore (Claire Trevor, Linda Darnell, Joanne Dru, Ava Gardner).

Cinematography

Ford's comments on cinematography were characteristically terse. He told Joseph McBride how he planned his shots. "Walk on the set, look at the set, look at the location. You do it by instinct. You tell the cameraman to place the camera here and get in So-and-so and So-and-so, so he does it. That's all there is to it".[58] He expanded upon this in another interview, reported by Mark Haggard, when he declared: "Forget about the camera. Get a good cameraman— he knows more about a camera than you'll *ever* know—and say: 'I want to get So-and-so and So-and-so in, and I want it very close, because I'm not going to shoot any close-ups in here. If I shoot close-ups, I'm going to move one group here and one there so I can take individuals.' But get a good cameraman and work with your people. Look at their faces. See their eyes. You can express more with your eyes than you can with anything else. And that's about all. . . . *Anybody* can direct a picture once they know the fundamentals—Directing is not a mystery, it's not an art. The main thing about motion pictures is: photograph the people's eyes. Photograph their eyes."[59]

However his collaborators spoke warmly of his ability. Photographer William Clothier said: "He knew more about photography than any other man who ever worked in the movies . . . He was a genius. He'd force me into situations where I'd have to sit up and take notice".[60] Cameraman Arthur Miller, describing Ford as his favorite director and the man he most liked to work with, said: "You'd only talk, I think you might say, fifty words to him in a day; you had a communication with him so great you could *sense* what he wanted. He knew nothing of lighting; he never once looked in the camera when we worked

[58] McBride and Wilmington, *John Ford*, p. 47.
[59] Peary, *John Ford Interviews*, p. 132.
[60] Davis, *John Ford*, p. 291.

together.... I always liked economy and that's why I liked being with Jack; on [*How Green Was My Valley*] we scarcely used a foot that wasn't in the final print (on a previous picture *To Have and To Hold* we shot half a million feet as against 100,000 for this one for the same length of story). Ford would make the best picture for less money than anyone I know. All the actors had to be punctual; nobody took a day off; he'd be improvising, changing freely all the time".[61]

Ford always knew exactly what he wanted, which is why he was so economical. He was renowned for cutting in the camera and leaving his editors with little to do but splice the footage together. He did not often look through the camera but left the cameraman to carry out his instructions. He was an intuitive artist who would, if he saw weather conditions or cloudscapes he liked, shoot a scene on the spur of the moment, as for instance the burial of Victor McLaglen in *Wee Willie Winkie* or the emergency operation during a storm in *She Wore a Yellow Ribbon*.

Between 1921 when he went to work for Fox and 1936, the year following the merger of 20th Century Pictures and Fox, Ford worked regularly with two cameramen: George Schneiderman (1921–35) who photographed 21 films in his distinctive soft-focus shimmer and Joseph H. August (1925–36) who photographed 12 films and alternated between a realistic semi-documentary style and a richly chiaroscuro Expressionism. From the late 1930s to the 1950s he would use a variety of cameramen but more than once with many: Bert Glennon (8), Archie Stout (5), Winton Hoch (5), Arthur Miller (4), Gregg Toland (2). Toland's death and Miller's retirement probably account for the relatively short association with Ford. Ford identified August, Toland and Miller as the three best cameramen he had worked with. William Clothier became the favored cameraman toward the end, photographing 4 of the later Ford films. Ford preferred filming in black and white to filming in color. "It's much easier to photograph in color," he said. "You have to be a real cameraman to photograph in black and white."[62] It was a sentiment he repeated often and it explains his fondness for such Expressionistic masterpieces as *The Long Voyage Home* and *The Fugitive*.

[61] Charles Higham, *Hollywood Cameramen*, London: Thames and Hudson, 1970, pp. 147, 149.
[62] Peary, *John Ford Interviews*, p. 91.

But what was Ford's visual style? A Ford film is unmistakable and yet it could be in one of several distinct visual idioms—the misty, soft-focus, shimmering black and white of George Schneiderman, the razor-sharp, high-contrast black and white of Bert Glennon, the richly textured, deep-focus black and white of Gregg Toland or the delicate Remingtonesque Technicolor of Winton Hoch. Certain techniques were favored by Ford but more than this, it is the absolute consistency of composition which marks out a Ford film as distinctive from a film by some other director.

Classical Ford is deceptively simple in technique. He had a fondness for the medium shot, he tended to cut from set-up to set-up rather than move his camera, and when he did move the camera it was generally as unobtrusively as possible—for simple tracking and dollying. He used comparatively few close-ups and the films in which there are more than a few (such as *Mary of Scotland* and *Pilgrimage*) are remarkable for their intensity of passion. He favored dynamically paced cutting.

His own advice to John Wayne when he was about to begin directing *The Alamo* was "give 'em a scene and then give 'em scenery". By this he seems to have meant that a dialogue exchange should be followed by a visual sequence rather than intermingled. He certainly practiced what he preached. For as far back as *The Iron Horse* he shoots dialogue exchanges against undistracting backgrounds and leaves the panoramic long shot of scenery for the big action scenes. In silents, this method had the advantage of allowing the audience to concentrate on the facial expressions and reactions of the actors ("Look at their faces. See their eyes"). In talkies, this concentration on the faces was combined with the delivery of essential information via the dialogue. For example, when Michael and Philadelphia go for a ride in the desert in *Fort Apache* there are some exhilarating long shots of them at full gallop. But these are intercut with studio-shot dialogue exchanges with a photographed backdrop behind them. Ford almost never allows his actors to talk while something distracting is going on behind them and generally there is a backdrop behind them. This philosophy is also extended to the long speech, which does not often occur in Ford but when it does, it is filmed in only a few takes and in close shot, with the camera concentrating on the face. This is the case in such memorable instances as Charles Winninger's sermon in *The Sun Shines Bright*, Henry B. Walthall's trial speech in *Judge Priest* and Henry Fonda's

description of the battle against the Indians in *Drums Along the Mohawk*. There is a marathon dialogue exchange between Richard Widmark and James Stewart beside a river in *Two Rode Together*, in which the two men chat on and on in medium shot and Ford keeps the camera on them until they have finished, with no cut and no change of angle.

Ford admitted to not liking camera movement much, "because it throws the audience off. It says 'This is a motion-picture. This isn't real'. I like to have the audience feel that this is the real thing. I don't like to have the audience interested in the camera. The camera movement disturbs them".[63]

The camera would move most in action sequences and it may be this which accounts for the bursts of excitement in Ford, as a static, carefully composed, succession of tableau scenes suddenly explodes into whirlwind lateral tracking shots of a fleeing stagecoach (*Stagecoach*), charging cavalry (the cavalry trilogy, *The Searchers*), a horse race (*The Shamrock Handicap, Kentucky Pride*), a posse pursuing outlaws (*3 Godfathers*). Less spectacularly, he employed long measured tracking shots in important walking scenes involving his characters—Edward G. Robinson arriving late at the office in *The Whole Town's Talking*, Henry Fonda nervously walking down a covered colonnade in one direction as police ride by in the opposite direction in *The Fugitive*, Madeleine Carroll and Franchot Tone walking to the station at the end of his leave from the front in *The World Moves On*.

By using these devices sparingly he heightened their impact. This also applies to the rapid dolly-in to a close shot of the face to express the sudden realization of something. Its most notable use comes in the dolly-in in *The Searchers* to John Wayne's face when he realizes his brother's ranch has been attacked. But it is also used to great effect in *Mary of Scotland* as the camera dollies in to Katharine Hepburn's face when she realizes Bothwell is dead, and in to Robinson's face in *The Whole Town's Talking*, when he realizes he has got the sack. There is a clever multiple use of it in *Four Men and a Prayer* when the camera dollies in to Aubrey Smith's face as he hears the verdict of his court martial and realizes he is disgraced. The same device is repeated four times as each of his sons receives the news and realizes the implication.

For those raised on a diet of classical Ford it comes as a surprise to observe that in his earlier years he did engage in technical experimentation using his

[63] McBride and Wilmington, *John Ford*, p. 47.

cameras daringly and innovatively, before he settled for the simple, economical style which became his hallmark. In *Riley the Cop*, he employs multiple superimpositions of a group of German yodelers to convey the effect of the drunken perspective of Riley. *Kentucky Pride* opens with an impression of a horse being born. The camera whirls round out of focus and gradually focuses on a horse's eye view of the three stablemen gazing down at it. In a comic sequence in *The Shamrock Handicap*, Ford uses slow-motion, out-of-focus shots and very low-key lighting to convey the effect of ether on a comical black man, Virus Cakes, who is visiting the hospital. *Men Without Women* is today chiefly remarkable for the technical experiments—a long dolly shot down a street which Ford was told was impossible to shoot, and the camera descending underwater in a glass box to capture the scene of a submarine diving. Most of these are subjective camera positions and Ford was later to make use of the first-person camera technique in two notable passages of low-angle child's-eye view of the world shooting to convey the impression of wonderment and apprehension with which Huw Morgan in *How Green Was My Valley* greets his first day at school and with which Priscilla Williams in *Wee Willie Winkie* greets her first visit to the Indian bazaar.

But whatever the particular photographic idiom, it is the composition which remains the constant factor. He seems to have had an instinctive understanding of pacing, framing and composition, as can be seen in the visual sophistication of his earliest surviving feature, *Straight Shooting* (1917). Ford told Bogdanovich "the only thing I always had was an eye for composition"[64] and his frames are unmistakable, composed with the ritual formality, formal symmetry and tableau groupings one would expect for an apostle of order and hierarchy. His screen is divided and bisected into neat and regular spatial areas by tent poles, hitching rails, sidewalks, gateways, stone walls, wooden fences, railway lines, the horizon. His delight in parades, dances, funerals and trials is partly to be explained by the fact that they are conducted according to the rules which give people set positions which can be composed into formal patterns. Even non-ritualized events are turned into rituals by posing and framing. For instance in *3 Bad Men*, there is a scene in which Bull Stanley carries his dead sister down the stairs of the saloon. Ford invests this scene

[64] Bogdanovich, *John Ford*, p. 108.

with the formality of a funeral rite. In this shot, the screen is divided diagonally by the staircase and the stair-rail. Beyond the rail, motionless in mid-frame, Bull stands holding his sister in his arms. At each side of the frame, posed hieratically, stands a man holding a flaming torch. Bull pauses and then descends the stairs to come out of the saloon—in the next shot—between two lines of torch-bearing horsemen. They are not carrying their torches for the purpose of a funeral but the presence of the torches adds a funerary formality to the movement and the framing of it. Examples of this technique can be multiplied many times over.

Ford's scenes are frequently framed by doors, windows, archways, entrances and exits of various kinds and these seem to serve a three-fold purpose. First they act as a sort of proscenium, delimiting the action as theater—whatever Ford may say about realism. Second, they create a regular frame within which groups may be posed. Third, they suggest a world poised on a narrow line between inside and outside, home and exile, order and chaos. It is characteristic of Ford that he nearly always shoots such scenes from inside. The most famous example of this is *The Searchers* which opens and closes with the door of the ranch-house opening and closing on Ethan Edwards. Characters in *The Searchers*, who manifestly live on this narrow line, are obsessively framed by the doorways. The gates of the fort in *Yellow Ribbon* and *Rio Grande* frame the arrivals and departures of the men whose mission it is to maintain order in a savage land. Both the Priest and the Lieutenant in *The Fugitive*, the two protagonists poised on their own borderlines between life and death, success and failure, salvation and damnation are continually framed in doorways. In *Pilgrimage* the two lovers embrace in the doorway of a barn—their illicit love having put them on the borderline of society.

Similarly windows frequently frame figures on this borderline. Examples of this would include John Wayne soliloquizing on the cavalry at the end of *Fort Apache*, Carleton Young waiting to signal the Confederate attack in *The Horse Soldiers*, Shirley Temple getting her first glimpse of India in *Wee Willie Winkie*. Frequently this window framing shot would be used for women grieving over a loss of some sort—thus Millie in *3 Bad Men*, Ruth and Irene in *Air Mail*, Mary Kate in *The Quiet Man*, Fleety Belle in *Steamboat*, Mary Warburton in *The World Moves On*.

The same symbolism lies behind the posing of figures on the horizon. Even more so than the gates and the windows, this obviously denotes the borderline

and all the most obvious borderline characters in Ford are seen on the horizon—the cavalry, the searchers, the three godfathers, Tom Joad.

Within the frames too, the actors were always posed formally. Quite apart from the posing necessitated by their frequent ritual occasions, tableau groupings were favored as a matter of course. In both *Mary of Scotland* and *The Plough and the Stars*, gatherings of the population are arranged in ranks. Groups of women gathered in knots in *The Fugitive* and *Fort Apache* are statuesquely still. For climactic confrontations too, balance of positioning is clear. In *The Hurricane* and *Mary of Scotland* two figures (Father Paul and Delaage in the former, Mary and Elizabeth in the latter) face each other across a table with a cross on the wall between and behind them. The camera holds them in medium shot and the balance is precise and perfect. Such groupings can also be used to express hierarchy within the general framework of order. For instance in *Rio Grande* the sequence in which the regimental singers serenade General Sheridan ends with a perfectly composed long shot in which the singers stand in a line behind a hitching post on the left of the frame, the officers face them directly standing on the right but raised slightly above them on a verandah. Between the two and standing alone is the sergeant—the figure who always stands between the officers and the other ranks. It is this framing and posing within shots which more than anything else constitutes the visual signature of Ford on a film.

However, despite the apparent simplicity of his technique and his fondness for economy and lack of flashy, obtrusive and unnecessary jiggery-pokery, he was quite capable of creating enormously complex and detailed sequences if he felt they were warranted. The Chuckawalla swing sequence in *Wagon Master*, composed of a multitude of shots from different angles of feet tapping, hands clapping, faces reacting, people mixing and dancing, beautifully and rhythmically cut together is a *tour de force*.

It is perhaps worth commenting at this point on the famous argument about Ford's split personality. This was developed by the *Sequence* school of critics, notably Lindsay Anderson. *Sequence* which only appeared between 1947 and 1952 originated with members of the Oxford University Film Society. Regarding film as an art form, they treated Hollywood films with much greater seriousness than did other contemporary intellectuals who tended to prefer silent or continental films. Several of the editors, Lindsay Anderson, Karel

Reisz and Gavin Lambert went on to have significant careers in cinema and film criticism. *Sequence* posed the proposition that Ford suffered from an artistic split personality. On the one hand, there were the "Expressionist" classics which they castigated for "conscious significance of theme", empty pictorialism, highly Expressionist lighting and formal groupings (*The Informer*, *The Fugitive*, *The Long Voyage Home*) and attributed in part to the baleful influence of Dudley Nichols. On the other hand, there are the Americana classics (*Drums Along the Mohawk*, *Young Mr. Lincoln*, *The Prisoner of Shark Island*, *My Darling Clementine*) with human stories, genuine involvement, poetic use of camera, naturalistic handling.

However, such a division is entirely artificial. Both sets of films are the product of a single outlook. The photographic idiom may be different, but what is consistent is the formalistic style of composition, the use of the stock company, the fondness for ritual and folk music. The use of Monument Valley for the Westerns gives them just as much as *The Fugitive* "an atmosphere expressly divorced from an identifiable time and place". Ford never hesitates to use artificial devices to heighten the mood he seeks to obtain in the Westerns as in the Expressionist films. A stylistic device which links the two so-called different schools in his works is the slow artificial darkening of the screen at the end of a trial or part of a trial, which is employed in *Mary of Scotland*, *Sergeant Rutledge* and *The Prisoner of Shark Island*. Ford uses entirely artificial blood-red skies as a background to massacre in both *The Searchers* and *She Wore a Yellow Ribbon*. He is also quite prepared to move inside the studio to obtain a precise effect of lighting and grouping which he wanted, thus the obviously studio-shot scenes of the searchers lost in a foggy swamp in *The Searchers*, the return of the Martins in the snow to the ruins of their house in *Drums Along the Mohawk* and the discovery of Mrs. Bell's body in a shadowy hollow in *Rio Grande*. A further device of composition which further links the two "schools" is to lead the viewer's eye directly into the frame by dividing the screen and framing some action by a corridor or avenue of trees which runs deep into the heart of the shot. This device occurs in such disparate films as *They Were Expendable*, *My Darling Clementine*, *Gideon's Day*, *The Long Voyage Home*, *Rio Grande* and *Drums Along the Mohawk*. But Ford had used Expressionist devices long before the so-called Expressionist classics in order to make a point. This was particularly true for instance of the stylized and

formally composed scenes of the Hanging Judge in *Hangman's House*. The use of the staircase to signal the approach of death occurs in *Mary of Scotland, The Fugitive, Four Men and a Prayer, The Whole Town's Talking, 3 Bad Men*. The use of the violent storm to symbolize passion occurs in *Pilgrimage, Mary of Scotland, The Hurricane, The Quiet Man*. The rich use of Catholic imagery is discussed elsewhere and John Baxter has drawn attention to the frequent use of shadow symbolism. "In a linkage that is typical of his work, Ford connects a human shadow or silhouette with death; they are literally 'shades' from the other world".[65] He cites a whole flock of examples, including Doc Holliday in *Clementine*, Peabody in *Liberty Valance*, Tom and Casy in *Grapes of Wrath*, the sailors in *Long Voyage Home*, and one can add to this the shadows of the duellists in *The World Moves On*, the priest in *The Fugitive*, the three godfathers in the film of the same name, Gypo in *The Informer*.

What is different is not so much the characteristics outlined by *Sequence* as the tighter structure which Nichols imposed on his scripts for Ford as against the more informal structure which Ford adopted for his non-Nichols scripts. But visually and thematically there is undoubted consistency between the two schools. What enriches his work in the last resort is the informal narrative structure, in which business, gesture and incident are paramount, so that what is conveyed to the audience watching a whole range of Ford films is the impression of a world teeming with life and color and variety and incident but governed by strict ideas of order, hierarchy, community and morality—individual diversity contained within a strict framework of political, social and religious absolutes.

When asked in interviews what were his favorite films, Ford tended to cite the same titles repeatedly. He most often cited *The Sun Shines Bright* ("one that I love to look at again and again"), *Young Mr. Lincoln, Wagon Master, How Green Was My Valley, She Wore a Yellow Ribbon, Drums Along the Mohawk*—all films about everyday life in small communities. But he also listed his Expressionist classics *The Long Voyage Home* and *The Fugitive*—studies of outsiders as exiles. In those films we can see encapsulated Ford's lost worlds, the elements and the essence that make him cinema's foremost poet of memory and loss.[66]

[65] Baxter, *The Cinema of John Ford*, p. 45.
[66] Peary, *John Ford Interviews*, pp. 79, 100, 101, 118; Sarris, *Interviews*, p. 199; Anderson, *About John Ford*, p. 22.

John Ford's Ireland

John Ford was a "professional Irishman". He regularly described himself as "an Irish rebel". He liked to be called Sean. He pretended to speak Gaelic, of which he knew only a few words and phrases. He called his beloved yacht *Araner* after the Aran Islands, where his mother's family originated. He sometimes even pretended to have been born in Spiddal, where his father came from, and to have participated in the Irish Independence struggle, though as an adult before 1951 he only visited Spiddal for four days in December 1921 when there was a truce in the War of Independence.[1] But he peopled his films with Irish and Irish American characters. They are positively full of Quincannons, Mulcahys and Donovans. In a recurrent private joke he would give his own family name, Feeney, to some of the most disreputable and unpleasant characters in his films (Jack MacGowran's lickspittle in *The Quiet Man*, Donal Donnelly's "razor boy" in *Gideon's Day* and John Crowley's gombeen man in *The Rising of the Moon*). He consciously sought to bring the work of Irish and Irish American writers to the screen: Donn Byrne's *Hangman's House*, Liam O'Flaherty's *The Informer*, Sean O'Casey's *The Plough and the Stars*, Eugene O'Neill's *The Long Voyage Home*, Edwin O'Connor's *The Last Hurrah*, Maurice Walsh's *The Quiet Man* and the short stories by Lady Gregory, Michael McHugh and Frank O'Connor grouped together in *The Rising of the Moon*. In the early 1950s he sought unsuccessfully to kick-start a native Irish film industry.

He loved the land of his fathers with a depth and tenacity of feeling which only the expatriate can feel. He consoled himself for living away from the emerald isle by creating the Ireland of his dreams on film. Between 1841 and 1925, four and three quarter million Irish people emigrated to the United States and the substantial Irish American community that resulted never lost

[1] Adrian Frazier, *Hollywood Irish: John Ford, Abbey Actors and the Irish Revival in Hollywood*, Dublin: The Lilliput Press, 2011, pp. 15–16.

its hatred of British rule or its romantic memory of the "Old Country". There was a sizable Irish American element in Hollywood: writers, producers, directors, actors. Film was the ideal medium for them to dramatize their interpretation of Ireland and Irish history. But the film industry traditionally sought to avoid controversy and, more seriously, Britain was the biggest market outside America for Hollywood films, and films that were too overtly anti-British were deemed to be potentially bad box office. Even after Southern Ireland gained independence, the continued existence of the British Empire provided a potent image of the status quo which Hollywood usually sought to endorse.

One of the most persistent of Irish American directors in seeking to bring Ireland to the screen was John Ford. Six films, made between 1926 and 1957, encapsulate Ford's vision. It was a vision of essentially two Irelands— the Ireland of "The Troubles", of darkness, suffering, tyranny and death, of the struggle of an oppressed people for freedom, and the Ireland of exiles' memories and poets' dreams, the peaceful, happy, communal, tradition-steeped Erin. The first Ireland is featured in *Hangman's House, The Informer* and *The Plough and the Stars* and the second in *The Shamrock Handicap* and *The Quiet Man*, with the three-part *The Rising of the Moon* linking the two and summarizing his Irish world. But Ford also contrived to Hibernicize *How Green Was My Valley* so it properly merits consideration along with the Irish films.

Of all Ford's worlds, Ireland is the one which changes least. Where his vision of America grows dark and bitter as he grows older and he sees all around him change and the decay of old ideals, his Ireland remains static, the product of ineradicable folk memories and cherished family myths. It is not perhaps too fanciful to see in Sean Thornton, the Quiet Man making his first visit to Ireland, echoes of Ford himself, the expatriate Irishman coming face to face with his long-cherished visions. The name itself combined Ford's Christian name in its Irish form and the surname of his IRA cousin Michael Thornton. Maurice Walsh's Quiet Man was called Paddy Bawn Enright.

In his authoritative study of the Hollywood Irish, Adrian Frazier explains Ford's commitment to his Irish project:

(He) wanted to lift the status of Roman Catholics in predominantly WASP [White, Anglo-Saxon, Protestant] America. He also wanted to depict Irish people as the prototypical immigrants in a democratic land . . . He wanted to

celebrate the high art, modernist magnificence of twentieth-century Irish literature by doing justice to certain key texts in motion pictures. Finally, he wanted to be seen within Ireland as an Irish artist himself, and contributor to the Irish Revival, with something to say of value as a result of his American experience.[2]

Myths and stereotypes are the essential elements of popular culture. They are far easier for audiences to identify and absorb than complex analyses of issues and historical problems. The myths and stereotypes of Ireland and Irishmen are as potent and indeed politically influential as any. They have a long history and the cinema is only the latest vehicle for their dissemination.

In cinematic terms, the image of Ireland has been largely in the hands of the British and American film industries. For Ireland experienced on an even greater scale the problems Britain faced in seeking to establish a native film industry: chronic under-investment, technical backwardness and the overwhelming dominance worldwide of Hollywood. There were schemes from the 1930s onwards for an Irish film studio. When Ardmore, Ireland's first and only permanent studio, eventually opened in 1958, it began promisingly enough with a series of adaptations of theatrical hits featuring the celebrated Abbey players. But it soon became, like many British studios, merely a rented facility for use by foreign film companies rather than the heart of a native Irish film industry. Indeed until the 1970s the silent era represented the most sustained period of indigenous Irish film-making both in quantity and quality. The creation of the Irish Film Board in 1980, film funding by the Irish Arts Council and the involvement of the broadcasting network RTE led to an Irish film-making renaissance not dissimilar to the British one, fueled by Channel 4 funding.

Ford did his bit to stimulate Irish film-making. In 1951 he set up with the Irish peer Lord Killanin and Belfast-born film director Brian Desmond Hurst Four Provinces Films (a defiant reference to the four provinces of the united Ireland—Ulster, Munster, Leinster and Connaught). The plan was to film Irish classics in Ireland with Irish casts. The company produced only two films, Ford's *The Rising of the Moon* (1957) and Hurst's *The Playboy of the Western World* (1962), both box office failures.

[2] Frazier, *Hollywood Irish*, p. 10.

Nevertheless in America, Britain and Ireland alike the same images of Ireland and Irishness have been purveyed. They are based on a cultural construction of Irishness in which the Irish themselves have happily collaborated. The figure of "Paddy", the Irish stereotype, goes back at least to the sixteenth century.

L. P. Curtis Jr. has argued that "Paddy" was defined in the nineteenth century specifically as the mirror image of John Bull. So the ideal Englishman was defined as a sober, law-abiding, mature, straightforward, phlegmatic, clean, rational gentleman, individualistic and private. But by contrast the Irishman was depicted as a drunken, lawless, unstable, emotional, dirty, devious, childlike, superstitious, lazy, vengeful and irrational peasant, clannish and tribal. In particular the Irish were violent: so a "paddy" became a colloquial term for a rage, a "hooligan" a description of mindless violence after a legendary family of brawling London Irish, and a "donnybrook" became a generic term for a free-for-all fight after the notoriously combative encounters at the eponymous fair.[3] The same contrast in types was to be found in America between the White Anglo-Saxon Protestant ruling class and the working-class immigrant Irish.

Prejudice against the Irish spread right across British and American society. It was a prejudice that was partly racial, reinforced by the new "science" of racism which graded human beings according to a scale of race and civilization; partly religious (Protestant prejudice against Catholics); partly class (urban industrial progress against peasant backwardness), and partly imperial (as a subject people, the Irish were automatically inferior and in need of good government). In America, the Irish immigrants clustered together in their own communities, with their own clubs and societies, newspapers and political organizations. Community life centered on home, the church and the saloon.[4] These communal elements meant much to Ford as did the anti-Irish prejudice he encountered growing up in Maine.

The English domination of Ireland was the context from which the cultural images of Irishness sprang. The stage Irishman was developed in the sixteenth and seventeenth centuries.[5] In English plays set in England the Irishman appeared usually as a servant or a soldier, accurately reflecting the reality of the Irish presence in England. These two characters evolved during the eighteenth

[3] L. P. Curtis Jr., *Anglo-Saxons and Celts*, Bridgeport, CT: Conference on British Studies, 1968.
[4] William V. Shannon, *The American Irish*, New York: Macmillan, 1966.
[5] On the stage Irishman, see Annelise Truniger, *Paddy and the Paycock*, Berne: Francke, 1976.

century, often in the hands of Irish playwrights, into familiar but attractive archetypes: the whimsical but faithful and resourceful servant, frequently and generically called "Teague" and classically embodied in the genial innkeeper Dennis Brulgruddery in George Colman's play *John Bull* in 1803, and the penniless, high-living, amorous, roistering gentlemanly soldier of fortune epitomized by Sir Lucius O'Trigger in Sheridan's *The Rivals* (1775).

These character archetypes survived in the nineteenth century when the era of mass-produced popular culture regularly reworked them to write them into the popular consciousness. The nineteenth-century novels of Charles Lever and Samuel Lover embodied both the soldier and the servant.

The new literary and dramatic interest in Ireland was a product of the Romantic movement. Ireland, like Scotland, had become a prime location and preoccupation for the creative imagination of artists, poets and balladeers, who saw in the "emerald isle" the elemental wildness and primitive picturesqueness that so appealed to Romantics and which in Ireland took the form of caves and cliffs, ruined castles, rugged landscape, ghosts, moonlight and fair colleens. This image was reproduced on stage in the work of scene-painters who provided an evocative background to Irish melodramas, directly reflecting the interest embodied in the rash of books of engravings of Irish scenes in the 1830s and 1840s.[6] A celebration of the Romantic Irish landscape was to become one of the enduring features of Irish films.

The Romantic spirit also permeated the work of the Irish Catholic poet Thomas Moore, whose ten volumes of *Irish Melodies* (1807–35) made a major contribution to the construction of a Romantic Irish identity. The same Moore who was the friend of Robert Emmet, biographer of Irish rebel Lord Edward Fitzgerald and author of a four-volume history of Ireland, was also Registrar of the Admiralty Prize Court, Bermuda, was married to an English Protestant, was a leading figure in London literary society and cultivated the friendship of Whig grandees. His career demonstrates that ambiguous relationship between nationalists and the Empire that runs through the history of Ireland.

But the songs, in which Moore provided words for traditional airs, were enduringly popular. As Miriam Allen deFord writes:

[6] Michael Booth, "Irish Landscape in the Victorian Theatre" in Andrew Carpenter, ed., *Place, Personality and the Irish Writer*, New York: Barnes and Noble, 1977, pp. 159–89.

> Up to fifty years ago at least, nearly every English speaking person, from operatic stars to members of the family gathering around the piano knew and sang "Believe me, if all those endearing young charms", "The Last Rose of Summer" and "The Harp that once through Tara's halls" ... Just as the more topical of the songs became hymns and political rallying calls in embattled Ireland, soldiers on both sides in the American Civil War ... sang them together in camp. They were popular songs in the truest sense.[7]

The songs which stress loss, tears, sorrows, battle and death became an integral part of the nationalist sensibility and run through the plays of Dion Boucicault and the films of Ireland, binding them together. A snatch of one of them is sufficient to evoke a picturesque and troubled past, whose legacy is still being lived through. Similarly Ford's films are steeped in folk songs.

A standard Irish play emerged in the nineteenth century which usually involved a romantic triangle with a villain seeking to discredit the hero and take over his land and his sweetheart, and a comic subplot usually involving the violent humiliation of some minor English functionary. The genre was comprehensively denounced by George Bernard Shaw in a review of a revival of Boucicault's *The Colleen Bawn*:

> To an Irishman who has any sort of social conscience, the conception of Ireland as a romantic picture, in which the background is formed by the Lakes of Killarney by moonlight, and a round tower or so, while every male figure is a "broth of a bhoy" and every female one a colleen in a crimson Connemara cloak, is exasperating ... The occupation of the Irish peasant is mainly agricultural; and I advise the reader to make it a fixed rule never to allow himself to believe in the alleged Arcadian virtues of the half-starved drudges who are sacrificed to the degrading, brutalizing, and, as far as I can ascertain, entirely unnecessary pursuit of scientific farming. The virtues of the Irish peasant are the intense melancholy, surliness of manner, the incapacity for happiness and self-respect that are the tokens of his natural unfitness for a life of wretchedness. His vices are the arts by which he accommodates himself to his slavery—the flattery on his lips which hides the curse in his heart; his pleasant readiness to settle disputes by "leaving it all to your honor", in order to make something out of your generosity in

[7] Miriam Allen deFord, *Thomas Moore*, Boston: Twayne, 1967, p. 33.

addition to exacting the utmost of his legal due from you; his instinctive perception that by pleasing you he can make you serve him; his mendacity and mendicity; his love of stolen advantage; the superstitious fear of his priest and his Church which does not prevent him from trying to cheat both in the temporal transactions between them; and the parasitism which makes him, in domestic service, the occasionally convenient but on the whole demoralizing human barnacle, the irremovable old retainer of the family. Of all the tricks which the Irish nation have played on the slow-witted Saxon, the most outrageous is the palming off on him of the imaginary Irishman of romance. The worst of it is, that when a spurious type gets into literature it strikes the imagination of boys and girls. They form themselves by playing up to it; and thus the unsubstantial fancies of the novelists and music-hall song-writers of one generation are apt to become the unpleasant and mischievous realities of the next.[8]

From this countervailing view of Ireland, Shaw constructed his play *John Bull's Other Island*, a play commissioned but rejected by the Abbey Theatre on the grounds of difficulty of casting and staging but in Shaw's view because "it was uncongenial to the whole spirit of the neo-Gaelic movement which is bent on creating a new Ireland after its own ideal, whereas my play is a very uncompromising presentment of the real old Ireland".[9]

But Richard Allen Cave has argued persuasively that the standard Irish play format was consistently and successfully subverted in the nineteenth century to create sympathy for, rather than mockery of, the Irish stereotype, against a new background created by the Catholic Emancipation Act (1829), the extending of parliamentary representation in the Irish Reform Bill (1832) and a more liberal attitude to Ireland.

The most celebrated exponent of the strategy was Dion Boucicault, whose Irish plays *The Colleen Bawn* (1860), *Arrah-na-Pogue* (1865) and *The Shaughraun* (1875) were continuously popular and played with success in England, Ireland and the United States from their first appearances. They had romantic settings, exciting incident and engaging heroes (Myles-na-Coppaleen, Shaun the Post, Conn the Shaughraun) who were daring, loyal, quick-witted, and able to use the

[8] George Bernard Shaw, *Our Theatres in the Nineties* II, London: Constable, 1932, pp. 29–30.
[9] George Bernard Shaw, *The Prefaces*, London: Constable, 1934, p. 439.

stage Irish persona to fool the English. His Irish melodramas appealed to the universal sentiments of the age, linked Irish and English by common adherence to gentlemanliness and dramatized the Irish problem in such a way as to awaken sympathy for the Irish without alienating the English audience. But there is no doubting that Irish sympathy.[10]

Throughout all the cultural manifestations, three continuing images have attached themselves to Ireland: violence, humor and communality. An Irish association with violence is as old as England's association with the island. As early as the twelfth century the chronicler Giraldus Cambrensis described Ireland as "barren of good things, replenished with actions of blood, murder and loathsome outrage". Fighting mercenaries have long been a prime Irish export. It was Shaw who said, not without some justice, that the best comedies in the English language had been written by Irishmen (Congreve, Farquhar, Goldsmith, Sheridan, Wilde and himself). They are all marked by a love of language, quick wits and high spirits, which in a negative sense— loquacity, blarney and fecklessness—have also been attached to Irishness. The communality, product of a peasant society, is the mirror image of the bourgeois individualism and imperial supra-nationalism of England. The informer, the perennial Irish hate figure, is the quintessential individualist in the Irish context.

The Irish melodrama is important to cinema as silent films appropriated melodrama wholesale. There were a large number of Irish dramas of a romantic nationalist tinge made in Hollywood in silent days. Among the earliest depictions of Ireland on film were a series of classic adaptations, filmed in Ireland by the Kalem Company and directed by a Canadian of Irish parentage, Sidney Olcott: *Rory O'More* (1911), *The Colleen Bawn* (1911), *Arrah-na-Pogue* (1911) and *The Shaughraun* (1912). This demonstrates the continuity to be found everywhere between the melodrama stage and the cinema, and the persistence of an essentially Victorian sensibility in the mass cinema-going public up until the 1940s.

The violence, humor and communality already mentioned figure strongly in cinematic depictions of Ireland. But in the imperial context it is struggle and

[10] Richard Allen Cave, "Staging the Irishman" in J. S. Bratton *et al.*, eds., *Acts of Supremacy: The British Empire and the Stage,* Manchester: Manchester University Press, 1991, pp. 62–128.

violence that characterize Ireland in cinema. The crimson thread running through the long and tangled story of Anglo–Irish relations is the Irish fight for independence, which has been imbued with a romantic aura as the classic struggle of a simple, united, rural people against imperial military might. Even in melodrama, plays were often set at the time of rebellion. The recurrent tropes are the use of violence, the role of the hated informer and communal solidarity. These myths, as Kevin Rockett has pointed out, mean that the cinema has consistently ignored inter-class rivalries and internal Irish conflict in favor of the communal solidarity necessary for sustaining the hallowed myth of united struggle.[11]

But the desire to dramatize the Irish struggle for freedom brought film-makers into conflict with the censors. The cinema in both Britain and America operated under the tight control of the censors, whose aim was to maintain moral rectitude and eliminate political controversy. While Ireland remained in the Empire, there was anxiety to avoid films stirring up ill-feeling. Sidney Olcott, who had directed the film versions of the Boucicault plays in 1910–12, returned to Ireland in 1914 to film *Bold Emmet, Ireland's Martyr,* which was banned in 1915 by the authorities on the grounds that it interfered with the recruiting drive in Ireland.

Even after independence, the British censors were for some years chary of allowing films about the Irish rebellion. The Irish-made film *Irish Destiny* (1926), released to coincide with the tenth anniversary of the Easter Rising, told a love story set against the struggle between the IRA and the Black and Tans, reconstructing the events of 1920–21 with many of the actual participants recreating their roles.[12] It was banned in Britain by the British Board of Film Censors (BBFC).

Although after several years of conflict, Ireland had been partitioned in 1921 with the six counties of north-east Ulster remaining part of the United Kingdom (as "Northern Ireland") and the remaining twenty-six counties becoming a self-governing dominion (the "Irish Free State"), there had been civil war in the Free State in 1922–3 and outbreaks of IRA activity in England in the 1930s. Under these circumstances, J. C. Robertson, historian of the

[11] Kevin Rockett, Luke Gibbons and John Hill, *Cinema and Ireland,* London: Croom Helm, 1987, p. 23.
[12] Rockett, Gibbons and Hill, *Cinema and Ireland,* pp. 42–44.

BBFC, observes that "potentially the greatest source of friction between the BBFC and American and British studios from 1919 to 1939 was Ireland".[13] In addition, T. P. O'Connor, veteran journalist and parliamentarian, and a former Irish nationalist MP in the British Parliament, was president of the BBFC from 1916 to 1929; Edward Shortt, BBFC President 1929–35, had been Chief Secretary for Ireland in 1918–19, and Colonel J. C. Hanna, Vice-President of the Board and Chief Script Examiner throughout the 1930s had served with the army in Ireland in the period 1918–22. So there was considerable interest and expertise in Irish matters on the British Board.

The Hollywood censors, the Production Code Administration (PCA) were as chary of Irish-themed films as the BBFC, though for different reasons. If the British authorities were concerned about the subject matter, in particular rebellion against the Crown, the PCA were concerned about the films' profitability if they were denied access to the lucrative British and Empire markets. These interests came into play when Ford decided to film *The Informer*. Ford and his scriptwriter Dudley Nichols, well aware of the censorship regulations, made key alterations to the script to avoid censorial interference. Nevertheless when the PCA received a shooting script for *The Informer*, they forwarded it to the BBFC. As Laura Burns-Bisogno discovered:

> The BBFC submitted five pages of new dialogue deletions and changes required if *The Informer* was to be awarded the seal essential for distribution in the UK and the Empire. A review of the lines to be deleted or amended revealed the deep sensitivities to any reference to British militarism in Ireland, to motivations of the Irish nationalists, and to the crown. Indeed, the very word "Ireland" was considered inflammatory and had to be exorcized again and again.[14]

Even after this, the BBFC excised four minutes from the finished version on June 6, 1935.[15] Ironically the film was initially banned in the Irish Free State as "a libel against the city of Dublin".[16] But it was passed with minor cuts after a

[13] James C. Robertson, *The British Board of Film Censors: Film Censorship in Britain 1896–1950*, London: Croom Helm, 1985, p. 86.
[14] Laura Burns-Bisogno, *Censoring Irish Nationalism*, Jefferson, NC and London: McFarland, 1997, p. 71.
[15] Robertson, *The British Board of Film Censors*, p. 88.
[16] Burns-Bisogno, *Censoring Irish Nationalism*, p. 77.

second viewing and broke box office records in Dublin and Cork. It was, however, banned in Peru, Palestine, Malaya, Guatemala and Hungary as likely to cause subversion.

The kind of approach the BBFC preferred was exemplified by the Samuel Goldwyn production *Beloved Enemy*. A synopsis was submitted by United Artists in 1936 under the title *Covenant With Death*. It centered on the love of an Irish rebel leader for the daughter of an English negotiator at the time of independence. The censors concluded that if the love interest remained central and no details of the conflict between the two sides were shown it would be acceptable. A scenario now called *Love Your Enemy* was submitted on August 20, 1935 and the censor reported: "I find nothing objectionable in this story. In spite of it being taken from recent history, the names are fictitious and in my opinion there is nothing to which the British or Irish Free State authorities could take exception."[17] It was duly filmed and released in 1936 under the title *Beloved Enemy*.

Although handsomely produced the film was dubbed by one American reviewer: "*The Informer* in evening clothes".[18] It emerged as a highly romanticized version of the career of Michael Collins grafted onto a fictional love story. Brian Aherne played the dashing Irish rebel leader Dennis Riordan who meets and falls in love with Lady Helen Drummond (Merle Oberon), daughter of the British peace negotiator. The secret love affair runs parallel with the end of the rebellion, and when in 1921 Riordan is instrumental in securing a treaty which partitions Ireland and sets up the Free State, he is accused by hardline colleagues of selling out the Republican cause. Campaigning for peace in Dublin, he is shot by his closest friend, and dies in the arms of Lady Helen. Concern at audience dissatisfaction led the studio to shoot an alternative happy ending, in which Dennis is wounded but survives. Although the original release print featured the unhappy ending, it is the happy ending which has been used in television prints of the film.

Significantly of the seven projects submitted to the Board at script stage, five were from Hollywood companies and the two British submissions were by individuals rather than film companies. This suggests that there was very little

[17] BBFC Scenario Reports 1935, no. 40.
[18] Alvin H. Marill, *Samuel Goldwyn Presents*, Cranbury, NJ: A. S. Barnes, 1976, p. 172.

interest by the British film industry in Irish stories in the 1930s. The success of *The Informer* generated a flurry of interest in Hollywood but the box office failure of *The Plough and the Stars, Parnell* and *Beloved Enemy* rapidly put an end to Hollywood's interest.

Hangman's House (1928), is one of the last and best of Ford's silent films. It is a demonstration of the state of the art of the medium which had now achieved a level of visual sophistication which enabled it to tell its stories almost entirely in pictures. Also apart from a few establishing shots and the exhilarating horse race it was created entirely in the studio. This gave Ford full control of lighting and visual effects and enabled him to create a memorable setting of foggy backstreets, mist-wreathed moors and marshes and shadow-haunted castle keep. It demonstrates quite clearly the influence of Murnau and German Expressionists on Ford's art. This is evident in the graceful tracking shots following Dermot as he rides through the woods, the disguised Hogan as he strides through the same woods singing the 1798 rebel song *Shan Van Voght* and, in a distinct visual echo of *Sunrise*, in the boat ride by Dermot and Conn through the marshes. It is an entirely appropriate romantic background in which to unfold a tale of revenge, daring escapes, star-crossed lovers and apparitions, while ever in the background lurks the menacing presence of the British army of occupation.

The plot, derived from a 1925 novel by the Irish writer Donn Byrne but set before independence, is effectively a cross between *The Informer* and *The Quiet Man*, intertwining two main themes, each of which extols family loyalty. Commandant Denis Hogan (Victor McLaglen), an exiled Irish freedom-fighter serving with the French Foreign Legion, obtains leave to return home—even though there is a price on his head for fighting the British—intent on killing the man who married and deserted his sister, causing her to die of a broken heart. The man is John D'Arcy, who, in accordance with the dying request of Lord Chief Justice O'Brien (Hobart Bosworth), marries his daughter Connaught (June Collyer). She does not love D'Arcy, who is a drunkard and a scoundrel, and who makes her profoundly unhappy. She spends much of her time with Dermot McDermott (Larry Kent) whom she loves and who loves her. But their relationship is entirely innocent—they are training and racing her horse "The Bard". After Dermot rides "The Bard" to victory, D'Arcy, jealous and embittered, shoots the horse dead and is blackballed by society. D'Arcy

recognizes Hogan, fears his appearance and informs on him to the "Black and Tans" and the British Army, who arrest him. The IRA break Hogan out of prison and he confronts D'Arcy at Hangman's House, the old Judge's castle. In the ensuing struggle a fire breaks out, Hogan escapes but D'Arcy is consumed by the flames along with the castle. Conn and Dermot are united and Hogan returns to the Foreign Legion. The original book concentrated on the D'Arcy-Connaught-Dermot triangle. The film script by Marion Orth and Willard Mack transformed Hogan, a minor supporting character into the hero, introducing his arrest, imprisonment and escape, and D'Arcy's role as informer into the narrative. This development is likely to have been directly influenced by Ford.

The principal villains of the film are renegade Irishmen, who serve the interests of the British. The Hangman of the title is the Hanging Judge, James, Lord O'Brien of Glenmalure. Ford takes full advantage of the presence of the majestic Hobart Bosworth as the Judge, tall, white-haired, commanding, and he poses him sculpturally hand on cane, against the grim stone setting of his castle. We first see him, shot through the flames in the fireplace, presaging his hellfire fate, a bent and weary old man, seated before a portrait of himself as he used to be, stiffbacked, stern and unrelenting. In the fire, he sees the silhouettes of executions he has ordered, the screaming faces of the women he has widowed, and he extends his arm to intone the familiar formula: "And may God have mercy on your soul". His reverie ends with the appearance of doctors who tell him he has only a month to live.

He dies soon after, seated by the same fire. Low-lit, he gazes into the flames as into his past, haunted by death and cruelty, gradually the screen mists over and from behind his chair, we see his arm drop limply and the silk handkerchief he was clutching flutter to the ground. Although he is dead, his malign presence reaches out from the grave, condemning his daughter to a loveless marriage. But his power is at last broken, his castle, symbol of the power of life and death he exercised in the name of the oppressors, goes up in flames, and there is a vivid shot of his portrait being eaten away by the fire, to underline the final exorcism of his influence.

But just as the Hanging Judge, hated and feared by his countrymen, is one instrument of British rule, so John D'Arcy is another. A suave, slimy cosmopolitan ("From Paris, Madrid, Moscow—anywhere but the Ireland that

bore him"), he has been chosen by O'Brien as a man acceptable to the English who will be able to maintain his daughter Conn in the state to which she belongs. But disgustingly drunk and heartlessly lecherous, in direct contrast to the fresh-faced young patriot Dermot who truly loves Conn, D'Arcy is locked out of the bridal chamber by his bride, whose Irish wolfhound lies down in front of the door. He shows his true colors when he shoots Conn's horse "The Bard" after it has won a race. This so incenses the crowd that they turn on him and he has to be rescued by the British. Furthermore after he informs on the fugitive patriot Hogan he is shunned by both his countrymen and the British. In the final confrontation with Hogan at the Hangman's House, D'Arcy reveals himself as a coward to boot. Begging for a chance to fight for his life, D'Arcy is offered a knife by Hogan, who chivalrously lays aside his revolver, whereupon D'Arcy shoots and wounds him. But ultimately he is consumed by the fire that destroys the castle.

So the tyrant and the informer-traitor-lecher typify the Irish renegade. The Irish patriot and Fordian hero par excellence by contrast is Denis Hogan, known in Ireland as Citizen Hogan and a hero of the Republican struggle. This would certainly accord with Ford's well-marked sympathy for the outsider. Indeed there is something of *The Searchers'* Ethan Edwards in Denis Hogan, exile, soldier, outlaw, who comes home for a while but leaves again at the end. In the opening scene, he is in North Africa, drinking, smoking and joking with his comrades in the officers' mess of a Foreign Legion fort but the arrival of a letter announcing that his sister has been seduced and abandoned by a cad and has died prompts him to request a leave of absence. The cad inevitably turns out to be D'Arcy and justice is done to him.

Although Hogan has found a congenial place in a military unit, a typical Fordian home for homeless heroes, his longing for his homeland makes his exile a fundamentally tragic matter. It prompts the most moving scene in the film. Having exacted his vengeance and united the star-crossed lovers, Conn and Dermot, Hogan prepares to leave Ireland. The pale moon silvers the sea in the little fishing village where he will take ship. He bids Conn and Dermot farewell and the film ends with a long, expressive close-up of Hogan gazing after them as they leave. His face mirrors the deep melancholy, emphasized by the obvious happiness of the lovers, that he feels at having

to leave the cool, green land he loves to return to the heat and brown sand of the desert.

Visually the film is stunning, lit and photographed by George Schneiderman, to give a constant impression of just that Ireland which Ford had in mind, the Ireland of bardic lore and Celtic myth, floating otherworldly in a sea of mist. Excellently engineered action scenes punctuate the plot, such as the escape of Hogan from prison, freed by the IRA amid the blast of machine guns, the crash of falling masonry and the splintering of wooden gates. There is also the exciting horse race, a succession of breathtaking spills and thrills, intercut with the reaction of excited spectators, among them an uncredited but unmistakable John Wayne, demolishing a fence in his enthusiasm, and a group who leap onto a cart, causing the donkey between the shafts to be lifted off the ground. The ritualistic aspects of Irish life are there too: the wedding of Conn and D'Arcy in the chapel and the funeral of the Judge, with mourners posed hieratically, women beating their breasts, the wolfhound howling and Conn, shawled like a grieving Madonna, bending over the coffin. For all the film's sweeping Romanticism, there is a leavening of typical Ford humor in McLaglen's disguises as a monk and a blind man and the little scene of a corpulent pubkeeper pulling a vengeful Dermot off the sniveling D'Arcy and then reprimanding D'Arcy for manhandling the young man. It is the first of Ford's lyrical celebrations of his ancestral home: "such a little place and so greatly loved" as one of the intertitles puts it.

William K. Everson has noted the influence of Murnau and in particular *Sunrise* on Ford:

> Virtually all of the basic Fox directors—William K. Howard, Howard Hawks, Raoul Walsh, and ... William Dieterle embraced Murnau's visual style ... Even so American a director as John Ford, whose basic influence came from Griffith ... temporarily changed (and slowed) his whole style to match that of Murnau Ford's *Hangman's House* (1928), which might have been a fairly conventional Irish melodramatic romance, became a very strange mixture of German-dominated visual stylistics ... with foreshadowings of Ford's later talkies, *The Informer* (1935) and *The Quiet Man* (1952). If nothing else, *Hangman's House* totally repudiates Ford's oft-stated claim that he was not an artist but merely a worker doing a job the best way he knew how. It is full of scenes and compositions that only an artist would use, including a

long tracking shot through the mist of a studio-made river—a scene that could have been dispensed with for its small narrative value, and probably would have been replaced by a fade or a title if Ford had been merely doing a job.[19]

The film's quality was recognized by contemporary critics. *Kinematograph Weekly* (May 31, 1928) said:

> In HANGMAN'S HOUSE Victor McLaglen gives what I consider the best performance of his career. His Citizen Hogan is the virile character that moves infrequently through the scene but dominates the story from the first title to the last ... Of course, many people will be interested primarily in the melodramatic climax and the misfortune of the informer's unwilling bride. Others will be impressed by McLaglen's acting, the brilliant vignettes of Irish life, which are seen at their best in the race sequence, and by the constant succession of beautiful compositions, admirably photographed. Really, it looks as if John Ford had discovered the secret of universal appeal.

Variety (May 16, 1928) said:

> This reviewer doesn't remember any other picture subject dealing with Irish society in a serious drama. Here the locale and characters are treated in a fine literary way and the scenic backgrounds ... are remarkable for their pictorial beauty, so much so that the photographic quality of the whole production is one of its outstanding merits. Besides there is a thoroughly interesting story, with fine, unaffected character drawing, a strong tug of suspense, and although the action has an abundance of dramatic force, it is never merely theatrical ... There are bits of mist-draped landscape that actually inspire real emotion; vistas of moorlands in dim morning lights, glimpses of an old gate and driveway to a castle that give the feeling of fine old prints. From start to finish the pictorial side of the production is a revelation of camera possibilities ... altogether a screen output that calls for unrestrained applause.

Sadly for the film, it was lost in the upheaval of the arrival of the talkies and was forgotten for fifty years until the rediscovery of Ford's silents revealed that he had indeed mastered that medium of universal communication.

[19] William K. Everson, *American Silent Film*, New York: Oxford University Press, 1978, p. 328.

The Informer was a film close to Ford's heart. He had been trying unsuccessfully to film the 1926 novel since 1930. He had become friendly with the book's author, the Irish Marxist writer Liam O'Flaherty when he came to Hollywood looking for work as a scriptwriter. Ford took an option on the book and approached a succession of studios (Fox, Columbia, MGM, Paramount, Warner Bros), all of whom turned it down as too depressing, too political and lacking in love interest. Eventually it was commissioned by RKO Radio Pictures on the strength of the surprise success of a previous offbeat Ford production *The Lost Patrol*. The production head Merian C. Cooper, who had sanctioned *The Lost Patrol*, was willing to take a risk again and paid $2,500 to Flaherty for the film rights. As he had on *The Lost Patrol* Ford accepted a pay cut and a percentage of the profits to do it. But Cooper resigned in 1934 and the other studio bosses, fearing that the project was hopelessly uncommercial, restricted the budget, limited the shooting schedule and banished Ford from the main RKO studio to a nearby rented facility, the California Studio, where he had to work with standing sets and painted backdrops. Ford had Dudley Nichols draft a screenplay and then worked closely with him to translate it into visual terms, keeping him on set to make any dialogue changes suggested during filming. Cameraman Joseph H. August did a superb job of disguising the poverty of the sets by the use of chiaroscuro lighting, fog and shadow. Ford used RKO contract players Preston Foster and Margot Grahame to play Commandant Dan Gallagher and Katie Madden but also veteran Abbey Theatre players Una O'Connor and J. M. Kerrigan as Mrs. McPhillip and Terry. (Contrary to what many books state, the Dennis O'Dea who plays the street singer is visibly not the same man as the Denis O'Dea playing Young Covey in *The Plough and the Stars*.) His greatest coup was insisting on Victor McLaglen to play Gypo, who under Ford's coaxing, bullying and coaching turned in the performance of a lifetime. Ford completed the filming in three weeks. The result was an enormous box office success. Costing a mere $243,000 to produce, it grossed $891,000 worldwide and won four Oscars (best actor for McLaglen, best director for Ford, best screenplay for Nichols and best score for Max Steiner). In gratitude, Liam O'Flaherty dedicated his next novel, *Famine*, to Ford.[20]

[20] On the making of *The Informer* see Frazier, *Hollywood Irish*, pp. 35–92 and Dan Ford, *The Unquiet Man*, London: William Kimber, 1979, pp. 82–89.

Figure 2.1 Victor McLaglen in *The Informer* (RKO, 1935)

For several decades, *The Informer* was regarded not only as one of Ford's masterpieces but also as one of the transcendent masterworks of the cinema. The critic Theodore Huff said "Nearly every list of 'ten best pictures of all time' include this film. Many consider it the greatest talking picture ever made in America".[21] The *Sequence* school of critics began to de-value it in the late Forties as part of their distinction between the art and folk films in the Ford canon and their disparagement of the former in favor of the latter. This process has continued and eminent Ford scholars Andrew Sarris and Peter Bogdanovich play down the film ("one of the most disappointing of all official film classics").[22] Even Ford, who used to number it as one of his favorites, later claimed to like

[21] Lindsay Anderson, *About John Ford*, London: Plexus, 1981, p. 63.
[22] Andrew Sarris, *The John Ford Movie Mystery*, London: Secker and Warburg, 1976, p. 68; Peter Bogdanovich, *John Ford*, Berkeley: University of California Press, 1978, p. 30.

the film less than heretofore on the grounds that it lacks humor, which he believed to be his forte.[23]

However, there have been attempts to reinstate the film. In his essay on the film Alan Stanbrook describes it as "a masterpiece that transcends its incidental shortcomings" (shortcomings which he lists as the score—"ludicrous hack work"—the uneasiness of the accents, the photography, which he believes is not as powerful as in later films) and says of McLaglen's performance: "A quarter of a century of development in film acting has done nothing to diminish the force of this well-deserved Oscar-winning performance".[24] Similarly John Baxter, agreeing that the film has been over-praised, lays stress on "the film's deep conviction, its assured technique and McLaglen's superb study of the traitor Gypo".[25] But most of all, what both these critics single out for discussion is the visual power of the film and it seems to me that it is in these terms that we should judge the film. Its fundamental unreality, the lack of humor, the sometimes uneasy accents are minor points compared to the visual impact of the film, the coherent and imaginative use of symbols, the inventive way in which the visuals rather than dialogue are used to create the mood and convey the detail of the drama. What Ford and Nichols have done is to conceive and create the story in pure cinematic terms. It is this which makes the film great and which contrasts so forcibly with the other Ford–Nichols collaboration, *The Plough and the Stars*, which is often static and theatrical, the antithesis of *The Informer*.[26]

The story outline, the major characters, and whole sections of the dialogue are taken from Liam O'Flaherty's novel. But there are some interesting omissions. Frankie McPhillip's father is deleted. This emphasizes the role of his mother and is fully in keeping with Ford's exaltation of the role of the mother (cf. *Pilgrimage, The Grapes of Wrath, How Green Was My Valley*). Also cut are Crank Shanahan the anarchist, Connemara Maggie, another prostitute and Katie's rival for the affections of Gypo, and Louisa Cummins, the elderly, bedridden room-mate of Katie—all of whom would have cluttered the

[23] Bogdanovich, *John Ford*, p. 59.
[24] *Films and Filming* 6 (July 16, 1960), pp. 10–12, 35.
[25] John Baxter, *The Cinema of John Ford*, London: Zwemmer, 1971, p. 50.
[26] For a comparison of the film and the novel see Patrick F. Sheeran, *The Informer*, Cork: Cork University Press, 2002.

narrative of the film and posed problems of effective integration. There is one major addition and that is Terry, the voluble, quick-witted opportunist, who attaches himself to Gypo and leads him round the town, trumpeting his praises and bleeding him of his money.

More interesting than this, however, is the alteration of the existing characters. George Bluestone, in a detailed comparison of novel and film, comments "What do these deletions, additions and alterations amount to? In general, they endow the characters with a nobility, honesty and reasonableness which the originals do not possess".[27] Commandant Dan Gallagher, who in the book is a pitiless, sadistic despot, feared and mistrusted by his own Communist organization ("I believe in nothing fundamentally. And I don't feel pity" he says), becomes in the film a handsome, upright, respected and fair-minded leader, who seeks justice and not vengeance. He is also in love with Mary McPhillip and a couple of short, tender love scenes (though disliked by some critics) help to round out his character and confirm its heroic transformation. Katie Madden (Fox in the book) is a prostitute, who in the tradition of Ford's fallen women, is treated with real sympathy. She has taken to the streets through poverty, genuinely loves Gypo and betrays him unwittingly. The Katie of the book, however, is a drug addict and degenerate, reveling in her degradation, who willfully betrays Gypo to his pursuers. Frankie McPhillip in the film, a clean-cut, likable fugitive patriot, who returns to Dublin just to see his mother, is a distinct contrast to the brutalized murderer of the book, who returns seeking money to finance his escape. These changes will partly have been inevitable, because of censorship, but will also have been in accordance with Ford's tendency to archetypalize his characters. Dan becomes an idealized revolutionary leader, Mary a typically Fordian pure-as-snow Irish heroine, Mrs. McPhillip the Fordian mother, Katie the tart with a heart of gold. It is Ford's great talent that he can endow what are on paper such conventional figures with the dimensions of living, breathing people and it is a talent which remained one of his enduring strengths.

There are also two major structural changes which are quintessential Ford and which make the film as personal to him as any of his great works. Despite the opening title "1922" Ford refocuses the context of the film from the Civil

[27] George Bluestone, *Novels into Film*, Berkeley: University of California Press, 1968, p. 77.

War which followed partition to the "Black and Tan" War and the last year of British Occupation. The Communist organization which Gallagher heads in the book becomes the IRA and as in *The Plough and the Stars*, Ford is at pains to stress the regular military nature of this army: "It is an army, though a secret one". Men are addressed by their ranks, a full-dress court martial is held for Gypo, the IRA headquarters with its rows of rifles has the appearance of a genuine field post, military discipline is enforced. Ford could have it no other way. He favors revolt, but not undisciplined anarchy. His revolt has to come as near as possible to organized military activity in a formal state of war. It is a mark of the conservative rebel. The killers of Frankie are now "The Black and Tans", whom Ford held in particular detestation. "The Troubles" are one of the periods of history which hold the most painful memories for Ford and he is happier telling a story in which the Irish fight the British than one in which the Irish fight the Irish. He has Gallagher explain to Mary that the murder of Gypo will not be revenge but to protect the Organization, and he has the elected murderer being reluctant to do it.

However, just as much as it is a melodrama of "The Troubles", it is also a Catholic parable, which merits inclusion with the religious films, just as much as it does with the Irish. The opening statement of the film makes it clear that the story has a definite religious dimension: "Then Judas repented himself and cast down the 30 pieces of silver and departed". The story that follows charts the torment and confusion and eventual repentance and forgiveness of Judas. So the characters take on New Testament roles: with Gypo as Judas, Katie as Mary Magdalene, Frankie as the Christ figure and Mrs. McPhillip as the Mother of Christ. This culminates in the superb final scene, in which Gypo, dying of bullet wounds, arrives at the church. There kneeling, black-clad and shawled like the Madonna is Mrs. McPhillip. Gypo staggers toward her. "'Twas I informed on your son ... Forgive me" he gasps. In reverential close-up, Mrs. McPhillip replies: "I forgive you, you didn't know what you were doing". Then with the camera high up behind the altar, the triumphal final shot has Gypo, arms outstretched in cruciform, gazing up in ecstasy at the image of Christ on the cross. "Frankie, Frankie, your mother forgives me" he cries, and falls dead. Gypo has made his peace with his God.

Although Ford does not for a moment condone Gypo's actions, he demonstrates for him the sympathy he has always shown toward outsiders.

Figure 2.2 The IRA in *The Informer* (RKO, 1935)

Gypo is an outsider—expelled from the IRA for what some might regard as the laudable act of refusing to carry out a political execution and sparing the life of a condemned man, a captured Black and Tan. Frankie is on the run for having dutifully carried out just such an "execution". It does not need to be stressed that Ford regards not belonging as the greatest tragedy there is and this is perhaps echoed in Gypo's bellowing of his name at the top of his lungs in the street. It is a sort of desperate assertion of his identity as the world closes in on him.

Gypo is drawn to another outsider, Katie, the prostitute. But not for them is the happiness accorded to two other outsiders, who draw together for a mutual sense of belonging: Ringo the outlaw and Dallas the prostitute in *Stagecoach*. They find their happiness on Ringo's ranch south of the border. Katie and Gypo seek it in the United States. It is in order to gain the £20 passage money that Gypo betrays his old friend, Frankie, to the authorities. Although Gypo subsequently tries hard to forget what he has done, he never loses sight of this

goal. At one point, he has a vision of himself and Katie, married, sailing on the ship, and as he is being led unwitting back to face trial, he meets Katie in the street and presses what is left of the money into her hand, while his captors exchange significant glances. It is this which leads me to disagree with John Baxter's interpretation of Gypo. "He is driven to betray his friend to the police less by the hope of escape than by a need to act against his society, to assert himself as an individual. He is unable to see that he is loved, that there is a place for him."[28] But surely the point is that there is not a place for him, since he was expelled from the Organization. What he is hoping to do is find a new place in a new country with another of society's cast-offs.

The film's themes are quintessential Ford, but the style is broodingly Expressionist, the first of his sound films to adopt this style, so appropriate to the story. Low-angle shots, low-key lighting, many close-ups and everywhere fog and shadows, consciously artistic perhaps but giving the story a Teutonic intensity and moody fatalism. Behind the credits, the plot is virtually acted out in a little poem of fog and shadow. The silhouette of Gypo looms up out of the fog, a patrol of soldiers cross the screen, shadowy women point accusingly at Gypo and his silhouette advances, arms outstretched, toward the camera.

Much of the effectiveness of the book depended on long interior monologues and literary similes and analogies. But neither of these devices was translatable into film. So Ford and Nichols conceived a series of symbols to convey the state of Gypo's mind. Some were taken from the book (the fog, the twenty pounds) but others were inventions (the poster, the blind man). These symbols woven skillfully into the fabric of the film, bind the characters together with the result that the film's impact was profoundly increased. Ford supplemented his symbols with superimposition, to show us what was actually happening in Gypo's brain. For instance, when Gypo first sees the wanted poster for Frankie, Ford superimposes on his face a scene of Gypo and Frankie, arms around each other's shoulders, singing together, and thus establishes without words their friendship. Later, after the betrayal, Ford superimposes on Gypo, a shot of Frankie sadly telling his friend that without him, he will be lost. Perhaps most notable is the scene where Gypo looks into the shop window with the model ship and the notice of passage to America, shot by Ford from low-angle inside

[28] Baxter, *The Cinema of John Ford*, p. 51.

the shop so that we see the model ship directly in front of us and Gypo's longing face above it, gazing down. Then onto this, he superimposes a scene of Gypo and Katie in wedding clothes actually on board the ship and sailing. Once again, Gypo's thoughts are made manifest without the need for a word of dialogue.

Of the symbols, perhaps the most obvious and in a way the most effective is the fog. *The Informer* must be the foggiest film ever made. This was partly functional, dictated by the necessity of disguising the characterless standing sets which economy compelled Ford to use (and whose characterlessness emerged forcibly when he used some of them again, without the fog, in *The Plough and the Stars*). But it also plays more important roles within the film. It symbolizes the mental confusion of Gypo and emphasizes his physical lostness, a doomed figure in a nightmare landscape. The fog, all pervasive, drifting, clinging, broken only by the pools of dim light cast by isolated street-lamps, also serves to provide an abstracted, dream-like setting, which generalizes the story and raises it from a precise time and place (Dublin of "The Troubles") to a universality, which the opening statement implies.

The wanted poster symbolizes the temptation of Gypo and is introduced in the very first scene. Gypo looms up out of the fog, bulky and ungainly, and the camera tracks him along the murky street until he halts before a wall which is plastered with a poster offering £20 reward for the capture of Frankie McPhillip. Ford dissolves to a close-up of the line reading £20 Reward, searing it visually into Gypo's mind. Angrily, he rips it down and throws it away, the wind catches it and blows it back toward him, and insidiously and prophetically it wraps itself around his feet.

He meets Katie, and once again Ford visually and succinctly sums up her background. Our first sight of her is as the conventionally shawled, Madonna-like Irish woman. But Ford cuts to a well-dressed man, watching her. Suddenly she drops the shawl, revealing a beret and walks to a lamp-post and leans against it, waiting. The man follows, leans over and blows smoke in her face and as it clears, we see the despair and degradation of the common prostitute written there. Once again, more eloquently than with words, Ford has conveyed the facts of her fall from the idealized young girl to the abused street-walker. But Gypo appears from the side-street, picks up and flings the man down the street and is greeted by the plaintive wail: "Gypo" from Katie, which floats away

on the fog. She excuses herself on the grounds of poverty and shows him a sign in a shop window, advertising passage to America, at £10 each. Their faces are reflected in the window over the sign and then Ford superimposes the £20 reward money sign over the notice of the passage money. Gypo now has his motive.

But Ford now uses the poster again to bring in Frankie himself. As a lone figure creeps surreptitiously along the street, the poster blown by the wind catches his feet. He picks it up and looks at it. It is Frankie and he finds himself gazing at his own features. He screws up the paper and throws it away. The tramp of an approaching patrol is heard and he dodges into an alleyway, gun at the ready. The British flash torches into the alley, their light beams accusingly lancing the murk. They pick up not Frankie but another McPhillip wanted poster on the wall behind him. They pass on.

Gypo is eating his dinner at the Dunboy House when Frankie comes in. Gypo stares at him transfixed, as if confronted with his thoughts made flesh. We see Frankie through his eyes, with the £20 reward notice superimposed under his face. It is immediately after this meeting that Gypo goes to the military headquarters and betrays Frankie to the authorities.

It is brilliantly done. The recurrence of the poster in each of these scenes not only inexorably links the protagonists (Gypo the informer, Frankie the victim and Katie the motive) together, but the repetition of the image serves to represent the building up of the temptation within Gypo until it becomes irresistible.

When the temptation has been succumbed to, the role of the poster is at an end, but it reappears once more to tie the deed into the exposure of guilt. Gypo is taken to IRA headquarters to be questioned about the informer by Dan Gallagher. As he is led in, Dan is gazing at the McPhillip poster and once again Gypo is mesmerized, mouth agape, by the sight of it. He watches in silence until Dan throws the poster on the fire and the camera holds on the poster, watching it burn and finally flutter away up the chimney in charred fragments.

The Blind Man represents Gypo's conscience and he appears for the first time as Gypo is sneaking out of the police headquarters after having informed. Seeing a figure indistinct in the fog and hearing the tapping of his stick, he seizes him roughly and then realizes he is blind, passes his hand before the

dead eyes to reassure himself, and shambles off. But the tapping stick haunts him and the shuffling, strangely menacing figure follows. When Gypo emerges from the pub, the man is there again and Gypo presses a pound note into his hand—the first indication of an attempt to buy off his conscience. Finally, in a chilling moment of recognition, we see the blind man among the witnesses at Gypo's trial, sitting motionless with sightless eyes but possessing evidence (the pound note which will help to convict him). His conscience has caught up with him.

The twenty pounds reward symbolizes Gypo's guilt. It is the blood money. The line of the poster advertising the amount reappears constantly in the early part of the film, battering at Gypo's limited consciousness with its promise of escape and a new life in America. Then in the police headquarters, Ford lingers on a shot of the "Black and Tan" officer tossing the wad of notes onto the table and contemptuously pushing it toward Gypo with his cane. The money becomes the mark of his guilt and it is by following him and studiously adding up how much he spends that Bartley Mulholland is able to prove this guilt. When he leaves the headquarters, Gypo goes straight to a pub and orders whiskey. He pulls the wad from his pocket with clumsy secrecy to detach a note and there is a threatening close-up of the publican watching him. After a while Katie comes in and her careless chatter about money and informing cause Gypo to flare up angrily and move off.

Gypo, already tormented by remorse, goes to Frankie's wake and pulling out his handkerchief, spills a number of coins onto the floor. The tell-tale clatter of the money on the floor alerts Bartley Mulholland and Tommy Conner. Ford holds his camera on the coins, which lie winking and gleaming reproachfully at him. Gypo scoops them up and tips them in Mrs. McPhillip's lap before hurrying out.

After this, Bartley and Tommy are on his trail. The garrulous little parasite Terry sidles up out of the shadows and attaches himself to Gypo, flattering him as "King Gypo" and taking him first to a fish and chip shop and then to a brothel, disguised as a shebeen drinking den. In the chip shop, Gypo offers to buy chips for all and in a splendid long shot, stands on the counter dispensing fish and chips to the sea of arms reaching up greedily at him. More money changes hands and the camera tracks through the crowd to the shop window and the hard, accusing face of Bartley Mulholland outside looking in.

At Aunt Bessie's brothel, they are greeted sourly until Terry reveals that Gypo has money and then they are made welcome. A deleted scene had the prostitutes boisterously but rapaciously going through his pockets. But even without this, the indication is that he is welcomed, as he was at the chip shop only for his money. When this has gone and Bartley and Tommy arrive to take him to his trial, the avaricious little Terry gets his comeuppance. Aunt Bessie demands that he pay for the last round and when it is clear he cannot, she calls for the bouncer and with resignation he remarks: "I have a queer feeling that there's going to be a strange face in heaven in the morning". That is the last we see of him. Gypo, escorted away, sees Katie and presses the last of the money into her hand for the passage money. There are significant close-ups of Bartley and Tommy. Finally at the trial, the trail of blood money is expounded and his guilt proved. The money, which had been intended for the new start, had proved his downfall in the end.

So these visual threads draw the story tightly together, but Ford uses Gypo's actual physical shape and ungainliness throughout as a constant reminder of his plight: the tragedy of a hulking, lumbering, stupid ox of a man who blundered into something he did not understand fully. His strength is really his only asset. Frankie has always been the brains of the team and he appears to Gypo after his death, shaking his head sadly: "Ah, Gypo, I'm your brains … you're lost". From the outset, this brute strength is emphasized. He flings away bodily the gentleman who is trying to pick up Katie. He knocks out two men, one of them a policeman, outside the chip shop. Later, escaping from the IRA he reduces a guard's jaw to jelly. But his violence is never sadistic and it is anyway offset by other facets of his character: the impetuous generosity (giving money to a homesick English prostitute (Grizelda Hervey) at the brothel to go home) and drunken sentimentality (weeping when someone sings "Those Endearing Young Charms" at the brothel) and the feeling for Katie, which prompted the deed. When he has been condemned to death by the Organization and has escaped, he takes refuge with her, the only place where he can be sure of safety, and curled up by the fire with his head in her lap, he confesses what he has done and why. While he sleeps Katie goes to Dan, to beg for his life. She explains he had not understood what he was doing, that he was doing it for her and that it was basically her fault ("Me shamin' him for his poverty and blamin' him for mine and puttin' the idea into his head"). But Bartley, listening outside

the door, gathers up his men, goes to Katie's and pumps Gypo full of bullets. So even her devotion to Gypo brings him to his doom in the end.

But the stressing of his clumsiness and his shape is constant, even in details of the action, such as him bumping his head on the chip shop sign and falling drunkenly down the steps of the cellar where the trial is to be held. Shots of him hunched childlike but still ungainly stick in the memory: hunched in a chair at the headquarters, nervously waiting for word of his action in laying information; hunched in the corner of the locked shanty where he has been placed by the IRA, a superbly lit scene, the darkness broken by light slanting in through the slits of the door and the silence broken by the steady drip of water from the roof. But most notable of all is his appearance at Frankie's wake, a brilliantly choreographed scene which serves both as a hieratic statement of community grief and a demonstration of Gypo's size and awkwardness. In the street outside the McPhillip's house, the tenor sings *The Minstrel Boy* and we hear the keening of female mourners. Inside, on one side of the screen stands the coffin, a group around it motionless, two nuns at the head, and priests intoning prayers for the dead. To the other side sits the mother, lost in her grief, staring fixedly ahead. Downframe left, a group of perfectly ordered mourners stand solemn and unmoving. Gypo shambles in, his size and awkwardness contrasting at once with the respectful formality of the grouping. He sits down, pulling up his knees to his chin, and says in a loud voice: "I'm sorry for your trouble". Everyone stares, he stands up, spilling his coins, and then departs.

It is not only the visuals that Ford orchestrates to create his mood, he uses sound with great creativity to heighten the tension. The clatter of the coins on the ground and Gypo's loud voice at the funeral have already been noted. There are two more memorable examples: the betrayal and death of Frankie. At the Army Headquarters, Gypo, hunched in a chair, listens for the sound of the returning troops. Doors slam, a clock ticks, preternaturally loud, a pen can be heard scratching laboriously on paper. The tension is thus conveyed aurally as well as visually. Similarly, for riveting horror, it would be hard to beat the scene of Frankie's death. Arriving home, he is greeted with joy by mother and sister, but the display of family feeling is shattered brutally and suddenly by the battering on the door, which signals the arrival of the "Black and Tans". Frankie flees up the stairs to escape by a back window. Ford frames the scene with the window. Frankie lets himself down from the ledge, his arm gripping it, all that

is visible of him. Below in the courtyard, the soldiers appear, raise their rifles and fire, the grinding scratch of his fingernails as his hand slips over the ledge and catches on the wood is far more chilling than any sight of Frankie's bloodstained body would be. Similarly, as ever, Ford uses folk tunes to evoke the time and the place—here "Those Endearing Young Charms" sung at the brothel, "The Rose of Tralee" and "The Minstrel Boy" sung by the street singer and "The Wearing of the Green" accompanying Frankie's appearances.

There is in fact not a superfluous gesture or image in the film. It has a cohesion and strength which lend support to Ford's claim that he had dreamed about the film for five years before he actually came to film it. Its great achievement it seems to me, and one which the passing of time has not diminished, is its desire and the largely successful accomplishment of this desire to render the story in cinematic terms, relying on a minimum of dialogue. Its dramatic unity, visual intensity, tragic inevitability are a great tribute to Ford's feel for the medium and his unsurpassed sense of atmosphere and tempo, and to his direction of Victor McLaglen. McLaglen, who was to become a regular member of the Ford stock company, here gives his finest performance and one which Hollywood deservedly recognized with an Oscar. Like others who have worked with Ford, McLaglen was a limited actor, who here by a combination of his physical rightness for the role, Ford's deployment of cinematic resources to help him, and by McLaglen's simply pulling out everything he had got, achieved a moment of cinematic greatness. The temptation, the betrayal, the remorse, and the spiral downwards toward the inevitable end, through bemusement, drunkenness, violence, maudlin sentimentality and final realization and admission, are supremely well managed. The trial in the underground cellar in particular demanded and received all McLaglen's resources, its freshness and vividness being due to Ford extemporizing freely, bullying and coaxing McLaglen into the right mood and to Preston Foster, on Ford's orders, adlibbing and interrupting McLaglen to create spontaneous reactions. Gypo comes rolling down the stairs, drunk, and sees the nervous, ailing tailor Mulligan, telling his beads in terror, and he greets him kindly and sympathizes with his illness, until he realizes that this is the man he had earlier named as an informer. Then he denounces him again, seeking to cover up his lapse of memory. But Mulligan has a perfect alibi. The blind beggar and Bartley Mulholland give evidence. Gypo sobering up rapidly denies, blusters, tries to leave and finally, prompted by

Gallagher, breaks down, covers his face with his hands and confesses: "I didn't know what I was doing". He is hustled away. Although shot by Mulholland, he dies having received the forgiveness of Mrs. McPhillip and he dies happy. *Sequence* to the contrary notwithstanding, it remains a fine performance and a fine film and is clearly, in its dramatization of "The Troubles" and Catholic morality, as close to Ford's heart and as personal as *Young Mr. Lincoln* or *She Wore a Yellow Ribbon*.

It is interesting to compare Ford's film with the unjustly neglected British version of Flaherty's novel, directed in 1929 by the German Arthur Robison, but not shown in America and banned by the censors in the Irish Free State. Ironically, Ford's version is far more Expressionist than that of Robison (himself the arch-Expressionist creator of films like *Shadows*) but it is nevertheless an extremely impressive piece of work. Like Ford's film, it is a work of pure cinema, putting little reliance on dialogue or intertitles. It achieves visual representations of sound, conveys reactions by an extensive use of point-of-view shots and lowering close-ups, and employs a vividly fluid technique (mobile camera, whip pans, dynamic staging of action) and a crisp, authoritative style of editing. But there is no fog and very little shadow.

Robison dutifully sets his film during the Civil War of 1922 opening with a gun battle between the rival factions. Although he includes many of the same episodes as Ford (the betrayal and shooting of Frankie, the visit to the wake and the dropping of the money, the gift of money to the homesick prostitute, the final shooting after the betrayal by Katie, and forgiveness and death in the church), his motivations are completely different and the whole ambiance of the film is different. It is not about "The Troubles". It is not a Catholic parable. It is not even an exploration of the psyche of Judas. It is a very characteristically Germanic drama of fate, revenge and sexual passion. The atmosphere of the slum streets, seedy back-rooms and crowded pubs is so Germanic that one almost expects to see "the Blue Angel" come gliding round the corner. Concerned as he is with human emotions, Robison has no need to justify with legality the activities of the IRA or the "execution" of Gypo. So he noticeably omits the trial, which is one of the high points of Ford's film, and shows the IRA being scrupulously fair, with judge, jury and properly conducted legal proceedings. Robison's protagonists are simply members of a Communist faction in the Irish Civil War, carrying out vengeance on one of their number who turned traitor.

The Gypo of Swedish star Lars Hanson is a very different figure from Victor McLaglen's pathetic, half-comprehending brute-man. Hanson's Gypo is a flashing-eyed Byronic figure, a Romantic anti-hero dogged by Fate and doomed to an unhappy end from the start, blood-brother, in fact, to Hanson's earlier and probably most famous role, that of Gosta Berling in *Gosta Berling's Saga* (1924). In the memorable finale, he decides to face his pursuers and to run no longer and in a grand gesture worthy of a tragic hero, he emerges from Katie's rooms and descends the stairs slowly, pointing to his heart. His pursuers fall back, in awe, until Gallagher arrives, shoots Gypo and they run off. This is of course in marked contrast to Ford's Gallagher, who does not kill Gypo and who comforts Katie when the sound of the shooting is heard.

The motivation, however, is probably the main difference and the film's tragedy revolves around misunderstandings based on jealousy. Gypo and Frankie (called Francis throughout) are friends but rivals for Katie. When Frankie flees after accidentally killing the Chief of Police, Gypo moves in with Katie (who has a sign "milliner" prominently displayed on her door, fooling no one). But Frankie returns to town, to ask her to go away with him to America. She refuses, but Gypo, believing that she intends to leave him, informs on Frankie. Later, he confesses to Katie why he did it and she reassures him she did not intend to leave. Then, she betrays his whereabouts to Gallagher, when he convinces her that Gypo was intending to leave her for the prostitute to whom he gave money to go home. Once again, this misunderstanding is cleared up by explanation but by then it is too late. The church ending is almost exactly the same as Ford's and equally effective, though unlike the Ford film there has not been the religious build-up to this as a triumphant conclusion. Gypo staggers into the church dying, Mrs. McPhillip in close-up forgives him and he lurches toward the camera, crying "Francis, your mother has forgiven me". He then topples forward and out of the frame. The film ends with a shot of Gypo's crumpled body, lying in a pool of light, and with the shadow of the cross falling across him.[29]

[29] A part-talkie version of *The Informer* was shot at Elstree by British International Pictures with synchronized music and sound effects until the last half hour when there are dialog scenes with Swedish Lars Hanson as Gypo and Hungarian Lya de Putti as Katie Fox dubbed with incongruous upper-class English accents.

The success of *The Informer* led Ford to propose to RKO a film version of Sean O'Casey's 1926 play *The Plough and the Stars* and to purchase the rights to Maurice Walsh's story *The Quiet Man* (1933). O'Casey's play was an even more controversial proposition than *The Informer*. The play had famously provoked a riot at the Abbey Theatre on February 11, 1926 because of its non-heroic depiction of Dublin during the Easter Rising. As a result, O'Casey had left Ireland in disgust and moved to England. But the play had been hailed as a masterpiece in Britain and America, and O'Casey as a major writer. O'Casey was a lower middle-class Protestant, a self-styled "proletarian Communist". He was anti-Catholic, anti-Republican and anti-Free State, in other words the antithesis of Ford. This suggested potential problems for the film adaptation. As Adrian Frazier writes:

> *The Plough and the Stars* is a play about the Easter rebellion that does not depict Irishmen rebelling. It depicts what other Irishmen did while a small number rebelled ... There is no scene in the GPO, headquarters of the rebellion. No scene anywhere depicts Irishmen dying like heroes ... It was at once historically true, and a heresy, that many Dubliners at first had neither sympathy for nor interest in the rebellion; the main interest of a sizable number was looting. By 1926, however, a surprising portion of the people in Dublin claimed either to have been in the GPO, or to be closely related to someone who was.[30]

As the play makes clear 250,000 Irishmen were serving with the British Army fighting the Germans on the continent. Fifty-thousand of them lost their lives. The Easter Rebels were booed by many of the onlookers after they surrendered. However the situation was transformed by the execution of the leaders who became instant martyrs to a sacred cause and by the brutality of the "Black and Tans", ex-soldiers recruited to reinforce the Royal Irish Constabulary (RIC) who ruthlessly pursued the Republican rebels. Popular opinion swung behind the idea of independence and this led to the establishment of the Irish Free State in 1921.

The studio took the precaution of submitting O'Casey's play to the British Board of Film Censors to see if their investment in the film would be threatened by its subject. Colonel Hanna was predictably appalled:

[30] Frazier, *Hollywood Irish*, pp. 74–5.

The language is impossible from the film standard. It is very coarse and full
of swearwords, and most of the political speeches would be prohibitive from
our point of view. The play is clever, cynical and bitter. Excellent character
studies of unpleasant characters. The rebellion in Easter Week 1916 evokes
many sad and painful recollections and will always prove highly controversial.
I am strongly of the opinion that it is undesirable to rouse these feelings
through the medium of cinema. The corporal and sergeant are not well-
drawn types and rather tend to discredit the English Army.[31]

But the company was anxious to proceed. RKO Radio Pictures' representatives
met with representatives of the Board, the President was consulted and it was
agreed that the subject in itself was not prohibitive (the Easter Rising was
nearly twenty years in the past) but it was agreed that the language must be
cleaned up. In due course the film was certificated for showing by the BBFC.

The studio sought to assuage British susceptibilities by adding a preface
stating that 1916 was a time of divided loyalties with thousands of Irishmen
fighting for England in the Great War and many other thousands fighting
under the Plough and the Stars "to free their country. So that Ireland could take
its place among the nations of the world". In the film itself the Irish patriotism
of Jack Clitheroe and the Citizen Army is countered by the vocal Protestant
Unionism of Bessie Burgess, who denounces the supporters of the rebellion
when her son is serving in the trenches in France, and who defiantly sings
"Rule Britannia".

But there were problems throughout. Ford had wanted Spencer Tracy for
the role of Jack Clitheroe but MGM refused to release him and he had to settle
again for Preston Foster. He had wanted to import the whole of the Abbey
Theatre players but had to settle for only five, Barry Fitzgerald (Fluther Good),
Denis O'Dea (The Covey), Arthur Shields (Padraic Pearse), Eileen Crowe
(Bessie Burgess) and F. J. McCormick (Captain Brennan). All of these except
Eileen Crowe had acted in the original stage play. Shields was given a special
credit as assistant to the director, for he was not only a veteran of the Abbey
Theatre company, he had been in the GPO during the Rising. Ford was able to
supplement the cast with two ex-Abbey players, now settled in Hollywood
as character actors and whom he had used in *The Informer*, Una O'Connor

31 BBFC Scenario Reports 1935, no. 415.

(Mrs. Gogan) and J. M. Kerrigan (Uncle Peter). He also had the same writer (Dudley Nichols) and cameraman (Joseph H. August) as on *The Informer*.

One of the most rarely seen of Ford's films, *The Plough and the Stars* is also one of his few resounding failures. The reasons for its failure tell us a lot about Ford. As it stands, it has none of the dramatic power of *The Informer*, or the affectionate observation of *The Quiet Man*, or the visual memorability of *Hangman's House*. Tradition has it that the film's failure was due in part at least to the casting of Preston Foster and Barbara Stanwyck in the lead roles, the price Ford allegedly had to pay for importing the Abbey Theatre players. In fact, they have little to do with the film's real failure, both turning in quite competent performances. The film collapsed under the weight of inherent ambiguities resulting from the Ford–Nichols conception of O'Casey's play.

Ford claims that the film was ruined by being partially re-shot, and was re-edited on the orders of production chief Sam Briskin and, in some versions, newsreel of the Irish Civil War was inserted. Ford told Peter Bogdanovich that in order to create romantic suspense, scenes were shot by director George Nicholls Jr. of Jack and Nora before they were married.[32] The version currently in circulation has no such scenes. The film opens like the play with Jack and Nora obviously married and the official running time does not allow for them. Eileen Crowe recalled that the Abbey players were not involved in the re-shooting having returned to Ireland on the completion of filming with Ford.[33] But she did learn that the studio were unhappy with the prominence in the finished film of the Abbey players and were concerned to build up the roles of the ostensible stars, Foster and Stanwyck. The pre-marital scenes may have been one answer to this question, but if shot, they were not used. The film opens with them already married and Jack playing "Kathleen Mavourneen" to her on the accordion. There may however be another answer. The film begins about two thirds of the way through Act I of the play with the entry of Nora (Barbara Stanwyck). The section prior to this which had centered on the Irish character parts, The Covey, Fluther and Uncle Peter, has all been cut. If in fact, these scenes were filmed and the studio wanted to build up the dominance of the stars then it is possible that this footage was cut and the opening re-edited

[32] Bogdanovich, *John Ford*, pp. 64, 66.
[33] Eileen Crowe, unpublished interview with Anthony Slide, September 14, 1972.

to begin with Nora's entrance. The remarkably short running time of seventy-two minutes would certainly support such an emasculation.

But this apart, the guts have been ripped out of the play anyway. O'Casey's play had humanity, warmth and humor backed by a raw tenement realism and the feel of life in the backstreets as rebellion raged. But cutting and additions have unbalanced and taken the life out of it for the purposes of filming. The uncompromisingly tragic ending, in which Jack's death is reported by Captain Brennan, Mrs. Burgess is shot dead by British troops and Nora has a miscarriage and loses her mind, is changed, so that both Jack and Mrs. Burgess survive, Jack and Nora are reunited and Ford adds an upbeat final line about the struggle continuing until Ireland is free. The text of the play has suffered very severely from cutting. As already noted, the first two thirds of act I have gone. Act 2, which involves the Abbey players in the local pub, has survived in a condensed version. Act 3 has been broken up and opened out, so that episodes like Nora's search through the streets for Jack and the looting of the shops by Bessie, Mrs. Gogan and Fluther are seen where in the play they were merely reported. The last act, also abbreviated, is retained but altered to explain and accommodate the survival of Jack. He flees across the roofs, snipes at the British troops and reaches his own house, hiding uniform and gun belt in the coffin of Mollser Gogan, who has died of consumption. The British troops searching the house fail to identify him as a rebel.

The resulting film is neither good Ford nor good O'Casey. First of all, there is a major structural alteration which disastrously shifts the emphasis of the play, and this is a direct result of Ford's preoccupation with "The Troubles". The 1916 Easter Rising, which is the background to O'Casey's play, moves to the foreground of Ford's film. It is as if he could not resist the opportunity to dramatize what for him is one of the classic "glorious defeats". The Rising is depicted unequivocally in terms of heroism, sacrifice and the homeland. Events which are simply reported in the play are shown in the film: the proclamation of the Republic by Padraic Pearse, the siege of the Post Office, the execution of "General" Connolly.

Yet as with *The Informer,* Ford shows himself as a conservative rebel. The Rising is depicted in exclusively military terms, as a war. The splendidly stirring and typically Fordian scene of the gathering of the Citizen Army confirms this. It is done with all the pageantry usually associated in Ford with the US cavalry.

The soldiers march in, bearing the flags of the cause: the Irish Tricolor and the Plough and the Stars. Boy pipers enter, playing "The Wearing of the Green". The soldiers drawn up in ranks, give the Republican salute. What is interesting is that the children and shawled women who gather to watch are also arranged in ranks, giving the impression that the whole population is under arms, fighting in an army of freedom. They listen in silence to a rousing speech from "General" Connolly. Connolly, who was in fact a trade union leader, is depicted exclusively in military terms in the film. Never seen without his uniform, always addressed as General, he is played as a soldierly archetype. His speech is shot from the apotheosizing low-angle, generally reserved for dignity and leadership (*cf.* the depictions of Lincoln in *The Prisoner of Shark Island*). Today, however, the fact that he is addressing an illegal organization of uniformed soldiers and Moroni Olsen's disturbing resemblance to Oswald Mosley give the whole scene an unintended Fascist overtone.

Furthermore, Catholic imagery and symbols are deployed by Ford to demonstrate the rightness of the Irish cause. The Madonna-like shawled women in their posed attitudes of mourning, the Catholic priest with his cross in the besieged Post Office, Nora fingering her cross as she hears the first explosions, and most vividly, the cruciform death of the boy sniper, who, shot from the roof by British troops, slides to his death, arms outstretched, lend the sanction of the Faith to the struggle.

The box office dictated that in some way the British must be exculpated. But Ford cannot forgive. So with each gesture of conciliation to the British, he undercuts with an unconciliatory effect. Connolly is led out in a wheelchair to be shot. He is very courteously treated by the British and declares: "I forgive all brave men who do their duty". But he is shot and the shooting of a man in a wheelchair leaves a nasty taste in the mouth. Later when the British troops are searching the tenement, the Socialist Covey denounces the British corporal but the corporal replies: "I'm a socialist myself. But I have to do my duty. A man's a man and he must fight for his country". But this is then offset by Fluther's passionate defense of sniping as the only recourse of a handful of unarmed patriots against the armed might of an Empire.

The funeral of Mollser, with which the film ends, comes to symbolize the dead hopes of the Rising. But as Jack and Nora follow the coffin and the mourners into the little church and they see the Tricolor torn down from the

roof of the Post Office and flung into the street, Nora asks "When will it all end?" "This is only the beginning" replies Jack, "We'll live to see Ireland free and go on fighting until we do". It is a defiant and noble ending, totally at odds with the tenor of the play but in keeping with Ford's heroized view of the Irish struggle for independence.

Yet what glory is there in a group of drunken, cowardly braggarts, Fluther, Uncle Peter and the Covey, who sit around playing cards, who plunder shops and who, for all their talk, do not lift a finger to help. In the context of the play, which did not deal with glory, there was nothing wrong for this was the normal way of life. But in the context of Ford's film, there is. Funny as some of the incidents are (Bessie Burgess and Maggie Gogan quarreling, being thrown out of the pub and hurling stones at the window, Fluther affrontedly dodging stray bullets and tottering home drunkenly, loaded with plunder), their humor is ill-timed. The characters seem suddenly stage Irish stereotypes. The knockabout, drunkenness, pub brawls and "Oirish" banter seem trivial when set against the great events which are seen and not just reported. For once, and this is rare in Ford, the humor seems intrusive and obtruded, not growing naturally out of the characters or the action, as it does so triumphantly in *The Quiet Man*. Perhaps after all humor is out of place when Ford is dealing with a subject so close to him as "The Troubles" and perhaps the very absence of humor, which Ford complains of, is one of the strengths of *The Informer*, which is in every respect a much superior piece of work to this one.

The Plough and the Stars should have been closer to *The Informer* with the private dramas of the protagonists holding the stage against a sketchy but ever-present background of historical events. But this again is difficult for Ford cannot sympathize with the central predicament of the Clitheroes. His concentration on the antics of the Abbey players seems to confirm this. The heroine is Nora Clitheroe, given the full heroine's soft-focus close-up treatment. But her behavior is entirely at odds with that of the usual Ford heroine. The film opens with her trying to persuade Jack her husband not to go to the meeting of the Citizen Army. But Captain Brennan arrives to inform him that he has been appointed commandant and he goes ("Ireland is my country and when she calls, I must go"). This is a sentiment close to Ford, of course. Nora is also echoing Ford when she tells Mollser, in a speech not in the play, of the different roles of men and women: "A woman is never happy unless she has a

man beside her. It's a woman's nature to love, just as it's a man's nature to fight and neither can help it more than the other". But it is also, in Ford's cosmology, a woman's duty not to interfere with man's desire to fight and this is what Nora does. When the Rising begins, and Jack reports for duty, she denounces the Rising and runs hysterically through the streets looking for him, until halted and denounced at the barricades by Irish women, who are quietly standing by their husbands and effacing their own feelings in the greater interests of the country. Nora finally becomes tiresome. Her personal concerns seem petty compared to the great issues at stake around her. Here again we get an ambiguity, between the Fordian heroine, as he tries to define her early on, and the dictates of the plot and the play, which eventually take over.

A similar and even stronger ambiguity lies in the looting episode. Ford consistently takes a strong line against mob violence (*Young Mr. Lincoln, The Prisoner of Shark Island, The Grapes of Wrath*). Yet here we see Fluther breaking into the pub and stealing beer, Bessie calling for a policeman when the goods she has plundered are stolen by children. His consistent principle is glossed and compromised by treating the looting as simply a lovable and comical manifestation of the Irish character. But there is a visible strain in the material. Equally distasteful, it might be added, is his glorification of sniping—another case of partisanship getting the better of moral absolutes.

All one can salvage in the long run are the fragments of genuine Ford which occasionally surface. The action scenes are impressive, punchily staged and vividly shot. Armored cars rumble through the streets, machine gun bullets splatter the brickwork, the Post Office is shelled. There is a memorably expressive long shot, which encapsulates the dignity and heroism of this last defiant stand, as Ford sees it. A tableau composition; a posed semi-circle of desperate men around the bed bearing the injured Connolly, rubble falling all around them, they sum up the Rising: defeated but not beaten. So do repeated shots of the Tricolor over the Post Office, increasingly bullet riddled, until it is finally torn down.

The Times (February 8, 1937) praised the action scenes:

Here the events of 1916 are shown at large, the meetings and the marches, the defence and capture of the Dublin Post Office, the looting of shops, the snipers on the roof and the hair's breadth escape of individual fighters. All this is very well done and successfully conveys the horror of fighting in the

streets of a modern town; the settings and photography are good and there is continuous suspense. But the majority of the film has little or no relation to the merits of the play, and even the story as it affects the chief characters is radically altered.

The gathering of the Republican army already described, the Expressionistic chase of Jack across the rooftops and the pitiful wake for the dead Mollser are also effectively done. It is the latter which is altered to accommodate Jack's survival. Arriving through the skylight, he finds the little coffin, with the black-shawled mourners, the candles lit, and on the floor, Fluther, Peter and Covey playing cards. The coffin serves as a hiding place for the uniform and gun and although the soldiers search, they find nothing and Jack joins the others in carrying the coffin to its last resting place.

In the version of the play that Ford and Nichols have adapted, the elements are so disparate that the film finally disintegrates from the strain of trying to accommodate them all. Given that cutting has removed the guts of the play, what we are left with is an uneasy mixture of the domestic drama of Jack and Nora (conflict of love and duty), the knockabout comedy with the Abbey players (sometimes funny but strangely seeming to lack Ford's usual zest) and the historical recreations of events in the Rising, reported but not seen in the original play. Even if box office demands and censorship requirements had not been made, it seems likely that the film would have failed because of the basically unresolvable differences between Ford's world view and that of O'Casey. *The Plough and the Stars* cost $482,732 to make and grossed only $316,000.[34] Plans to film *The Quiet Man* were abandoned.

Ford's earliest evocation of Ireland is in *The Shamrock Handicap* (1926), the story of a penniless Irish aristocratic family who make enough money from racing in America to return home. Ford's sensitive handling and inventive way with knockabout comedy lift the slender story above the mere programmer level indicated by the plot. Ford transforms it into a fairy tale in which he celebrates his two countries with equal enthusiasm: Ireland, the beloved homeland from which you start out and to which in the end you return, and the United States, the land of opportunity where even an immigrant can rise to fame and fortune.

[34] Scott Eyman, *Print the Legend: The Life and Times of John Ford*, New York: Simon and Schuster, 1999, p. 179.

Sir Miles O'Hara of Dunhara Manor (Louis Payne) is forced to sell all but one of his horses to a wealthy, cigar-chewing American, Orville Finch (Willard Louis), in order to meet his debts. Having seen him ride, Finch offers to take O'Hara's stable lad, Neil Ross (Leslie Fenton) to America where he will make him a champion jockey. Neil parts sadly from Sir Miles' daughter, the Hon. Sheila O'Hara (Janet Gaynor), whom he loves, promising to return. But in America in a big race he is thrown and badly injured. Meanwhile Sir Miles mortgages the manor and travels with Sheila, his loyal retainer Con O'Shea (J. Farrell MacDonald) and Con's wife Molly to America, planning to race his remaining horse Dark Rosaleen in the Shamrock Handicap. Jockey Ginsberg is set to ride but Dark Rosaleen throws him. The crippled Neil volunteers to ride and wins. The O'Haras and the O'Sheas return to Ireland where Neil and Sheila are united. Janet Gaynor and Leslie Fenton play a standard pair of innocent lovers in the conventional form of the silent screen and much of the comedy is in the hands of J. Farrell MacDonald as the twinkling-eyed faithful retainer.

The opening section of the film is a loving, sentimentalized evocation of Old Ireland, a land drenched in tradition and *noblesse oblige*. As photographed by George Schneiderman, it glows with the misty sheen of fond remembrance. The opening shots establish the milieu: huntsmen galloping across the turf, boys tending their sheep in the green pastures, the lord strolling in the gardens of his ancestral home, a crumbling, ivy-covered castle. It is an idealized land of penurious but good-hearted aristocratic landlords, innocent young lovers, faithful retainers and loyal tenants. In the first scenes Sir Miles O'Hara remits the rent of some poverty-stricken tenants, even though he badly needs the money to pay five years' back-taxes, and the daughter of the tenant family kneels before a carved Celtic cross to give thanks. Respect for the Faith and deference to a lord are the strongly emphasized keynotes of this society.

There is community feeling too, recalled in the bustling details of market day in the little town: geese driven cackling through the streets, joyous Irish jigs being performed and horses appraised for purchase. The overall picture is of a peaceful, traditional, agrarian society, slightly run down (several ruins are in evidence) and sometimes in debt (a condition common to lord and tenants) but happy in shared traditional values, the beauty of the landscape and the feeling of belonging. This is visually expressed in the moving shot of the hero

Neil Ross gazing out at the fields and trees of his homeland in silent farewell before he departs for America.

And so to America where the affectionate nineteenth-century pastoral idyll of the opening gives way to a string of anecdotes, full of broad Irish humor and comic knockabout. Ford emphasizes the multi-racial nature of the society as Neil is befriended by a diminutive Jewish jockey Bennie Ginsberg (Georgie Harris) and his solemn black valet Virus Cakes (Ely Reynolds). Neil comes to the defense of Virus Cakes when he is knocked down by a white jockey who mistakes him for another black man who threw water over him. This sparks a marathon donnybrook in the jockeys' room which makes Neil feel at home. When Neil is recovering in hospital, the jockeys invade his room with flowers and chocolates, filling it with noise and cigarette smoke until they are evicted by the nurses. Virus Cakes, distracted by the sight of corpses being wheeled by, nervously enters the wrong room to encounter three white robed and white masked figures, who beckon him forward; there is a close-up of a bottle of ether and he backs out in slow motion as the screen mists over. There is more comic mayhem when Con tries to teach Virus Cakes to ride a horse, a lesson which ends with Virus Cakes thrown and the horse galloping off. When his wife Molly cooks goose for dinner, Con's eyes widen with horror as he thinks it is his pet goose, Brian Boru, which he has brought with him from Ireland. His relief is obvious when he discovers Brian Boru outside. The climactic steeple chase is filmed in a helter-skelter series of actuality long shots, with horsemen tumbling off at every jump, and intercut close-ups of Neil and his rival, Chesty Morgan, neck and neck until almost the last minute.

The all-pervasive influence of the Irish in America is hilariously demonstrated by one of the best comic passages. Sir Miles and Con take jobs ditch-digging to support the family while they wait for the crucial horse race. When a laborer mocks Sir Miles' title, Con knocks him down and starts a fight. The fight is broken up by the foreman who turns out to be Mike O'Flaherty, the father of the tenant family whose rent Sir Miles remitted. A policeman called to the scene turns out to be Con's cousin Pat. He calls together a whole group of other Irish American policemen and they all sit down together and reminisce about "the Old Country". For all its democratic ways and equality of opportunity, there is still a hankering for the old ways and "the Old Country" and at the end the family return there, now provided with enough money to live in the style

to which they are accustomed. The call of the traditional, genially hierarchical Irish society proves too strong.

Variety (July 7, 1926) said of *The Shamrock Handicap* "Ford ... loves anything Irish, and he made the most of the little human touches. It is as much Ford's direction as anything else that puts this one over, for he did not have a particularly effective cast and his leads did not seem to get across at all". Tag Gallagher compares it to *The Quiet Man*, praising Ford's inventiveness and seeing in the film "much of his fifties compositional style, painterly, spacious and balanced, deep in field".[35]

The Irish diaspora also formed the background to *Mother Machree* (1928), a film of which only three reels now survive. It was shot in September 1926 and first released as a silent film with tinted sequences in January 1928 and again with synchronized music and sound effects in March 1928. Based on a famous song by Chauncey Olcott and Ernest Ball with words by Rida Johnson Young, this was a thoroughly sentimental story of mother love along the classic lines of *Madam X*. The *New York Times* (March 6, 1928) called it "a sympathetic and skilful blending of gentle humor and restrained sentiment ... beautifully staged and photographed".

It opens in 1899 in the idealized Irish fishing village of Ballymoney where Ellen McHugh (Belle Bennett) and her son Brian bid fisherman Michael McHugh goodbye. A ferocious storm breaks out with strikingly Expressionist lighting. Father McShane brings to Ellen and Brian the tragic news of Michael's drowning. There is a somber wake, full of sad-faced shawled women. Ellen and Brian decide to emigrate to the United States. En route to the port at Queenstown, they are befriended by three circus performers, the Dwarf of Munster, the harpist of Wexford and Terence O'Dowd, the Giant of Kilkenny. In America, Ellen fails to find work until Terence turns up with the offer of a job in the circus. This much of the film survives in reels one and two. During the rest of the film, Ellen sends Brian to school but in her continuing poverty agrees to him being adopted by the School Principal. She goes to work for the wealthy Cutting family and effectively raises their daughter Edith. In the other surviving reel, reel five, the grown-up Brian, now Brian Van Studdiford, falls in

[35] Tag Gallagher, *John Ford: The Man and his Films*, Berkeley and Los Angeles: University of California Press, 1986, p. 34.

love with and courts Edith and at one point Neil Hamilton as Brian sits at the piano and sings the title song. It all ends happily with Edith and Brian united and Brian and his mother reunited. As in *The Shamrock Handicap* there are scenes directly foreshadowing *The Quiet Man*: a grieving face looking out of a window with rain pouring down like tears; a girl herding sheep under the trees; and Victor McLaglen's brawling, overbearing Irish lummox O'Dowd, who ends up as a New York policeman, foreshadowing his Red Will Danaher.

The Quiet Man is the ultimate evocation of the Ireland Ford had loved and celebrated in his celluloid dreams. It marked the first occasion when he actually went to Ireland to film, his previous Irish pictures having been made in the United States and in the case of three of them, *Hangman's House, The Informer* and *The Plough and the Stars,* almost entirely in Hollywood studios. It was to become one of his most beloved films for cinema audiences. In 1996 readers of the *Irish Times* voted it the best ever Irish film.[36]

Ford had been dreaming of making *The Quiet Man* for nearly twenty years. He had read and fallen in love with a short story by Maurice Walsh, *The Quiet Man*, published in the *Saturday Evening Post* in 1933. He took an option on it. It told the story of Shaun Kelvin who leaves Ireland for America where he labors in the Pittsburgh steel works and becomes a professional boxer. Fifteen years later he returns home, buys a little farm and courts Ellen O'Grady. They marry but her brother Liam refuses to hand over her dowry. Ellen insists on having her dowry and when Shaun refuses to fight him for it, she calls him a coward. He marches her over to Liam's farm and returns her to her brother. Shamed in front of his men, Liam produces the money. Shaun burns the money in the firebox of the threshing machine and then beats Liam in a fight before taking Ellen home.

In 1935 Walsh reworked and expanded the story, including it in a linked collection of stories called *Green Rushes* which became a best-seller. Ford purchased the film rights in 1936. He paid $10, but after the film rights were sold to Republic, paid another $500 and a final payment of $3,750 after the film was finally made.[37] Walsh changed the names of Shaun Kelvin, Ellen O'Grady and Liam O'Grady to Paddy Bawn Enright, Red Will and Ellen Roe O'Danaher.

[36] Luke Gibbons, *The Quiet Man*, Cork: Cork University Press, 2002, p. 4.
[37] Maureen O'Hara (with John Nicoletti), *'Tis Herself*, London: Simon and Schuster, 2004, pp. 158–9.

In this version, Paddy is drawn into the fight of the IRA against the "Black and Tans" in the struggle for Irish Independence. The second-in-command of the IRA flying column is a new character, Mickeen Oge Flynn. Also Red Will permits the marriage of Paddy and Ellen only when his desire to marry the Widow Carey is thwarted by her refusal to enter his house with another woman in the kitchen. However, she changes her mind and marries her cattleman, to Red Will's fury. Ford's plans to film it were interrupted by the war. After the war, Ford and Merian C. Cooper set up Argosy Pictures Corporation and Ford got verbal agreement from John Wayne, Maureen O'Hara, Barry Fitzgerald and Victor McLaglen to play the leading roles. Ford took *The Quiet Man* project to Fox, Warner Bros and RKO but as Maureen O'Hara recalled "all the studios called it a silly, stupid little Irish story. 'It'll never make a penny, it'll never be any good' they said."[38] Plans to film it with Sir Alexander Korda fell through but then Cooper negotiated for Argosy a four picture deal with RKO, including the proviso that if the first film made a profit, they could film *The Quiet Man*. Argosy's first film *The Fugitive* was a resounding flop and RKO canceled plans to take on *The Quiet Man*.

In 1950 Ford hired Richard Llewellyn, author of *How Green Was My Valley*, to turn Walsh's short story into a prose novella with instructions to set it in 1920–22. Later he got him to turn the novella into a shooting script. Meanwhile John Wayne suggested Ford take the project to Republic Pictures, to whom Wayne was under contract and whose greatest asset he was. Republic's head, Herbert J. Yates, alarmed by the rise of television, had decided to vary the traditional Republic diet of "B" Westerns and serials by making prestige "A" pictures and had succeeded in luring such established talents as Frank Borzage, Fritz Lang, Lewis Milestone and Orson Welles to Republic to produce cherished projects. Ford and Argosy signed a three-picture contract with Republic but Yates, who had little faith in *The Quiet Man*, insisted on a sure-fire success first and so Ford produced *Rio Grande*, with Wayne, O'Hara and McLaglen, which turned out to be the required box office success. He now set to work with Frank Nugent preparing a final script. There were name changes, Paddy Bawn Enright became Sean Thornton. Ellen Roe O'Danaher became Mary Kate, names Peter

[38] Gerry McNee, *In the Footsteps of The Quiet Man*, Edinburgh: Mainstream Publishing, 1990, p. 20.

Bogdanovich believed combined the names of his wife Mary McBryde Smith and Katharine Hepburn, with whom he had developed a romantic obsession in the 1930s and who remained a close friend.[39] The Widow Carey became the Widow Sarah Tillane. Mickeen, now Michaeleen Oge Flynn, was transformed from an IRA commander to the village *shaughraun* (matchmaker) and general busybody. Ford and Nugent added the Catholic priests Father Lonergan and Father Paul and the Protestant Rev. Cyril and Mrs. Playfair. It was decided to drop the political element and set the film in the late 1920s at an unspecified time after peace in Ireland had been achieved. So when Sean is introduced to IRA Commandant Forbes, the commandant disclaims his title and says pointedly "We're at peace now". Ford and Nugent invented Thornton's backstory, seen in a stylized flashback. While fighting as Trooper Thorn he had accidentally killed his opponent in the ring and that explains his reluctance to fight Red Will.[40] They gave the village the name of Inisfree after the celebrated poem by W. B. Yeats *The Lake Isle of Innisfree* (with two ns). Ford and Nugent came up with a script that mingled comedy, drama and romance in equal proportions.

As Ford told Peter Bogdanovich:

> We had a lot of preparation on the script, laid out the story pretty carefully, but in such a way that if any chance for comedy came up, we could put it in—like Barry Fitzgerald bringing the crib into their bedroom on the morning after the wedding night and seeing the broken bed. That was just taking advantage of the situation. Nobody has ever heard what he says when he comes in, you know—because the laugh is too loud.[41]

The line when he sees the collapsed bed is "impetuous-Homeric".

This follows another scene added during shooting. When Wayne complained the script had him passively accepting the situation when Mary Kate locked him out of the bedroom on their wedding night, Ford said: "Duke, I'm going to let you do what you always do when a broad locks you out. I'm going to let you kick the fuckin' door down".[42] That is what happened. After he breaks the door

39 See the documentary film, *John Ford: Dreaming The Quiet Man*, Loopline Films, 2011, directed by Sé Merry Doyle.
40 On the making of *The Quiet Man* see in particular McNee, *In the Footsteps of The Quiet Man*, and *John Ford: Dreaming The Quiet Man*, Loopline Films.
41 Bogdanovich, *John Ford*, pp. 90–91.
42 Dan Ford, *The Unquiet Man*, p. 244.

down, Sean throws Mary Kate on the bed which promptly collapses and he retires to sleep in a chair. Frank Nugent accompanied Ford to Ireland to be on hand for script changes.

Although Yates had agreed to the filming of *The Quiet Man,* he remained perpetually anxious about the project and complained constantly. Ford wanted a budget of $1,750,000 but Yates would only authorize $1,464,152 and Ford had to ask Wayne and O'Hara to accept salary cuts. Wayne was paid a flat $100,000 without the 10 percent of net profits that his contract called for and O'Hara was paid $65,000. Ford insisted on Technicolor when Yates wanted him to shoot more cheaply in black and white. Yates complained about the rushes ("it's all green"), he wanted to change the title (to *The Prizefighter and the Colleen*) and he wanted to cut the film to a maximum 120 minutes. Ford got his way on all these matters. The film runs for 129 minutes.

Ford's insistence on shooting on location kept Yates from interfering in person. The company that Ford assembled had an extraordinary family feel to it. Wayne was accompanied by his wife Chata and four of his children, Michael, Patrick, Toni and Melinda. The children can be seen among the spectators at the horse race. Ford was accompanied by his son Patrick who fulfilled various production duties, his brothers Francis Ford, who played Old Dan Tobin, and Edward O'Fearna, who was second assistant director, and his brother-in-law Wingate Smith who was first assistant director. Victor McLaglen was accompanied by his son Andrew who was third assistant director. Maureen O'Hara was accompanied by her brothers, Charles Fitzsimons and James Lilburn who played Commandant Hugh Forbes and Father Paul respectively. The brothers Barry Fitzgerald (real name William Shields) and Arthur Shields played Michaeleen Oge Flynn and Reverend Cyril Playfair. Ford regulars Ward Bond played the Catholic priest Father Lonegan who narrates the story, and Mildred Natwick, Mrs. Sarah Tillane. To fill small supporting roles, Ford recruited present and past members of the Abbey Theatre company, including Eileen Crowe who had been in the 1936 film of *The Plough and the Stars*, May Craig, Joseph O'Dea and Eric Gorman. Back in Hollywood he cast Mae Marsh in a tiny cameo as Father Paul's mother.

Principal photography took place between June 7 and August 23, 1951, the first six weeks on location in Ireland and the rest of the time at the Republic Studio in Hollywood. In Ireland, the village of Cong in County Mayo stood

in for Inisfree, with additional scenes shot in the grounds at Ashford Castle, Ballyglunin Station (standing in for Castletown) and Lettergesh beach (for the horse race). Locals were used as extras for nine pounds a day when the average weekly wage was three pounds. Ford kept off the drink for the duration but halfway through the shoot became ill and depressed. After he took to his bed, John Wayne, Pat Ford and Andrew V. McLaglen shot the horse race. But Ford recovered and resumed the direction.

The Quiet Man signifies an important stage in Ford's artistic evolution. For it shows him fleeing after three successive war pictures (*Rio Grande, This is Korea* and *What Price Glory)* from the sounds and sights of war to a settled, traditional, communal society, where the old values remain unchallenged and where time stands still, somewhere where he can refresh himself and renew his poetic inspiration. It is the first of several such hymns to traditional society (*The Sun Shines Bright* and *The Long Gray Line* are others), a trend which decisively ends with *The Searchers.*

Like Ford, his hero Sean Thornton is fleeing from violence and from modern American society back to the land which bore him, a quieter, gentler, more peaceful land. This is no Ireland like the one in *The Informer*, with its foggy tenements and sudden death; it is an Ireland of cool green fields, white-painted cottages, venerable moss-encrusted ruins and cheerful pubs, an Ireland where the local IRA commandant and the parish priest spend their time keeping the peace and maintaining harmony.

Ford has called it his first love story and there is certainly a fully developed and affectionately observed mature sexual relationship, warm, human and entirely convincing.[43] But it is also an expression of Ford's own love for Ireland, which informs every frame from the opening credits, which unfold to the strains of a lilting Irish air, against a shot of a mellow sun setting over a gray stone castle and gilding the waters of the lake before it. The cool and fresh Technicolor photography perfectly captures the greens and browns and grays and whites that are the basic colors of the symbols of an unchanging rural Ireland: the white-painted cottage, the little green country station, the brown beach lapped by a gray sea, the rolling hills and verdant meadows studded with reminders of the past like the venerable Celtic cross.

[43] Anderson, *About John Ford*, p. 22.

As always, music forms an integral part of the action and a veritable treasury of Irish folk melodies cascades onto the soundtrack. Ford indicated to composer Victor Young where the songs should go and he obliged. "Mush, Mush, Mush" is sung by the drunken wedding guests bringing the furniture to White O'Morn. "Galway Bay" and "The Wild Colonial Boy" are sung in the pub; "The Humour is On Me Now" is sung at the wedding reception; "The Kerry Dance" and "Those Endearing Young Charms" accompany the courtship scenes and Maureen O'Hara sings "The Young May Moon" and "The Isle of Innisfree" at her spinet.

As always in Ford, there is a Shakespearean wealth of characters, as indeed there is a Shakespearean theme in the Taming of the Shrew (also named Kate). It is not just the major stars and the supporting actors that are excellent, but the small part players are a constant delight: the sycophantic acolyte Feeney (Jack MacGowran) who lists Red Will's enemies in a little book, Father Paul's mother (Mae Marsh) flustered and nervous at his participating in the horse race, and even the Widow Tillane's diminutive maid (Elizabeth Jones), who crossly announces Will Danaher and whose very size emphasizes Will's clumsy bulk.

But it is surely Barry Fitzgerald's finest hour as he gives the definitive Fitzgerald performance as the pugnacious leprechaun of a matchmaker, whose devotion to the drink marks him as a true denizen of Ford's world. His horror at being offered water with his whiskey by Mary Kate ("When I drink whiskey, I drink whiskey and when I drink water, I drink water") is matched only by his disgust when offered buttermilk ("The Borgias could do better"). He turns up in frock coat, top hat and buttonhole—and drunk—to conduct the marriage negotiations. Even the pony drawing his trap is trained to pull up outside the pub without prompting. Drink is not just a comic attribute, but it is used to seal bargains, to demonstrate masculinity, and to express community feeling. This is the mainspring of the important scene when Sean Thornton first arrives in Inisfree. He goes to the pub. He says good-day, but nobody answers him. He offers to buy drinks; but nobody replies. When he announces that he is Sean Thornton come home again, there is immediate change of atmosphere. It is drinks all round and they are soon joining in the singing of *The Wild Colonial Boy*.

The story centers on the return of an expatriate Irishman from the United States, a free and easy, democratic society, to Old Ireland, a strongly ritualized

and traditional society, and his adaptation, reluctant at first, to the customs of the country. His acceptance of them is completed when he fights to implement one particular tradition, the dowry, and of course, to re-establish himself in both the eyes of the community and of his wife.

The opening is a classic little vignette of perfectly played comedy (which Ford was later to expand into the middle episode of *The Rising of the Moon*). A train pulls into a little country railway station, Sean Thornton emerges and asks the way to Inisfree, and there is a comic altercation which grows to involve the station staff and the passengers about what is the best way to Inisfree, until Michaeleen Oge Flynn marches in, pipe between teeth, and says simply "Inisfree—this way" before picking up Sean's cases and leading him out to the waiting pony and trap.

They drive across the countryside, stopping for Sean to look across at the little white-painted cottage, White O'Morn, home of the Thornton family before they left for America. On the soundtrack we hear his dead mother's voice describing to Sean how it used to be, words he has never forgotten and which have inspired him to come home ("Inisfree became another word for heaven to me"). It is one of the classic homecoming scenes. Sean determines to purchase the cottage from its present owner, the Widow Tillane.

Ford's method of shooting is demonstrated by this opening trap-drive. He lingers, though never excessively, over the exteriors as he photographs in long shot the trap bowling along, and for dialogue, he cuts in studio-filmed close shots, with backdrops. I am inclined to believe that this is not due to the bad weather which dogged the location shooting and which Lindsay Anderson believed to be the reason for this practice. For it coincides too closely with his advice about directing, given to John Wayne when he was directing *The Alamo*. He told Wayne "Give 'em a scene and then give 'em scenery", which being interpreted meant, don't shoot dialogue scenes with beautiful scenery in the background or it will distract the audience. So very often we get a simple cloudscape in the back and the essential dialogue is exchanged. That this is not simply a functional thing, dictated by the weather, is suggested by the fact that Ford used exactly the same method when shooting a similar sequence in *Fort Apache*, the desert horse-ride of John Agar and Shirley Temple. He was presumably not troubled by excessive rain but also chose to shoot handsome long shots of horse-riding and intercut with studio close shots for the dialogue

exchanges. To a lesser extent Ford uses the same method for shooting the courtship sequence. He does have recourse to the studio for the kiss between Sean and Mary Kate in the thunderstorm when he wanted very precise effects of wind, rain and storm not achievable except in controlled studio conditions. But the use of very obvious cramped and crowded studio sets for the preliminaries to the horse race is less excusable, even though they do conform to the principle.

Sean calls at the pub as soon as he gets to Inisfree and announces his intention of buying White O'Morn. He is opposed by the blustering, bellicose Red Will Danaher, self-styled squire of Inisfree, who has his eye on the land. The villagers however back Sean up. "It's his land, he's entitled to it," says Old Dan Tobin. However, Danaher continues to make loud and objectionable protests and these lead the Widow Tillane to sell the cottage, without further ado, making Will an enemy of Sean.

The next step is for Sean to find a wife. But this presents little difficulty. For there can be only one woman for Sean and that is the woman he saw as he was driving to the village. "Hey, is that real?" he asks Michaeleen at the first sight of his sweetheart: a distillation of the legendary image of the Irish colleen. Framed by trees, with yellow gorse bushes lining the front of the screen, stands Mary Kate, scarlet-skirt, blue bodice, bare feet and red hair. She tends her sheep and gazes at him in a mixture of startlement and admiration. As the trap moves off and she dashes away, there is a lovely backward glance close shot of her, with admiration now uppermost in her gaze. Sean sees her again at the village church and later makes his first contact in a sequence of very great beauty. Sean makes his first visit to his cottage. The slate-colored sky lowers, trees bow before the wind and the gusts animate angry veils of water spray, from a freshet racing down the hillside. Sean arrives to see Mary Kate tidying his home, having lit a fire. He first throws rocks at the window startling her and then entering, grabs and kisses her, causing her to run off.

But the die is cast and Michaeleen calls on Red Will, Mary Kate's brother, in his official role as matchmaker to arrange for Sean to court Mary Kate. For without Will's consent, Mary Kate may not marry and Will refuses his consent. Michaeleen restrains the angry Sean, who has turned up in Sunday suit and bowler hat carrying a bunch of flowers, and exhibiting the embarrassment at the enforced formality which Kirby York had shown to Kathleen in *Rio*

Figure 2.3 John Wayne and Maureen O'Hara in *The Quiet Man* (Republic, 1952)

Grande. Sean angrily tosses the flowers away and stalks off and the sequence ends with a close shot of Mary Kate, framed by the window, down which raindrops pour like tears. Sean rides his horse angrily over the hills, inconsolable at the failure of his hopes but bound inextricably by the rules of the society he finds himself in. It is worth noting that throughout his film, Ford uses a very familiar but nonetheless effective symbolic notation for various moods: grief is expressed by rain, passion by storms and strong winds, memory by rivers.

However, Father Lonergan and the Playfairs get together to trick Will into giving his consent and this clearly demonstrates the continued paramountcy of tradition. They do not want to overthrow or circumvent it, but to implement it. They convince Will that his chances of marrying the Widow Tillane are obstructed by the presence in his house of Mary Kate, since no woman wants to enter a house where another holds sway in the kitchen. It is the view which Gwilym Morgan expressed in *How Green Was My Valley* when he would not have Bronwen to live in the house with Beth. The kitchen is the exclusive

domain of the woman of the house. They also suggest that Sean, thwarted in his desire for Mary Kate, might well turn to Widow Tillane. The annual horse race is utilized to demonstrate this. The local women put up their bonnets, and the riders coming in, pick them up and return them to their owners. The race, which is an affirmation of community feeling like the organized fist-fight, is something in which it does not really matter who wins or loses, it is how you play. The race is competently done, across hills and sand and through the shallows of the sea, but it lacks the breakneck excitement of the early races both in *Hangman's House* and *The Shamrock Handicap,* and this is perhaps due to the fact that Ford was ill during the shooting of this episode. But Sean wins and picks up not Mary Kate's bonnet but Sarah Tillane's, returning it to her. At the end, all the bonnets have gone except for Mary Kate's to her embarrassment and annoyance. But Will is convinced and gruffly orders Michaeleen to arrange the courting.

The courtship ritual is splendid. Mary Kate and Sean sit on opposite sides of the trap, back to back, for their first outing. But Sean soon becomes impatient with this and is allowed to walk with Mary Kate a few yards behind the trap. This also proves too constricting and so the two of them borrow the Playfairs' tandem and ride off at high speed, leaving an angrily expostulating Michaeleen behind them. They stop and get off the tandem and in a glorious gesture of liberation from convention, Sean flings his bowler hat across the fields, which in their pattern of walls and regular division represent the order he is temporarily defying. He chases her across a stream and catches her in an old churchyard. They are caught by a sudden thunderstorm and in the most erotic scene Ford ever devised, amid thunder, lightning and rain Sean embraces Mary Kate, her wet dress clinging sexily to her, and kisses her, urging immediate marriage.

Ford cuts from this to the wedding photograph and the wedding celebrations. Danaher now expects that the marriage means that he can proceed to his own nuptials with the widow and blithely announces this fact to the assembled company, without having bothered to consult the widow, who angrily repudiates his announcement. Will now realizes that he has been tricked and he retaliates by refusing Mary Kate her dowry. She refuses to leave without it and when Sean remonstrates with her, Will knocks him out. When Sean comes too, he is helped away and at their cottage, in a tender and effective

long-medium shot Mary Kate and Sean sit by the fire and she tells him that she cannot consummate the marriage, that it cannot indeed be regarded as a true marriage until she gets her dowry. "There is 300 years of happy dreaming in those things of mine. I want my dream". She is totally rooted in her traditions, even to the extent of sacrificing her marital happiness. She goes into the bedroom and locks the door but he kicks it in, saying there will be no locked doors in his house. He kisses her roughly and pushes her on the bed, which collapses. But he respects her wishes and sleeps in a chair. Next morning, their friends still singing drunkenly arrive with the furniture which they have persuaded Will to disgorge but he cannot be persuaded to part with the money.

Relations between Mary Kate and Sean continue to be strained and so he goes to the pub to ask Danaher to give up the money. Danaher offers to fight him for it but Sean refuses and leaves. Everyone thinks he is a coward and a silence falls over the company. Michaeleen weeps.

The marriage is eventually consummated. Mary Kate and Sean drive into town for market day but quarrel again about the dowry. He goes to see the Protestant Rev. Cyril Playfair to seek advice about what he should do. He does this because Playfair has recognized him as the prizefighter Trooper Thorn and knows he left America after killing a man in a fight and therefore has determined not to fight again. Playfair says he must do what he thinks is right, though his own inclination is evidently that Sean should fight. Meanwhile Mary Kate is explaining to the Catholic Father Lonergan in Gaelic that the marriage has not been consummated and he is outraged. Back home Sean sits down disconsolately in a chair by the fire and puts his arms around Mary Kate. She buries her head in his shoulder and in the next shot, he emerges from the bedroom satisfied.

When he gets up the next morning, she has gone. Because she loves him too much to bear the disgrace of his cowardice, she is taking the train to Dublin. This provokes Sean to fight. The very real cause of his pacifism has already been demonstrated in a flashback where we see him killing his opponent with a punch. But even though pacifism may have a just cause, there are some occasions when you must fight. Unyielding pacifism, Ford is saying, is as good as cowardice. So Sean will fight but it is important to note that he fights in defense of a tradition (the giving of the dowry) and within rules and not vindictively, and Ford handles it both as comic, in a splendidly choreographed

marathon donnybrook, in which the protagonists knock seven bells out of each other, and also as a community ritual, participated in by the villagers and surreptitiously watched by the priest and the vicar, who place bets on the outcome.

The build-up is superb and the whole final section, a gloriously managed romp. Sean drives to the station, in time to drag Mary Kate from the train. He starts to walk her back to the village and everyone can see from his expression that the long-awaited confrontation is at hand. Even though the train is already four and a half hours late, the station crew follow them and the crowd gradually swells as word goes out. The news is spread by telephone. Coaches are organized to bring people from nearby towns. Sean, face set, drags Mary Kate after him with an iron grip, heedless of her falling or stumbling. At one point a shawled woman hands Sean "a nice stick to beat the lovely lady with". This whole episode has troubled feminist film critics who have suggested it is evidence of a chauvinist attitude to women. But there is no evidence of Mary Kate as a doormat. Although she keeps house for her brother and is seen serving food to the farmhands and later demonstrates her love for Sean by making his cottage habitable, she is shown to have a fiery temper, being willing to slap her husband, and her brother, to insist on her traditional rights and to withhold sex until she gets them. Sean has to come to terms with the traditions of the Old World. He wants to dispense with the courting rituals and ignore the dowry as he would in America. But eventually he goes along with both and demonstrates his acceptance of the fact that the measure of a man in the Fordian and Irish worlds is how much you can drink and how hard you can fight.

When he gets the dowry money and he burns it, he is demonstrating that it is not the money but the principle he is fighting for. The fight begins. At first, others join in but Michaeleen stops the fight and re-starts it on Queensberry rules. The contestants fight each other right round the village and back again. Buckets of water are regularly thrown over them. They stop at one point for a drink in the pub, but quarrel over who is to pay and end up knocking each other through the door. Michaeleen runs bets on the outcome. Playfair and his bishop, who is visiting have a wager on the result as does Widow Tillane. The publican is so excited he announces that the drinks are on the house—to stunned disbelief. Even here, however, Ford cannot resist a dig at the English. A stuffy old English

Figure 2.4 John Wayne and Victor McLaglen in *The Quiet Man* (Republic, 1952)

gentleman, sitting in the bar reading his newspaper is the only person to take no notice whatever of the fight, remaining where he is while the others surge out into the street to watch the fun. The Englishman is naturally anti-social. Old Dan Tobin rises from his deathbed to see the events and recovers at the sight. Finally, the two men fight each other to a complete standstill. Later that night, arms around each other, singing lustily and thoroughly reconciled, Sean and Will stagger into the cottage where Mary Kate, glowing with pride at their accomplishments, dutifully waits to serve supper. Finally, the film ends with Sarah Tillane and Will setting out on their courtship-drive watched by the whole village, in groups, who wave at them—and at us—as the Quiet Man and his colleen go into their cottage and close the door.

The roles of the Catholic parish priest, Father Peter Lonergan, who narrates the film, and Protestant minister and his wife, Rev and Mrs. Cyril Playfair, have been crucial in effecting the union of Sean and Mary Kate, working together without a hint of sectarian difficulty. They concert the plan to trick Will into permitting Mary Kate to marry. They give advice to the couple: Playfair to

Sean, Father Lonergan to Mary Kate. They are present finally at the fight, lending it the sanction of both churches.

Indeed, religion is all pervasive and ever present, a system of values to sustain and nourish, a ready-made service of advice and support. The priests are thoroughly integrated in the community. At the wedding reception, where Father Paul sits playing the piano and singing with the guests "The Humour is On Me Now", they fall silent at Lonergan's entry but he calmly takes over the piano playing and leads the singing, recalling Mr. Gruffyd's similar participation in the wedding feast in "How Green Was My Valley", which also demonstrated his involvement in community life. Father Paul competes in the horse race.

The signs and symbols of religion are all around and also physically bless the union of Sean and Mary Kate. Sean pays an early visit to the church, where he sees Mary Kate again and which allows Ford a lingering reverential long shot of a glorious stained glass window. Sean and Mary Kate's first physical contact occurs when they dip their fingers in the holy water at the church and their fingers meet. Later, they have their passionate meeting in the ruined churchyard.

Even though Father Lonergan and Mr. Playfair are equals in the village, there is an important difference in the way they are presented and in the relative strength of their faiths—so that tolerance apart, Ford confirms the pre-eminence of Catholicism. Just as in *The Last Hurrah*, the Protestant Bishop Gardner is a just and worthy man but the representative of an unrepresentative faith, so too the Playfairs, a tweedy genial Anglicized couple who play tiddley winks and ride a tandem, are seen as a quaintly absurd if lovable pair, who although they have virtually no parishioners, were born to Inisfree, attend local festivities and are regarded as a full part of the community. This is triumphantly affirmed at the end when Father Lonergan, learning that there is a danger that Playfair will be transferred by the bishop because of lack of support, arranges for the whole village to turn out and cheer him as he drives the bishop to the station. He even joins in the cheering himself.

The Quiet Man is a joyous film, rejoicing in the beauty of the landscape, the warmth of community feeling, the strength of the Faith and the consuming power of love. Ford identified totally with Sean Thornton, returning from America to his Irish roots and discovering all these values alive and enduring. It is this sense of identification that explains the extraordinary rambling love

letters written by Ford, probably when drunk, to Maureen O'Hara in the months leading up to the shooting of the film as he completed the script with Frank Nugent. She believed that this happened at this time because John Ford *was* in his own mind Sean Thornton and was writing not to her but to Mary Kate Danaher.[44] Maurice Walsh liked the film, writing "The picture is just good entertainment, but the technicolor of the Connemara scene is extraordinar' fine. Moreover, Barry Fitzgerald steals the show".[45]

Back in Hollywood, Ford began trimming the film and cutting out extraneous scenes to get it down to 120 minutes. A scene of Thornton in conversation with a mother and two children on the train, a scene in the pub building up to the horse race with a discussion of the various runners and riders, a much longer wedding scene were among the cuts.[46] The final version came out at 129 minutes but Yates was still insisting it run no longer than 120 minutes, until Ford pulled off a masterstroke. At a meeting of exhibitors to see Republic's new offerings, he stopped the film at 120 minutes, omitting the fight, and the clamor from the exhibitors was such that Yates had to relent.

According to documents in Ford's papers, he brought the film in $17,491 under budget.[47] According to Republic files it came in $234,102 over budget but there was some financial jiggery-pokery on the part of Yates.[48] The film was a critical and box office success. It won the Silver Lion grand prize at the 1952 Venice Film Festival, was voted best picture of the year by the National Board of Review and was nominated for 8 Oscars, winning 2 for the best director (Ford) and best cinematography (Winton Hoch and Archie Stout). But although it was 12th on *Variety*'s list of top grossing 1952 films, and film rentals amounted to nearly $5.8 million, Argosy found itself receiving small sums as its share. They started a lawsuit, initiated an audit of Republic's books by Price Waterhouse and found that Republic were deducting all foreign costs and distribution fees from American rentals, drastically reducing net profits. Eventually Ford and Cooper were paid $546,000 each to settle the lawsuit.[49]

[44] O'Hara, '*Tis Herself*, pp. 144–52.
[45] Steve Matheson, *Maurice Walsh, Storyteller*, Dingle: Brandon Books, 1985, p. 91.
[46] McNee, *In the Footsteps of The Quiet Man*, pp. 19–25.
[47] Joseph McBride, *Searching for John Ford*, London: Faber and Faber, 2003, p. 511.
[48] Jack Mathis, *Republic Confidential* volume I, Barrington, IL: Jack Mathis Advertising, 1999, p. 267.
[49] Randy Roberts and James S. Olson, *John Wayne: American*, New York: The Free Press, 1995, p. 369.

But the fallout from this swindle was great. Ford blamed Cooper for not keeping a better watch on the finances and Cooper left the company.[50] Ford did not renew his connection with Republic after completing his third contracted film *The Sun Shines Bright*. Wayne, disgusted by the treatment of Ford and Yates' continual prevarication over his cherished production plans for *The Alamo*, left Republic for Warner Bros when his contract expired in 1952.

Ford's last completed Irish film, made like *The Quiet Man* on location in Ireland, was *The Rising of the Moon* (1957). For Ford it was a labor of love ("I made it just for fun and enjoyed it very much").[51] It was the first production from Four Provinces Films and was produced by Ford's partner in the company, Michael Morris, Lord Killanin. It consists of three short stories, linked by an unconvincing commentary by Tyrone Power, proudly proclaiming his Irish ancestry in front of a painfully false house front. These inserts were directed by Killanin. The three episodes are *The Majesty of the Law* from a Frank O'Connor short story, *A Minute's Wait* based on a one-act play by Michael McHugh from 1914 and *1921*, based on Lady Gregory's 1907 play *The Rising of the Moon*. Ford took no salary and persuaded Frank Nugent to write the script for a union minimum rate of $1,000. The score consisted of much-loved Irish ballads either sung on screen or incorporated in the background music: "The Rising of the Moon", "The Girl I Left Behind Me", "Come Back, Paddy Reilly", "The Lowbacked Car", and "Slattery's Mounted Foot". Ford imported the distinguished British cinematographer Robert Krasker, who had photographed such black and white classics as *Brief Encounter*, *Odd Man Out* and *The Third Man*. He provided the luminous black and white images of Galway, Dublin and County Clare. Ford recruited an almost entirely Irish cast of character actors, many of them Abbey Theatre veterans. Denis O'Dea and Eileen Crowe, who had both featured in the 1936 film of *The Plough and the Stars*, returned to play Sergeant O'Hara and his wife in *1921* and Jack MacGowran who had been in *The Quiet Man* returned to play the moonshine distiller in *The Majesty of the Law*. Joseph and Jimmy O'Dea, Maureen Potter and Donal Donnelly were recruited from the Dublin stage. Ford filmed it on a mere $256,016 budget and completed it in thirty-five days, ten days ahead of schedule.[52]

[50] Eyman, *Print the Legend*, pp. 414–15, Dan Ford, *The Unquiet Man*, pp. 250–51.
[51] Bogdanovich, *John Ford*, p. 143.
[52] Gallagher, *John Ford*, p. 500; Eyman, *Print the Legend*, p. 454.

In *The Majesty of the Law* Police Inspector Michael Dillon (Cyril Cusack) visits old Dan O'Flaherty (Noel Purcell), chats amiably to him, drinks with him, chats to the neighbors and then as he is leaving reluctantly raises the matter of Dan having injured a gombeen man (moneylender), Phelim O'Feeney, in a fight. Dan refuses to pay the fine but agrees to turn up at the jail on Friday after dinner to serve his sentence. The story ends with him leaving his cottage, making the walk to jail and being welcomed.

Ford and Nugent, taking the original simple little tale, told mainly in dialogue, add to it layer after layer of detail to emphasize all the things Ford most values. Firstly, Dan is seen as the embodiment of principle and brings home most forcibly the basic Fordian view that there is a set of moral principles which lie above man-made laws. If they conflict with the law, there is no question of the law being ignored. Dan will pay the penalty demanded by the law in the form of prison. He refuses to get out of it by paying the fine, as he could so easily do. We do not know why he hit the moneylender and this reinforces his stand on an abstract principle. He did what he believed to be right. When he refuses to pay the fine, his neighbors offer to pay it for him (demonstration of community feeling) but he produces a tin box containing sufficient money to cover the fine. He has it but he won't pay it. Even when his victim, the moneylender, turns up, prepared to pay the fine (in a timely display of repentance and one which suggests that Dan was probably right in hitting him), he will not allow it. His principles are unshakable.

Secondly, Dan incarnates tradition and becomes a quintessential Ford figure, living in and for the glories of the past. He inhabits a small cottage in the shadow of a great ruined tower, the symbol of Ireland's proud past. He laments the passing of the old days, when the wise ones knew the remedies for all ills, when fine heather moonshine was made and the making was an art, and when there were songs. Now all the songs and the secrets (like making moonshine) are lost; modern inventions (the automobile, the radio, television) and the dispersal of the peoples have seen to that. His whole lifestyle and mentality is summed up in the revealing little gesture he makes as he leaves for prison. He picks up a stone from outside his cottage, kisses it and puts it in his pocket, as a reminder of his home and his land when he is in jail. In all of this Dan O'Flaherty is Ford as Ford has made plain in his Irish films like *The Shamrock Handicap, Hangman's House* and *The Quiet Man*, where he

has sought to recreate a vanished world of pastoral innocence, of community ritual, strong liquor, lilting melodic songs and a willingness to fight when necessary.

Community feeling is strong in *The Majesty of the Law* and the community celebrates its solidarity in drink. For Ford, drinking is as much a ritual as church-going. Indeed, on being presented with some newly distilled moonshine, Dan declares it is too good to drink and should be used for baptizing babies, thus explicitly drawing the religious parallel. Mickey J., the Puckish bootlegger (splendidly played by Jack MacGowran, giving the finest performance in this episode) turns up, armed with peat moonshine. They drink it together and soon the neighbors gather and join in. But the community can only be sustained by obedience to the law and Dan makes his way dutifully to prison to pay the price of his law-breaking.

The second episode *A Minute's Wait* is the pick of the bunch. Filmed at Kilkee Station, and in a sense an expansion and reworking of the opening scene of *The Quiet Man*, it shows Ford at his best. Beautifully judged and meticulously observed, it is a gloriously funny comedy, memorably acted by a perfect cast of Irish character players. The facial expressions, gestures and bits of business, delivery of lines are all deployed by Ford in a masterful blend of character and situation comedy, in which the timing is impeccable.

The train stops at Dunfaill for a minute's wait and a succession of minute's waits are proclaimed so that a prize goat can arrive and be put aboard, so that the lobsters for the Bishop's golden jubilee dinner can arrive, so that the local hurling team who have just won the all-Ireland championship can arrive, and so that the engine driver can finish telling a ghost story and downing a pint. The officious station master, who is concerned as the delays mount up, is persuaded each time to extend the wait, by the threat of the exposure of some dark secret in his family's past (his father was a freemason, who took to drink at the age of eighty-six and died before his time, his sister left for the United States "under most peculiar circumstances", and his grandfather was seen creeping down an alley during a famine with a bowl of soup).

At each announcement of a further wait, the passengers pile off the train and tear into the bar to drink. As the diminutive barmaid Miss Mallory, Maureen Potter has a field day, leaping over the bar at each fresh invasion of customers, delightedly dancing a jig to the strains of "Slattery's Mounted Foot"

and when the telephone rings, timorously enquiring of it: "What'll ye have?" During the wait Mrs. Folsey and Mr. Dunnigan arrange the marriage of her niece Mary Ann to his son Christy. The ritual courtship once it has been settled is pure Maureen O'Hara. Mary Ann waits for the shy Christy to pluck up the courage to kiss her and when this fails, she grabs him and kisses him and then slaps his face and he embraces her warmly and when the train leaves, they are happily hand in hand. Paddy Morrissey the porter (Jimmy O'Dea), having courted Miss Pegeen Mallory for eleven years, finally proposes: "How would you like to be buried with my people?" Finally when the Ballyscran hurling team arrives with flags waving and pipes playing, the passengers start singing, everyone gets aboard and the train departs.

Behind all the comical toing and froing lies an affirmation of all the old values. The strength of community feeling is, as usual, manifested in scenes of drinking together and singing together, in respect for the church (the Bishop's lobsters), sport (the hurling team) and the past (the ghost story). The arranged marriage, though treated with amusement, is a part of the ritual which is the community's cement. Once again, Ford stresses that the older generation know what is best for the younger. These values are pointed up by the presence of outsiders, but they are English outsiders and for them, Ford has no sympathy. One of the film's themes is their progressive humiliation and their characteristics are seen as the antithesis of the real values of the Irish. When they arrive, they are in a First Class carriage, separate from and in their own eyes superior to the rest. But they are moved out, to make way for the goat, and placed in a Third Class carriage where they are joined by the bishop's lobsters. They then disembark, they take no part in the communal festivities, and instead of drinking beer, they have tea served at a little table at the back of the station. They have no sense of community spirit and seeing the hurling team arrive carrying their injured and with their pipes playing, Mrs. Frobisher can only say haughtily: "Is it another of their rebellions?" When the train departs, they are left behind and stand disconsolately on the platform watching it vanish in the distance. Ford shows no mercy and the caricature of Colonel and Mrs. Frobisher as played by Michael Trubshawe and Anita Sharp Bolster is devastatingly funny.

With the third and final episode, originally dating from 1907 but updated to 1921, we are back with the case of what was originally a short dialogue

piece between the policeman and the fugitive on the quayside, expanded with detail and dramatic incident into Ford's last statement on "The Troubles". Power introduces it with the statement that the story is set at the time of "The Troubles" or as some (i.e. Ford) call it "The Black and Tan War". It is important for Ford who does not subscribe to the notion of rebellion, to stress the idea of the Irish Troubles as a war. "The Black and Tans" are shown as heartless, brutal and disrespectful to nuns, putting them beyond the pale. The regular army Major (Frank Lawton), a decent and humane man, is shown as tormented by the necessity of executing a captured Irish patriot ("Four years of war and I end up as a hangman. How much longer are they going to keep us here?"). Even the halfway decent members of the British race disapprove of British involvement in Ireland.

The first part of the episode, which is not in the original play, details the escape of the fugitive and does so with a stress, as in *The Plough and the Stars,* on the Catholic nature of the struggle and the sanction which the Faith lends to it. Outside the prison, an endless line of women and men shuffle in continual procession, telling their rosaries and praying for Sean Curran, the patriot hero held by the British. The Irish Police Sergeant (Denis O'Dea) who is ordering them to keep moving, has an altercation with a British officer, and then is seen to join the shuffling throng, reciting with them The Lord's Prayer. Two "nuns", allowed into jail to see Sean, rescue him, one of them, protected by an American passport, changing place with Sean, so that he goes out in "nun's" disguise (the holy veil being an actual instrument in his preservation). There is no doubt but that religion is on their side, stressed by our first sight of Sean, young and fresh-faced, on his knees before the crucifix on the wall.

As in previous "Troubles" films, Ford stresses the unanimity of popular participation in and support for the Irish "War of Independence". The ordinary people outside the jail are praying for Sean's deliverance, and their prayers are of course answered. The warder, who sees what is happening, delays discovery of the escape by blarney and "incompetence". In a nearby theater, actors disguise Sean as a ballad-singer (thus making him an incarnation of the most precious aspect of Ireland, her heritage). Finally, on the quayside where he is to join the ship to take him to safety, Curran is recognized by the Police Sergeant Michael O'Hara. O'Hara talks to him about his ballad-singing and about "The

Rising of the Moon", which becomes a symbol of the Rising of the Irish. "I used to sing it myself" reflects the Sergeant, "though there was a bit of treason in it. But then there's a bit of treason in us all". He lets Curran go and strolls away, singing "The Rising of the Moon". The last shot, the most beautiful in the film, is of the moon shining down on the water, and a boat rowing Curran out over its silvery reflection, as a lilting tenor voice sings "The Rising of the Moon". What is irritating about the episode is that it is shot entirely at a tilted angle, doubtless intended to suggest the disorientation caused by "The Troubles" but becoming swiftly an insufferable mannerism.

In a sense what the film gives us is the three faces of Ford's Ireland which have cropped up singly or together in all his Irish films: the homily, set in a never-never Ireland, about the importance of principles, tradition and community feeling and the unimportance by comparison of money (*The Majesty of the Law*), the broad and detailed comic knockabout which says the same things but with warmth and humor, and the heroized Ford version of "The Troubles", a noble struggle against oppression, backed by the people and blessed by the Faith.

The Rising of the Moon received only sporadic distribution, made a loss of $250,000 and effectively put an end to the idea of a native Irish film industry for the time being. But there was worse news than this. The film was banned in Belfast on account of the 1921 episode. In March 1958 Limerick County Council unanimously approved the suggestion of one of its members, D. P. Quish, that the Eire government should "contact all countries with which Ireland has diplomatic relations and have *The Rising of the Moon* withdrawn from exhibition". The reason for this motion was that "the film is a vile production and a travesty of the Irish people".[53] The director of the West Cork Railway complained at Ford's use of an 1886 steam engine for *A Minute's Wait* because it gave the impression that Ireland was backward and anti-modern. *The Evening Herald* (June 1, 1957) spoke for many when it declared:

> To the more naïve and uninformed foreigner—especially Americans—it may seem all very quaint and wonderful, but it will do nothing to bolster our status in the eyes of the more enlightened. Whatever may be our faults ... I do not subscribe to the depiction of rural Ireland as a place peopled by

53 Anthony Slide, *The Cinema and Ireland*, Jefferson, NC and London: McFarland, 1988, p. 83.

buffoons and poltroons, happy-go-lucky, work-shy poteen swillers, porter-soaks, mercenary matchmakers, uncouth lovers, sly malingerers and the rest of the incredible litany.[54]

But Ford did not set out to paint a realistic picture of modern Ireland. His Ireland was an exile's Ireland, an Erin of the imagination, peopled by characters he loved.

The wheel of Ford's Irish experience almost came full circle with *Young Cassidy*. He was approached by two young producers Robert D. Graff and Robert Emmett Ginna in 1963 to direct a film version of Sean O'Casey's autobiography *Mirror in My House*. The film which renames its hero Johnny Cassidy covered O'Casey's self-education and emergence as a writer while working as a laborer, his romances with Daisy Battles and Nora, the promotion of his work by the Abbey Theatre, and his eventual departure from Ireland. They had a script (by John Whiting) and the backing of MGM and Ford was their first choice of director. He was so anxious to do it that he accepted a cut in his usual salary, agreeing $50,000 and a 5 percent share of the producers' share of the profits. He saw it as a way of making amends for the debacle of *The Plough and the Stars*. The plan was to shoot location scenes in Dublin and interiors at MGM's Elstree Studio. But things went even more disastrously than the filming of *The Plough and the Stars*. First of all, Sean Connery, the original choice for the title role, had to withdraw to fulfill a commitment to appear in *Goldfinger*. He was replaced by an MGM contract star, the Australian Rod Taylor. There were quarrels with the producers, Ford lost confidence in the script, started drinking heavily and fell ill. He had to withdraw from the project and return home. He suggested that Rod Taylor, with whom he had established an immediate friendship, take over and direct it, using his notes. But the producers brought in the distinguished cameraman-director Jack Cardiff saying he would work to Ford's design. Ford had completed some ten minutes of filming, including Cassidy's opening scene as a laborer, a love scene between Cassidy and prostitute Daisy Battles, a punch-up between the three Cassidy brothers and a Gaelic football team in a country pub, and Cassidy's grief at his mother's death.[55] Cardiff was irritated when the critics tried to

[54] Barry Monahan, *Ireland's Theatre on Film*, Dublin: Irish Academic Press, 2009, p. 156.
[55] Gallagher, *John Ford*, p. 543.

identify Ford's contribution to the finished film on its release in 1965. Several of them identified the riot scene as distinctively Fordian when in fact it was directed by Cardiff, who had re-shot some of Ford's scenes and reckoned only four and a half minutes of Ford remained in the film.[56] The film was billed as "A John Ford production, directed by Jack Cardiff".

It is easy to see what would have attracted Ford to the project. It embraces the Fordian theme of family break-up. There is a strong and concerned mother, Susan Cassidy, to whom Johnny is unconditionally devoted. But she dies, leaving him inconsolable. His sister Ella dies of poverty. His two brothers, actor Archie and British army soldier Tom, go abroad. So poignantly Johnny is the only family mourner at his mother's funeral.

The film provided another chance to visit the story of the Easter Rising. Johnny drills in the hills with Republican volunteers, who demand uniforms so that the British will see them as a proper army and who reverently bare their heads as the Plough and Stars banner is paraded. During the Rising itself, there are direct echoes of *The Plough and the Stars* film as scenes of British armored cars racing round Dublin streets, demolishing rebel barricades and machine-gunning rebels and innocent civilians, are intercut with gleeful scenes of looting. But the film also recreates the famous riot in 1926 when *The Plough and the Stars* is put on at the Abbey Theatre and W. B. Yeats has to come on stage and reprimand the audience for not recognizing an authentic Irish genius.

Cassidy is in many ways a Fordian hero. The film traces the process by which he emerges as a major artist during the course of which he becomes more and more isolated until at the end he leaves Ireland and goes into exile to fulfill himself creatively. First of all he gradually loses his family, then he is rejected by his own class, the working class, with his room-mate Mick Mullen furiously denouncing him for caricaturing their class in his plays and the nationalist audience at the Abbey Theatre denouncing him for betraying Ireland and the sacred cause of independence, and finally Nora, the woman he loves, leaving him because she cannot live with his genius. He is in a way an identification figure for Ford, the rebel, outsider, exile, fulfilling his own genius through film.

[56] Jack Cardiff, *Magic Hour*, London: Faber and Faber, 1996, p. 236.

But whether or not it would have turned out to be a late masterpiece is by no means clear. Rod Taylor was hopelessly miscast as Cassidy. Anne V. Coates, the editor, dealing with Ford's footage recalled:

> I thought the footage was okay, but not great. I was expecting something quite extraordinary. I thought the footage was a little old-fashioned, stagey and with not much energy. His direction didn't seem nearly as dynamic as I thought it would be. I think he was getting old.[57]

The finished film, despite a fine cast (Flora Robson as Cassidy's mother, Julie Christie as the prostitute Daisy Battles, Maggie Smith as Nora, the book shop assistant who loves Johnny, Michael Redgrave as W. B. Yeats, Edith Evans as Lady Gregory) and some striking scenes – notably the riot when mounted, saber-wielding police break up the transport workers' strike – largely fell flat. As *The Monthly Film Bulletin* (March 1965) noted perceptively:

> (It) has virtually no style or personality attributable to either Ford or Cardiff. What should have been vibrant, hard-hitting and redolent of its author's world, becomes instead an anonymous work, weighed down by that feeling common to many British films of a script being faithfully shot page by page without any real creative participation by the director.

What it lacks conspicuously is all the detail and bits of business Ford habitually inserted which gave his films such life and warmth. The pub brawl directed by Ford which ends with Cassidy flooring a self-important RIC officer and the hitherto antagonistic Cassidy brothers and the Gaelic footballers escaping together in the jaunty car has the feel of authentic Ford. But for the most part his famed "grace notes", those scenes which gave his films their distinctive identity, are missing. One such was described by Ford to Peter Bogdanovich:

> Well, after the play was over, and after Maggie Smith had left—while he was standing there in the rain outside the theatre—I wanted Julie Christie, by now a streetwalker, to come over to him and say, "O Sean, I loved it—it was wonderful—you ought to be proud of yourself. God bless you." It took this poor little tart to appreciate what he's done. And then she walks away, disappears in the rain, leaving him there. The producers . . . promised to do it after I got sick and left. But they didn't.[58]

[57] Eyman, *Print the Legend*, p. 514.
[58] Bogdanovich, *John Ford*, pp. 106–7.

Donal Donnelly told Lindsay Anderson that Ford directed the scene in which the two undertakers, one of them played by Donnelly, refuse to move Mrs. Cassidy's coffin until they are paid. But he described the film as "a deplorable enterprise. Eileen (O'Casey, Sean's widow) says the only good thing about Sean's death was that he died before seeing it . . . they had that guy in it. That Rod Taylor, you know—the whole thing was appalling".[59]

John Ford's *How Green Was My Valley* (1941) was arguably the finest example of a Forties phenomenon, the cinema of memory. It was born amidst the gathering clouds of a European War. Its tone wistful and nostalgic, it was permeated with regret for a lost past, a vanished innocence, a longing for the certainties of the world of the day before yesterday. This was the hallmark of such films as Sam Wood's *Goodbye, Mr. Chips* (1939), Orson Welles' *The Magnificent Ambersons* (1942), Mervyn LeRoy's *Waterloo Bridge* (1940) and *Random Harvest* (1942) and John M. Stahl's *The Keys of the Kingdom* (1944).

How Green Was My Valley is also the defining Welsh film, just as *The Quiet Man* became the defining Irish film. It was based on the best-selling novel by Richard Llewellyn, first published in 1939 and continuously in print ever since. Dai Smith, one of the most shrewd and sensitive analysts of Welsh culture, has called *How Green Was My Valley* "the most important 'document' . . . ever written about South Wales". It is, of course, a selective picture, and a deeply romantic one, which is what upsets some. Smith says, "as economics this is infantile, as history a falsification, as literature . . . it is feeble, but as Romance . . . it is perfect".[60] It contains most of the elements of the Welsh myth of identity—the pit and the heroic pitman, the male voice choir, the chapel, the beauties of the countryside—but interwoven with the timeless elements of romance—growing up, falling in love, the joys and sorrows of family life, death. It was the almost perfect realization of this blend on film that made it so successful.

The film became a cherished project of 20th Century-Fox's production chief Darryl F. Zanuck, who paid $300,000 for the film rights. At Fox, Zanuck exercised total control over all aspects of production. He would assign projects to the writers and directors he deemed most appropriate, would personally

59 Anderson, *About John Ford*, p. 232.
60 Dai Smith, "Myths and Meaning in the Literature of the South Wales Coalfield—the 1930s", *The Anglo-Welsh Review* (Spring 1976), p. 40.

approve the final script and the editing, which he sometimes dictated.[61] The book was successively assigned first to Liam O'Flaherty and then Ernest Pascal. Both writers emphasized the battle between capital and labor in the coal industry. Dissatisfied with this approach, Zanuck sent Pascal's script to Philip Dunne, who told him that "while it was beautifully written I found it so gloomy and depressing that I wondered what had prompted him to buy the rights to the novel in the first place". Zanuck then sent him the book, Dunne read it and was entranced. He sent a memo to Zanuck: "The gist of my memo was that I thought the Pascal script had emphasized the labor strife and the industrial ruin of the valley, while virtually ignoring the warm human comedy and tragedy which glowed on almost every page of the novel. I felt that the emphasis should be on the family, on the process of the boy Huw growing up and learning about life and love, as well as tragedy and death as he remembered all in his old age."[62] Dunne was commissioned to write a new script and between July 15 and August 23, 1940 he produced his first draft. Llewellyn's book was lyrically and evocatively written in readily visualizable terms. So Dunne simply dramatized and re-arranged whole sections of the book, using much of the original dialogue. But it came out at four hours in length. The original plan was to shoot it in Technicolor on location in Wales. But the outbreak of the war scotched that idea.

Zanuck now borrowed William Wyler from Samuel Goldwyn to direct and Gregg Toland to photograph the film. Wyler and Dunne worked together for ten weeks cutting and polishing the script but at the end of the period they had not reduced it by much. The impasse was resolved by the casting of English evacuee Roddy McDowall as the young Huw Morgan. The original plan had been to follow the life of Huw from boyhood to adulthood with Tyrone Power taking the role of the adult Huw. But Wyler and Zanuck were so pleased with McDowall that it was decided to concentrate on his boyhood. This would give the film an emotional and perceptual unity as it became a child's eye view of an idyllic world gradually destroyed. Tyrone Power confided to Dunne that he was relieved by the change as he did not fancy being in only half a film. Dunne

[61] George Custen, *Twentieth Century's Fox: Darryl F. Zanuck and the Culture of Hollywood*, New York: Basic Books, 1997, pp. 239–56.
[62] Philip Dunne, *How Green Was My Valley—The Screenplay*, Santa Barbara: Santa Teresa Press, 1990, p. 18.

refocused the script on Huw. But the Fox Board in New York, presented with
the script, refused to commit the money, believing it was a potential disaster.
They hated the script, were concerned at the absence of star names, thought
the inclusion of the union and the strike too controversial, worried about
Wyler's reputation as a perfectionist, and the danger of the budget and the
shooting overrunning. But Zanuck told them it was the finest script he had
seen and that if necessary he would take it to another studio to film it. They
backed down but Zanuck decided that it would be shot in black and white on
a strict budgetary limit and shooting schedule. The loan period agreed with
Goldwyn for Wyler and Toland ran out and Goldwyn wanted them back to
film *The Little Foxes* so they left Fox and the project. Zanuck had outlined his
concept of the director's role to Wyler:

> I believe a director is engaged to direct and that he should be allowed full
> opportunity to express his ability—but I do want to say that the script that he
> shoots must, before it goes into production, represent the combined
> viewpoints of the writer, the director and myself.[63]

He assured Wyler that he would rarely visit the set and would let him get on
with it. But he would supervise the final cut carefully.

The same conditions applied to the new director Zanuck brought in. John
Ford had recently completed *The Grapes of Wrath*, another drama about the
break-up of a family and a way of life. Ford was given an eight-week shooting
schedule and a budget of $1,250,000. Although it was customary for Ford
to work closely with screenwriters to develop a script, particularly when he
worked with Dudley Nichols and Frank Nugent, while he was at Fox he tended
to be presented with finished scripts. Fortunately he liked the Dunne script
and he got on with Dunne, who was Irish American and sometimes a guest on
the *Araner*. As he told Peter Bogdanovich: "Phil Dunne wrote the script and we
stuck pretty close to it. There may have been a few things added, but that's what
a director is for. You can't just have people stand up and say their lines—there
has to be a little movement, a little action, little bits of business and things".[64]

Ford completely recast the film, retaining only McDowall. Wyler and
Zanuck had agreed on Katharine Hepburn for Angharad, Laurence Olivier for

[63] Custen, *Twentieth Century's Fox*, p. 251.
[64] Bogdanovich, *John Ford*, p. 80.

Mr. Gryffydd and Greer Garson for Bronwen. But Ford cast Maureen O'Hara as Angharad and brought in Abbey Theatre veterans Sara Allgood to play Beth Morgan, Barry Fitzgerald, Cyfartha, Arthur Shields, Deacon Parry and J. M. Kerrigan, the tailor. He also cast English actors Anna Lee as Bronwen and John Loder as Ianto, a role for which Wyler had rejected him.[65] The Scotsman Donald Crisp was cast as Gwilym Morgan. Ford's brother Eddie and brother-in-law Wingate Smith were assistant directors. The only genuine Welshman in the cast, Rhys Williams (Dai Bando), coached the cast in Welsh accents. To boost the star power, at Zanuck's suggestion, Canadian Walter Pidgeon was borrowed from MGM to play Mr. Gruffydd. He did not bother with a Welsh accent and as Dunne observed he made a "perfectly acceptable Gruffydd, but when I watch him I'm always conscious that I'm in the presence of a Hollywood leading man, not quite a preacher who has worked his way up through the mines".[66] The effect of Ford's casting was to Hibernicize the story. This is confirmed by Dunne who visited the set when Ford was filming the wedding reception after the marriage of Ivor and Bronwen and found him improvising a sequence in which Gwilym is singing an Irish drinking song "Peter O'Pee", while trying to walk a straight line. Dunne protested but Ford replied: "Ah, go on. The Welsh are just a lot of micks and biddies, only Protestants".[67] Ford's grandson Dan recalled that Ford modeled Gwilym and Beth on his own father and mother and the brothers on his own brothers Patrick, Francis and Eddie.[68] Roddy McDowall recalled "Ford created an atmosphere that was unique. He forged a unique sense of family with all of us. Everyone who worked on *How Green Was My Valley* became very emotionally connected to one another".[69] That the film meant something special to Ford too is indicated by the fact that he chose it to be shown when he was honored with a tribute dinner by the Screen Directors Guild in 1972.

Dunne was on the whole satisfied with the filming, noting that Ford duly devised extra lines and bits of business to enliven the action. But he was annoyed that between them Ford and Zanuck rewrote one scene:

[65] Anna Lee (with Barbara Roisman Cooper), *Anna Lee*, Jefferson, NC, and London: McFarland, 2007, pp. 132–8; John Loder, *Hollywood Hussar*, London: Howard Baker, 1977, pp. 127–8.
[66] Dunne, *How Green Was My Valley*, p. 31
[67] Dunne, *How Green Was My Valley*, p. 26.
[68] Dan Ford, *The Unquiet Man*, p. 156.
[69] Dan Ford, *The Unquiet Man*, p. 158.

The sequence in question was the inception of Iestyn's courtship of Angharad. I had followed the book in having Ianto knock Iestyn down outside the chapel for daring to speak to Angharad. Iestyn's father, the mine owner, threatens Ianto with the law, but when he discovers that his son has actually violated custom and morality by speaking to the girl, he says "If a man spoke to Iestyn's sister, murder would be done" and pushes his son into asking permission of Morgan to speak to his daughter.

The scene was shot but Zanuck hated it, cut it and had a new scene shot in which Gwilym, bathing his feet, when the mine owner arrives, receives him barefoot and has Beth rushing in with socks and shoes. Dunne complained:

> But they had the entire Morgan family not only respectful but actually servile. Morgan bows and scrapes; Beth comes simpering in ... the militant union leaders Ianto and Davy hide their pipes like guilty schoolboys....What really puzzles me is how Jack could have got the relationship so wrong, when obviously he got it exactly right when he shot the original scene.[70]

Dunne also discovered when he saw the completed film that Zanuck had cut three sequences which had been filmed: Gruffydd presenting Huw with a pencil box and talking to him about the true nature of wealth and poverty, sorrow and happiness, the scene when Huw gets his first long trousers at the tailor's with J. M. Kerrigan as the tailor and later Mr. Gruffydd tells him about Adam and Eve, and the scene in which Huw tricked the widowed Bronwen's suitor into giving up his pursuit of her. Dunne worked out that Zanuck cut them for not advancing the narrative.[71]

Zanuck assigned his top talents to the film: Arthur Miller as cinematographer, Richard Day and Nathan Juran for art direction and Alfred Newman for the score. An entire Welsh village modeled on Cerrig Ceinnen and Clyddach-cum-Tawe was built in the hills above Malibu. Newman's score incorporated many Welsh hymns and folk tunes ("Men of Harlech", "Myfanwy", "Guide Me, O Thou Great Redeemer", "The Ash Grove"), though the love theme was based on an Irish song "The Sixpence". It bathed the film in melody in the same way that Irish folk tunes permeated Ford's Irish films. Every rite of passage is marked by song: marriages, departures, reconciliations. Ivor Morgan and the

[70] Dunne, *How Green Was My Valley,* pp. 30–31.
[71] Dunne, *How Green Was My Valley,* p. 33.

choir he conducts are summoned to a command performance at Windsor and sing "God Save the Queen" at receipt of the news. The deep-focus black and white imagery was down to Arthur Miller. As Charles Higham noted: "John Ford is a director of a marked personal style, but again his films look entirely different one from another".[72] This depended on who the cameraman was. Miller told Higham that Ford was his favorite director. He admired Ford's economy and inspired improvisations. He felt that they enjoyed an intuitive rapport.[73] As Miller says of his own style: "I was never a soft-focus man. I like to focus very hard. I liked crisp, sharp, solid images. As deep as I could carry the focus, I'd carry it."[74] The result is to be seen in *How Green Was My Valley.* Ford shot the film between June 11 and August 12, 1941. The narration was recorded by Rhys Williams, but concerned that audiences might think Dai Bando was narrating, Ford replaced it with a new narration by actor-director Irving Pichel. Williams' version was apparently used in the version released in Britain.[75]

Both the book and the film establish a trajectory of change—and it is change for the worst. The united family is part of the community—a community whose unity is represented by common faith, common work, common leisure. There is an Edenic beginning, a white-painted village set in majestic rolling hills. But as time passes, the slag heaps encroach and the village becomes dirty and disfigured. The people change as the environment changes and they become spiteful, vicious and narrow-minded: the boycotting of Gwilym for opposing the union and the stoning of his house; the expulsion of Meillyn Lewis by the chapel deacons; the vicious gossip about Angharad and Mr. Gruffydd. After the divisions caused by the strike, Mr. Gruffydd says: "Something has gone out of this valley that may never be replaced". It is perhaps the unalloyed sense of community. Industrialization and its attendant ills disfigure the landscape of the valley and the landscape of the soul.

The film is narrated by an unseen adult Huw Morgan who is packing his belongings to leave his valley forever. As he packs he recalls his childhood there in the 1890s. Whether or not it is an accurate picture of the life of a

[72] Charles Higham, *Hollywood Cameramen: Sources of Light,* London: Thames and Hudson, 1970, p. 8.
[73] Higham, *Hollywood Cameramen,* pp. 147–9.
[74] Higham, *Hollywood Cameramen,* p. 134.
[75] Gallagher, *John Ford,* p. 186.

mining family is irrelevant, for it is life as seen through the eyes of a small boy. As the narrator says:

> I am leaving behind me my sixty years of memory—Memory. There is strange that the mind will forget so much of what only this moment is passed, and yet hold so clear and bright the memory of what happened years ago—of men and women long since dead. For there is no fence or hedge round time that is gone. You can go back and have what you like of it—if you can remember.

The camera tracks past the narrator out through the window of the house and into the street. The houses are grimy, coal dust blows through the street, everything looks squalid. Then there is a magical dissolve back to how it was with white-painted cottages and verdant hills.

With an affection born of personal experience, Ford recreates the rituals of family and community life. The first scene of the flashback sees Huw walking hand in hand with his father Gwilym Morgan over the hillside. The narrator explains that everything he ever learned came from his father "and I never found anything he ever told me to be wrong or worthless". It is an affirmation of the receiving of wisdom from generation to generation. It includes reverence for God and chapel ("Respect for chapel was the first thing my father taught us") and the Crown next to God, as Gwilym says: "For you are Our Father, but we look to our Queen as our mother". The scene in the script in which the narrator introduces each of the brothers as they work in the pit has been replaced by Ford with a lyrical scene in which Huw and Angharad call to each other across the valley, long, melting, wistful calls, like ghostly voices echoing down the corridors of time.

Huw the narrator then recalls the rituals of life in the village. The miners collect their pay from the colliery, and seen in long shot, march down the hill, striking up a song, so that their rich voices fill the air, expressing unity and comradeship. Beth Morgan the mother rushes out and sits on a stool by the gate to receive the wages of husband and sons tipped into her apron. There is the scrubdown in the yard, Father happily smoking his pipe until Beth mischievously tips a bucket of water over him.

Dinner is the quintessential family occasion. Everyone stands around the table in silence. Huw reaches for a piece of bread until fixed stares from his

brothers and father compel him to put it back. Grace is said, Ivor reaches for a slice of meat and Father slaps his hand and he hands it to the old man. Mother bustles around serving, helped by Angharad. After dinner, pocket money is handed out from the Box, the receptacle for family savings, and Huw gets his penny last and dashes off to the sweet shop.

These opening scenes are not only ritual events in themselves but are composed and photographed as such. The men file past the pay window in a line. They march down the hill in ranks. Father leads the five older sons in a line past the seated Mother. The family stand in order round the table and later file past the Box. The return home is framed by the cottage door and seen from inside, the perspective of the home. The structure of the family is perfectly observed ("if my father was the head of our house, my mother was its heart"). The saying of grace sanctifies the food, which is eaten in silence as Father believed that no talk he ever heard was as good as good food. The whole opening section of the film bespeaks order, regularity, hierarchy and harmony.

There follows a beautiful child's eye view of events when Huw sees Bron for the first time in a low-angle shot of her carrying a basket and coming down past the chapel. Huw falls in love with her and retreats shyly before her into the house. It is a ritual courtship visit. Mother and Father greet her and Father pushes the nervous Ivor toward her. They sit down with the other four brothers lined up in order to be presented to her.

The marriage of Bron and Ivor is another formal occasion. Ivor fidgets and Father smacks his hand; Mother weeps. Exchanged glances between Angharad and the new minister Mr. Gruffydd indicate the burgeoning of love. Bron and Ivor are married. Outside the chapel, men and women line each side of the steps, swaying back and forth and singing.

The wedding feast follows, its detail improvised by Ford and clearly based on his own family memories, as none of it is in the script. Barrels of beer are broken open in the backyard and glasses filled, the cake is carried in and almost dropped. Father sings *Peter O'Pee* while walking a straight line, Mother shows her petticoat to the other women, and there is a joyous sing-song. So family and community spirit is stressed again.

But both begin to break down when, after wages are cut, the men strike. At dinner, the sons led by Ianto demand the formation of a union. Father denounces the idea as "Socialist nonsense". Father orders Ianto to leave the

table. "I will leave the house" he retorts. All five of the grown-up sons leave, with only Huw remaining at the table. As the strike lengthens, bitterness grows against Gwilym who is known to oppose it. Stones are thrown at the cottage window. Beth receives word of a meeting of the strikers on the mountainside and gets Huw to take her there. At the meeting, amid falling snow, Beth fiercely denounces the strikers for threatening Gwilym, defends him from charges of siding with the owners and threatens to kill anyone who lays a hand on him. On the way back, Beth and Huw fall into an icy river. They are rescued and taken home but are both seriously ill and spend many months confined to bed. Ford could identify totally with Huw's experience, having missed a year of school after being bed-bound with diphtheria at the age of twelve.

Both family and community spirit are restored when Beth is brought downstairs from her sickbed. Singing is heard. The people from the village come and stand outside and sing. She is taken outside and bouquets are handed to her. Then in an intensely moving scene, the brothers return home,

Figure 2.5 The archetypal Fordian Family: The Morgans in *How Green Was My Valley* (20th Century-Fox, 1941)

coming in one after another and kissing her as they file back into the house. She is overcome and when asked to speak, can only think to invite everyone inside to eat.

This involves the first major departure from the book. The first seven chapters have been transposed more or less intact into the screenplay, though the characters of the individual brothers are not developed as they were in the book. Both in the book and the screenplay Father invites them all to return home but abdicates his authority as head of the house, saying in future they will all be lodgers. Such an abdication would be unthinkable for Ford. So he has the boys return home unconditionally, re-establishing the family unity.

Although the strike ends, there will never be enough work for everyone and gradually and inexorably the process of decay begins. Owen and Young Gwilym are made redundant and decide to go to the United States for work. Father reads a verse from the Bible, mother weeps. But then a telegram arrives from Windsor requesting a performance by the choir before Queen Victoria. Father orders a combined celebration party for the choir, conducted by Ivor, and a going away party for Gwil and Owen. That night at the party the choir sing "God Save the Queen", Father prays and the camera pans from Mother and Bron listening as the brothers slip away.

Later Ianto and Davy must also leave, Davy for New Zealand and Ianto for Canada. Mother is lighting the fire as the boys enter and lead her to her rocking chair. Father reads from the 23rd Psalm. Father looks up as the two sons slip away and returns to the text with "My cup runneth over".

Angharad marries but without the joyousness of Ivor and Bron. The mine owner's son Iestyn Evans courts her with Father's permission. She goes to see Mr. Gruffydd, confessing her love and he tells her he cannot marry her because this would condemn her to a life of poverty and premature ageing. So she marries but there is no singing until Gwyilym calls for it. As the carriage bearing Iestyn and Angharad departs, Mr. Gruffydd rushes from the back of the chapel to stand among the gravestones and watch them go. Ford does this in long shot to emphasize the distance between them, and in a departure from the script in which he is seen in the chapel putting away the hymnbooks.

After a year spent in bed, Huw is helped by Mr. Gruffydd to walk again and attends school. Once more the child's eye view of the first day at school is perfectly captured by Ford. But he is mocked by the snobbish and sneering

sadist schoolmaster Mr. Jonas and beaten by the school bully in the school yard. When his father sees the damage, he sends for prizefighter Dai Bando to teach him to fight. Beth is disgusted but Gwilym insists "a man must fight". It is an echo of the familiar Fordian philosophy that a man is measured by how much he can drink and how well he can fight. Huw wins his next schoolyard fight, but is flogged brutally by Jonas. When they hear about this, Dai Bando and his henchman Cyfartha go across to the school and in the guise of giving Mr. Jonas a boxing lesson leave him unconscious. It is a very beautifully timed and performed comic vignette.

The family suffers another blow with the first mine disaster of the film. Whistles blow, people rush up the hill and the cage ascends from the depths with Gwilym sitting blankly cradling the dead Ivor in his arms. The body is carried home, Bron collapses in the doorway and later her son Gareth is born. Huw gets his certificate of education and the family discuss a career for him as doctor or lawyer. But when Bron tells him how much she misses Ivor and still puts out his work clothes, Huw insists on going down the pit and lodging with Bron to give her someone to care for. It is another manifestation of family solidarity.

Like the Catholic priests in Ford films such as *The Quiet Man*, the other authority figure in *How Green Was My Valley* is the Protestant minister Mr. Gruffydd. He comes direct from the university at Cardiff but has spent ten years down the pit. He represents the open-hearted, generous-minded, strong-willed spirit of service and sacrifice. His acceptance as a member of the community is demonstrated at the wedding reception for Bron and Ivor. He arrives at the party where they are all singing. They fall silent and he helps himself to a glass of beer and joins in the song and the laughter.

It is also Mr. Gruffydd who gives his support to the union. When at the party, Deacon Parry chides Ianto with not going to chapel, Ianto says he cannot stomach a faith which teaches men and women to exist on little pay and be happy with a wretched lot. The family try and silence the quarrel but Gruffydd insists on having it out. To the surprise of everyone he supports the idea of the union so that they may bargain for better conditions but they must remember that with strength goes responsibility. Parry reproves Gruffydd for stepping outside his sphere and preaching Socialism. Gruffydd replies that his concern is anything which comes between Man and the Spirit of God.

It is Mr. Gruffydd who teaches Huw to walk again and gives him a lesson on faith and prayer ("Prayer is only another name for good, clean, direct thinking"). But there is a nasty side to chapel, mean-spirited, petty-minded, tyrannical, embodied with memorable malignancy by Arthur Shields as Deacon Parry. He presides at the denunciation and expulsion from chapel of an unmarried mother, Meillyn Lewis. He takes visible pleasure in tormenting her and is denounced for it by Angharad.

This nastiness spreads when Angharad returns alone from South Africa and divorce is rumored. Huw fights another boy for insulting his sister. Women point at Huw and cackle in the street. The Evans housekeeper assembles a gaggle of gossips in the kitchen to spread the rumor. Huw reports that for the first time the curtains are drawn in daytime and the door locked because of the scandal. Rumors spread of an affair between Angharad and Mr. Gruffydd. He resigns and delivers a denunciatory sermon, saying he had done nothing wrong but has failed because they are a bunch of hypocrites and cowards who come to chapel out of fear not love. He has been unable to convince them of the truth of the love of God.

But the mine signals another disaster. This time Gwilym is trapped under ground. Gruffydd leads a rescue bid and Huw finds his father wedged under beams. He dies in Huw's arms. Above ground Beth is transfigured, declaring "He came to me just now—Ivor was with him—they spoke to me and told me of the glory they had seen". Huw concludes his narrative: "Men like my father cannot die. They are real in memory as they were real in flesh—loving and beloved forever. How green was my valley then". The proof of the life after death that Beth spoke of is underlined by the final scenes of the film introducing Father and Mother, Brothers and Sister, real in memory as they were real in flesh.

There are several reasons why *How Green Was My Valley* provokes hostility in some quarters. One is the charge of inauthenticity. There is only one genuine Welsh actor in the cast and an overwhelming sense of Irishness. The second is political. There is an entrenched mythology of the Welsh coalfields: the villainy and exploitation of the owners, the heroism of the unions, the united struggle, the prevailing socialism. This is largely bypassed by the film. Gwilym is fervently anti-Socialist and anti-Union and defends the owners ("They're not savages"). His is the value system of the film. But Gruffydd defends the idea of

Figure 2.6 The Fordian Family ("our father was the head but our mother was the heart"): Sara Allgood, Roddy McDowall and Donald Crisp in *How Green Was My Valley* (20th Century-Fox, 1941)

the union as long as it acts responsibly in the most overtly political scene in the film. The villagers are devout monarchists and several of the sons migrate to the Empire. There is—and Ford would have enjoyed this—a residual element of anti-Englishry, seen in the sneering sadism of Mr. Jonas, the icily snobbish Iestyn Evans and his pompous father, mine owner Evans, all Anglicized Welshmen. But none of this matters. It is a film that speaks from and to the heart. Only the most flint-hearted curmudgeon or diehard ideologue could fail to respond to its potent mixture of myth, romance, idyll, dream, memory, melody and emotion.

That it chimed with the emotions of the audience is demonstrated by its critical and box office success. It was loved by critics and audiences alike. Cecilia Ager in *PM* said: "This is a film conceived and executed with dignity, honesty, thoroughness and superlative competence. It is a full-bodied work. It has stature and completeness; a maximum of cinematic skill, the minimum of

movie trickery. It does what it sets out to do. And so it commands, and holds, your respect; it compels your serious consideration." *Variety* (October 29, 1941) called it "an exposition of the cinematic art that pars the best . . . It's a film that holds much to remember". *Life* (November 10, 1941) said "Best-selling novels regularly go through the mill in Hollywood and emerge as movies. But none has emerged more successfully than *How Green Was My Valley* . . . John Ford . . . has converted it into one of the year's most beautiful and stirring films". It topped the 1941 list of box office successes for Fox with domestic rentals of $3 million. Nominated for ten Oscars, it won five, best picture, best director, best cinematography, best supporting actor (Donald Crisp), best art direction (Richard Day, Nathan Juran and Thomas Little). In its unforgettable evocation of a child's eye view of life and the world, *How Green Was My Valley* demonstrates the truth of the statement Ford made to an interviewer in 1966: "My childhood profoundly marked me."[76] For Ford's Irish films are bound together by his feel for the Irish landscape and traditions, by the enduring values of family, community and religious faith, and by reverence for the heroic struggle for Irish Independence. The best of them successfully mingle myth, idealization and elements of personal autobiography.

[76] Gerald Peary, ed., *John Ford Interviews*, Jackson: University Press of Mississippi, 2001, p. 103.

John Ford's Empire

The Thirties were pre-eminently Hollywood's imperial decade when the ethos and rituals of British imperialism were given glamorous celluloid life. The pattern was definitively set by Paramount's *The Lives of a Bengal Lancer* (1935). This film, made with all the pace, polish and excitement of the best Hollywood action films, exalts the life of service and obedience to discipline as the ideal and a chivalric "Three Musketeers" all-male camaraderie as the behavioral norm for heroes. The film brings this home to the audience by tracing the process through which two outsiders are initiated into the ethos. The outsiders, who serve as perfect vehicles for audience identification, are Lt. McGregor, the self-styled "Scotch Canadian" (Gary Cooper) and Lt. Stone (Richard Cromwell), the half-American son of the Commanding Officer of the Lancers. The important thing to note about them is that they are not *pukka* Indian Army officers, and they, along with the audience, have to be taught the meaning and value of service, duty and discipline. But also they are both North Americans and therefore particularly useful identification figures for United States audiences. Initially they resist the ethos but by the end of the film, they have learned the message. Even though McGregor is killed, he is awarded a posthumous Victoria Cross and the playing of the National Anthem signals the triumphant fusion of the individual with nation, Crown and Empire. The box office success of this film inspired a stream of imitations and follow-ups, with United Artists contributing *Clive of India* (1935), Warner Bros, *The Charge of the Light Brigade* (1936), Fox, *Wee Willie Winkie* (1937), Republic, *Storm Over Bengal* (1938), Universal, *The Sun Never Sets* (1939) and RKO Radio, *Gunga Din* (1939).[1]

[1] On the cinema of Empire see Jeffrey Richards, *Visions of Yesterday,* London: Routledge, 1973, pp. 1–220.

It has been said with some justice that the mass working-class audience in the 1930s preferred American to British films. But it is not true to say that Hollywood promoted a single coherent and attractive world view that was democratic, egalitarian and classless. Some films certainly fell into this category. But for every *Mr. Deeds Goes to Town*, Hollywood produced a *Cavalcade*, glorifying the British class system, and for every *Grapes of Wrath*, it produced a *Charge of the Light Brigade*, a paean to romantic and militarist imperialism. In fact throughout the 1930s Hollywood produced a stream of films promoting a deeply conservative, romantic and admiring world picture which included a class system, imperial values and aristocratic ideals.

Nothing is more indicative of this fact than the films of Shirley Temple. Shirley Temple was a worldwide phenomenon. The top box office attraction both in Britain and America from 1935 to 1938 inclusive, she had singlehandedly saved the Fox Film Company from bankruptcy, won an Academy Award in 1934 at the age of seven and become a millionairess before entering her teens. Her star only waned as she began to grow up and by 1940 she was finished, "a superannuated sunbeam" as one critic put it.[2] Her films included handsome versions of childhood classics such as *Heidi* and *Rebecca of Sunnybrook Farm* and "little miss fix-it" pictures in which she reconciled estranged couples, humanized crusty grandfathers and generally spread sweetness and light (*Dimples, Bright Eyes, Curly Top*). But she also made a trio of films glorifying the nineteenth-century British Empire, which were every bit as lavish and admiring as *The Lives of a Bengal Lancer* and *The Charge of the Light Brigade*. In *Wee Willie Winkie* (1937) Shirley intervened in an Indian frontier war to reconcile a rebel Khan to the Raj. A similar plot was provided for *Susannah of the Mounties* (1939) in which the Royal Canadian Mounted Police stood in for the British Indian Army and a Red Indian tribe for the tribes of the North-West Frontier. *The Little Princess* (1939) featured Shirley as a spirited Victorian girl, reduced to poverty when her adored father is believed killed in the Boer War. She is rescued from her plight by a kindly aristocrat and reunited with her father by the intervention of Queen Victoria herself. The film is a wholehearted and entrancing affirmation of aristocracy, monarchy and Empire.

[2] Lester and Irene David, *The Shirley Temple Story*, London: Robson Books, 1984, p.107.

But significantly Shirley also appeared in *The Little Colonel* (1935) and *The Littlest Rebel* (1935), post-American Civil War dramas, in which she acts as reconciler of North and South, black and white, but on the basis of a surviving *antebellum* world of Southern aristocrats, cotton plantations and faithful black servants. In all her films, Shirley acts as a reconciling figure but in the Empire and post-Civil War films she is reconciling subject peoples to the status quo.

The Western, of which Ford became one of the most admired exponents, was in serious eclipse between the arrival of sound in the late 1920s and the dramatic revival of the genre in the late 1930s. While Poverty Row studios turned out a stream of cheaply made "B" Westerns, the genre barely figures in the ranks of prestige "A" pictures. Between 1932 and 1934, "A" Westerns averaged only 0.3 percent of all major studio productions and 2.4 percent of all Westerns.[3] But production increased from four "A" Westerns in 1938 to 14 in 1940 and as Richard Slotkin points out: "The 'renaissance' inaugurated a thirty-year period ... in which the Western was the most consistently popular and most widely produced form of action film and a significant field for the active fabrication and revision of public myth and ideology".[4]

The silent Western had been a predominantly visual and action-based genre, not especially dependent on dialogue. The arrival of the talkies led the studios to maximize the opportunity to add speech to the existing attractions of the movies, hence the immediate rush to film stage plays and stage musicals. Also two action-based genres in particular came to the fore: the crime film and the British Empire epic. The crime film, in addition to the aural attractions of staccato machine gun fusillades and the squealing tires of high-speed car chases, addressed such pressing social problems as gangsterism and urban corruption. The British Empire epic was, in Slotkin's words "an appropriate vehicle for allegorizing public concerns about foreign affairs: specifically, the rise of anticolonial movements in Asia, Africa, and Latin America (and) the Great Power rivalries that divided Europe and Asia into democratic, Fascist, and Stalinist camps ... Thematically, these movies deal with a crisis in which civilization—symbolized by the Victorian Empire or its equivalent—is faced

3 Richard Slotkin, *Gunfighter Nation: The Myth of the Frontier in Twentieth-Century America*, New York: Harper Perennial, 1993, p. 255.
4 Slotkin, *Gunfighter Nation*, p. 256.

by a threat from an alliance between the opposite extremes of savage license and totalitarian authority".[5]

Writing in 1939, Margaret Farrand Thorp discerned another motive behind the production of Imperial epics, the economic motive:

> The immediate explanation of this burst of British propaganda is a very simple one. As continental audiences dwindled, Britain, which had always stood high, became an even more important section of the American movies' foreign public. It was highly desirable to please Great Britain if possible, and it could be done without sacrifice, for the American public too, seemed to be stirred with admiration for British Empire ideals. Loyalty as the supreme virtue no matter to what you are loyal, courage, hard work, a creed in which *noblesse oblige* is the most intellectual conception; those ideas are easier to grasp and very much easier to dramatize on the screen than social responsibility, the relation of the individual to the state, the necessity for a pacifist to fight tyranny, the nature of democracy, and the similar problems with which the intellectuals want the movies to deal.[6]

However by the late 1930s, there had been an ideological shift in America which Slotkin attributes to the politics of the New Deal, "the rediscovery of America" by the Popular Front and the crisis of world politics leading to World War Two. The studios turned to American history and to the Western to emphasize American ideals and Ford was in the vanguard of this movement with three masterworks released in 1939, *Stagecoach, Young Mr. Lincoln* and *Drums Along the Mohawk*.[7]

The war, which America entered in 1941, promoted a new dominant ethic rendering imperial epics suddenly and dramatically out of fashion. For the war was a struggle for democracy, a crusade which preached racial equality, self-determination and freedom. Its enemies were the cruel and racist tyrannies of the Third Reich and the Italian and Japanese empires. It would be wrong to equate the British Empire with the Axis powers but they did share a belief in a racial hierarchy, in which one race was superior to the others. This became an embarrassment when expressed in Hollywood films at a time when India's role as a bulwark against Japanese aggression in Asia was crucial. Consequently the

5 Slotkin, *Gunfighter Nation*, pp. 265–6.
6 Margaret Farrand Thorp, *America at the Movies*, New Haven: Yale University Press, 1939, pp. 294–5.
7 Slotkin, *Gunfighter Nation*, p. 271.

Office of War Information scotched MGM's plans for a film version of Rudyard Kipling's *Kim* and forbade reissues of *Gunga Din*, which had been banned in India, Malaya and Japan on its initial release because it offended "racial and religious susceptibilities".

Imperial epics inevitably came John Ford's way, given his track record as a director of action films. So how did he as a "professional Irishman" who saw the British Empire as cruel and oppressive reconcile himself to these projects? He did so by emphasizing and celebrating a military ethic of service, duty and sacrifice. His thinking seems to have been along the lines discerned by Richard Slotkin in his discussion of the allegorical role of the Imperial epic:

> The Victorian or civilized order is embodied in a regiment or military outpost whose values are nominally those of a liberal and progressive imperium but whose heroes are warriors and whose politics are those of a justified and virile patriarchy happily exercised over consenting White women and childlike brown faces. A fanatical ... chieftain ... is uniting the hill tribes against our regimental utopia ... There is often a foreign power, an evil empire ... working behind the scenes ... The only one who can save us is the hero ... And we *are* saved—though typically at the cost of the hero's sacrificial death ... There is a striking and not fortuitous resemblance between this formula and the classic Indian-war scenarios of the Myth of the Frontier.[8]

The idea of the imperial epic as surrogate Western is borne out by the fact that two of Ford's imperial films, *The Lost Patrol* (1934) and *Four Men and a Prayer* (1938) were actually remade as Westerns, *Bad Lands* (1939) and *Fury at Furnace Creek* (1948) respectively and Slotkin's paradigm perfectly fits Ford's imperial films *The Black Watch* (1929) and *Wee Willie Winkie* (1937), as well as his US cavalry trilogy.

Talbot Mundy's *King of the Khyber Rifles* is one of the classic romances of empire. Published in 1916, it has rarely been out of print since. It is set during World War One. Its hero is Captain Athelstan King, an English officer serving in India and fluent in native dialects. With India weakened by the withdrawal of British troops to fight in Flanders, King is given a secret mission. There are rumors of an impending *jihad* (holy war), funded by the Germans. Disguised

[8] Slotkin, *Gunfighter Nation*, pp. 266–7.

as a *hakim*, a wandering healer, King is to suppress this potential uprising. He penetrates "The Heart of the Hills" in the mountains beyond the Khyber Pass and there meets Yasmini, a mysterious white woman who exerts a mesmeric influence over the hillmen. In a theme lifted from Rider Haggard's *She*, Yasmini shows King the perfectly preserved bodies of a Roman commander and a Grecian maiden who look exactly like Yasmini and King. She believes they are reincarnations of the pair and are destined to conquer India. He resists her blandishments but is kidnapped by a jealous mullah, Mohammed Anim who, knowing that Yasmini loves him, seeks to use him to obtain wealth and arms for her. But Yasmini blows up the ammunition dump, destroying Anim and his men and putting paid to the *jihad*. She also facilitates King's escape, her love triumphing over her dreams of conquest.

Fox planned to produce this as a silent film and John Stone prepared an adaptation. While retaining the central thread of Mundy's narrative he departed so far from its detail that when Mundy saw the film, he described it as a travesty.[9] King, renamed Donald, is made to be an officer of the Black Watch, merely seconded to the Khyber Rifles, and unlike the book which took place entirely in India, the film version features the Scottish regiment in action on the Western Front. King, on the eve of his regiment's departure for war, is given the secret mission to stop the planned *jihad* by the hillmen, led by a mysterious white goddess. The Field Marshal explains that she plans to lead her hillmen down the Khyber Pass into India and "she would give over our peaceful subjects of India to the horrors of holy war. They look to us for protection and we won't let them down". As a result of his return to India, King is shunned by his fellow officers. In India stationed at Peshawar, he poses as a drunkard who has accidentally killed a fellow officer and escapes from custody to join the rebel hillmen as a renegade. Once in the hills he meets Yasmini who falls in love with him and explains that there is a prophecy that a white goddess and her white lover will conquer India. As the descendant of Alexander the Great, she is white and King is the perfect mate. But he persuades her that such a conquest would involve needless slaughter. She calls on her followers to lay down their arms. Instead they shoot her. She dies in his arms. A detachment of lancers who have

9 Brian Taves, *Talbot Mundy, Philosopher of Adventure*, Jefferson, NC: McFarland and Company, 2006, p. 164.

infiltrated the rebel camp turn machine guns on the hillmen and extinguish the proposed *jihad*. King rejoins the Black Watch on New Year's Eve. Stone eliminated the idea of reincarnated lovers, the kidnapping of King by the mullah and King's pose as a *hakim* and he added all the Great War episodes.

Although conceived as a silent film, *The Black Watch* was reconceived as a talkie after Winfield Sheehan, head of production at Fox, ordered an end to silents following the box office success of Raoul Walsh's location-shot talkie *In Old Arizona*, which premiered on December 25, 1928. The young Irish American writer James Kevin McGuinness was brought in to provide dialogue. A conservative Catholic, he is described by Robert Parrish as an "archreactionary".[10] But the studio feared that the ability of those of its directors who had no experience of handling dialogue would be compromised. One of them was Ford whose entire career had been in silent films. So for seven of his first eight talkies he was assigned a dialogue director. Andrew Bennison was credited with having "staged" *Men Without Women* and *Born Reckless*. William Collier Sr. was given the same credit on *Up the River* and *Seas Beneath*. He was billed as "dialogue director" on *The Brat* and *Pilgrimage*. On *The Black Watch* it was veteran English character actor Lumsden Hare, playing the Colonel in the film, who functioned as dialogue director. It was probably Hare who was responsible for the ponderous, agonizingly slow delivery of the actors in some of the dialogue exchanges. But it is also the case that the dialogue scenes in *The Black Watch* share the faults of other early talkies such as *The Lights of New York* (1928), *The Terror* (1928), *Atlantic* (1929) and *Dubarry, Woman of Passion* (1930): unnecessarily lengthy pauses, exaggeratedly expansive gestures and expressions, over-emphatic line readings. Ford recalled:

> That was another picture they changed after I'd gone. Winfield Sheehan was in charge of production then, and he said there weren't enough love scenes in it. He thought Lumsden Hare was a great British actor—he wasn't but he impressed Sheehan—so he got Hare to direct some love scenes between McLaglen and Myrna Loy. And they were really horrible—long, talky things, had nothing to do with the story—and completely screwed it up. I wanted to vomit when I saw them.[11]

[10] Robert Parrish, *Growing Up in Hollywood*, New York: Harcourt Brace Jovanovich, 1978, p. 148.
[11] Peter Bogdanovich, *John Ford*, Berkeley and Los Angeles: University of California Press, 1978, p. 50.

The story has been faithfully repeated by most Ford biographers. But there is more to it than that. For one thing, the love scenes are essential as one of the central themes of the story is Yasmini's bid to secure King's love and collaboration. But Myrna Loy who played Yasmini tells a different story in her autobiography, recalling that Victor McLaglen was terrible in the love scenes:

> He would not *give*. He forgot that he was an actor, I guess, and resisted playing the lover. "Myrna, she's just a child", he kept telling Jack Ford. . . . We tried everything, but he never responded. I think Jack finally gave up on the love scenes.[12]

Scott Eyman filled in more of the background from information provided by propsman Lefty Hough.[13] The film was premiered at the Carthay Circle cinema in Hollywood and the love scenes provoked derisive laughter. A horrified Ford, fearing for the future of his career, went on one of his notorious benders. Sheehan ordered the love scenes to be re-shot by Lumsden Hare with Hough assisting. The reshoot was completed just two days before the New York opening. But the *New York Times* (May 23, 1929) reported that the love scenes were still greeted by laughter.

McLaglen is indeed dreadful in the love scenes. But then he is actually miscast as the stalwart English officer. Although born in Tunbridge Wells, the son of an Anglican bishop and a veteran of the Great War during which he served as Provost Marshal in Baghdad, Victor McLaglen with his prizefighter's face and physique and classless English accent was better suited to the role of tough proletarian sergeant which he subsequently played for Ford (*The Lost Patrol, Wee Willie Winkie*, the cavalry trilogy) than pukka British officer, a part calling for a gentlemanly actor such as Clive Brook.[14]

The film is superbly shot by Joseph H. August, much of it in diffused lighting, with foggy London streets, smoky railway station and hill caves, misty mountains and battlefields, giving the whole film a dream-like quality. The opening twenty-four minutes of the film which owe nothing to Talbot Mundy are pure Ford and show him determined to take full advantage of the

[12] James Kotsilibas-Davis and Myrna Loy, *Being and Becoming*, London: Bloomsbury, 1987, p. 57.
[13] Scott Eyman, *Print the Legend: The Life and Times of John Ford*, New York: Simon and Schuster, p. 119.
[14] On the problems presented by sound see Alexander Walker, *The Shattered Silents*, London: Elm Tree Books, 1978.

possibilities provided by the coming of sound. Tag Gallagher goes so far as to describe this opening sequence as quasi-operatic.[15] It is a sequence which enshrines the ideas of duty, service and camaraderie which so appeal to Ford but they are located in a Scottish milieu, enabling him to downplay the Englishness of the original story.

A title "London, August 1914, the officer's mess of the Black Watch" is followed by a shot of doors opening and lines of pipers, three abreast, marching into the room. The Colonel (Lumsden Hare) stands up and declaring: "Gentlemen, this is a war", urges the assembled officers to uphold the Scottish tradition and display the customary duty owed to the regiment by them as descendants of the Highland chieftains who fought with Wallace and Bruce. They are to fight for the honor of the Highlands, the protection of the people and their loyalty to the King. They stand to drink the toast to the King. Then as the pipers march round the table, playing "Bonnie Laddie", there is a long shot of the dining table with officers standing on each side and in succession they ritually smash the glasses they have just used. The Colonel calls for a song and a young officer sings "Annie Laurie" as the officers relax and light their pipes and cigars. Captain King is sent for by the Field Marshal and he lingers at the door of the mess, slowly putting on his coat and filling and lighting his pipe as if reluctant to tear himself away from the camaraderie being demonstrated. Eventually he goes out into the street where cockney buskers are singing "Home, Sweet Home". At the office of the Field Marshal, he is given his mission—to foil the *jihad* being planned on the North-West frontier of India by Yasmini and her hillmen. He asks to be spared the mission but is told it is his duty and he accepts it. Returning to the mess, he tells the Colonel that he has requested a transfer to the Khyber Rifles and is leaving for India. Officers, misunderstanding his motive, turn their backs on him. He asks his brother Malcolm to trust him. Inside the mess, the officers link hands and sing *Auld Lang Syne*. Outside, King, pipe clenched between his teeth, listens sadly to the song.

This is followed by the departure of the troop train which again makes full use of the possibilities presented by the availability of sound: singing, marching

15 Tag Gallagher, *John Ford: The Man and his Films,* Berkeley and Los Angeles: University of California Press, 1986, p. 61.

feet, shouted orders, the hissing of the steam train, the blowing of the whistle, ringing bells. The troops arrive preceded by the pipers, singing "Loch Lomond". A woman mounts a box to sing "Annie Laurie". There are little vignettes: a henpecked Scottish soldier is given a lecture by his diminutive wife (the redoubtable Mary Gordon) on how to behave, a tearful little girl begs her father to take her with him and Donald and Malcolm King have a stiff-upper-lip parting, Donald solicitously adjusting Malcolm's uniform. Then the train steams off, with everyone singing "Annie Laurie".

This evidently struck a chord with audiences. Mordaunt Hall wrote in the *New York Times* (May 23, 1929):

> Those who witnessed the trains carrying soldiers to the front during the black nights of London town, will be affected by these sequences, for they are without doubt the most realistic thing of their kind that has come to the screen, and the fact that these scenes are presented with a variety of sounds ... render them particularly vivid ... they are so true to those unhappy days that they cause one to recall the cheerful gallantry of the men and the anguish of the mothers and children. The bagpipes fill the theatre with their peculiarly stirring strains, and whether it is *Auld Lang Syne, Loch Lomond* or *Annie Laurie*, one feels the power of such airs and one harks back to the stirring quality of these melodies during hostilities.

The scene shifts to Peshawar where the muezzin calls the faithful to prayer and King meets up with his old friend Rissaldar Major Mohammed Khan, a robustly dignified figure who asks Allah's forgiveness every time he strikes or kills someone, which is quite often. A group of civilians outside the club discuss King, saying he is a rotter because he is shirking the war, drinking to excess and fraternizing with the natives. Overhearing this, the commanding general declares that Mohammed Khan is "a gallant soldier and a gentleman". Inside the club Ford gets to indulge his anti-Englishry in the character of the braying bore Major Twynes, a monocled chuntering silly ass of monumental proportions. He seeks to regale other officers with a joke about two Irishmen, Pat and Mike, but they all escape from him. He quarrels with King ("You're a drunken boundah, sir"), is knocked down and pronounced dead. In the General's office, he revives and the trick is explained. The General tells King that Yasmini is a goddess with an eye for handsome men. He must use this to win her affection and locate and blow up her ammunition dump. Reaching for

his pipe, as he does at all moments of emotional stress, King declares: "This is the dirtiest job I've ever tackled". King "escapes" from custody, takes refuge at Yasmini's house and agrees to join her cause. An Oriental song "Flowers of Delight" is sung behind the action in this scene.

The film then cuts to Flanders in mid-October and scenes of the Black Watch, marching through the mud singing "Annie Laurie". The comic other ranks joke and grumble; one of them plays "The British Grenadiers" on a harmonica. The officers are visibly exhausted but when one of them makes disparaging comments about King, his brother Malcolm leaps to his defense and the officer apologizes and hands him a cigarette as a gesture of reconciliation.

Back in India, King, in native costume, and a group of Indians, actually Mohammed Khan and a detachment of lancers, arrive at the Khyber Pass to join Yasmini. They are escorted to her headquarters, the Cave of Echoes. The great door into the cave is opened by a giant wheel, turned by captured British soldiers, lashed by their captors. One of them is Major Macgregor (Francis Ford), blinded now, but an old friend of King. King makes himself known and promises to get him out.

In a temple in the cave, hordes of hillmen are roused to fight by a speech from the mullah. Rewa Gunga, Yasmini's suspicious henchman, demands that King prove himself fit to join them. Yasmini appears on top of a rock to announce her support for King. But the tribesmen demand that he fight. Amid leaping flames, beating drums and shouts from the onlookers, King strips to the waist and wrestles one of the hillmen, eventually subduing him and hurling him bodily into a fiery pit. Yasmini summons King to her boudoir and he orders Mohammed Khan to locate and destroy the ammunition dump. Mohammed Khan follows Hurrim Bey, extracts the location of the ammunition from him by threatening to burn off his beard and when he tries to raise the alarm, casually runs him through, wiping his sword on the robe of one of his lancers. Ford had wanted to blow up the ammunition but his sound man told him the noise would damage the recording equipment. So there is no explosion.

The overblown love scenes follow with Yasmini proclaiming her love for King ("It is sweeter to be a woman to one man than a goddess to thousands"), telling him of the prophecy that a leader would arise among the hillmen ("strong, brave, white"). Together they could conquer India. "It cannot be" he

declares, confessing that he loves her but tries to dissuade her from her cruel plans for conquest. "Empires are not won by mercy, Donald" she tells him.

In her crystal ball she shows him the progress of the war in Flanders. In a series of forward tracking shots, linked by a succession of dissolves, the Black Watch, with their ever-present pipers playing, are seen charging across the muddy fields. Malcolm is shot and falls apparently unconscious and the screen goes white. The scene recalls Donald to his senses. "Duty, honor, loyalty" he declares, explaining that he was sent to betray her and must do his duty.

King joins Mohammed Khan and his men who throw off their disguises to reveal their uniforms. They free the prisoners, including Macgregor, who joins them. They set up a line of machine guns at the top of the steps. Mohammed Khan casually pushes the suspicious Rewa Gunga off the cliff. King tells Yasmini that the only way to save her men is to urge them to lay down their arms. She instructs them to do so, and they shoot her as a traitor. They then charge the steps and are mown down by the machine guns. "The job is finished" says King bitterly. The film ends as it began at the Black Watch mess in London. It is New Year's Eve. The Colonel addresses the officers, many of them wounded, and tells them they have upheld the bravest traditions of the country. They toast the King and the pipers play. King enters, salutes the Colonel and tells him he is returning to duty with the Black Watch. The Colonel announces that King has been promoted to Major and awarded the DSO for distinguished service in India. Donald and Malcolm are reunited. The company all join in "Auld Lang Syne".

Ford responds fully to the regimental ritual, the camaraderie, the celebration of tradition, duty and service, reveling in the Scottish element of kilts, bagpipes and Scottish folk song. One senses that he is less happy in the Oriental melodrama but he takes it in his stride, demonstrating considerable visual power in the sequences in the Cave of Echoes, the wheel being turned by the captives, the wrestling match, the final explosive confrontation between the hillmen and the lancers. The prominence of the Black Watch caused Fox to retitle the film *The Black Watch* for its US release. In Britain it retained the novel's title *King of the Khyber Rifles*. Made at a cost of $400,000, it grossed an estimated $800,000 at the American box office.[16]

[16] Gallagher, *John Ford*, p. 498.

The Times (July 30, 1929), calling the film, "the oddest mixture of Rider Haggard romance and Drury Lane pantomime", agreed with the *New York Times* when it said: "The best scenes are those in the officers' mess, with the pipers playing to the toasts, and again at the departure of the troops for France. These pipes make stirring music in synchronized form, and we would not have less of them. It is to the credit of Mr. Ford that he has managed his story in a way to give it greater scope for movement than is usual in films of this kind, so that the eye is at no moment fatigued".

Ford's soundtrack received an extraordinary tribute when *King of the Khyber Rifles* became the first example of a talking picture shown to the blind. It was shown to 240 blind boys and girls at the Royal School for the Blind at Leatherhead. Captain Sir Beachcroft Towse VC commented that "the blind from their keenness of hearing knew what was being presented by the film and would form pictures in their minds that might excel those formed by their sighted brethren".[17]

Ford told an interviewer in 1955: "I have been accused of being interested in masculine subjects. War and prison life have fascinated me over the years. But is that so strange? I have lived through the experience of two world wars. I myself have experienced the hell that is war. But I have also learned about friendship, bravery, and deprivation ... And the sea, and the hardship of men at sea have fascinated me since early youth".[18]

The subject of men, and their behavior under stress is a recurrent theme in Ford and succinctly summed up in the title of his 1930 naval film *Men Without Women*. Given this preoccupation, it is obvious what attracted Ford to Philip Macdonald's 1927 novel *Patrol*. He took the project to RKO Radio Pictures and it appealed at once to the head of production, the noted adventurer and documentary-maker Merian C. Cooper. He gave Ford the go-ahead for a film version but in view of the unconventional nature of the subject sanctioned only a modest budget ($227,703) and a limited shooting schedule (21 days). Ford also accepted a reduced salary plus 12.5 percent of the profits. The novel had been filmed as a silent British film under the title *The Lost Patrol* in 1929. The leading role, the sergeant, was played by Cyril McLaglen, the brother of Victor McLaglen.

[17] *The Times*, May 24, 1930.
[18] Gerald Peary, ed., *John Ford Interviews*, Jackson: University Press of Mississippi, 2001, p. 61.

But ten days before shooting was due to start, Ford, dissatisfied with the script he had (presumably by Garrett Fort, credited with "adaptation") called in Dudley Nichols, who had scripted *Men Without Women*, *Born Reckless* and *Seas Beneath* for Ford and had contributed to the script of *Pilgrimage*. They worked intensively for eight days and produced a workable script. It largely follows the narrative line of the book which was written almost as a blueprint for a film, with the inevitable elimination of the swearing to meet the requirements of the censor. Characteristically Ford introduced a new character into the script, a talkative Irishman, Quincannon played by Abbey Theatre veteran J. M. Kerrigan.

The film was shot entirely in the Arizona desert near Yuma in temperatures of 110 degrees Fahrenheit, and completed just two days over schedule. *The Lost Patrol*, as it was retitled, has a classical simplicity of structure and tight dramatic unity. It is set in Mesopotamia in 1917, reminding audiences that World War One was imperial in its scope. It opens with the lieutenant in command of a British army patrol shot dead, leaving the patrol bereft of knowledge of their location, mission and destination. The Sergeant (Victor McLaglen) takes command and leads the men northwards in the hope of reaching the river. They find an oasis and a mosque where they camp for the night. But overnight two of the sentries are knifed and the horses driven off. Thereafter they are pinned down by unseen Arab snipers and picked off one after another. Private Pearson (Douglas Walton) and Corporal Bell (Brandon Hurst) are the sentries who are knifed. Hale (Billy Bevan) is shot out of a palm tree when he climbs it to get a better view of their location. Jock McKay (Paul Hanson) and Cook (Alan Hale) set out to try and find help but their mutilated bodies are returned, tied to two horses. Quincannon goes berserk and charges into the desert firing only to be shot down. Brown (Reginald Denny) slips away at night to circle round the Arabs but never returns and is presumed killed. Abelson (Sammy Stein) gets heatstroke, wanders off into the desert and is shot dead. Ford distorts the image of the desert to convey the effects of heatstroke. An RAF plane spots them and lands but the pilot is shot dead as he climbs out of the plane. The Sergeant sets fire to the plane to try and signal for help. Sanders (Boris Karloff), a religious fanatic, goes steadily mad and finally marches off, carrying a large cross and is shot dead, as is Morelli (Wallace Ford) who tries to bring him back. Having buried his comrades, the Sergeant digs his own

grave and stands in it waiting. The Arabs, only half a dozen of them, close in as the Sergeant, laughing manically, machine guns them. At this moment, a British military column, alerted by the smoke, rides in. The Sergeant is asked where his patrol is and he points silently to the row of graves, each marked by an upright sword. In the book, there is no relief column and the Sergeant dies at the end, the last member of the lost patrol.

The film is generally well acted by a cast of reliable character actors, headed by Victor McLaglen, who had actually served in Mesopotamia. The single exception is Boris Karloff's melodramatically overwrought Sanders. Max Steiner's score provides individual musical motifs for the leading characters.

The film charts the behavior of the men under stress. But it is also a film of memory, as several of the main characters recall their past lives. Pearson talks to the Sergeant about his mother, who wept for the first time when he joined up, and his love of Kipling which is what caused him to enlist. George Brown, the pseudonymous gentleman ranker, recounts to his enthralled comrades his travels in the tropics and all the beautiful women he has known. McKay and Quincannon, old comrades of many years standing, recall their service together

Figure 3.1 *The Lost Patrol* (RKO, 1934) with Victor McLaglen, Boris Karloff, Reginald Denny among others

in India. Cockney Herbert Hale recalls his wife seeing him off on the troopship but when he tells Morelli and Brown that he has a two-year-old son, we see Morelli and Brown mentally calculating how long they have been away and realizing he has been cuckolded, but they say nothing. Morelli, a jaunty ex-music hall performer, tells the Sergeant he is a Jonah and describes the death of his stage partner Jessie in an accident.

What had seemed to some at the studio the disadvantages of the film, the single location, the absence of women and romance, the grimness of the tale earned critical plaudits. The film was hailed as a welcome change from the conventional studio output with its realism, its convincing location shooting, its claustrophobic intensity, its careful characterization, and its allegorical evocation of the futility and wastefulness of war. It also attracted audiences, grossing some $750,000.[19] It featured in the annual ten best film lists of both the National Board of Review and the *New York Times*.

The most successful of Ford's British India films was *Wee Willie Winkie* (1937). When Zanuck told Ford that he was pairing him with Fox's biggest star Shirley Temple, Ford was apparently horrified. But Zanuck sought to sweeten the pill by saying he could have a budget of a million dollars and Victor McLaglen as co-star. He also stressed that it was the beginning of a change in the nature of her vehicles. Zanuck outlined his ideas at a story conference on July 30, 1936:

> My idea about doing this picture is to forget that it is a Shirley Temple picture. That is, not to forget that she is the star, but to write the story as if it were a *Little Women* or *David Copperfield* ... the characters must be made real, human, believable. Only then can we get a powerful, real story. The role must be written for Shirley as an actress, ... we don't want to depend on any of her tricks. She should not be doing things because she is Shirley Temple but because the situations ... call for them. In other words, write a role and let Shirley adapt herself to the picture ... And it must be told from the child's point of view, through her eyes.[20]

Shirley Temple was put into lavishly produced versions of Victorian and Edwardian childhood classics, beginning with Rudyard Kipling's *Wee Willie*

[19] Gallagher, *John Ford*, p. 498.
[20] Rudy Behlmer, ed., *Memo from Darryl F. Zanuck*, New York: Grove Press, 1993, pp. 6–7.

Winkie. It would be followed by *Heidi, Rebecca of Sunnybrook Farm* and *The Little Princess*. The hero of Kipling's short story, Percival Williams, underwent a sex change to Priscilla to accommodate Temple and the screenwriters Ernest Pascal and Julien Josephson fleshed out the story with elements of *Little Lord Fauntleroy*. Indeed C. Aubrey Smith played the grandfather both in *Winkie* and the film version of *Fauntleroy* (1936).

In *Winkie* a little American girl, Priscilla Williams, and her widowed mother, Joyce (June Lang) travel to India in 1897 to live with Joyce's father-in-law, Colonel Williams (C. Aubrey Smith), commander of a British army post near Rajpore. She is taken up by tough Sergeant Donald MacDuff (Victor McLaglen), who obtains a small uniform for her, teaches her military drill and christens her Wee Willie Winkie, Private Winkie for short. During the course of the film, Winkie humanizes her starchy grandfather, facilitates a romance between her mother and the dashing subaltern Lt. "Coppy" Brandes (Michael Whalen) and brings about peace between the British and a hostile Pathan chieftain Khoda Khan (Cesar Romero).

In her autobiography Shirley Temple tells how she did everything she could think of to endear herself to Ford but he remained gruff and aloof until the restraint she showed in Victor McLaglen's deathbed scene when he recognized her professionalism, put his arm around her and his attitude changed.[21] In fact he would cast her as an adult in *Fort Apache* in 1948 and act as godfather to her eldest child. She concluded "outwardly he is a rugged person, but inside he's kindly and even sentimental".[22]

Ford famously disliked the English and had no time for the British Empire, which he held responsible for enslaving Ireland. But *Winkie* contains a classic defense of Empire which Colonel Williams delivers in explaining to Priscilla what the British are doing in India:

> Up in those hills there are thousands of savages, all waiting for the chance to sweep down the Pass and ravage India. It's England's duty, it's my duty, to see that they don't, and as long as I live, that duty is going to be done.

Later he explains that the Empire wishes to be friends with everyone and facilitate peace, trade and prosperity, and this is the message she takes to Khoda

[21] Shirley Temple Black, *Child Star*, London: Headline, 1988, pp. 179–80.
[22] Joseph McBride, *Searching for John Ford*, London: Faber and Faber, 2003, p. 260.

Khan in the hills. This directly echoes the justification for Empire given in *The Black Watch* by the Field Marshal.

But Ford indulges his dislike of the English by having almost all the officers played as monocled, chuntering Blimps of the "I say, by Jove, eh what" variety, much like Major Twynes in *The Black Watch*. Even Smith is encouraged to parody himself in the early part of the film as a tetchy, stiff old man with a parade ground bark. But after he has been softened by contact with Priscilla he then plays the role straight and delivers the imperial message with sincerity.

The characterization of Khoda Khan is also interesting. In imperial epics of the 1930s there were two archetypes of the native chieftain, the wild-eyed, power-lusting fanatic (Mischa Auer in *Clive of India*, Raymond Massey in *The Drum*) and the suave, Oxford-educated schemer, sneakily plotting the destruction of the British (George Arliss in *The Green Goddess*, Douglass Dumbrille in *Lives of a Bengal Lancer*). But Cesar Romero's Khoda Khan fits neither archetype. He gives a sympathetic performance of strength and dignity.

But Ford responds most of all to the life of the British outpost. For as in *The Black Watch*, the regiment is Scottish. The skirl of the pipes is heard behind the credits and regularly throughout the film. Alfred Newman's lilting score draws recurrently on Scottish ballads such as "Annie Laurie", "Loch Lomond", "Charlie is my Darling", "Comin' through the Rye" and "Auld Lang Syne".

In many ways *Wee Willie Winkie* prefigures Ford's later cavalry trilogy, *Fort Apache* (1948), *She Wore a Yellow Ribbon* (1949) and *Rio Grande* (1950). The child's eye view of the morning routine on the outpost and the regimental ball in *Winkie* are directly reproduced in *Fort Apache*, the rescue of Khoda Khan, MacDuff's boxing lesson and the final march past, in *Rio Grande*.

Ford sees the army post as a microcosm of the ideal society, with its rigidly defined hierarchy and the bonds of ritual and tradition. *Winkie* features the raising of the flag, parades and drills, the regiment moving out, ceremonial affirmations of the social cohesion and the raison d'être, an expression of patriotism, service and the need to belong. MacDuff's funeral similarly embodies these ideas. Cinematographer Arthur Miller recalled that there was no funeral in the script. But on location at Chatsworth in the San Fernando Valley, Ford observed that it had been raining, the sky was streaked with light and clouds and the atmosphere was visually right for the funeral. So he turned

Figure 3.2 C. Aubrey Smith, Shirley Temple and Cesar Romero in *Wee Willie Winkie* (20th Century-Fox, 1937)

to cast and crew and said: "We've got everybody here—let's bury Victor".[23] It became one of the most notable scenes in the film, the coffin draped in the Union Jack on a gun carriage, pulled by four black horses, followed by the regiment led by C. Aubrey Smith in a slow march and, to the right of the screen, a row of crosses.

But equally memorable is McLaglen's death scene. Sergeant MacDuff is mortally wounded on patrol. Priscilla brings him a bunch of flowers. He asks her to sing "Auld Lang Syne" which she does and he dies. She tells the others he is asleep and tiptoes away but behind a screen, the pipe major plays a lament. It is beautifully played by McLaglen and Temple.

But before the film reaches that point, there has been a lot of barrack room knockabout which looks as if it has been improvised by Ford. When reveille

[23] McBride, *Searching for John Ford,* p. 261.

sounds, the men leap from their beds and proceed to ablutions, MacDuff pulls up the covers and goes back to sleep until boy soldier Mott blows his trumpet in MacDuff's ear and then hides under the bed, from which MacDuff pulls him to dump him in a water barrel. There is a boxing match scene in which MacDuff, teaching the other soldiers the technique of boxing, knocks one out causing him to knock another four over. Then in a scene in which he instructs Sneath to steal a dog for Winkie, to make his point he knocks him out and Sneath does a perfect backward somersault and lands on his stomach.

The friendship between MacDuff and Winkie is cemented by his teaching her to drill, swindling Mott out of his new uniform which he shrinks so it will fit Winkie and bamboozling Mott into giving up a dog he has acquired so that Winkie can have it. McLaglen's sergeant, a two-fisted, conniving, lovable, lachrymose sentimentalist, is a dry run for his Irish sergeants in the later cavalry trilogy.

But Ford never forgets it is a Shirley Temple film and he achieves what Andrew Sarris has called "extraordinary camera prose passages from the wide-eyed point of view of a child".[24] These include her arrival at Rajpore where she is surrounded by beggars and hawkers, her wandering round the bazaar and watching a sword-swallower, her view of the post coming to life in the morning and the memorable sequence in which Ford intercuts scenes of her wandering disconsolately through the empty barracks and the funeral of MacDuff.

Shirley Temple thought it was her best film "because of its manual of arms, the noisy marching around in military garb with brass buttons, my kilts bouncing. It was best because of daredevil stunts and stampeding horses. It was also best because I finally seemed to earn the professional respect of someone so blood-and-thunder macho as Ford".[25] To the astonishment of Lindsay Anderson, Ford confirmed that "he had *enjoyed* making *Wee Willie Winkie* and was charmed by Shirley Temple".[26] The film grossed an estimated $1,250,000.

[24] Andrew Sarris, *The American Cinema: Directors and Directions 1929–1968*, New York: E. P. Dutton, 1968, p. 45.

[25] Temple Black, *Child Star*, p. 181.

[26] Lindsay Anderson, *About John Ford*, London: Plexus, 1981, p. 22.

The trade paper the *Motion Picture Herald* (July 3, 1937) recognized the development of Temple's character prescribed by Zanuck and also Ford's contribution:

WEE WILLIE WINKIE is a good audience and exhibitor picture for many reasons. The most important one, and there is no doubt the public will be quick to perceive it and upon which managers will be eager to lay their hands, is that in it a new and very different Shirley Temple is presented. No longer is she just a cute youngster, possessed of remarkable talents. Never once is the ranking box office personality called upon to fall back upon her familiar bag of tricks, her singing, dancing and mimicking that have been considered such standby assets in other films. Instead she is cast in a dramatic role which she handles in masterful fashion and from which she emerges a decidedly new and different character ... Production detail, exterior and interior backgrounds, military pageantry and stirring martial conflict expertly staged and photographed in sepia tint and the quality of musical accompaniment visibly and auricularly augment the power and appeal of the thematic content. In personalities, story and production facilities John Ford had a lot available. Placing due stress upon each, he has wrapped them all together into a piece of film merchandize in a convincing believable way which goes without saying the public and showmen will appreciate.

In 1938 Ford received two studio assignments from Fox, *Submarine Patrol* and *Four Men and a Prayer*, in which the handsome young English actor Richard Greene was being groomed as the new Tyrone Power. Ford's view of *Four Men* was "I just didn't like the story or anything else about it, so it was a job of work. I kidded them slightly".[27] In fact he kidded it more than slightly. He sent it up whenever possible. But this was not entirely his own doing. The script by Sonia Levien from David Garth's novel was extensively rewritten with contributions from Richard Sherman and Walter Ferris as the tone and approach of the film was drastically altered by order of Darryl F. Zanuck. Although it had been conceived as a hard-hitting imperial adventure, Zanuck decided that he wanted the story treated along the lines of *The Thin Man* "with a delightful sense of humor instead of a melodramatic thriller". A relic of the original treatment was Peter Lorre playing the secretary of the munitions dealer, "a monk-like odious creature". Two weeks into filming, Zanuck rewrote

[27] Bogdanovich, *John Ford*, p. 69.

the script reducing the secretary's role to a bit part and replacing Peter Lorre with Paul McVey.[28] Zanuck also seems to have deleted after the film's completion the scene of the coroner's inquest into the death of Colonel Leigh (with Lionel Pape as the coroner), replacing it with a newspaper headline announcing a verdict of suicide.

The film opens in the Indian outpost of Jerishtabi where the court martial of Colonel Loring Leigh (C. Aubrey Smith) is under way. Leigh is accused of ordering troops elsewhere while drunk and causing them to be massacred by native rebels. He is found guilty and dishonorably discharged from the army. He cables his four sons with the news, asking them to meet him at the family home, Leigh Hall, in the village of St John-cum-Leigh. The brothers, barrister Wyatt (George Sanders), RAF officer Christopher (David Niven), Oxford undergraduate Rodney (William Henry) and Washington Embassy attaché Geoffrey (Richard Greene) learn from their father that he was framed by a munitions syndicate who were supplying guns to the natives. But before he can present his evidence he is murdered and his papers stolen. The death is deemed to be suicide. But the brothers determine to discover the truth. Wyatt and Rodney head for India to question the colonel's batman Corporal Mulcahy. Christopher and Geoffrey head for South America in pursuit of the principal witness against their father, Captain Douglas Loveland (Reginald Denny). Meanwhile madcap American heiress Lynn Cherrington (Loretta Young) is pursuing Geoffrey. Christopher, Geoffrey and Lynn join the yachting party of American businessman Fernoy (Alan Hale) and find themselves caught up in a revolution on Marlanda, "an island kingdom far off the beaten track, hurled into revolt by the machinations of a munitions syndicate". The syndicate turns out to have been selling guns to both sides. The Revolution is suppressed and its leader General Torres is executed. Loveland, about to reveal the name of the syndicate boss, is murdered. But the brothers discover that the guns have been supplied by the Atlas Arms Company, a business owned by Lynn's father, Martin Cherrington (Berton Churchill). Lynn joins forces with the brothers. They track Martin down to Alexandria where he reveals that Fernoy effectively runs the company for him. The brothers board Fernoy's yacht, seize him and compel him to sign a confession. The film ends with the brothers

[28] Stephen D. Youngkin, *The Lost One*, Lexington: University Press of Kentucky, 2005, p. 162.

at Buckingham Palace receiving a posthumous decoration for their father from the King.

Four Men is very far from being a typical Ford film. It is a fast-moving exotic thriller in which the scene shifts with dizzying rapidity from India to South America and from England to Egypt. The complex narrative structure involves cross-cutting between the two sets of brothers on different sides of the globe and the serial-style adventures encompass a host of clichéd situations, such as the scene in which a suspect is shot just as he is about to reveal the identity of the villain, a device that was old when Fritz Lang used it in *Spione* (1928).

Although faced with a story, a structure and an ethos—upper-class Englishness—which he found alien, Ford nevertheless did what he could with it. In principle the idea of family and family rituals should appeal to Ford. The portrait of the dead mother hangs over the fireplace and presides in death over Leigh family gatherings. After their father is dead, the brothers drink a toast to their parents, gazing up at the portrait. The boisterous family feeling is typically Ford. The brothers rib one another, mocking Geoff's American accent ("Say 'okay, toots'" says Chris with comic disdain). When they meet on the dockside at Alexandria, they rugby tackle each other and roll round on the ground. Rodney the youngest is regularly picked on, pushed about and insulted but all with affection. But this is all essentially at odds with the material. For Ford is working in an idiom with which he is not only unfamiliar but intrinsically unsympathetic—upper-class Englishness. So the family make their jokes as they hand round the port after dinner. They greet their father with stiff-upper-lip smiles when he returns to discuss his disgrace. The dinner-jacketed junketings inevitably lack the warmth and depth of feeling in the family rituals of *How Green Was My Valley*. This alienation effect is at its strongest when the family meets and father lines them up with a peremptory "squad 'shun" and gets them to reel off their ridiculous boyhood nicknames, Beano, Bosun, Nosey and Snicklefritz and then walks along shaking hands with them all. So while Ford responds to the family feeling, he reacts against the public school attitudes involved.

The decision to kid the story leads to David Niven walking off with the picture, giving a delicious light comedy performance, complete with the inimitable Niven facial expressions (bemused, quizzical, mocking) and overplaying the love scenes to emphasize the clichéd dialogue. At one point he shoots off his gun before he gets it out of his pocket, and at another, for no

apparent reason, Christopher and a native steward start talking to each other in squeaky Mickey Mouse voices.

But two sequences that appear particularly Fordian involve performances by two of his favorite actors, whose casting was probably his doing. Barry Fitzgerald plays the batman Corporal Mulcahy in India. Meeting in a bar, he tells Wyatt and Rodney that their father was drugged and he is convinced of his innocence. An Indian bumps into him deliberately and calls him an "English dog". An outraged Mulcahy immediately starts a fight, calls on his comrades, O'Brien and Feeney, to join in and a fully fledged saloon brawl ensues, with Mulcahy shouting "up the Rebels", and taking time out to empty the beers into a single glass and finish it off, in emulation of Fluther Good in *The Plough and the Stars*. The fight carries on to the accompaniment of a broken pianola belting out an Irish jig. Ford would repeat this episode in *Donovan's Reef*.

The other Ford regular is John Carradine, playing the elegant and sardonic General Adolfo Arturo Sebastian. General Torres, the leader of the Revolution, is discussing his plans with Lynn and Loveland in the warehouse containing his munitions, when General Sebastian strolls in with two officers and chats genially to the group before escorting Torres outside and standing him against a wall. Torres and Sebastian drink a glass of champagne. Torres is offered a cigarette but refuses it. "But it is expected" says Sebastian. So Torres takes it. He rejects the offer of a blindfold. "Magnificent" purrs Sebastian. The camera pulls back to reveal a firing squad which shoots Torres. Unsentimental, casual and darkly funny, it is one of the film's highlights.

It is followed by a grim scene which presumably remained from the previous straightforward approach of the story. Armored cars and machine guns surround the warehouse. Machine guns are lined up. The revolutionaries pour out and fill a long steep staircase. They prepare for a last stand but discover their guns are useless, lacking firing pins. They are ruthlessly mown down by the machine guns, men and women alike. The long staircase recurs as a symbol of death in *Mary of Scotland* and *The Fugitive*.

Ford responds to the ritual formality of the court martial, frames shots where possible in archways, tracks his camera on movement, straightforwardly films his dialogue exchanges in medium shot. He might have responded better to the material had it been recast as a Western, as it was in 1948 as *Fury at Furnace Creek*, with the four brothers reduced to two but the same plot.

Ford experts have in general dismissed the film: "regressive" (Scott Eyman), "almost meaningless" (Tag Gallagher), "formulaic ... potboiler" (Joseph McBride), "absurd" (Andrew Sinclair), "ranks high as his least satisfying film" (J. A. Place).[29] It is perhaps worth noting that at the time of its release the *New York Daily News* called it "an exciting and romantic affair" and the *New York Post* found it a source of "continuous amusement, excitement, suspense and pleasure".[30] The *New York Times* (May 7, 1938) pronounced it "energetically told, compactly presented ... the players are uniformly in excellent fettle". But Otis Ferguson in the *New Republic* (August 3, 1938) deemed it "confused, silly, dispirited and dull".

Ford seems to have approached it in the spirit he described in a 1973 interview:

> Being under contract you make pictures that you don't want to make, but you try to steel yourself, to get enthused over them. You get on the set and you forget everything else. You say these actors are doing the best they can. They also have to make a living. As a director I must help them as much as I can.[31]

It grossed $600,000 but did not figure in Fox's annual list of top ten successes.

Four Men and a Prayer did not go down very well in Britain. *The Observer* (July 17, 1938) called it "one of those extraordinary panegyrics of British phlegm with which our friends in Hollywood insist on honouring us, and which quite a lot of British people find a little painful". *The Times* (July 18, 1938) said: "There are certain American films, and this is one of them, that owe their origin and their complete failure to an almost childish appreciation of British character and tradition. Had satire been intended this film would still have been negligible; but attempting, as it does, to praise in terms of sickly sentiment the rigid rules of loyalty the result is merely ridiculous".

For someone long typed as a man's director, Ford achieved the remarkable feat in *Mogambo* of guiding two actresses to Oscar nomination. *Mogambo* (apparently the Swahili word for "passion") was a remake of the 1932 drama

[29] Eyman, *Print the Legend*, p. 188: Gallagher, *John Ford*, p. 142; McBride, *Searching for John Ford*, pp. 266–7; Andrew Sinclair, *John Ford*, London: George Allen and Unwin, 1979, p. 76; J. A. Place, *The Non-Western Films of John Ford*, Secaucus: Citadel Press, 1979, p. 233.
[30] Tom Weaver, *John Carradine: The Films*, Jefferson, NC: McFarland and Co., 1999, p. 99.
[31] Peary, *John Ford Interviews*, p. 158.

Red Dust which had starred Clark Gable and Jean Harlow. John Lee Mahin, who scripted the original, reworked and updated the story for *Mogambo*, changing the setting from Indochina to Africa. Ford was characteristically terse about his reasons for taking on the project: "I never saw the original picture ... I liked the script and the story, I liked the set-up and I'd never been to that part of Africa—so I just did it".[32] Scott Eyman suggests that he did it "for purely commercial reasons", to retrieve his bankability after the critical and box office failure of his previous film, *The Sun Shines Bright*.[33] It is certainly untypical of Ford's mature work. It is a conventional romantic triangle on-safari story with a wisecracking American playgirl competing with a prim and proper British wife for the affections of the macho white hunter. The area of Africa is not specified in the film but in this generalized Africa, authority remains in the hands of the white hunter, Catholic priest and District Officer. Originally intended as a vehicle for Stewart Granger and Ava Gardner, studio chief Dore Schary decreed that Clark Gable, whose box office appeal had been waning, should be cast as the hunter, in a blockbuster that would return him to the top. The studio suggested Deborah Kerr for the wife but Ford insisted on the newcomer Grace Kelly ("This dame has breeding, quality, class") and shot a test of her which convinced the MGM top brass.[34]

Under Ford's direction both Ava Gardner and Grace Kelly would be nominated for best actress and best supporting actress Oscars, losing out to Audrey Hepburn and Donna Reed. Initially Ford treated Ava Gardner badly, having wanted Maureen O'Hara for the role but he warmed up to her when she stood up to him and he proclaimed her "a real trouper".[35] The person Ford gave a really hard time to on *Mogambo* was another newcomer, Donald Sinden. Sinden recalled in his memoirs that Ford was "the most dislikeable person I have ever met. I know now that the cause of the trouble was the fact that I was (am) pro-British and Ford was pro-American and pro-Irish. His was a romanticized American view of Ireland and he blamed me personally for all her troubles".[36] Ford and his cast traveled to Africa for the location shooting of

[32] Bogdanovich, *John Ford*, p. 141.
[33] Eyman, *Print the Legend*, p. 148.
[34] Dore Schary, *Heyday*, Boston: Little Brown, 1979, p. 260.
[35] Charles Higham, *Ava*, New York: Dell, 1974, p. 109.
[36] Donald Sinden, *A Touch of the Memoirs*, London: Hodder and Stoughton, 1982, p. 168.

the film. They were there from November 17, 1952 until January 28, 1953, filming in both British East Africa and French Equatorial Africa. A foreword gives fulsome thanks to the colonial authorities in Kenya, Uganda and Tanganyika for their cooperation. The film had no fewer than three second units, headed by Richard Rosson, James C. Havens and Yakima Canutt shooting background scenes for rear projection in the studio sequences and the copious animal footage. The location scenes were photographed by Robert Surtees and the studio scenes at Elstree by Freddie Young. Ford's bad temper with his stars may have been due to his ill health. He contracted amoebic dysentery and was suffering from blurred vision due to cataracts. Anxious to leave Africa as soon as possible, Ford rewrote some scenes so that they could be filmed in the studio rather than on location. Despite his handicap, Ford had lost none of his skill, as Freddie Young attested:

> Ford was masterly, he knew exactly what he wanted, he never hummed and
> hawed over the set-up. He'd stand on the set and say, "Take it from here. Full-
> length figure", making a shape with his hands. Then he'd go to a tighter shot
> above the knees, followed by close-ups. He'd already worked out which shot
> to do on which line of dialogue. He told me, "I only shoot what I want to use,
> to stop the bastards recutting the film afterwards" . . . But with a John Ford
> movie they couldn't do that. There was no footage left for anyone to re-edit
> in a different way. John didn't look through the camera. He didn't even like
> viewing rushes. He never tracked or panned if he could help it, believing that
> camera movement was disconcerting for the audience. He saw each shot as
> a separate picture: he'd start with a group composition then cut from one
> static set-up to another. It was a crisp style of directing and cutting. A lot of
> young directors move the camera all the time . . . But sometimes a simple cut,
> which shows a direct cause and effect, is more effective.[37]

On *Mogambo* Ford does track his characters but only when they are walking and the camera moves with them, not otherwise so the audience don't become camera-conscious.

Red Dust had run for a tight eighty-three minutes, but *Mogambo* stretched the same story out to nearly two hours. Much of the extra footage was the obligatory inclusion of scenes that feature in all safari films: colorful and exotic

[37] Freddie Young, *Seventy Light Years*, London: Faber and Faber, 1999, pp. 89–90.

footage of native dances and repeated scenes of wild animals in which someone points to a creature and says "Look, what's that" and is told "that's an impala" or "that's a Thompson's gazelle" and getting a potted history of the species. There are scenes of hippos, rhinoceros, flamingos, lions, leopards in the wild and a cute baby elephant for Ava Gardner to pet.

Clark Gable plays white hunter Victor Marswell who with his partner John Brown-Pryce, nicknamed "Brownie", traps animals for zoos. Ava Gardner is Eloise Kelly, tough wisecracking American broad who arrives at Marswell's headquarters, hoping to find her friend, an Indian Maharajah, who has already left Africa for India. While waiting for the boat to take her back, Eloise falls in love with Vic. They have a bantering relationship, addressing each other by their surnames. British anthropologist Donald Nordley (Donald Sinden) and his wife Linda (Grace Kelly) arrive to film and tape-record gorillas. Linda is drawn to Vic after he rescues her from an animal trap into which she falls while out walking and where she is threatened by a leopard. Vic is sufficiently attracted to Linda to agree to guide her and Donald into the dangerous and remote gorilla country. Eloise goes too after the river boat on which she was leaving is wrecked. The two women, now rivals for Vic's affections, have several acid exchanges while Donald is blissfully unaware of the clandestine meetings of Vic and his wife. The safari intervenes to rescue a wounded British District Officer from angry tribesmen who have turned on him when he discovered they were ivory poaching. They move on to a Catholic mission where the missionary priest Father Joseph arranges canoes and guides for them. Vic has to undergo the ceremony of courage in which spears are thrown at him while he remains stock still. They reach gorilla country and Donald takes his films and recordings. This features some remarkable footage of gorillas, taken by the second units, and intercut with shots of the stars in a studio jungle back at Elstree. Vic saves Donald's life when he is threatened by an enraged gorilla. He and Linda decide that Donald must be told of their love but Vic cannot bring himself to break up a marriage when Donald so obviously loves his wife. He and Eloise get drunk together. Linda discovers them and shoots him in the arm. Eloise quick-wittedly tells the aroused camp that a drunken Vic had made a pass at Linda and she had responded like a virtuous and outraged wife. Linda and Donald leave and Vic, realizing he loves Eloise after all, proposes marriage to her.

What is entirely missing from the film is the rich gallery of supporting characters that normally people a Ford film and give it its innate warmth and distinctiveness. Ford has to manage with only two familiar faces: Philip Stainton, who played the visiting Anglican bishop in *The Quiet Man* and here plays "Brownie" and Denis O'Dea, Abbey Theatre veteran and a key player in *The Plough and the Stars*, here cast as the genial Irish priest Father Joseph. Typically Ford caricatures his Englishmen. "Brownie" is the bluff, monocled Nigel Bruce-type hunter who calls men "laddie" and Donald is a rather soppy and naïve "I say that's absolutely delightful" English juvenile. Ford gets in an element of Catholicism with Eloise crossing herself in the mission church and getting Father Joseph to hear her confession.

The two women embody types that recur in Ford's work. There is the correct, prim, well-born lady and the tough worldly broad with a heart, who in this case "hit the high spots" to forget the loss of her flier husband shot down over Berlin in 1945 after a short marriage. They recall the contrast between Dallas and Mrs. Mallory in *Stagecoach* and Chihuahua and Clementine in *My Darling Clementine*.

Ava Gardner is excellent as Eloise whether standing on the quayside defiantly twirling her parasol or sexily crooning "When a *body* meets a *body*, comin' through the rye" to the embarrassment of the correct Britishers. She combines exactly the toughness and vulnerability that the part calls for. Grace Kelly also scores as the married woman gradually yielding reluctantly to her growing desire for the *macho* hunter. Produced on a budget of $3.1 million, *Mogambo* grossed $8.2 million worldwide, put Gable back on top and effectively launched Grace Kelly's career as a major Hollywood star.[38] It is, however, one of the least typical of Ford's mature works and could easily have been directed by one of MGM's house directors such as Richard Thorpe or Mervyn LeRoy.

Variety (September 16, 1953) reported: "The lure of the jungle and romance gets a sizzling workout in *Mogambo* and it's a socko package of entertainment, crammed with sexy two-fisted adventures of the kind that will attract plenty of cash customers". But as the *Saturday Review* (October 10, 1953) pointed out "John Ford's direction is capable, but lacking completely the stamp of individuality that characterizes his films".

[38] Eyman, *Print the Legend*, p. 424.

Actually *Red Dust* is the superior film. Mahin certainly thought so.[39] It is a sweaty, steaming jungle melodrama, expertly directed by Victor Fleming. Clark Gable gives an electrifying performance as rubber planter Dennis Carson, unshaven, tough, bad-tempered and two-fisted. He is loved by sexy, wisecracking Saigon prostitute Vantine (Jean Harlow), with whom he trades amusing insults and enjoys a robustly physical relationship. But he also falls for the very proper ladylike Philadelphian Barbara Willis (Mary Astor), wife of the boyish engineer Gary (Gene Raymond); he eventually gives her up in a burst of nobility. As Fleming's biographer Michael Sragow put it the film became "one of Hollywood's lasting comic-romantic melodramas about sex, love, honesty, and duty" in which "Barbara, Dennis, and Vantine dance out a roughhouse gavotte".[40] The mood is epitomized by passionate clinches, slapped faces and a jealous shooting, plus scenes of Harlow bathing naked in a water barrel and Gable carrying Astor through the monsoon, both drenched and dripping rain and with their clothes clinging to their bodies.

Samuel Goldwyn had snapped up the film rights to *The Hurricane* (1936) by Charles Nordhoff and James Norman Hall while the novel was still in galley proofs. He had sensed another best-seller from the authors of *Mutiny on the Bounty*. Also it was to be Goldwyn's contribution to the expensive but popular series of disaster movies such as *The Last Days of Pompeii* (1935) (volcano), *San Francisco* (1935) (earthquake), *The Good Earth* (1937) (plague of locusts) and *In Old Chicago* (1937) (fire). Goldwyn had originally planned for Howard Hawks to direct it until they fell out during the shooting of *Come and Get It* and Hawks was replaced by William Wyler. Goldwyn then turned to John Ford, who had directed *Arrowsmith* for him and had a track record in maritime dramas. Ford read the novel three times and cabled Goldwyn an enthusiastic acceptance of the project. Contrary to Joseph McBride's view that Ford "approached the film with only the most superficial level of involvement", Ford's enthusiasm suggests that he may well have seen in *The Hurricane* the perfect vehicle for the critique of imperialism he was unable to mount in his films directly dealing with the British Empire.[41] Oliver H. P. Garrett had written a script but Ford brought with him Dudley Nichols to rewrite it in the Ford

39 Pat McGilligan, *Backstory*, Berkeley and Los Angeles: University of California Press, 1986, p. 255.
40 Michael Sragow, *Victor Fleming*, New York: Pantheon Books, 2008, p. 183.
41 McBride, *Searching for John Ford*, p. 264.

style. They agreed to emphasize the visuals at the expense of dialogue and Nichols' script contained a third less dialogue than the average script. Goldwyn wanted contract star Joel McCrea to play the male lead, the Polynesian native Terangi, but McCrea rejected the role on the grounds that he did not look remotely Polynesian. So Goldwyn instituted a talent hunt which came up with small part actor Charles Locher, who had an excellent physique, was an expert swimmer and did not look like an actor. He also happened to be the nephew of James Norman Hall. Locher was signed and Goldwyn changed his name to Jon Hall. He loaned McCrea to Paramount and in return borrowed Dorothy Lamour, who had made a striking debut in *The Jungle Princess* in 1936. Goldwyn surrounded the newcomers with a first-rate cast: Thomas Mitchell, Mary Astor, Raymond Massey (replacing Basil Rathbone who found the role of the Governor too unsympathetic), C. Aubrey Smith, Jerome Cowan and Ford regular John Carradine. Goldwyn was the kind of producer Ford detested—a hands-on merchant who would regularly turn up on the set and interfere. Their relations began badly when Goldwyn, who had originally agreed to have the film shot on location, changed his mind, sent a second unit to Pago-Pago in American Samoa to shoot background footage and had two native villages built on Catalina Island and on the United Artists back-lot. Typically Goldwyn turned up one day to demand more close-ups of the two leads, claiming the film was not personalized enough. Shooting lasted from January to August 1937, with the actual hurricane taking five weeks to film. Historians have often credited the hurricane sequence to James Basevi, the special effects maestro borrowed from MGM, who had created the special effects in *San Francisco* and *The Good Earth*. The screen credit read "hurricane and special effects staged by James Basevi". But Ford explained to Peter Bogdanovich what happened:

> Jim Basevi conceived the hurricane itself and actually did all the mechanics. While he and I were shooting it, I gave Stu Heisler (credited as associate director) a second camera—you never knew what the hell would happen— and I said: "If the roof blows off or a sarong blows off or somebody falls down—get it". And as a matter of fact I think he had quite a few shots in the picture.[42]

[42] Bogdanovich, *John Ford*, p. 133.

Both Mary Astor and Raymond Massey confirmed that Ford directed the hurricane sequence.[43]

Both Astor and Massey expressed admiration for Ford. Astor described Ford painstakingly instructing a small boy in his lines, though the scene was later cut.[44] Massey recalled:

> I know that I never worked with another movie director who knew as much about acting as he did or cared so much about performance ... he could guide an actor through a difficult characterization with much skill ... the story was a bit shopworn, the characters were off the movie stockpile ...But Jack Ford put freshness and tension into the plot. He managed to infuse some originality into the stereotypes we had to play. Finally he succeeded in preserving us as human beings, and not just bodies, in the hurricane sequences. That was no mean achievement.[45]

Ford's feelings can only be imagined then when Goldwyn assembled the cast after seeing the rough cut of the finished film and said: "I am so excited by what you and John Ford have done that I am going to shoot all the interiors again with new dialogue". "I remember the look on Jack Ford's face" said Massey.[46] But Goldwyn had paid Ben Hecht to rewrite the dialogue in the interiors and Ford duly shot them with Massey's new scenes having to be in close-up as he was in a wheelchair, suffering from a blood clot in his leg.

The film cost nearly $2 million to produce but Goldwyn managed to break even on it as it became one of the year's top twenty moneymakers and United Artists' most successful release in years. While reviews were mixed, there was universal praise for the twenty-minute hurricane sequence which won an Oscar for sound recording (Thomas Moulton) and audiences flocked to see it.

The Hurricane has been unaccountably neglected by film scholars, many of whom have dismissed it as a potboiler. Some of them have perhaps dismissed it by association with the string of Dorothy Lamour "sarong" pictures which followed it (*Aloma of the South Seas, Typhoon, Beyond the Blue Horizon*), each of them worse than the one before. But it is one of Ford's masterworks, a gem

[43] Mary Astor, *A Life on Film*, New York: Delacorte Press, 1971; Raymond Massey, *A Hundred Different Lives*, London: Robson Books, 1979, p. 215.
[44] Astor, *A Life on Film*, pp. 134–5.
[45] Massey, *A Hundred Different Lives*, pp. 212–15.
[46] Massey, *A Hundred Different Lives*, p. 217.

of glowing Romanticism, pure, noble, beautiful, superbly directed, thrillingly scored (Alfred Newman) and culminating in the unforgettable hurricane, one of the great disaster spectacles of cinema. At the time some critics appreciated its qualities. The *Hollywood Reporter* (November 5, 1937) said:

> This is a great picture. On more than one count it goes far beyond anything ever filmed. The hurricane that fills its last 1500 feet with awe and terror is supreme spectacle. The film is also the most masterly and moving marriage of music and picture ever achieved, and is truly great as a pictorial work of art ... John Ford's direction of the work will be acclaimed as his most distinguished achievement. For breadth of canvas, for emotional and dramatic power, and for capture of beauty in mood and movement, it stands high in film annals.

The simple but powerful story amounts to an indictment of European Colonial rule. It opens with the marriage on the island of Manakura of two islanders, Terangi (Jon Hall) and Marama (Dorothy Lamour), who are parted after a few days when Terangi has to sail on the schooner *Katopua* to Tahiti. He is the first mate to Captain Nagle. In Tahiti he gets into a fight with a drunken bully and breaks his jaw. He is sentenced to six months in jail. But unable to bear captivity, he makes repeated attempts to escape and his sentence is continually extended until it stretches for 16 years. One man could save him, Eugene Delaage, Governor of Manakura. But despite appeals to him to intercede and get Terangi paroled back to Manakura to serve his sentence, Delaage insists that the law must be obeyed. Eventually Terangi succeeds in escaping but accidentally kills a guard. He steals a canoe and sails 600 miles back to Manakura. Delaage discovers that Terangi has returned and commandeers Nagle's schooner to search for him. After they sail, the hurricane hits and devastates the island. Terangi saves his wife and daughter Tita and the Governor's wife, Germaine, by roping them all to a giant tree, which is eventually carried away but takes them to a sandbar where they light a signal fire. Delaage in the battered schooner, looking for survivors, rescues Germaine, while Terangi and his family slip away in a canoe found floating nearby. Tempted to pursue, Delaage agrees to Germaine's desperate lie that it is merely a floating log, apologizing to her for his failure as a husband.

Although the film deals with French imperialism, the whole idiom and feel of the film is British. There are no French actors or French accents. Eugene

Delaage, for which South African-born British actor Basil Rathbone was originally sought, is played superbly by English-accented Canadian Raymond Massey, fresh from the London stage and from playing Sherlock Holmes in a British film and the villainous "Black Michael" in David O. Selznick's production of *The Prisoner of Zenda*. The French priest Father Paul is played by the quintessential English character actor C. Aubrey Smith, without the celebrated mustache but with his trusty pipe. An uncredited actor plays the Governor of Tahiti who sentences Terangi to jail as an exaggeratedly pukka English Blimp.

Conversely Ford sees the Polynesian natives as a South Seas version of the Irish, cheerful, uninhibited, clannish, hard-drinking, children of nature. The wedding feast for Terangi and Marama and the joyous spontaneous celebration of dancing, drinking and drum-beating which greets news of Terangi's escape parallel the Celtic celebrations following weddings in *How Green Was My Valley* and *The Quiet Man*. The natives live in a traditional society with a Catholic priest Father Paul and a hereditary chief Mehevi, but constrained by the straitjacket of French Colonial rule.

The film is narrated in flashback by Dr. Kersaint (Thomas Mitchell), an alcoholic French doctor very similar to Doc Boone as played by Mitchell in *Stagecoach* two years later. He is traveling on board ship and a female passenger asks him what is the low desolate sandbar they are passing. Kersaint tells her: "The most beautiful and enchanting bit of paradise in all the world. It made the mistake of being born in the heart of the hurricane belt". The image dissolves to a long panning shot of the island before its destruction, with its church, its residency, its wharf and its native huts, an unsullied Eden, an innocent land of love and laughter, palm-fringed, sun-kissed and later moon-bathed.

The symbol of colonial rule Governor Delaage establishes his position in his first appearance. He is delivering judgment on a native who has stolen a canoe. The native's excuse is that there was moonlight and his lady love wanted to go for a ride: a simple, childlike innocent explanation. Dr. Kersaint has to interpret for Delaage as he does not understand the language, symbolic of his total lack of sympathy with the culture. Sentencing the native to prison, Delaage tells Kersaint: "I'm as sensitive to the whims of love as the next man. But as Governor of these islands I cannot afford to sit around admiring the quaint and the curious. Thirty days, my good fellow". Knowing him to be a fundamentally decent man, Kersaint tells Delaage that if he tries to rule the

people of Manakura according to his own ideas, he will destroy himself. Delaage speaks of his honor and is told: "A sense of honor in the South Seas is about as useful and silly as a silk hat in a hurricane".

Successive attempts are made to persuade Delaage to intervene on Terangi's behalf. When he is asked why the sentence has stretched to 16 years, Delaage replies "For thinking himself greater than the law. For breaking jail. For defying authority". He tells the doctor: "I am doing my duty, doctor. I come from a family that has administered the affairs of my country for generations ... It is not a question of justice or injustice to a human being. It is a question of upholding the law under which these islands are governed. I am not asking for anyone's smiles for my reward".

Delaage loves his wife and sympathizes with Marama but is inflexible and is gradually becoming embittered and undermined by the hatred manifested by the islanders toward him: "I represent a civilization that cannot afford to show confusion and conflict to the people it governs".

But an extension of Delaage's legalistic imperialism is the racism manifested by the white bully who provokes Terangi to fight ("Make way for a white man") and who has relatives in the Colonial ministry demanding retribution, and the sadism of the Warden (John Carradine), determined at all costs to break Terangi's spirit. He watches with a satisfied smile as Terangi's bronzed flesh is lacerated by the whip or as he is broken on the wheel.

There are powerful anticolonial voices arguing against Delaage's position and seeking to persuade him to intervene. First and foremost there is his wife Germaine (Mary Astor) who has a woman's compassion for the suffering of the pregnant Marama whom she embraces to comfort her. There is Father Paul who picks up an exhausted Terangi at sea and lands him ashore, keeping his arrival a secret, even though Terangi has killed a man. He muses that Terangi has sinned but others have sinned against him. He refuses to judge Terangi: "This is between me and someone else" (i.e. God) he tells Terangi as he brings him ashore. When Delaage demands to know on behalf of the government the whereabouts of Terangi Father Paul tells him "There are stronger things than governments in this world". In other words, there is a higher morality. Dr. Kersaint, a philosophical drunken doctor and remittance man, argues for the natives to be allowed to preserve their lifestyle, ways and customs. He gets drunk with them but also heroically delivers a baby in a surf-boat at the height

of the hurricane. Captain Nagle who witnessed the fight appeals on Terangi's behalf, denouncing the unfairness of the situation. Chief Mehevi appeals for Terangi, telling Delaage: "The people in my island were once happy. They are now very unhappy. This is not good law or good justice".

Terangi himself simple, honest, chivalrous, becomes a symbol of resistance to imperialism. His successive attempts to escape and finally his successful bid

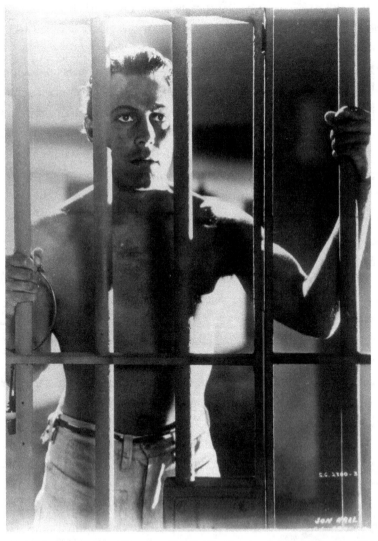

Figure 3.3 Victim of Imperialism Jon Hall in *The Hurricane* (United Artists, 1937)

make him a legend. "Terangi is their soul and symbol: the last of the world's afflicted race of humans to believe in freedom", says Kersaint. Delaage scoffs: "Murder and anarchy will leave no legend behind". But Kersaint points to the gleeful native celebrations of the escape: "That's the answer to your law". Terangi's 600 mile journey from Tahiti to Manakura in a flimsy canoe, in which he survives a storm, kills and eats raw a shark and drinks rainwater make him an epic hero. He rescues the Governor's wife and effectively reunites them, demonstrating a superior humanity to Delaage's earthbound law. In the end untamed Nature intervenes to vanquish colonial culture, and Terangi and his family escape to a new life. The hurricane also represents catharsis for Delaage, who freely allows compassion to prevail over the letter of the law.

Ford responds to the story and location in a series of memorable images which blend Archie Stout's South Seas location photography and Bert Glennon's luscious black and white studio photography. There is a striking Expressionist montage of Terangi's successive escapes with hails of bullets, scaling of walls, whippings and superimposed images of himself, Marama and the Warden. There is a strained dinner party with everyone in formal evening dress, drinking port by candlelight and the storm bursting, throwing open the windows, dousing the lights and leaving the alarmed diners standing in semi-darkness as the wind howls round them. There is the final watery apocalypse, with trees uprooted, houses blown away, the French flag over the residency shredded, survivors huddling in the church which gradually crumbles under the battering from the waves while Father Paul serenely plays the organ until the roof finally collapses.

Ford tracks only on movement and basically composes within the frame using close-ups to emphasize key points in the dialogue. He poses bronzed faces and bodies against sea and sky. He imbues key sequences with symbolism by the use of lighting and the elements.

The celebration of a traditional society which has made its peace with Catholicism is demonstrated by the double wedding. Terangi and Marama are married in church in European clothes but after they leave the church, they are surrounded by laughing natives who strip off their European clothes to reveal their native garb for the wedding feast. Ford responds directly to the idea of expulsion from paradise and the longing for home of the exile, capturing the anguish in Terangi's eyes as he watches the schooner sailing for Manakura past

the headland where he toils as a convict. It eventually leads him to throw himself over the barbed wire and dive from the cliffs into the sea in a vain attempt to catch the schooner.

Ford's final film with John Wayne was *Donovan's Reef* (1963). It was partly a holiday film full of color and fun, partly one of several latter-day reunions with old friends and partly an evocation of an idealized society far from the United States with whose development Ford was increasingly unhappy. "Our ancestors would be bloody ashamed if they saw us now" he told one interviewer in the 1970s.[47]

Ford and Wayne agreed on the project while they were filming *The Man Who Shot Liberty Valance*. *Donovan's Reef* was based on a story by James A. Michener developed for the screen by Edmund Beloin. It was an unproduced property in the files of Paramount Pictures. A script was produced by James Edward Grant, Wayne's house dramatist. He had scripted seven previous Wayne films and was familiar with the formula for success. Grant's view was expressed to Frank Capra:

> All you gotta have in a John Wayne picture is a hoity-toity dame with big tits that Duke can throw over his knee and spank, and a collection of jerks he can smash in the face every five minutes. In between, you fill in with gags, flags and chases. That's all you need.[48]

But Ford disliked the script though elements of the Grant formula remain, and he brought in Frank Nugent to try and give it something of the quality of *The Quiet Man*. The script was not complete when shooting began and so some scenes were invented and improvised on set.[49] They bear the distinct hallmarks of Ford's previous work in both individual lines and situations. Location shooting was to take place in Hawaii on the island of Kauai and the interiors and township scenes at Paramount Studios, where the standing Western town set was decorated with a few palm trees to make it more exotic. Paramount, who were originally to finance and distribute the film as part of their ten picture deal with Wayne, pulled out of financing the film just after Ford arrived in Hawaii. So he decided to finance it himself from John Ford Productions

[47] Peary, *John Ford Interviews*, p. 140.
[48] Randy Roberts and James S. Olson, *John Wayne: American*, New York: The Free Press, 1995, p. 499.
[49] Gallagher, *John Ford*, p. 384.

with Paramount still distributing. Paramount may have been influenced by the adverse critical reaction to *Liberty Valance*, dismissed by many critics as old-fashioned and creaky.

Ford shot the film between July 23 and September 25, 1962 at a cost of $3.62 million though he finished under budget. He turned it into a family affair by inviting stars John Wayne and Lee Marvin to bring their families. John's son Patrick Wayne took the small role of an Australian naval officer and Ford cast Anna Lee's son Tim Stafford who was his godson, as Lukey Dedham. Veterans Mae Marsh and Frank Baker had tiny roles as a Boston aunt and the captain of the *Araner* respectively. Old friends from long past films were recalled: Cesar Romero (*Wee Willie Winkie*), Dorothy Lamour (*The Hurricane*) and Dick Foran (*Fort Apache*). Ford's own yacht *Araner*, kept moored in Honolulu, was used in the film playing one of the two yachts owned and run by Michael Donovan, the *Araner* and the *Innisfree* (recalling *The Quiet Man*).

In search of his paradise Ford returns to the scene of his pre-war South Seas drama *The Hurricane* but with elements from it broadened and farcicalized. In the same way Wyatt Earp and Doc Holliday, from *My Darling Clementine*, return in the broad and farcicalized Dodge City intermezzo in *Cheyenne Autumn*. On the island of Haleakaloa, the French Governor, Marquis Andre De Lage (Cesar Romero) recalls *The Hurricane's* Governor Eugene Delaage but only in name. Where Delaage was a tormented martinet, De Lage is a suave, crafty likable rogue who has set his sights on marrying Amelia Dedham's fortune of $18 million. Instead of the tall, upright and humane Catholic priest Father Paul, *Donovan's Reef* features a diminutive, comically lachrymose Father Cleuzot (Marcel Dalio) forever bewailing the leaking roof of his church. The equivalent of Dr. Kersaint is the non-alcoholic Doc Dedham (Jack Warden) who ministers to the natives and has married one of them. Dorothy Lamour's Marama has evolved into the sassy but slightly shopworn saloon singer Fleur.

The island of Haleakaloa is an idealized multi-racial society which in addition to the native Polynesians has a population including French, Chinese, American, Japanese and Polish characters. Like Manakura, its authority figures are the French Governor, the French priest and the hereditary native ruler, Princess Lelani. There is almost a family feeling with the 3 children calling Donovan, Gilhooley, and De Lage respectively "Uncle Guns", "Uncle Boats" and "Uncle Andy".

The background to the action is World War Two, during which stranded US sailors, Michael "Guns" Donovan (John Wayne), Tommy "Boats" Gilhooley (Lee Marvin) and William "Doc" Dedham joined with Princess Manulani to fight a guerrilla campaign against the occupying Japanese forces. After the war Dedham remained, built a hospital, staffed it with nuns, married Princess Manulani and fathered three children, Lelani, Sally and Lukey before she died. Donovan after knocking around the world, settled on the island, bought a saloon (Donovan's Reef) and ran several yachts as a charter business. Gilhooley remained in the Navy but returned every December 7, a birthday shared with Donovan but significantly too the date of the Japanese attack on Pearl Harbor. Like so many Ford heroes, they demonstrate their affection for each other by boozing and brawling. Behind it all lies the shared memory of wartime comradeship. Dedham's house too is dominated by memory, in the full length portrait of Princess Manulani before which the Japanese servants Yoshi and Koshi reverently place flowers. It parallels similar scenes in *The Blue Eagle*, *Four Men and a Prayer*, and *The Last Hurrah*.

The central theme of the film is the "taming of the shrew" plot so memorably explored in *The Quiet Man*. This time it is a prim and starchy Bostonian Amelia Dedham (Elizabeth Allen) who is to be tamed and brought down to earth by macho saloonkeeper Donovan. Amelia is the daughter of Doc Dedham, heir to the Dedham Shipping Line millions, who never returned to Boston after the war. He can be deprived of his inheritance if he can be proved to have behaved immorally. So Amelia sets out to find him. The Doc is away on medical business and Donovan, realizing that Amelia knows nothing about his second marriage and second family, pretends the three children are his. The initial antagonism between Amelia and Donovan eventually melts as during the course of the film she is dunked in the bay, blown over by a hurricane, toppled off water skis, bounced off the back of a truck and finally spanked by Donovan to complete her humanization. When Amelia and her father meet for the first time, she is almost immediately assisting him in an operation. The emergency operation, usually in primitive conditions, is a feature of numerous Ford films. It represents the triumph of skill and human initiative without the aid of modern medical aids, the dedication of the doctor and the heights to be reached by humanity. See for instance *My Darling Clementine*, *She Wore a Yellow Ribbon*, *The Hurricane*, *The Horse Soldiers*, *Cheyenne Autumn* etc. Amelia takes to the three

children whom she supposes to be Donovan's but gradually works out that they are Doc's. She joyfully embraces them as her sisters and brother and berates Donovan for the deception. Family feeling and human warmth have won out over convention and potential prejudice. Amelia will marry Donovan and Fleur will marry Gilhooley in an appropriately marital finale. As Lindsay Anderson perceptively writes of *Donovan's Reef*:

> It is an elaborate, far-fetched plot, though perhaps hardly more fantastical than *The Tempest* or *The Winter's Tale*, whose themes of conflict and eventual harmony, all in a remote, idyllic setting, it to some extent echoes. There is indeed a kind of Shakespearian expansiveness about *Donovan's Reef*, a fairy tale humour and eccentricity that is refreshing in a cinema from which the easy-going and the poetic seem to have been mostly squeezed out.[50]

The religion of Haleakaloa is essentially syncretic. As Lelani explains to Amelia: "I believe in the one God as we all do—but I respect the customs and traditions of my people". One of the funniest and most charming sequences in the film is the nativity service at Christmas, when the whole community is gathered in the leaky wooden church where Andre De Lage narrates the Christmas story, saloon entertainer Fleur sings *Silent Night*, and the children process in white dresses with wings and golden crowns, Lukey still wearing his baseball cap. Father Cleuzot is reduced to tears by the spectacle. Then the three wise men arrive bearing gifts: the King of Polynesia, played by the police sergeant Menkowicz (Mike Mazurki), the Emperor of China, played by the Governor's Amherst-educated, bespectacled and customarily pith-helmeted secretary Mr. Eu (Jon Fong) and the King of the United States of America, Gilhooley. The congregation includes a detachment of the Royal Australian Navy on a goodwill visit. Halfway through the service, a storm breaks out and torrents of rain pour through the broken ceiling to drench the faithful. As Anderson again correctly observed:

> Only Ford could have conceived, in Hollywood of the 1960s, the sequence in which the children of Haleakaloa perform a naively charming Christmas play … and only Ford would have known how to punctuate the sentimentalism with a storm, a leaking roof and a sudden sprouting of umbrellas among the rapt audience.[51]

[50] Anderson, *About John Ford*, p. 166.
[51] Anderson, *About John Ford*, p. 166.

The church service is followed next day by a sequence directly inspired by a similar scene in *Four Men and a Prayer*. Three Australians, including an Irish-born NCO (Dick Foran) arrive at the saloon. Foran gives a rendition of *Waltzing Matilda*. They are ordered out by Gilhooley who calls them "limeys". "Limeys is it" declares Foran, taking offense like Barry Fitzgerald in *Four Men*, and a marathon punch-up breaks out, with Donovan and other Australians joining in. The saloon is demolished until an Australian officer (Patrick Wayne) turns up and marches his men off.

The film ends with the enthronement of Lelani, her hand kissed by the Governor as the traditional ruler, and reunion with Amelia. Amelia distributes Christmas presents and the marital futures of her and Guns, Fleur and Boats are decided. Elizabeth Allen gives an attractive and spirited performance and is an admirable addition to the parade of Ford regulars.

It is *par excellence* a holiday film, glowingly shot in Technicolor (William H. Clothier), in beautiful surroundings with lush greenery, bright tropical flowers, a sapphire blue, sun-dappled sea, sunsets and cloudscapes. But it is also staged very formally in classic Ford fashion. Groupings are hierarchic, fights ritualized, individual shots framed by palm trees, carved idols, bed posts, wharf poles, and there are recurrent processions. *Donovan's Reef* was released in June 1963. Many critics thought it unworthy of Ford. *Variety* called it "a potboiler" (June 13, 1963). But the public lapped it up. It grossed $5,753,600 in the first five years of its release.[52] It was the last purely joyous film that Ford directed. Tragedy would be the keynote of his next two films, *Cheyenne Autumn* and *7 Women*, the last he would direct. They would reflect his darkening and disillusioned mood.

[52] McBride, *Searching for John Ford*, p. 639.

4

John Ford's Faith

Andrew Sarris writes of "Ford's casual Catholicism".[1] But it is far from being casual. It is central to his philosophy and his world view. He came from a devout Catholic family; his nephew John Feeney became a priest. As a practicing Catholic who went to mass regularly, and died clutching his rosary beads, he saw religion as the cement of society and Catholicism as the best of all available faiths. Asked in 1964 to name his ten favorite films he included two notable Catholic dramas, Henry King's *The Song of Bernadette* (1943) and Leo McCarey's *Going My Way* (1944).[2] Asked to name his favorite among his own films he would regularly mention *The Fugitive*, a notorious box office failure but a film which retold the story of Christ's Passion. In recognition of his contribution to Catholic culture, he was made a Knight of Malta by Pope Paul VI. The importance to Ford of his faith is underlined by the fact that his Protestant wife Mary McBryde Smith converted to Catholicism upon marriage. Also while they married in a civil ceremony because Mary was divorced, when her ex-husband died in 1941 they remarried in a Catholic church ceremony. It is from his Catholic faith that two of the recurrent images of women in his films derive: the Madonna and the Magdalene—the mother to be revered, the prostitute to be redeemed.

For Ford, religion is all pervasive and ever present, a system of values to sustain and nourish, a ready-made source of leadership, advice and consolation. "Respect for chapel was the first thing my father taught us" says Huw Morgan in *How Green Was My Valley*, pausing in his headlong run to the sweet shop to walk reverently past the chapel. In several of Ford's key films the role of the priest is crucial, defending and preserving the moral values that transcend

[1] Andrew Sarris, *The American Cinema: Directors and Directions 1929–1968,* New York: E. P. Dutton and Co., 1968, p. 48.
[2] Joseph McBride, *Searching for John Ford,* London: Faber and Faber, 2003, p. 184.

earthly concerns. This is nowhere more true than in *The Fugitive* where the Priest symbolizes the church eternal and whose death is followed by a resurrection as a new priest arrives to take his place. The priest/minister as the embodiment of the higher truth can also be seen in the characters of Father Lonergan (*The Quiet Man*), Father Paul (*The Hurricane*) and Mr. Gruffydd (*How Green Was My Valley*).

Beyond actual priests, there are community leaders who are also spiritual leaders. This role is perfectly summed up by the character of Judge Priest in *Judge Priest* (1934) and *The Sun Shines Bright* (1953). Favorite films of Ford, they embody his perfect community leader. The very name, Judge Priest is rich in symbolism. He is not sheriff or senator but judge, with its Old Testament connotation of the all-knowing, all-powerful father figure. His surname is even more significant, suggesting a charismatic leader chosen by higher powers, imbued with special gifts for whom leadership is a sort of sacrament. To make the point even more forcibly the Judge is a celibate figure, his wife and children long dead, and he has a nephew called Rome Priest. At the end of *The Sun Shines Bright*, the Judge literally does become a priest, conducting a funeral and preaching a sermon on forgiveness. There are strong echoes of this character in Elder Wiggs, the Mormon wagon train leader in *Wagon Master* (1950) and Captain the Reverend Samuel Johnson Clayton the Texas Ranger commander in *The Searchers* (1956). He carries a Bible in one hand and a rifle in the other and at one point lays aside his military duties to perform a wedding. Both roles are played by Ward Bond. Clayton is prefigured by Father Joe in *The Blue Eagle* (1926), naval chaplain and slum priest, leading the fight against drug pushers.

Beyond the actual religious leaders, there are the heaven-born leaders, the redeemers who take on their shoulders society's sins in a direct parallel with Christ. It is significant that it was Henry Fonda who played the Christ figure in *The Fugitive*. For it was also Fonda who played recognizable Christ figures in *Young Mr. Lincoln*, *The Grapes of Wrath* and *My Darling Clementine*. There was a grave serenity, inner strength and iconic composure about Fonda that made him perfect for these parts. It is no coincidence that one who knew him described Lincoln as "the greatest character since Christ".[3] For Lincoln was cast by popular legend in the mold of Christ, the Redeemer, the man who took on

[3] Jeffrey Richards, *Visions of Yesterday*, London: Routledge, 1973, p. 234.

his shoulders the suffering and the sins of America and won a martyr's crown for his pains. In *Young Mr. Lincoln* he quotes "The Sermon on the Mount" to quell a lynch mob. The Christian imagery is less obvious in *Clementine* but Doc Holliday senses the redeemer in Earp when he declares on meeting him "You haven't taken it into your head to deliver us from all evil?", to which Earp replies "I hadn't thought of it like that. But it's not a bad idea". Tom Joad in *Grapes* is introduced walking down a dusty road which forms a giant crucifix bisecting the screen.

The symbols of the Faith are everywhere in Ford's films. They evidently meant much to him and interestingly he told Peter Bogdanovich that the only thing he could remember about *Hangman's House* was a shot of a carved Celtic cross with people streaming past it.[4] In *The Shamrock Handicap* there is a touching scene in which a tenant family's daughter kneels before a similar carved cross to give thanks for the remission of rent. In *The Quiet Man* Ford deliberately slows down the film to allow for a long reverential look at a stained glass window, heedless of the fact that it reduces John Wayne's walk to an ungainly waddle. The first physical contact between Sean Thornton and Mary Kate Danaher occurs when their fingers meet as they dip them in the holy water at the church font. Their first passionate embrace takes place in a ruined churchyard amid the Celtic crosses. A stolen crucifix, the symbol of truth, purity and justice, leads heroes to the truth behind the murder of an innocent child in *My Darling Clementine* and *Sergeant Rutledge*. The quasi-devotional offering of flowers beneath the portrait of a dead wife or mother (*The Last Hurrah, Donovan's Reef*) recalls veneration of the Virgin Mary. The conversation with a dead loved one, their presence indicated by a gravestone, is a feature of *Young Mr. Lincoln, Judge Priest, She Wore a Yellow Ribbon,* Ford's episode in *How the West Was Won* and *My Darling Clementine,* confirming a belief in life after death. This is echoed too in the recall of leading characters at the end of family sagas (*How Green Was My Valley, The Long Gray Line*) to show they are alive in memory and in the great beyond. This too is the idea behind the ghostly superimposition on the screen at the end of films of characters who have been killed (*3 Bad Men, Fort Apache, 3 Godfathers*).

[4] Peter Bogdanovich, *John Ford*, Berkeley and Los Angeles: University of California Press, 1978, p. 126.

The strength of religion is demonstrated by the importance in Ford's films of the actual church buildings. Like the Faith, the church building tends to be physically at the center of the community—for instance on top of a hill in the middle of the village (*The Fugitive, How Green Was My Valley*). Equally, it is at the center of village life. In *Drums Along the Mohawk*, the community of German Flats gather in the church to hear not only a sermon from the pastor but also the latest war news, the latest gossip (in the form of injunctions to individuals to mend their ways), and news of the latest consignment of goods to arrive at the store. The dedication of the new church in Tombstone in *My Darling Clementine* draws all sections of the community together and provides one of the best syntheses of values in all Ford's work. The church bells ring (the Faith), the stars and stripes flutter beside the church building (patriotism) and the parishioners have a hoedown dance on the newly laid church floor (communal life). Thus the political, religious and social ideas of Ford wordlessly fuse. The close links between love of God and love of country are again stressed in *The Long Gray Line*. The West Point community are gathered at services in the church when news of the declaration of war arrives and they rise and sing the national anthem. The venue lends sanction to the sentiment of the patriotic hymn and a promise of justification and consolation in the coming struggle.

Ford accords great respect to simple religious faith when it is doing good (the Quakers in *Cheyenne Autumn*, the Mormons in *Wagon Master*). But when it comes to a choice of faiths, it is Catholicism every time. He often sees something mean-spirited in Protestantism. He memorably satirizes the fundamentalist preacher The New Moses in *Steamboat Round the Bend*. He also highlights meanness in the Protestant church services in *Just Pals* and *When Willie Comes Marching Home*. He emphasizes the viciousness of Deacon Parry's denunciation of an unmarried mother in *How Green Was My Valley*.

Several of his films can be described as religious allegories dealing with the themes of repentance and forgiveness. *The Informer* has an opening statement that makes the religious dimension clear: "Then Judas repented himself and cast down the thirty pieces of silver and departed". The characters take on New Testament roles with Frankie as Christ, his mother as the Virgin Mary, Gypo as Judas and Katie as Mary Magdalene. Gypo dies gazing up at a crucifix in a church, ecstatically declaring that Frankie's mother has forgiven him. And *3 Godfathers* is a story to which Ford was sufficiently devoted to make two

versions of it, *Marked Men* (1919) and *3 Godfathers* (1948). It reworks the story of the nativity and the three wise men as a story of repentance and forgiveness in the Old West.

Even in films which are not specifically religious the themes of forgiveness, redemption and compassion occur and recur. Religious fanatics receive scant sympathy in Ford, figures like Sanders in *The Lost Patrol*, Pollock in *Men Without Women*, John Knox in *Mary of Scotland*, Roger Sugrue in *The Last Hurrah*, Agatha Andrews in *7 Women*. By contrast Ford shows a marked compassion toward prostitutes (*The Sun Shines Bright*, *Stagecoach*, *The Long Voyage Home*, *The Informer*, *The Fugitive*).

Sin or failure can be redeemed by a heroic death in the service of fellow men. This is most often reserved for an army officer who has failed in his trust and who redeems himself by dying nobly. This is notably true of Colonel Thursday in *Fort Apache*. In the original story he commits suicide; in Ford's version he rejoins his outnumbered men and dies with them. But he is only the latest of a series of disgraced officers who similarly redeem themselves and their honor: Burke in *Men Without Women*, Cabot in *Seas Beneath*, George Brown in *The Lost Patrol*, Hatfield in *Stagecoach*, Smitty in *The Long Voyage Home*.

There is no clearer evidence of Ford's deep Catholic faith than his film *The Fugitive*. He chose it as the first production of Argosy Pictures, the independent company he set up with Merian C. Cooper after the war. Ostensibly an adaptation of Graham Greene's 1940 novel *The Power and the Glory* (published in America as *The Labyrinthine Ways*), it actually takes characters and incidents from the book and weaves them into an allegory of the Passion, as is made clear in the prologue, spoken by Ward Bond: "The following photoplay is timeless. It is a true story, an old story, first told in the Bible. It is timeless and topical and it is still being played in many parts of the world". As in *The Informer*, leading characters have Biblical counterparts, with the Priest as Christ, the informer as Judas, the prostitute as Mary Magdalene and the Gringo as the Good Thief who dies next to Christ on the cross. The censorship code made it impossible to film Greene's novel as it stood. The leading figure, the corrupt and drunken "whiskey priest" with an illegitimate child was entirely prohibitive. It was Dudley Nichols who suggested making the film an allegory of the Passion. Ford enthusiastically agreed and they worked closely together on the screenplay. Ford informed Darryl Zanuck: "It is really not a sound commercial gamble but my heart and

my faith impel me to do it".[5] Ford and Cooper purchased the film rights from Alexander Korda for $50,000 and signed with RKO Radio Pictures to produce it as part of a four-film deal. Ford's first choice for the Priest was Henry Fonda, who had played the secular Christ figures in *Young Mr. Lincoln* and *The Grapes of Wrath*. But Fonda thought he was entirely wrong for the role and advised Ford to consider the Puerto Rican actor José Ferrer for the part. A stage commitment prevented Ferrer from doing it and Ford persuaded Fonda to take it on, borrowing him from 20th Century-Fox to whom he was under contract. The film was shot entirely on location in Mexico and at the Churubusco Studios in Mexico City, though the prologue carefully explains that the film is not meant to depict Mexico and thanks the Mexican authorities for their cooperation. Ford enormously admired two notable Mexican films, *Maria Candelaria* (1943) and *The Pearl* (1945), directed by Emilio Fernandez, photographed by Gabriel Figueroa and starring Pedro Armendariz and Dolores del Rio, for their distinctive visual qualities. So he cast Armendariz and del Rio in the other two starring roles, engaged Fernandez as associate producer and Figueroa as cameraman in order to provide a similar visual approach. The film was shot between November 4, 1946 and January 27, 1947. It was released on November 3, 1947. Some critics hailed *The Fugitive* as a work of art. Bosley Crowther in the *New York Times* (December 26, 1947), calling it "strange and haunting" pronounced it "one of the best films of the year ... a symphony of light and shade, of deafening din and silence, of sweeping movement and repose ... a thrilling modern parable of the indestructibility of faith". It duly figured in the *New York Times* ten best films of the year list. On the other hand, James Agee in *The Nation* (January 10, 1948) called it "a bad work of art, tacky, unreal and pretentious" and *Variety* (November 5, 1947) thought it "rich in atmosphere and ... sincerely done, but ... slow in spots and uneven in dramatic power. It lacks romantic appeal." Sadly Ford's prediction about its lack of commercial viability proved all too true. Budgeted at $1.13 million, it made only $818,000, leaving an enormous hole in Argosy's finances.[6] Ford's own view of the film as expressed to Peter Bogdanovich was:

[5] Tag Gallagher, *John Ford: The Man and his Films*, Berkeley and Los Angeles: University of California Press, 1986, p. 234.
[6] Scott Eyman, *Print the Legend: The Life and Times of John Ford*, New York: Simon and Schuster, 1999, pp. 322, 326.

It came out the way I wanted it to—that's why it's one of my favorite pictures—to me, it was perfect. It wasn't popular. The critics got at it, and evidently it had no appeal to the public, but I was very proud of my work . . . It had a lot of damn good photography—with those black and white shadows. We had a good cameraman, Gabriel Figueroa, and we'd *wait* for the light.[7]

Ford was awarded the Venice Film Festival's International Prize for his direction of the film. But it has generally been dismissed by Greene experts as a travesty of the novel. It has caused problems also for Ford scholars. Scott Eyman pronounced it "boring".[8] Joseph McBride calls it "a lifeless series of holy-card tableaux".[9] Lindsay Anderson wrote:

Taking full advantage of his hard-won freedom from Front-Office control, Ford shot it with absolute self-indulgence, departing considerably from the script where the fancy took him. He turned out a long, ponderous film, whose slowness of pace was unsupported by any true dynamism of conception. Superbly photographed in a style of unrestrained opulence, it's atmosphere was suffocatingly "arty" and the actors were either poor or (in Fonda's case) plainly uncomfortable in their roles.[10]

The comment on Fonda is entirely misplaced. Ford wanted him to appear uncomfortable as throughout the film he is questioning his worthiness as a priest. Fonda does not mention the film in his autobiography and it led to Ford's estrangement from Nichols, perhaps because of the cavalier way Ford treated his script. Ford and Nichols never worked together again. But interestingly John Baxter wrote of *The Fugitive* that it is "one of his most personal and significant works, its examination of religious conscience making it fit to be compared with the greatest European films on this theme".[11] Tag Gallagher invokes the realism of Rossellini and Bunuel as a point of comparison.[12] For me it is a masterpiece, deeply felt, ravishingly shot, brilliantly acted and emotionally overwhelming.

It is clear that Ford consciously set out to make an art film. The characters are symbolic, listed in the credits as "A Fugitive", "An Indian", "A Lieutenant of

[7] Bogdanovich, *John Ford*, p. 85.
[8] Eyman, *Print the Legend*, p. 326.
[9] McBride, *Searching for John Ford*, p. 440.
[10] Lindsay Anderson, *About John Ford*, London: Plexus, 1981, p. 76.
[11] John Baxter, *The Cinema of John Ford*, London: Zwemmer, 1971, p. 67.
[12] Gallagher, *John Ford*, p. 235.

Police", "A Refugee Doctor" etc. For Ford there are evident echoes of *The Informer* and of his vision of Ireland: there is a fugitive tormented by his conscience; there is an oppressed but devout peasantry; there is an informer; and there is violence from the armed police reminiscent of "The Black and Tans" whose excesses Ford abominated. Characteristically Ford's sympathies are with outsiders: the fugitive priest, the prostitute, the bank robber. His style of shooting did not change. His camera tracked on movement. He framed his shots in doorways, arches and windows. He bisected the screen with colonnades, stone walls and aqueducts. But his central focus was on the photography. Every shot was lit and framed like a painting, figures carefully composed, shadows conveying mood and meaning.

The film is set in an unnamed South American country where a presumably Communist revolution has taken place. The new regime has banned alcohol and outlawed the Catholic Church. The priests have fled or been shot. The Lieutenant of Police (Pedro Armendariz) is informed that one priest remains. He is ordered to hunt him down. The Priest (Henry Fonda) flees across the country, helped by a prostitute Maria Dolores (Dolores del Rio) and an American bank robber El Gringo (Ward Bond) but dogged by an informer (J. Carrol Naish), seeking to obtain the reward for his capture. Eventually he escapes to the neighboring country where he explains to a refugee doctor (John Qualen) that he is tormented by his inadequacy, his feelings initially of pride and later of fear making him unworthy of his calling. He returns across the border at the behest of the dying robber to administer the last rites and is captured by the waiting Lieutenant, alerted by the informer. He is tried and sentenced to death. He goes willingly to his execution, having refused to recant his faith. His example of Christian fortitude causes the watching Lieutenant, ostensibly an atheist, to cross himself. The film ends with the arrival of a new priest at the fugitive's church, justifying the Priest's statement to the Lieutenant: "You want to kill God. You can't do it".

The Priest functions on the two symbolic levels. As Christ, he suffers, dies and is resurrected. As the embodiment of the Church Eternal he is harassed and persecuted but survives. The opening image of the film, the Priest on the donkey riding down a dusty road, immediately evokes Christ. When he rides up the hill to the abandoned church, his body forms the sign of the cross as he pushes open the doors. He sets up fallen crosses and candles on the altar. The

cry of a child alerts him to the presence of the Indian Woman, Maria Dolores, evidently a prostitute. She explains that she is unmarried and her child unbaptized. He agrees to baptize the child and she kisses his hand. It is the performance of his duties that leads him every time into danger. He is pursued after performing the baptism. He is prevented from leaving the country when a boy summons him to the bedside of his dying mother. He is arrested after trying to buy wine for the mass. He is captured when returning to administer the last rites to the dying American.

The signs and symbols and rituals of the church are everywhere in the film. People cross themselves and wear crosses and religious medals. Three crosses mark the border of the country. A wooden cross is handed to the Priest in his cell by Maria Dolores. Typical of Ford's approach is the superb baptismal ceremony which combines hierarchic groupings, ritual elements, iconic emblems and consciously artistic lighting. It begins with the Priest tolling the church bell to summon the faithful. The people process, carrying candles. The font is filled with water that gleams in the candlelight. A hymn of praise is sung and the camera picks out the upturned faces of a young girl, an old man and a cripple, linked by their common faith. The Priest baptizes Maria Dolores' child and then the others presented to him. The sequence affirms the strength of the Faith as the basis of the community.

A contrast to the ritual solemnity of the baptism is the sequence which follows. The Priest leads the donkey with children on its back ("Suffer the little children to come unto me") as the peasants march, singing joyfully, to the market. In a dynamically staged and edited scene, the mounted police charge into the crowd, trampling the produce for sale, smashing bottles, overturning tables, knocking over people. The villagers are rounded up and questioned by the Lieutenant about the whereabouts of the Priest. When no one will speak, the headman is arrested and dragged off at rope's end. The Priest's plea to be taken instead is ignored as he is not recognized.

The Priest determines to leave the country but encounters the reptilian police spy, cringing, wheedling, sniveling. He recognizes the Priest from a wanted poster and sticks to him. They rest in a hut for the night and the Priest wakes to find the informer rifling his valise and swigging the communion wine. The Priest flees, pursued by the voice of the informer, "Hear my confession, father".

Prevented from leaving Puerto Grande by boat because of the summons to the deathbed of a dying woman, he is asked to perform mass and, guided by the woman's son, seeks wine for the ceremony. In a memorably Expressionist sequence, he is led through shadowed streets, thronged with drunks and prostitutes, to a seedy hotel where the Governor's cousin deals in black market liquor. He and his associates produce wine and brandy, sell it, but then proceed to drink it, insisting he join them. Eventually he gets away, flees but runs straight into the police and is imprisoned for drunkenness and possession of liquor. Next morning, cleaning the yard, he sees the headman being led to his death.

Released by the police, the Priest flees. At a cantina he is hidden by Maria Dolores, who dances on the bar to distract the searching police. The scene is broken up by the disgusted Lieutenant who denounces Maria Dolores. The Priest flees again, pursued by the police. This time, El Gringo holds off the pursuers and there is another dramatically staged action scene, a gun battle in a cornfield as the police ride up and down looking for the concealed robber and he exchanges gunfire with them.

After the final confrontation between the Priest and the Lieutenant, he is led away to be shot. The informer throws himself at the Priest's feet, spilling the money he has been paid for betraying him. He begs for a blessing. The Priest says: "Go and pray and give the money to the poor". He is marched up a flight of steps—symbolic of the ascent to heaven—and we only hear the sound of the firing squad. But in the finale as shawled women gather in the Priest's church to pray, there is a knock at the door. It opens. There is the dark silhouette of a man, resembling Fonda—it is in fact Mel Ferrer, acting as directorial assistant on the film. He says, "I'm Father Serra. I'm your new priest". The door closes and light streams through a cross carved into it. Voices rise in a hymn of triumph. The Savior has risen. The Church is eternal.

A strong contrast is set up between the Priest and his persecutor, the Lieutenant. The Revolution which banned the Church is, apart from the Lieutenant, personified only by corrupt functionaries and timeservers (the Chief of Police, the Sergeant, the Governor's cousin). Dedicated, austere and fanatical, the Lieutenant seeks to promote the Revolution by force. He tells his prisoners: "I am an Indian like you. I want to give you everything" and tells the villagers that the Revolution is a force for good and the Church has misled them. But he is most often characterized by close-ups of his polished boots and

riding crop. He has the narrowness of mind, inflexibility of outlook and lack of compassion which Ford has always abhorred. He tries to impose the Revolution by force. He is harsh and unforgiving to the prostitute, something Ford and his heroes never are. He is also hypocritical in his denunciation as he is the father of her child and abandoned her to fight for the Revolution, causing her to be expelled from the village and reduced to working in the cantina. He imprisons people for drunkenness, something Ford famously does not regard as a sin. But a residual fear of God survives. When he arrives at the Priest's church, he stares up at the cross and laughs defiantly. Suddenly a child's cry is heard and he turns startled and disconcerted. It turns out to be the cry of his own child, carried by Maria Dolores, a reminder of his own past sin. He is eventually defeated by the Priest's faith. *The Fugitive* is essentially the story of a Catholic martyr. It was Ford's second such portrait. For many of the elements in *The Fugitive* can be found in his earlier film *Mary of Scotland*.

Mary of Scotland is a film unique in Ford's oeuvre. It is the only film he ever made that could be described as a full-blown historical epic in the accepted

Figure 4.1 Henry Fonda in *The Fugitive* (RKO, 1947)

sense of the word. It was a prestige project and was RKO Radio Pictures' contribution to the 1930s cycle of historical dramas, which included such notable films as *The Crusades* (1935), *Queen Christina* (1933), *Cardinal Richelieu* (1935), *Lloyds of London* (1936) and *The Scarlet Empress* (1934). It was their second most expensive production of 1936, exceeded in cost only by the Fred Astaire–Ginger Rogers musical *Swingtime*.

The studio purchased the film rights to the 1933 verse play *Mary of Scotland* by Maxwell Anderson which had been a Broadway success for Helen Hayes. It was intended as a vehicle for Katharine Hepburn and aimed at restoring her box office appeal after the failure of her previous film *Sylvia Scarlett*. Fredric March who had a proven record of playing virile, masterful men in costume dramas (*The Barrets of Wimpole Street* (1934), *The Affairs of Cellini* (1934), *Les Miserables* (1935), *Anna Karenina* (1935)) was cast as Lord Bothwell. As a freelance artist, he was paid $125,000, almost three times the salary of RKO contract star Hepburn.[13] After the studio failed to borrow Bette Davis from Warner Bros to play Elizabeth I, they cast March's wife Florence Eldridge in the role. A large cast of mainly British character actors was assembled to support the stars (Douglas Walton, Alan Mowbray, Ralph Forbes, Gavin Muir among them). Two actors who became Ford regulars, Donald Crisp and John Carradine, also played the important parts of Lord Huntley and David Rizzio.

Contrary to his normal shooting style, Ford included many luminous close-ups of Katharine Hepburn. This seems to reflect the fact that a romantic friendship sprang up between them. Opinion is divided as to whether this became a full-blown sexual affair. Certainly Ford, a tormented, guilt-ridden alcoholic, shared many character traits with the man who became her long-term partner, Spencer Tracy.[14] The film was shot between January and March 1936 and released in July. The film cost $864,000 and made a worldwide gross of $1.2 million but recorded an overall loss of $200,000. The film garnered respectful reviews. The *New York Times* (July 31, 1936) said: "A nicely produced, dignified and stirringly dramatic cinematization of one of the most colorful periods and personalities in history … *Mary of Scotland* must be considered

[13] Charles Tranberg, *Fredric March: A Consummate Actor*, Albany, GA: Bear Manor Media, 2013, p. 111.

[14] On the relationship of Ford and Hepburn, see McBride, *Searching for John Ford*, pp. 228–41.

one of the year's notable photoplays". *Variety* (August 5, 1936) praised Ford for "telling the story beautifully, artistically, delicately, with meticulous attention to detail and portrayal". Otis Ferguson in the *New Republic* (August 19, 1936) said: "*Mary of Scotland* owes a good part of its success ... to Katharine Hepburn as a personality and a moving force. A good deal is also owed to its production, direction, screen treatment etc. ... *Mary of Scotland* is mainly good as superior and handsome melodrama ... Yet there is something in this borrowing from history that is stronger than melodrama. There is the knowledge or at least belief ... that these people had their time in the world." It has fared less well with later commentators. Joseph McBride pronounced it "ponderously paced, turgid ... humorless" and Scott Eyman thought it "an almost complete disaster".[15] Hepburn biographer William J. Mann called it "a dreary, tedious picture".[16] On the contrary, it is a carefully crafted, artistically conceived and immensely personal portrayal of a Catholic martyr, or as Andrew Sarris put it "a soft-focused, unfairly slandered Madonna of the Scottish Moors".[17] Ford's only comment on it was: "It did very well ... though it was cut badly after I left".[18] Eight minutes were cut after its Hollywood preview.

Between them, Ford and his scenarist Dudley Nichols expanded and opened out the action, putting rich celluloid flesh on the bare bones of Anderson's narrative. The play is not really all that good. Anderson self-consciously strives after a pseudo-Shakespearean English, which is sometimes (as in John Knox's fulminations) vividly expressive but at other times grossly inadequate. For instance, Bothwell's comment on Darnley ("He is a punk and he'll rule like a punk") would be more appropriate in the mouth of a Chicago gang boss than a Scottish peer. Nichols wisely jettisoned most of Anderson's text and all of his verse and substituted his own, sometimes based on Anderson's but more often invented. Though he too is not entirely free from linguistic infelicities, as witness again a comment of Bothwell, this time to Darnley ("Still hanging around eh, Darnley"). The action of the play consists of the dramatization of the main episodes in Mary's life (her arrival in Scotland, her marriage to Henry Stuart, Lord Darnley, the murder of her secretary Rizzio and finally the

[15] McBride, *Searching for John Ford*, p. 229; Eyman, *Print the Legend*, p. 170.
[16] William J. Mann, *Kate*, London: Faber and Faber, 2006, p. 252.
[17] Sarris, *The American Cinema*, p. 48.
[18] Bogdanovich, *John Ford*, p. 132.

fictitious meeting of Mary and Elizabeth, obligatory ever since Schiller). Nichols has used these episodes but has woven them into a much more detailed and continuous historical framework and Ford has added his own distinctive visual contribution. Superbly realized Fordian set-pieces, such as the serenade, the trial and the execution are all absent from the original play. It is almost operatic with the people serenading Mary, regular performances on pipes and drums and David Rizzio singing two songs.

Over a musical score by Max Steiner in which "Loch Lomond" strives for mastery against the wildly inappropriate "British Grenadiers" (symbolizing the conflict between Mary and Elizabeth), titles appear proclaiming that a life and death struggle between rival Queens took place in the sixteenth century, "a lurid struggle that still shines across the pages of history", and the film depicts this struggle. The play is undoubtedly pro-Mary and anti-Elizabeth but the film intensifies this, partly because it is so much better than the play.

Basically, Ford believes that it is unnatural for a woman to rule and that ruling is a man's job. This is part of Mary's tragedy. But the other part is the denial of her instincts and her true identity. It is this, as well as the treachery of others, which brings about her downfall. When she realizes her mistake and does what she should have done in the first place (marry Bothwell), it is too late.

The film opens with her return to Scotland. She is welcomed at Holyrood Palace by her half-brother, the Regent James Stuart, Earl of Moray (Ian Keith) and the nobles of Scotland. She promises to rule fairly and justly. But she soon realizes that their words of welcome are hollow, as they are followed by demands that she change her religion, dismiss her Italian secretary Rizzio and marry a man of their choice. Mary defies them and walks out, declaring: "I am going to begin to be myself—Mary Stuart". She retires to her room, feeling alone and despondent despite her declaration of independence, the key statement of the first part of the film.

Now Ford stages the first of his brilliantly managed set-pieces. As Mary stands with Rizzio in her rooms, she hears singing and goes over to the windows. Framed by the windows, she watches as the people pour into the courtyard, bearing torches and lustily singing: "We shall fight for our Queen, she's the fairest ever seen". There is a highly characteristic low-angle shot of ranks of shawled women joining in, and then the soft-voiced lyric tenor Dennis

O'Dea from *The Informer* takes the verse. The adoring fans are intercut with big close-ups of Mary and medium close shots of her and Rizzio, as they listen to these musical expressions of loyalty. Suddenly, the singing is interrupted by a harsh, discordant voice, as the robed and heavily bearded figure of the Protestant preacher John Knox (Moroni Olsen), arms flailing expressionistically, thrusts himself in front of the camera, blocking out the people and drowning the singing with his own blast against "The Jezebel of France". But he in his turn is drowned out by the triumphant skirl of the pipes as Bothwell and his men arrive and he instructs the pipers to play on until Knox falls impotently silent. Thus, with the effective combination of music, movement, grouping and positioning of actors, Ford is able to express in visual terms the love of the people, the poisoning intolerance of the fanatic, and the victorious strength and support of Bothwell.

Bothwell, sturdily played by Fredric March, now meets Mary and declares his support for her. She is obviously attracted to the bold, outspoken soldier and he visibly returns her interest. He marches into the council chamber and declares to the quarreling lords that he has been appointed the Queen's lieutenant-general. He is photographed on a higher level than the lords so that he visually as well as physically dominates them.

With the support of Bothwell and his troops, law and order is restored and maintained. Mary's love for him grows and this again is beautifully depicted by Ford. Rizzio urges the Queen to marry to secure her position and suggests a variety of Continental princes—all of whom she rejects—and finally her cousin, Henry Stuart, Lord Darnley (Douglas Walton), next claimant after her to the English throne. Her devotion to the Faith and her concern for her duty temporarily weaken her resolve and she orders Rizzio to go and bring Darnley to her. But as he is leaving, the sound of Bothwell's pipes is heard and tremulously she cancels her order and rushes to the window, to watch him returning.

However, instead of marrying Bothwell, who has proved his ability to defend her, she allows herself to be seduced into the ways of statecraft. The English ambassador Lord Throckmorton (Alan Mowbray) arrives with a message from Elizabeth, to the effect that Elizabeth will recognize her claim to the English throne if she marries the Earl of Leicester. Mary is furious. The whole world knows Leicester is her favorite. For her to accept the Queen's cast-off would make her a laughing stock. She declares defiantly: "It is not in my nature to play

politics but now I shall." She tells Bothwell she will marry Darnley for reasons of state. He denounces her, tells her he loves her and resigns from her service. Brokenly she sends for Darnley, who is a painful contrast to Bothwell, pointed up by their confrontation in the council hall as both wait for Mary: Darnley, painted, powdered, earringed is an effete, mincing fop, exquisitely dressed in English style court clothes: Bothwell, plain-speaking and down to earth, wears kilt and claymore, and attended by his faithful hound, warms his rump before the fire. In a superbly lit scene, Mary receives Darnley, seated beside an ornate fireplace, she tragic-faced, he eager. She announces her decision to marry him. He kneels, she turns her head away and stands up. Her face half in shadow, she allows him to kiss her and then recoils.

Tragedy follows the marriage. At a council meeting, attended by the drunken and embittered Darnley (whose conduct has led to his exclusion from the Queen's bed), the nobles again demand the dismissal of Rizzio. The Queen walks out, the nobles sign a document agreeing to Rizzio's removal and they persuade Darnley to join their murder plot.

The Rizzio murder is one of the film's high points and is staged with considerable power and visual flair by Ford. The Queen and her ladies sit sewing by the fire, Rizzio leans against the fireplace strumming his mandolin and singing a song of longing for his homeland in the South. Suddenly a group of armed and armored nobles burst in, headed by Darnley. The ladies cluster protectively around Mary and Rizzio hides behind the Queen's skirts. But when their mission becomes apparent, he kisses the hem of her dress and darts into the next room. Escape, however, is impossible. In long shot, they advance on him from all sides, casting huge menacing shadows as they do. Silk hangings and naked sword-blades shimmer in the candlelight. Retreating backward, he falls onto the bed. He cries desperately: "Justice". But they fall on him, stabbing furiously and he expires with a gasp of "Madonna", convulsively pulling a silk coverlet over him as he does so.

Word now arrives that Bothwell is marching on the castle. Mary is placed under guard and the conspirators prepare to ambush Bothwell. But Mary now persuades the feeble Darnley to help her escape and she greets the avenging Bothwell, who sweeps into the courtyard with his men and disperses the conspirators' men after a short fight. The conspirators flee, swearing revenge on Darnley for betraying them.

Time passes and her son the baby Prince James is presented to his mother, Queen Mary, on his first birthday. The ladies in waiting cluster appreciatively around him and Bothwell arrives with a claymore as a birthday present. But the general happiness is soured by the arrival of Darnley, drunk and resentful. He denounces Mary for having tricked him and threatens to disown the child. She tries to reassure him but he withdraws to Kirk O' Field. There, after a vivid little scene of him in a white nightshirt, holding a candle and a pistol, and listening to strange tapping sounds coming from the cellar, he is blown up by his erstwhile noble allies.

Rumor, aided by the fanatical rantings of John Knox, blames Mary for the murder and this suspicion is compounded when Mary allows herself to be kidnapped by Bothwell and carried off to his stronghold Dunbar Castle. Bothwell and Mary are married. But Huntley, hitherto a loyal supporter, denounces this action for the impression it will cause. His discussion with them is a classically posed scene. The sequence takes place in a bare room, framed by thick pillars. In the center is a fire, before which sits Mary and equidistant from her on either side are Huntley and Bothwell. After the wedding Huntley goes

Figure 4.2 *Mary of Scotland* (RKO, 1936) with Katharine Hepburn as doting mother

alone into another room and solemnly breaks his sword. Mary and Bothwell go up onto the battlements. Largely in medium shot, but with some sumptuous close-ups of Mary, she and Bothwell talk. She tells him of her dreams and memories, of her girlhood in France and her marriage to the dying boy king, and of her return to her homeland ("I came back to my old dream, Scotland"). This hunger for home and reverie about the past fixes Mary decisively in the category of archetypal Ford figures. But ironically the scene was actually directed by Hepburn. Ford considering it too wordy, wanted to cut it. Hepburn opposed him, so he told her to direct the scene, which she did very effectively.

Scotland unites against Mary and Bothwell and the lords under Moray besiege them in Holyrood. With no hope of relief, they parley with Moray in the courtyard, the men lined up regimentally and two banners fluttering in the foreground. Bothwell suggests a personal duel between himself and Moray but when this is rejected agrees to leave Scotland, if Mary is restored to the throne and to power. It is agreed. He tells Mary that he must go: "You're the Queen of Scotland. That's your destiny. And I'll love you till the day I die. That's mine." He leaves on horseback followed by his pipers and Mary stands stock still in the courtyard, as the pipers pass by behind. When he has gone, she is escorted into the council chamber and ordered by Moray to abdicate. He had no intention of keeping his word. She refuses and is marched away to prison.

She escapes from Lochleven in a lovely dream-like sequence, in which her boat, containing herself and two page-boys, floats across black water through drifting mist and spiky clumps of reeds. She arrives in England and is escorted by English soldiers to a castle. In a large room, she is introduced to her host, Sir Francis Knollys. She describes how happy she is to be free, and grimly, silently Sir Francis draws back the curtains to reveal bars on the windows. As the door closes behind her captors, we hear the lock turn in the door. As the screen darkens, she moves into the shadows and slumps in a seat beneath the window.

In a prison cell in Denmark, Bothwell raves, imagines he hears the pipes and dies and Ford using again the visual device to suggest the almost physical link between the two parted people in love which he had first employed in *Pilgrimage*, transmits the emotion of his death to Mary. From Bothwell's body, he pans up to the windows of the cell, outside which a storm rages. He dissolves to trees bent by the gusts of wind, to the sea whipped up by the storm, to a stark landscape lit by lightning flashes, then the windows of Mary's bedroom burst

open. She sits upright in bed, and her face is illuminated by vivid flashes as the wind blows her hair back from her face and Ford dollies in rapidly to register the horror on her face.

The trial is another of the fine set-pieces, greatly enhanced by Van Nest Polglase's set: a great empty hall, polished floor, towering dais on the right with the dark-visaged judges perched on it like carrion crows; in the center of the floor a single chair. Mary enters, dressed in black, between lowered spears. High angle shots from the dais isolate her in the hostile emptiness. She asks him where Elizabeth is and the judges point to a throne with a crown upon it. "Her majesty is present symbolically" says the Judge. They motion her toward the seat. "I prefer to stand—symbolically" replies Mary.

They cite the precedents of the trials of sovereigns down the ages and she reminds them of the trial of the greatest of sovereigns, who died on the cross fifteen hundred years ago. Then Mary gives an eloquent and moving description of her imprisonment, done in loving close-up. The judges, low-lit and satanic, hector and badger her but she remains composed and defiant, until they bring in Bothwell's servant. He kneels before her brokenly to give her the news of his death. "And all the time you knew" she says to the judges, her voice breaking with emotion and from high up behind the judges, we see her walk slowly across to the seat and slump in it, her reason for living and fighting on ended with the news of Bothwell's death. The camera dollies into a close shot of her grief-stricken face, in a repeat of the movement of the camera which first introduced Mary to the audience on the arrival in Scotland. As the screen goes dark, the judge drops a black silk handkerchief as a sign of the death penalty.

Mary's death and the last scene of the film remain one of the most stunning and emotional things Ford ever did. The last morning of her life dawns to find Mary asleep on her knees before her crucifix. Knollys wakes her and after she prays for forgiveness from God leads her outside. There is a low-angle shot of her emerging between two lines of armed guards, who kneel and lower their halberds. The camera tracks back in front of her as she moves to the foot of the scaffold praying. She stops, her head turned upwards to the heavens and her cap and ruff are removed by shamefaced captors. Ford cuts to the view of the courtyard from the top of the scaffold, the railings of the steps bisecting the screen and leading our eyes down to her motionless figure. She starts to move up the steps, the courtyard goes dark, lightning forks around her and thunder

crashes apocalyptically. The camera retreats before her as she contemplates her climb up these long stairs, which take on the visible meaning of a stairway to heaven. At the top she stops, and the sound of the pipes and drums come to her. Bothwell is waiting. With a radiant smile, her eyes turn up to the heavens and the camera pans up into the clouds. Mary is united with Bothwell for eternity. She triumphs in death like the Priest at the end of *The Fugitive*, who similarly and symbolically mounts a flight of steps and who is accompanied earlier by thunder and lightning.

Given that her tragedy is to some extent of her own making, Mary is still helped on her way by three hostile forces: her cousin Queen Elizabeth I of England, her nobles headed by her half-brother Moray and the Protestants of Scotland under John Knox. For the drama, the most important of these forces is the first-mentioned. The opening scene of the film, which is an explanatory scene-setter, and which reverses the order of the play's opening scenes, shows Elizabeth reviewing the danger to her throne presented by Mary and authorizing her favorite, the foppish, lapdog-fondling Lord Randolph (Ralph Forbes) to capture her on a privateering raid (Randolph stalks out calling "Drake, Hawkins, follow me!"). Thereafter Elizabeth remains throughout the film a malign, shadowy power manipulating the forces against Mary, her envy spidering out across the border to encompass her rival's doom.

When the privateer attack fails, Elizabeth declares her intention of stirring up the Scottish nobles against Mary, and sends Throckmorton north as her ambassador to accomplish this. Thereafter, it is successive reports from Throckmorton which provoke action from Elizabeth and which fill in the historical details absent from the play. Elizabeth's plans are temporarily foiled when Bothwell drives out the murderers of Rizzio and installs Mary firmly on her throne. There is a splendid scene in which Throckmorton arrives in the middle of a ball at court, to announce to Elizabeth that Mary has given birth to a son. Elizabeth screams and runs into the darkened next room and when candles are brought, she is found slumped at the foot of her bed, declaring brokenly "I've failed, I've failed." When Burghley suggests war with Scotland, Elizabeth declares, "War—it is all you men think of" and resolves to get her way by secretly supporting Moray and the nobles.

Later Throckmorton reports the marriage of Mary to Bothwell, the proclamation of the infant James VI by Moray, the siege of Holyrood by the

rebel lords, the failure of Bothwell's rescue bid and his flight to Denmark, Mary's imprisonment in Lochleven. Mary appeals to Elizabeth for support and warns of the danger of rebellion in England if she encourages it in Scotland. "Rebellion, how I hate that word" declares Elizabeth, arranging to denounce Moray publicly and support him privately. Finally, she has Mary executed.

Elizabeth's reasons for hating Mary are two-fold. There is the undoubted female reason of envy. This is brought out early on when Randolph, dispatched as the first envoy to Scotland, returns rhapsodizing about the young Queen. He declares that she is no danger to Elizabeth's throne. With a vicious crafty look on her face, she asks what Mary is like. "A creature of love" replies Randolph, producing a miniature of her. Elizabeth compares the painting with her own image in a mirror, and then angrily dismisses Randolph and orders him replaced with Throckmorton, "a cold fish", who will be less susceptible to Mary's charms.

But beyond this, there is the basic difference in philosophy between them and this is brought out in the final confrontation. Elizabeth enters Mary's cell after she has been condemned, to find Mary kneeling before her cross. Their exchange is shot in one of Ford's symmetrically arranged framings, the two women facing each other across a table, end on to the camera, with a single candle on it. Elizabeth justifies her action:

"You were born too close to my throne. It was you or I."

She chides Mary for having been a woman first and a Queen second.

"I'm a Queen, you've been a woman. See where it has brought you."

Mary replies:

"It has brought me happiness you will never know. I wouldn't give up the memory of one day with Bothwell for a century of your life."
Elizabeth: "You threw away a kingdom for love."
Mary: "I'd do it again, a thousand times."

Elizabeth says that she gave her life to her country. In a moment of compassion Elizabeth offers Mary her life if she will renounce her claim to the English throne. Mary refuses.

"I shall win. My son will inherit your throne. My son will rule England. Still, still I shall win." Elizabeth flees and the screen darkens as Mary kneels

again before her cross, and there is a huge close-up of her as she turns her gaze upwards to the cross.

There is no doubt which of these arguments engages the sympathy of Ford and of the film. For the full star treatment is reserved for Mary. Katharine Hepburn has never looked more lovely than in this film, which, ravishingly photographed in soft focus by Joseph August, becomes in effect a rhapsodic love poem, quite unlike anything else in Ford's oeuvre. Mary has more than two dozen long lingering close-ups and in the big scenes, Ford lovingly explores her face with his camera: the serenade, the battlement reverie, the denunciation of Rizzio's murderers, her address to the nobles at the outset, the trial, the confrontation, the execution are all built around big melting close-ups. The very first appearance of Mary, so strikingly contrasted with the previous scene of the scheming Elizabeth plotting her downfall, is an indication of what is to follow. A boat, with raised oars, comes to rest at the quayside in Leith. The landscape floats in a dreamy mist as Mary disembarks. She kneels on the ground to pray for guidance and the camera dollies in almost imperceptibly until her face, transfigured with joy at her homecoming, fills the screen. The luminous heavenly quality remains with Mary until the end. By contrast, Elizabeth does not have a single big close-up. The most she gets is a grudging medium close shot when Ford intercuts her face and that of Mary, in big close-up, during the confrontation.

To her natural beauty and sincerity, Ford adds the strength of her faith. She remains a staunch Catholic ("My religion is not a garment to be put on and off with the weather") and Catholic imagery and adoration exalt her. In her first appearance, she kneels, crosses herself and prays. She inspires an almost mystical adoration in Rizzio, who calls her "Madonna" (not in the play), and dies with this name on his lips. As he and Mary watch the serenaders, the torchlight gleams on the cross he wears constantly. Mary too wears a cross. She clutches it fervently during her confrontation with Elizabeth, while behind her the shadow of the cross on the wall indicates the justness of her cause. Her very death can be interpreted as nothing other than martyrdom, as she has already in her trial compared her fate to that of Christ. In a very real sense, she is a martyr to her faith, as she is to her love for Bothwell.

Against her stands Elizabeth, a vitriolic portrait of an ageing and embittered shrew, hating Mary for her youth, for her beauty, for her child, fearing her as a

Figure 4.3 *Mary of Scotland* (RKO, 1936) with Katharine Hepburn as Catholic martyr

rival and as a Catholic. Her world is a world of treachery and intrigue, empty of real love and happiness, a denial of the wife and mother role of the Fordian woman. Indeed, it is Ford's pre-Liberation vision of a liberated woman, one who dominates the men around her, takes on male functions, and denies everything womanly, which Mary on the other hand incarnates.

It is a portrait unique in cinema. In almost every other depiction of Elizabeth I (*Fire Over England* (1937), *The Private Lives of Elizabeth and Essex* (1939), *The Sea Hawk* (1940), *Young Bess* (1953), *The Virgin Queen* (1955), *Elizabeth* (1998), *Elizabeth: the Golden Age* (2007)), the Queen is glorified for sacrificing her happiness to her duty, and for leading her beleaguered island kingdom to victory against the might of the Spanish Empire. She is a heroized and idealized "Virgin Queen", every bit as noble and praiseworthy as Ford's Martyr Queen version of Mary. But *Mary of Scotland* is entirely in accord with Ford's view. For Ford Elizabeth stands for everything he dislikes and distrusts: English Imperialism, Protestant intolerance, the liberated woman.

Mary's second source of enmity is her own aristocracy, a greedy, quarrelsome, power-hungry, treacherous group, concerned only to maintain their own hold on the country. From the outset, there is a powerful contrast between the courts of England and Scotland. The film opens in England, doors are flung open, two lines of beefeaters march in and take up positions, Ford dissolves to a gathering of courtiers as an usher announces: "The most high and mighty sovereign Elizabeth". The courtiers part respectfully forming two lines, between which Elizabeth sweeps, attended by favorites and ministers. From then on, she is totally in control. In Scotland, our first sight of the nobles is of men squabbling and drawing swords on each other, hounds baying, total confusion, as the Regent Moray, his face half in shadow, sits watching them. When Mary arrives, Ford picks out the faces of the nobles one after another, looking like Eisenstein's boyars in *Ivan the Terrible*, hard, crafty, unscrupulous. Only when Huntley kneels do the rest follow suit, reluctantly, and soon they are insulting Mary to her face and dictating their terms: change in her religion, marriage to Darnley, the dismissal of Rizzio. When she walks out on them, they pledge themselves to protect the interests of the nobles, "the true rulers of Scotland". Thereafter they plot and scheme constantly. They murder Darnley and blame the Queen. They stir up civil war and having given their word to set Mary on the throne again, they betray their trust and imprison her. It is clear that their embrace of Protestantism is political and not a genuine spiritual transformation.

The third force against which Mary contends is John Knox, symbol of Protestant fanaticism. Mary makes her position quite clear when she first meets her nobles, and they tell her "It is John Knox's day in Scotland". She will not give up her religion but she promises tolerance to all men ("I shall worship as I please and hope for all men to worship as they please"). When Knox interrupts her serenading subjects with his ranting, she asks him in to talk and again promises toleration. "I'll give you as much freedom as I ask for myself. I believe in your sincerity. I only ask you to believe in mine". But he simply renews his rant and then walks out. Later he is found denouncing her for murdering Darnley and siding with the rebel lords. But the other Protestants are equally unpleasant: Elizabeth, Moray, the Scottish lords. Catholicism is characterized by loyalty (Huntley, Bothwell, Rizzio) and tolerance, generosity and beauty (Mary).

Visually the film is richly Expressionist. Low-key lighting enables Ford to use much shadow and the presence of shadow is used symbolically in Ford to signify approaching death and destruction. Elizabeth's guards entering in the first scene cast large shadows and throughout the film, dire events are preceded by shadow-casting soldiers parading through corridors or along battlements and proclaiming: "Ten o'clock and all's well". The conspirators advancing on Rizzio cast shadows; Huntley breaking his sword casts a shadow; John Knox stalking out of the palace casts a shadow; the dancers at Elizabeth's court just before news arrives from Scotland cast shadows; Rizzio listening to the nobles plotting his death casts a shadow; Darnley in the castle courtyard sinks back against a wall darkened by the shadows of fighting men.

Of all the characters in the film, Rizzio is constantly in the shadow, the most doomed of them all. He is superbly played by John Carradine, a slender, graceful, black-clad figure, earringed, wearing a gold cross, an elegant, devoted, doomed figure. Ford also darkens the screen artificially at moments of great drama, most notably in the execution scene, when all the watching figures are blotted out and Mary seems to be alone, climbing the ladder to eternity, and when the nobles persuade the drunken Darnley to join their plot against Rizzio and climax their argument by tossing a dagger on the table. The screen goes dark except for the dagger, which glints murderously. Similarly, when Mary discovers her place of refuge in England is really a prison and when sentence is passed on her at the trial, the screen darkens. Ford also uses other elemental forces symbolically: fog and mist to symbolize loneliness and lostness (the arrival in Scotland, the escape from Lochleven) and storms, thunder and lightning to symbolize turbulent passions (the death of Bothwell, the execution of Mary).

As always in Ford, his groupings are posed. The confrontation scene, the execution, the trial, the council meeting, the wedding, the discussion with Huntley, all have figures and groups of figures symmetrically placed, soldiers ranked, rulers enthroned, etc. Scenes are framed by doorways, arches, windows and lines of people.

The film does have its weaknesses. Ford has always pared dialogue to a minimum and generally filmed that minimum in static medium shot. But here he is faced with a mass of dialogue, much of it indispensable given the play's structure. In this event, his normal method of shooting becomes after a time rather dull. This is particularly true of the first confrontation between Mary

and the nobles. After the Eisensteinian introduction of the nobles, Ford settles down to a simple cross-cutting between nobles and Queen which is prolonged as they go through their demands. Similarly, in the opening scene, which is designed to convey a great deal of historical information, Ford uses the same technique and the result is stilted, though admittedly made much worse by the hamfisted performance of Lionel Pape as Lord Burghley, who rehearses the reasons for the danger from Mary in such a way as to suggest he is reading very badly from prompt boards. But this having been said, there is a visual richness in much of the film, the incandescent presence of Katharine Hepburn, the excellent supporting cast (Florence Eldridge, Ian Keith, John Carradine particularly), some good writing and the stunning finale, enough to make one regret perhaps that Ford did not tackle historical themes more often.

What would turn out to be Ford's last film was also one of his strangest, *7 Women* (1965). (Most scholars refer to it as *Seven Women* but McBride discovered from Ford's papers that he preferred *7 Women*, in line with his other titles *3 Bad Men* and *3 Godfathers*.)[19] Based on a short story by Norah Lofts, appropriately entitled *Chinese Finale*, it is set in North China in 1935 at an American Christian Mission. Mostly shot on the MGM sound stage, it is essentially a chamber work exploring the conflict between the seven women of the title. The film was scripted by the husband and wife British writers Janet Green and John McCormick. Together or singly they had written the British films *Sapphire* (1959) which dealt with racial problems, *Victim* (1961), the first mainstream feature to address the subject of homosexuality, and *Life for Ruth* (1962) which explored problems presented by fundamentalist religion. Aspects of all these subjects figured in *7 Women*. Ford's producing partner Bernard Smith persuaded him to cast Margaret Leighton as Agatha Andrews—after Ford's first choice Katharine Hepburn turned down the role—and Patricia Neal as Dr. Cartwright. MGM insisted on Sue Lyon for the young teacher Emma Clark. Ford cast his regulars Anna Lee, Woody Strode and Mike Mazurki in supporting roles and chose Flora Robson, who had appeared in *Young Cassidy*, to play the British missionary. Only two weeks into filming Patricia Neal suffered an incapacitating series of strokes which necessitated her replacement by Anne Bancroft. Principal photography lasted from February 8

to April 12 and the film was shot in continuity. It cost $2,298,181. Public previews and the trade press reviews of the film were totally negative and *7 Women* turned out to be a critical and box office disaster. MGM dumped it on the market as the lower half of a double bill with the thriller *The Money Trap* and canceled Ford's next production *The Miracle of Merriford* a week before shooting was due to start. In the end, *7 Women* made only $937,432, less than half its production cost.

However, the film developed something of a cult following in Europe and several well-informed Ford critics came to see it as a major work. Joseph McBride observed:

> Even some Ford scholars and biographers continue to treat *7 Women* as an embarrassing aberration, yet there also are those (such as myself) who regard this mordant drama of religious fanaticism, sexual repression, and social breakdown as one of Ford's masterpieces.[20]

Andrew Sarris concluded:

> *Seven Women* is a genuinely great film from the opening credit sequence of Mongolian cavalry massing and surging in slashing diagonals across the screen to Anne Bancroft's implacable farewell to Mike Mazurki's Mongolian chief "So long, you bastard" ... The beauties of *Seven Women* are for the ages, or at least for a later time when the personal poetry of film directors is better understood between the lines of genre conventions ... Ford represents pure classicism of expression in which an economy of means yields a profusion of effects.[21]

Tag Gallagher wrote:

> *7 Women* is astonishing for its vitality. It may be the most quickly cut of all Ford's movies; it is certainly the most inventive, as rich in detail and revelation as any picture ever made ... Each moment confronts us with unequaled virtuosity and unsurpassed depths of humanism.[22]

Sarris is right about the classical purity of Ford's style. His shots are framed by doorways, arches and corridor walls. He avoids unnecessary camera movement,

[20] McBride, *Searching for John Ford*, p. 663.
[21] Andrew Sarris, *The Great John Ford Movie Mystery*, London: Seeker and Warburg, 1976, pp. 184–5.
[22] Gallagher, *John Ford*, p. 436.

using tracking shots only when characters are moving. He uses close-ups sparingly and intercuts only when necessary. Flora Robson recalled him moving his actors within the shot as carefully as if he were directing a ballet.[23]

Ford described the women at the mission as "a bunch of kooks".[24] This was true for Ford in two respects. Firstly, they are not Catholics, but Protestants, members of the unified Christian Missions Educational Society of Boston. In the original story, the missionaries were British but they are now American and from a city Ford often satirized as puritanical and uptight. Mission head Agatha Andrews is armored in certainties both national ("The bandit wouldn't dare to molest us. We are American citizens") and religious ("We are soldiers in the army of the Lord"). One of the film's themes is the crumbling of these certainties.

Secondly, Ford was famous for celebrating woman as wives and mothers. In *7 Women*, Florrie Pether (Betty Field), the only one fulfilling her "natural" function and declaring "what is a woman without a child", is a demanding, self-centered, perpetually complaining neurotic. Her statement about women and children is echoed by Dr. Cartwright who tells Agatha Andrews she should have married and had sons ("That's real living"). All the others are unmarried. Agatha Andrews (Margaret Leighton), head of the mission, is a sexually repressed authoritarian troubled by lesbian longings for the innocent, inexperienced young teacher Emma Clark (Sue Lyon). There are two spinsters, Miss Argent (Mildred Dunnock), Andrews' faithful and put-upon assistant, and Miss Binns (Flora Robson), an English missionary from a nearby mission destroyed by bandits, who is sensible and compassionate, speaks Chinese, was born in China and has never been "home" to England. Finally there is Mrs. Russell (Anna Lee), neurotic widow of an abusive alcoholic English army officer, who develops a prurient interest in watching half-naked Mongols wrestling. The only male at the mission is the ineffectual Charles Pether (Eddie Albert). A would-be minister, mother-dominated until her death, he finally married his long-term sweetheart Florrie, now pregnant at forty-two.

The even tenor of their existence is disrupted, first by the arrival of the new doctor, Dr. Cartwright (Anne Bancroft), who turns out to be a woman. Dressed

[23] Gallagher, *John Ford*, p. 461.
[24] Bogdanovich, *John Ford*, p. 107.

in trousers, leather jacket and a Stetson; chain-smoking, whiskey-drinking, profane, atheist, she is a female John Wayne. Ford called Bancroft "Duke" (Wayne's nickname) throughout the shooting. Like the other women, she as the archetype of the liberated woman had to cope with failure and disappointment, the failure to obtain a job in the United States because of her sex and the failure of an affair with a married man. She clashes at once with Andrews, defying her dictatorial rule, and inspiring jealousy by Emma's obvious admiration for the newcomer. However, the doctor copes successfully with an outbreak of cholera among the Chinese who take refuge at the mission after the destruction of their town by marauding Mongolian bandits. Then Tunga Khan (Mike Mazurki) and his men arrive at the mission. They are out and out savages, who have raped, burned and slaughtered their way through the area on a vicious rampage. They smash up the mission, shoot all the Chinese, imprison the white women and degrade and rape the aristocratic Miss Ling (Jane Chang). Charles Pether is killed trying to save two Chinese girls from rape, Florrie's baby is born and Andrews now breaks down, becoming hysterically racist and condemning the doctor in Biblical terms when to get medicine, food and shelter for the captives, she agrees to sleep with Tunga Khan. Finally, having persuaded Tunga Khan to release the captives by agreeing to stay with him, she dons Chinese dress and prepares tea for them both. It is poisoned and having drunk, they both die. It leaves us with the paradox that it is the atheist doctor with her selfless dedication to helping people and her willingness to sacrifice her life to save others who displays the true Christian spirit.

There are echoes in the film of Ford's own *The Lost Patrol* with its British army patrol, trapped at a desert tomb by Arabs and slowly being wiped out. Boris Karloff's Sanders who cracks up under the strain and becomes a religious maniac prefigures Agatha Andrews. There are echoes too of the Powell and Pressburger classic *Black Narcissus* (1946), in which a group of Anglican nuns in the Himalayas, one of whom goes mad, are defeated by the local culture. The finale also recalls Frank Capra's *The Bitter Tea of General Yen* (1933) in which Megan Davis donned Chinese costume as a sign of her submission and General Yen takes poison.

7 Women is certainly an improvement on Ford's last venture into this territory, a half-hour television film, *The Bamboo Cross* (1955), an entry in the

Fireside Theatre series. A crude anti-Communist propaganda piece, set in contemporary China, it has a pair of American missionary nuns being pressured by a Communist warlord to denounce a priest for poisoning local children. The nuns are helped to escape by a young Chinese Communist who has seen the light. Joseph McBride called it "appallingly bad" and Tag Gallagher described is as "the low point of Ford's career".[25]

There were some more tender-minded critics who found the depiction in *7 Women* of the bandits as savages racist and felt that Cartwright's suicide was the revival of an old-fashioned attitude to miscegenation, "death before dishonor". But as Joseph McBride points out the doctor had already had sex with the bandit chief to obtain food and medicine and that her suicide was a bid to avoid a future of sexual servitude.[26]

It was a film totally out of tune with the age and its values. Ford said in interview: "I think it is one of my best, but the public didn't like it. It wasn't what they wanted".[27] But it directly reflects Ford's disillusioned and despairing view of the contemporary world. It is set in a mission which stands for Western values (Christianity, Americanism) which cannot be communicated to the people they are trying to help (epitomized by the scene in which Pether delivers a hellfire sermon to a class of uncomprehending Chinese children). The order, discipline and hierarchy of the mission are subverted by the arrival of a disruptive liberated woman and invaded and destroyed by barbarians. It ends with abandonment of the mission by the women and the death of the liberated woman. Ford, having retreated from the present as far as he is able (to North China in the 1930s), has nowhere left to go.

[25] McBride, *Searching for John Ford*, p. 573; Gallagher, *John Ford*, p. 537.
[26] McBride, *Searching for John Ford*, p. 674.
[27] Gallagher, *John Ford*, p. 436.

5

John Ford's Underworld

Contemporary crime films have always been one of the staples of the cinema. They come in a variety of forms, among them private eye tales, police procedurals, prison dramas, gangster films. They tend to appear in cycles responding to upsurges of public concern about criminality, for instance during Prohibition (1920–33) and after the official enquiries into organized crime in the 1950s. Ford made only six crime films. They included a gangster film (*Born Reckless*), a film featuring the wrestling racket (*Flesh*) and a Scotland Yard police procedural (*Gideon's Day*). But three of his crime films were comedies (*Riley the Cop*, *The Whole Town's Talking* and *Up the River*). Even in his non-comic crime films he sought every opportunity to inject comedy.

The comedic approach to law and order was perhaps a result of his self-described status as a rebel. This is nowhere more true than in *Riley the Cop* (1928), a silent film with synchronized musical soundtrack and sound effects (laughter, cheering, applause, yodeling). A modest program picture, running sixty-seven minutes and featuring two character actors, J. Farrell MacDonald as officer Aloysius Riley and Louise Fazenda as waitress Lena Krausmeyer, it will have come and gone without creating much of a stir but it is a prime example of the vignette style that Tag Gallagher sees as one of the sources of Ford's greatness.[1] Ford himself said of it only: "That was a story that had actually happened ... and I thought it was a funny idea".[2] A defiant paean to the joys of drinking made at the height of Prohibition, and the apotheosis of the Irish cop, it is basically a good-natured, free-wheeling, amusing and inventive anecdote. The simple narrative line in the script by James Gruen and Fred Stanley

[1] Tag Gallagher, *John Ford: The Man and his Films*, Berkeley and Los Angeles: University of California Press, 1986, p. 35.
[2] Peter Bogdanovich, *John Ford*, Berkeley and Los Angeles: University of California Press, 1978, p. 127.

(New York cop is sent to Germany to bring back suspect) is embellished with a string of comedic situations. The opening title outlines the philosophy of Officer Riley: "You can tell a good cop by the arrests he doesn't make". We see the shadow of the cop on the sidewalk, a close-up of his feet, the stamping out of a cigar butt and the twirling of the truncheon. Riley's feet become a running gag throughout the film as he is continually identified as a cop with close-ups of his feet. At a parade of policemen the Sergeant upbraids Riley for not matching up to the military efficiency of his German colleague, Eitel Krausmeyer. Their rivalry becomes one of the threads of the plot. After the police march off with the local children following them imitating their tread, we get a series of vignettes of Riley's life on the beat, beautifully staged and timed. Riley gets an African American shoeblack to polish his shoes and appears to reward him with two tickets for the policemen's ball but then insists on being paid for them. A drunk staggers down the street, doing hopscotch on the children's chalked squares. Riley stops him, telling him to go and do it on Krausmeyer's beat. Then he starts doing the hopscotch, only to catch the Sergeant staring disapprovingly at him. He turns on the fire hydrant so that the local children can play in the water. Spotting the innocent young lovers, Mary Coronelli and Davy Collins, sitting on a step, with Davy professing his love, Riley joins them, puts his arms around both of them and reminisces about how he used to play with them as kids. Riley discovers a street trader with a barrow illegally trading on his street and orders him to move to Krausmeyer's beat, taking great delight when Krausmeyer is reprimanded for not moving the barrowboy on. Riley joins a group of kids playing baseball and knocks the ball through the bakery window; one of the children quickly slips his truncheon back into his hand and removes the baseball bat. Dropping into a friendly kitchen for a smoke and bite to eat, he flees when a kid warns him of the approach of the Sergeant. Returning he discovers the Sergeant has taken his place in the kitchen, so he heaves a brick through the window and escapes to witness the Sergeant's wrath from a distance.

Riley is now ordered to proceed to Germany and bring back Davy who has been arrested on suspicion of embezzlement from the bakery. He had gone to Germany in pursuit of Mary, who was on a tour with her aunt. Riley arrives in Germany in top hat and morning suit and takes custody of Davy. Germany is characterized by heavy ornate interiors, medieval dungeons, and ranks of

uniformed, bemedalled, saber-rattling policemen, moving in unison. Riley takes Davy straight to a beer garden and the rest of the film consists of Davy's attempts to get Riley back to America, reversing the prisoner and guard relationship. Riley is immediately attracted to waitress Lena. They gaze at each other, sighing in unison. "All my life I've been searchin' for a colleen like you— to say nothing of the beer" says Riley. Riley and Lena get drunk together but he lurches over to join a group of cadets who all salute in unison. Yodelers from the Police Glee Club arrive and the drunken Riley has a multi-image, whirling shot of them before crashing into them and causing a fight to break out. The police arrive with a telegram ordering Riley to return at once to America and he and Davy are escorted to an airship and take off for Paris. Once aboard, Riley realizes he has forgotten something—Lena, who is left tearfully waving farewell on the tarmac. In Paris, Riley is recognized by the gendarmes, again because of his feet, and abandons Davy to go on a drinking spree with the French cab driver who picks him up in a battered old taxi. Getting steadily drunk in a nightclub, they ogle the scantily clad dancing girls performing a fan dance. Ford inserts an unusual shot of a single girl posing with a glass superimposed on her and wine being poured in, so that she seems to float in alcohol. It is a succinct metaphor for Riley's condition. Next morning he wakes up in a hotel bedroom to discover two glamorous women watching over him, and the taxi driver asleep on the floor beside the bed. His horror is assuaged when the gendarmes arrive and explain that the women are police agents who retrieved him and his driver from the nightclub and brought them safely to the hotel. Lena turns up, having followed Riley to Paris, and he with some difficulty explains the presence of the women in his room. Davy arrives, handcuffs himself to Riley, and orders the taxi driver to take them to Le Havre to catch the boat to America. Riley promises to meet the next boat with Lena on it and to marry her. Riley, identified again by his feet, receives a telegram to say the real embezzler has been caught and Davy can be freed. He finds Mary and her aunt aboard and they are reunited. The film ends with Mary and Davy married, Riley and Lena married and Lena recognizing Riley's old rival, Officer Krausmeyer, as her long-lost brother.

Ford tells the story simply and unpretentiously but allows himself the luxury of a few technical experiments (the multiple superimpositions in Riley's drunken fight and the nightclub scene, and the use of first-person camera in

the breakneck taxi ride to Le Havre). It is also interesting to observe the use of German, French and Irish dialect accents in the intertitles.

Riley the Cop received an appreciative press. *Film Spectator* (May 12, 1928) recorded: "Every excruciating bit in the picture gives you the impression that it was shot the moment someone thought of it … It's just funny because it is downright brilliant. J. Farrell MacDonald gives the finest performance of his career … but it is a director's picture and my hat is off to John Ford". This view was endorsed by the *New York Times* (December 3, 1928) which said that the film is "suffused with life through the direction, the capable acting, the amusing and really funny gags … The big asset to this production is Mr. MacDonald as he is directed by John Ford." The critics accurately attribute the film's success to the combination of Ford and MacDonald and highlight the spontaneity and inventiveness which can still be appreciated when the film is viewed today. It is another example of the way in which Ford has mastered the art form of silent film just as it was being eclipsed by a new form—the talkies.

Ford adopted a similar approach in his comedy *Up the River* (1930). The Auburn Prison Riot in 1930 had made the subject of prisons topical and MGM cashed in on this interest with *The Big House* (1930) and Columbia with *The Criminal Code* (1931). Winfield Sheehan of Fox wanted his studio to have a prison drama and commissioned Maurine Watkins, author of the Jazz Age satire *Chicago* (1928) to write the script for a film to be called *Up the River*. Ford gave Peter Bogdanovich an account of what happened next:

> Sheehan wanted to do a great picture about a prison break, so he had some woman write the story and it was just a bunch of junk. Then he went away for a while, and day by day Bill Collier, who was a great character comedian, and I rewrote the script. There was so much opportunity for humor in it that eventually it turned out to be a comedy—all about what went on inside a prison; we had them playing baseball against Sing-Sing and these two fellows broke back *in* so they'd be in time for the big game. We did it in two weeks; it was Tracy's and Bogart's first picture—they were great—just went right in, natural.[3]

Ford had seen Tracy playing a hardened killer in the Broadway hit *The Last Mile* and insisted that Fox test him for the lead. Collier got a "staged by" credit.

3 Bogdanovich, *John Ford*, p. 52.

A stage actor and veteran character comedian, William Collier Sr., playing baseball coach "Pop" in the film, probably did help Ford stage some of the comic routines. As a result of the rewrite, the film bore no screenplay credit but only "from an original story by Maurine Watkins". Andrew Sinclair said that *Up the River* was memorable only for the debuts of Tracy and Bogart.[4] But it is very much more than this. It is a fresh, funny and inventive comedy with Spencer Tracy impressive as St. Louis the tough guy with a heart of gold and Warren Hymer amusing in his regular role of aggressively dim-witted criminal, here called Dannemora Dan. Humphrey Bogart has little to do as a conventional juvenile lead, Steve Jordan.

The film opens with St. Louis and Dannemora Dan escaping from a Southern prison together. But St. Louis dumps Dan and commandeers the escape vehicle to head off on his own. Cut to Kansas City where Dan is marching with the band of the Brotherhood of Hope, a Salvation Army analog. He delivers a lecture to onlookers on the theme "Crime does not pay". But St. Louis drives up in a flash car with two women. Dan declares that he forgives "the depraved wretch" who led him into crime but cannot resist slugging St. Louis and ends up hauled off by the police. At Bensonatta Prison in the Midwest Dan is marching now with the prison band when St. Louis arrives in style, genially requesting top quality conditions in his cell. He ends up sharing a cell with Dan, "Pop" the baseball coach who regards him as his star pitcher, and Steve Jordan, a young man from a respectable New England family who accidentally killed a man in a fight and whose relatives believe him to be in China. St. Louis convinces Dan that he left him behind by accident after their earlier prison break. Ford depicts the prison as an ideal community, complete with brass band and baseball team, presided over by a benign Warden. Steve and St. Louis intervene to prevent a vulnerable young inmate being bullied by an uncredited Ward Bond. Romance blossoms between Steve, who acts as a clerk in the reception office, and Judy Field, who is in the adjoining women's prison, serving a sentence for fraud, having been tricked into assisting a crooked stockbroker who left her to carry the can for the swindle. The convicts do tricks to entertain the Warden's little girl, Jean, who is also taught arithmetic by Judy. A do-gooding prison visitor Mrs. Massey is sent up by a black female

[4] Andrew Sinclair, *John Ford*, London: George Allen and Unwin, 1979, p. 40.

inmate who puts on an exaggerated show of repentance and by an English-accented con man who greets her with exaggerated upper-class politeness.

Steve is paroled and returns to his mother and sister in Connecticut. Judy informs St. Louis that her old confederate, Frosby, having learned of her involvement with Steve, intends to blackmail him into helping sell bogus shares. St. Louis and Dan arrange to escape from jail and go to his aid. They do it under cover of a show put on by the prisoners. The show includes a blackface cross-talk act, Black and Blue, played by Bob Burns and John Swor. Ford conspicuously inserts a rare full close-up of a black inmate uproariously laughing at their act. A tenor sings a sentimental song about Mother and the camera tracks along the wistful and sometimes tearful faces of the convicts in the audience. St. Louis does a knife-throwing act with Dan as the target. The grand finale has the cast and audience standing and singing "Red, White, and Blue". The lights briefly fail and under cover of darkness, St. Louis and Dan escape. They travel to Connecticut, meet Steve and are invited to dinner by his mother. They join a hayride. But returning they find that Frosby has swindled Mrs. Jordan out of bonds and Steve is preparing to shoot him. St. Louis gives a graphic description of his time on death row and persuades Steve to hand over the gun. They then proceed to burgle Frosby's office and return the bonds to Steve. They head back to Bensonatta with a proposal of marriage for Judy from Steve. Back at the prison, a vital baseball match is under way with "Pop" lamenting the absence of his star pitcher. Before the match kicks off he and the rival coach demonstrate the fouls the participants must not commit in a comic scene that Ford would reproduce in *Rio Grande* twenty years later. Having given the newly paroled Judy Steve's proposal, St. Louis and Dan arrive in time to win the game. Everyone stands and sings "Red, White and Blue".

The picture is very simply filmed with medium shots for dialogue exchanges, long shots for action, and tracking shots on movement. There are very few close-ups. Despite the absence of a musical score, the film is full of music (the Brotherhood of Hope band, the prison brass band, the prison show, the hayride). The structure gives plenty of space for the comic vignettes so beloved by Ford, for example a scene in which Dan painstakingly creates a paper doily by origami, a delightfully irrelevant incongruity.

Mordaunt Hall in the *New York Times* (October 11, 1930) reported that the film proved to be "violently funny to the thousands who filled the seats in the

Figure 5.1 Spencer Tracy in *Up the River* (Fox, 1930)

big theater yesterday afternoon". He himself thought the film had "a number of clever incidents and lines, but now and again it is more than a trifle too slow", but added that "Spencer Tracy and Warren Hymer do particularly well in their respective parts." He also revealed that Joan Marie Lawes, "the little daughter of Warden Lawes of Sing Sing prison, makes her screen debut. She plays with considerable confidence the daughter of the warden of Bensonatta prison." *Variety* (October 15, 1930) pronounced it "good entertainment".

The only real gangster film that Ford directed was *Born Reckless* (1930). But it came nowhere near equaling the impact of the three gangster films that became classics and set the standard for the genre, *Little Caesar* (1931), *The Public Enemy* (1931) and *Scarface* (1932). It had none of the violence, realism or visceral power of that trio. It was a studio assignment that did not particularly interest Ford. As he remembered:

It wasn't a good story—something about gangsters—and in the middle of the picture, they go off to war; so we put in a comedy baseball game in

France. I was interested in *that*. In those days, when the scripts were dull, the best you could do was to try and get some comedy into it.[5]

Although it was adapted by Ford's regular collaborator Dudley Nichols from a 1929 novel *Louis Beretti* by Donald Henderson Clarke, it emerged as a fragmented and episodic narrative, suffering from too frequent and too abrupt changes of tone. In Ford's hands it becomes a sentimentalized story of a gangster's redemption, rather than a hard-hitting exposé of the underworld.

The film stresses the devotion of Louis Beretti to his Italian immigrant parents. He is also highly protective of his sister Rosa whose admirers he checks out for suitability. She marries with his approval a bespectacled bank clerk Charlie who is subsequently murdered in a robbery. Louis avenges him by killing his murderer in a shoot-out. But the gentlemanly Edmund Lowe is no one's idea of a gangster and is not remotely ethnic, unlike the stars of the classic gangster films. Apparently the role had been intended for Paul Muni, star of *Scarface*. Louis redeems himself both by his war service and by rescuing the kidnapped child of the society woman he unrequitedly loves. But the film sidesteps the clearly implied tragic ending when Louis returns to his nightclub after the rescue for a confrontation with the brains behind the kidnapping, Big Shot. In the perfunctory ending, after Louis is shot in the confrontation, journalist Bill O'Brien (Lee Tracy) who has assisted in the rescue, declares "He'll be alright" and sends for a bottle of whiskey.

After the jewel robbery with which the film opens, Louis and his cohorts Gibbons and Donnelly are arrested. At O'Brien's suggestion, the District Attorney sends them to the Western Front as soldiers. It is in the war sequence that Ford inserts the baseball game which has the lively, improvisational feel missing from the rest of the film. Louis strikes a baseball which hits the General's horse, upending him onto the ground. The soldiers scatter and Louis thrusts the bat into the hand of a Sergeant, who is identified as the culprit and reduced to the ranks. Later Louis trades sugar for kisses from the waitress at the estaminet. A montage of exciting war action ends this section.

Back in New York after the war, Louis reports to the District Attorney that, of his cohorts, Gibbons is with the army of occupation in Germany, and Donnelly was killed. He also visits Joan Sheldon, sister of wartime comrade

[5] Bogdanovich, *John Ford*, p. 52.

Frank to tell her how Frank had died in his arms. He had been planning to propose to her but learns she is engaged to Captain Milburn (Randolph Scott). Two years later he is running a successful nightclub and provides an alibi for Big Shot (Warren Hymer) who has shot police informer Ritzy Reilly. Then in 1922 after Big Shot is released and masterminds the kidnapping of Joan's baby, she turns to Louis who tracks down and rescues the child and kills Big Shot in a shoot-out back at his club.

Once again, Ford was saddled with a dialogue director, this time Andrew Bennison, who had co-written an earlier and currently lost Ford film *Strong Boy* (1929), and now earned the credit "staged by". Ford recalled:

> Andy was a friend of ours ... so we said he could rehearse the actors. After he'd been working for four days, I went in and he was still on the first scene—and he was stark staring drunk. So I sent him home. Next day he was all right.[6]

Evidently Bennison was responsible for some of the ponderous and slow-moving dialogue exchanges, often punctuated by long and unnecessary pauses. The snappy naturalistic exchanges in the French section and some of the nightclub scenes suggest that Ford took over for those scenes.

Ford seeks to exploit the possibilities of sound by emphasizing the street noises (whistles, hooters, sirens, etc.). He also bathes the action in song with characters singing "On the Banks of the Wabash", "Over There", "The Caissons Go Rolling Along" and "Mademoiselle from Armentières".

Ford enlivens the action with characteristic comic vignettes. Gibbons, mustered into the army, declares that he is a "boigler" (burglar) and is handed a bugle. In the nightclub, an incongruous barber's shop quartet of dinner-jacketed plug-uglies sing sweetly "On the Banks of the Wabash". When Louis presents his father with a German helmet, he promptly puts it under the bed to serve as a chamber pot. Despite such incidental felicities and the comic baseball match, the film must be accounted one of Ford's failures.[7]

Most Fordians dismiss *Born Reckless*. Andrew Sarris said, "By any standard *Born Reckless* is one of the worst movies ever to come out of Hollywood".[8]

[6] Bogdanovich, *John Ford*, p. 128.
[7] Although J. Farrell MacDonald is in the cast list as the District Attorney, it is obviously not him playing the role.
[8] Andrew Sarris, *The John Ford Movie Mystery*, London: Secker and Warburg, 1976, p. 40.

Joseph McBride thought "the dialogue scenes are so wooden and tedious they make the entire film seem comatose".[9] Tag Gallagher similarly complains of its "woodenness".[10] Andrew Sinclair, Ronald L. Davis, Dan Ford and J. A. Place do not mention it at all. One voice is raised in its defense, that of Scott Eyman who says "it isn't bad. It's better than most of the 1930 Fox productions; it has atmosphere, picturesque settings, a good-bad hero and a remarkable charm. It's one of the few Ford films of this period that's brisk and unexpected enough to hold a modern audience's interest".[11]

It was viewed differently at the time. The *New York Times* (June 7, 1930) thought that "[a]lthough this film is not weighty material, it makes a good entertainment" and praised Ford for his "able direction of this current offering which is blessed with clever acting, keen humor and a minimum of stereotyped stuff". *Variety* (June 11, 1930) thought it "only fair ... Plenty of action but with very little relationship between one scene and the next".

MGM hired Ford to direct *Flesh* (1932). He was closely supervised and not permitted to make changes to the script. It is wholly untypical of his work and Karen Morley confirmed that Ford saw it as an assignment and not a personal project.[12] He managed, for instance, to include only one member of his stock company, Ward Bond who has one scene as an American wrestler. Ford shot it much as he shot *The World Moves On* efficiently but with little sense of personal involvement. Much of it consisted of medium shot dialogue exchanges with the camera tracking on movement of character and with infrequent close-ups for emphasis.

It is much more of a Wallace Beery film than a Ford film and was scripted as such by Leonard Praskins and Edgar Allen Woolf from a story by Edmund Goulding with dialogue provided by Broadway playwright Moss Hart. Beery had become a major star playing a vicious thug in MGM's prison drama *The Big House* (1930). He won a Best Actor Oscar as the broken down boxer making a comeback in the smash-hit saga of father love, *The Champ* (1931) and remained an MGM stalwart until his death in 1949. He could play comedy

9 Joseph McBride, *Searching for John Ford*, London: Faber and Faber, 2003, p. 170.
10 Gallagher, *John Ford*, p. 68.
11 Scott Eyman, *Print the Legend: The Life and Times of John Ford*, New York: Simon and Schuster, 1999, p. 123.
12 Eyman, *Print the Legend*, p. 136.

or melodrama in his unique character of the lachrymose lummox/the lovable rogue/the shambling plug-ugly/the uncouth proletarian bruiser with a heart of gold, a type which has no counterpart in modern cinema. *Flesh* was the direct follow-up to *The Champ* with Beery cast as a wrestler rather than a boxer. But it crucially lacked the cute kid (Jackie Cooper) who was one of the keys to the success of the earlier film. The *New York Times* (December 10, 1932) thought Beery was "in his element in this film, and is especially good in the wrestling matches, which look very real" and pronounced Ford's direction "competent". But *Flesh* failed to match *The Champ* in box office appeal. *The Champ* achieved a North American gross of $1.5 million; *Flesh* grossed only $850,000.

Unusually for Ford, *Flesh* dealt with obsessive love: Lora's for Nicky ("It isn't right to love anything the way I love you") and Polokai's for Lora ("I love Lora so much that anyone take her from me, I kill him"). It echoes German Expressionist classics like *The Blue Angel*, *Variety* and *The Last Laugh* in charting the decline and degradation of a basically decent man.

Beery plays Polokai, a naïve, gauche, bashful, trusting innocent, who works as a waiter in the Kaiserhof Beer garden and wrestles for the entertainment of the diners and drinkers. American confidence trickster Lora Nash (Karen Morley) is released from prison and goes to the beer garden where she eats a meal but cannot pay the bill. Polokai who is attracted to her pays the bill and discovering she has nowhere to stay, allows her to use the bed in his room, while he sleeps on the sofa. She obtains another room in the building and teaches him to read English. Herman (Jean Hersholt) and his wife Clara who own the beer garden and apartment building celebrate selling their business and preparing to move to the United States to open a beer garden in Hoboken, New Jersey. Polokai and Lora go boating with the Hermans and Herman proposes marriage to Lora on behalf of Polokai, who is too shy to broach the subject. That night Lora tries to rob Polokai and flee. When she is caught, she tells Polokai that she needs the money to get her brother Nicky out of jail. Polokai willingly pays his fine and gets him out of jail, welcoming him to the apartment. But in fact Nicky (Ricardo Cortez) is Lora's lover and accomplice and she is pregnant by him.

Nicky, pretending his mother is ill, borrows money from Polokai and leaves for America. In desperation Lora marries Polokai and subsequently bears a child, which Polokai believes to be his. He wins the wrestling championship

Figure 5.2 Ricardo Cortez and Karen Morley in *Flesh* (MGM, 1932)

of Germany and he and Lora emigrate to the United States where they are welcomed by the Hermans and other old friends. Nicky turns up again, offering to manage Polokai. Wrestling promoter Willard offers to take him on if he will throw matches when required. Polokai refuses and then loses his first fight because of a crooked referee. Polokai wants to return to Germany. But Lora takes the baby, leaves him and returns to Nicky. He refuses to take her in, roughs her up and sends her back to persuade Polokai to do what Willard wants. Polokai agrees. He wins his first fights, establishes a reputation but then is matched with world champion Zbyszko. Willard orders him to throw the fight, so he can clean up with the bookies. Tormented by shame and guilt, Polokai gets drunk. Lora, who hates seeing Polokai hurt, confesses all. When Nicky tries to silence her, an aroused Polokai strangles him. He goes on to win the fight but is arrested as he leaves the ring. The final scene takes place in prison where Polokai is visited by Lora. She tells him that the District Attorney will go easy on him and she apologizes for all she has done to him, saying she will now go away. But Polokai declares that she is still his wife and he loves her and wants her back. They touch hands through the bars and she agrees to wait for him.

There is clear evidence that Ford tried to lighten the prevailing gloom of the story by the insertion of comic business. He successfully creates the warmth and bustle of the beer garden with its voluble head waiter Pepi (Herman Bing), the bossy but good-hearted Frau Herman and her henpecked husband, and a diminutive accident-prone waiter Karl (Vince Barnett) who keeps getting drenched in beer and told off by Pepi. Ford also repeats the scene from *Up the River* (and which later reappears in *Rio Grande* and *The Quiet Man*) in which Beery is poked and punched to show him the banned moves in wrestling. He ends up knocking his opponent out. There is also a comic scene when Polokai accidentally locks himself and Lora into the bedroom and, anxious to dispel her suspicions of his motives, he punches out the panel of the door with his fist just before Lora successfully unlocks it.

Beery dominates the proceedings but Karen Morley gives a richly nuanced performance as the tough, wisecracking female convict who under the surface is intensely vulnerable, wracked by her desperate love for Nicky and her shame at misleading the innocent Polokai. Lindsay Anderson thought her performance "first rate".[13]

There were occasions when Ford took on projects that would appear to have been more suited to other directors. *When Willie Comes Marching Home* seemed to be more of a Preston Sturges project than a Ford film. *The Whole Town's Talking* (1936) looked rather like a Capra film. It felt like one too, with Robert Riskin and Jo Swerling, Capra's regular screenwriters, co-writing the script based on a story by W. R. Burnett. It also had Jean Arthur giving the first version of the feisty, independent, wisecracking professional woman befriending the innocent hapless male she was to play so notably in Capra's masterpieces *Mr. Deeds Goes to Town* (1936) and *Mr. Smith Goes to Washington* (1939). Most Ford scholars have professed disappointment with it though Andrew Sarris called it "one of the most likeable and least likely works in Ford's oeuvre".[14] J. A. Place thought it "a totally unsuitable film for Ford".[15] Andrew Sinclair said it was "all good broad fun but hardly Ford at his most definitive".[16] Scott Eyman thought Ford took it on "for the sake of staying busy", citing

[13] Lindsay Anderson, *About John Ford,* London: Plexus, 1981, p. 57.
[14] Sarris, *The John Ford Movie Mystery*, p. 65.
[15] J. A. Place, *The Non-Western Films of John Ford*, Secaucus: Citadel Press, 1979, p. 46.
[16] Sinclair, *John Ford*, p. 59.

W. R. Burnett's comment that Ford contributed nothing to the project at story conferences.[17] Ford himself said characteristically: "It was all right—I never saw it".[18] But this general dismissal does not accord with its contemporary reception. The *New York Times* (March 1, 1935) called it "riotous", saying "Pungently written, wittily produced and topped off with a splendid dual performance by Edward G. Robinson, it may be handsomely recommended as the best of the new year's screen comedies". *Variety* (March 6, 1935) said "It's a model in the expert manipulation of such hokum as the office worm thrust into danger by coincidence and emerging with fame, fortune and the girl" and found Robinson's mild-mannered clerk "human and believable". Edward G. Robinson, borrowed from Warner Bros by Columbia to star, recalled in his autobiography:

> As for the director, John Ford, from my first meeting with him to the day the picture was completed I knew I was in the hands of the consummate professional. I felt safe and secure with him … Almost entirely throughout the film, when we clashed, it turned out he was right and I was wrong. The main point to be made is that he would sit me down and *show* me where I was wrong. He is a totally remarkable director and one of the few deserving a place in the Pantheon.[19]

This certainly bespeaks a commitment to the project and Ford's involvement can also be seen in the presence in the cast of several of his regulars (Wallace Ford, J. Farrell MacDonald, Edward Brophy, Francis Ford). He employs rapid lateral tracking shots, dynamic cross-cutting and surges of action involving the police and the press to imbue the story with pace and urgency. It emerges as a fast-moving and thoroughly contemporary comedy. It depicts the tyranny of office life with rows of identical desks manned by wage slaves toiling away on accounts. Cars race at full speed through the streets. Screaming newspaper headlines punctuate the action. The police hector and bully, the press harass and intrude. Ford handles the farcical complications and multiple confusions with assurance and aplomb.

Mild-mannered, conscientious and wholly inoffensive clerk Arthur Ferguson Jones is plunged into the modern maelstrom by virtue of his facial similarity to

[17] Eyman, *Print the Legend*, p. 188.
[18] Bogdanovich, *John Ford*, p. 131.
[19] Edward G. Robinson, *All My Yesterdays*, New York: Hawthorn Books, 1973, p. 152.

escaped gangster "Killer" Mannion. Edward G. Robinson's portrayal of the two characters is neatly differentiated and entirely convincing.

Jones, who lives alone with a cat Abelard and a canary Edouard (not Heloise as Gallagher has it), is an incurable romantic.[20] He idolizes his fellow employee at the accountancy firm, Miss Wilhelmina Clark, known as "Bill". He calls her Cymbaline and keeps her photograph next to his bed. He writes poetry which he sends to her anonymously. He dreams of visiting exotic overseas locations like Egypt and Shanghai. He has never been late for work in eight years. When the boss J. G. Carpenter hears of this he orders office manager Mr. Seaver to give him a rise and to sack the next employee who arrives late. But Jones oversleeps as his new alarm clock fails to work and he arrives late. This gives Mr. Seaver a dilemma—he has to give a rise to and sack the same person. The dilemma is resolved when Miss Clark arrives even later, sauntering in, smoking and shrugging off Seaver's rebuke. She will have to leave at the end of the week. Sitting at the desk reading the paper, she spots the resemblance between Jones and "Killer" Mannion, whose photograph is in the paper following his escape from prison. The office gather round to see and have a good laugh at Jones's expense. Later she joins him at the restaurant for lunch and he tells her of his dreams of being a writer and visiting exotic places. Their conversation is intercut with scenes of a fellow diner, Mr. Hoyt (Donald Meek) spotting the Mannion resemblance and calling the police. The police descend on the restaurant in a phalanx of cars, pour in and grab Jones and Miss Clark, hauling them off to the station despite their protestations. In the reporters' room at police headquarters, the reporters, all hard-boiled, fast-talking, cigar-chewing hustlers, wait for news and when it arrives race for the telephones and then crowd into the office for information. Ford now intercuts between scenes of a terrified Jones being given the third degree by bullying policemen while protesting his innocence ("I am a member of the YMCA") and asserting his identity and scenes of Miss Clark being questioned by a pair of rival Irish cops, Boyle and Howe, gleefully assuming the character of a gangster's moll and confessing to all Mannion's crimes. Successively Jones's employer, J. G. Carpenter, the Prison Warden and a nervous "Slugs" Martin (Edward Brophy), the stool pigeon who betrayed Mannion to the police, all identify

[20] Gallagher, *John Ford*, p. 108.

Jones as Mannion. He is about to be charged when reporter Healy (Wallace Ford) rushes in to say that Mannion has just been identified robbing a bank, Mr. Seaver arrives to identify Jones and his fingerprints prove that Jones is not Mannion. He has to be released but he is given a police passport identifying him as Jones in case he is mistakenly arrested again. He is bustled into the Reporters' Room and bombarded with questions. Very unusually Ford deploys a montage of flash photography superimposed on close-ups of a sweating Jones who eventually faints under the pressure.

Back at the office J. G. Carpenter sends for Jones and everyone expects him to get the sack. Instead Carpenter and Healy want to use his name on a series of ghost-written articles about the life of Mannion by "the man who looks like Mannion". Carpenter thinks the publicity would help the firm. Although Jones neither smokes nor drinks, he is plied with cigars and whiskey and in a very funny scene, all three get drunk together. Eventually the door of Carpenter's office opens, voices are heard drunkenly singing "It's Always Fair Weather" and Jones emerges, declares to the horrified Seaver "A woman is only a woman but a good cigar is a smoke", tells him he is taking the afternoon off, reinstates Miss Clark, kisses her and leaves shouting "Whoopee".

When he gets home, he finds Mannion waiting, played by Robinson as a sneering, tough-talking bully. Jones's courage evaporates. Mannion tells him he is going to hide out at Jones's flat and carry on his criminal career, using the passport to establish his innocence. Terrified that Mannion will see the newspaper article in which he calls Mannion a coward, Jones tries to contact Healy to have it withdrawn but fails to find him. Meanwhile Miss Clark tells Jones he needs looking after and she has appointed herself his guardian. She begins by negotiating payment for his articles in the *Daily Record*. Back at the flat, Mannion sees Jones's column. Jones offers to get it stopped but Mannion says it can continue but he will dictate the content. He now gives a bravura account in underworld slang of his prison escape. Miss Clark calls to see Jones, who is out, and encounters Mannion who kisses her. She spots his gun and heads to a phone box to call the police but is seized by Mannion's henchmen who have followed her. The police decide that until Mannion is caught, Jones would be safer in protective custody at the prison. Mannion ties Jones up and takes his place at the prison where he seeks out and eliminates "Slugs" Martin (his death taking place off camera). Jones is summoned back from prison by

the police because the Justice Department have become suspicious of the detail in the ghosted column. Mannion hijacks the car taking him back and with it Mr. Seaver, who, having to come up to visit Jones, was being given a lift back to town. Back in his hideout with Miss Clark and Seaver imprisoned in the cellar, Mannion decides to have Jones killed but in the guise of Mannion. He releases Jones and tells him a sob story about planning to leave the country and wanting to provide for his mother. So he asks Jones, disguising him with a mustache, to deposit money for her at the Bank. He then phones the police to tell them Mannion is going to rob the Bank. Once again, the police swarm in, remove the staff, fill the Bank with marksmen and wait. Jones races to the Bank, realizes he has left the money behind and turns back. He is spotted by Mr. Hoyt who follows him. Mannion had gone out to see a girlfriend and when Jones arrives the gang mistake him for Mannion. When Mannion is seen returning, they think it is Jones and ask if he should be killed. Jones agrees and Mannion is machine-gunned when he enters the building. Jones drives the gangsters back with the machine gun, frees Miss Clark, Mr. Seaver and his Aunt Agatha, seized when she came to visit him. The police, alerted by Mr. Hoyt, arrive to round up the criminals. Jones faints. The film ends with newspapers proclaiming Jones the killer of Mannion. He has received the reward and has married Miss Clark. They are last seen boarding a ship for Shanghai.

The film is full of incidental delights: Jones pulling faces in the mirror as he tries to look like Mannion and when he does it in the restaurant, provoking Mr. Hoyt to put his tongue out in retaliation; Jones getting drunk with Carpenter and Healy; Etienne Girardot as the fussy, diminutive office manager preoccupied with the "McIntyre Account"; Donald Meek constantly seeking to claim the reward for identifying Mannion. The photography (Joseph H. August) is also extremely well done with one particularly memorable shot in which Robinson as Mannion is looking over the shoulder of Robinson as Jones in the mirror. There would not be another crime film from Ford until 1957.

One of the most unlikely of Ford's projects was his final crime film *Gideon's Day*, based on J. J. Marric's 1955 novel, filmed in London in 1957 and released in Britain in March 1958 and the United States in February 1959. Most Fordians have dismissed it as "anomalous" (Joseph McBride), "peculiar" (Andrew Sarris) or "a minor work" (Andrew Sinclair) or have ignored it completely

(Dan Ford).[21] Even some of the people who worked on it did not think much of it. Cinematographer Freddie Young said: "*Gideon* was not a great film … That particular thing was not his cup of tea. I don't know why he did it".[22] Art director Ken Adam said: "It wasn't a very interesting picture".[23] Scriptwriter T. E. B. Clarke described it as "easily forgotten".[24] It cannot have been helped by the appalling treatment of the finished film by its distributor, Columbia Pictures. A joint production of John Ford Productions and Columbia (British) Pictures, filmed at MGM's Borehamwood Studio, and shot in glorious Technicolor by Freddie Young, it was cut from ninety minutes to fifty-four minutes, retitled *Gideon of Scotland Yard* and released to art house cinemas in black and white. It cost only $453,000 to make and still only grossed an estimated $400,000.[25]

However, the film did have some admirers. French critics liked it. *Cahiers du Cinéma* went so far as to call it "the freest, most direct, least fabricated film ever to sprout from one of Her Majesty's studios".[26] Tag Gallagher thought it "among Ford's most personal and ambitious movies".[27] For what it is worth, I consider it one of his late masterpieces, handicapped only by a mediocre score (Douglas Gamley) consisting largely of variations on "London Bridge is Falling Down". With its 50 speaking parts and 30 distinct episodes, it pioneers the multi-plot *policiers* of the future. When ITV produced *Gideon's Way* (1965–6) starring John Gregson as Gideon and based on the Marric novels, they dramatized only one theme in each episode from the multi-plot structures. It would be 25 years after Ford's film that the television series *Hill Street Blues* (1980–7) would be hailed as an innovator for the multi-plot structure of its episodes.

As usual Ford's own comments are unhelpful. He told Peter Bogdanovich: "I wanted to get away for a while, so I said I'd like to do a Scotland Yard thing and we went over and did it".[28] There is evidence that it was indeed

21 McBride, *Searching for John Ford*, p. 585; Sarris, *The John Ford Movie Mystery*, p. 140; Sinclair, *John Ford*, p. 184.
22 Eyman, *Print the Legend*, p. 459.
23 Christopher Frayling, *Ken Adam: The Art of Production Design*, London: Faber and Faber, 2005, p. 77.
24 T. E. B. Clarke, *This Is Where I Came In*, London: Michael Joseph, 1974, p. 196.
25 Gallagher, *John Ford*, p. 500.
26 Gallagher, *John Ford*, p. 358.
27 Gallagher, *John Ford*, p. 359.
28 Bogdanovich, *John Ford*, p. 144.

something personal to Ford. It is a little known fact that he was a great fan of suspense stories and in particular the Gideon novels of J. J. Marric (the pen name of prolific thriller writer John Creasey).[29] His own company John Ford Productions co-produced it and Ford accepted a salary of only $150,000 plus a percentage of the profits (of which there were none). Ford worked closely on the script with T. E. B. Clarke, who had written the classic British police thriller *The Blue Lamp* (1949). The result was an intricate overlapping mosaic of stories distilling the career of a senior police officer into a single day. It underlines Ford's deeply held beliefs in family, duty and service.

The key to Ford's understanding of Scotland Yard is a comment he made to Clarke: "Scotland Yard . . . is the British equivalent of the Wild West".[30] For Ford then the London police are an analog of the US cavalry. Jack Hawkins, who looks exactly like the book's description of Gideon, plays the commanding officer. Ford even gives him some of John Wayne's lines from the cavalry trilogy: "I suppose it's what we're paid for" when given an unpleasant duty and "You're due for a promotion in ten or twenty years" to a subordinate doing a good job. He tells a corrupt policeman "You're a renegade and a traitor and if this were the army, you'd be shot—and I'd be pleased to pull the trigger" (a line from the book). Scotland Yard functions like an army headquarters, the flurries of activity, the camaraderie, the phone continually ringing, giving it the air of an authentic hub of action and teamwork. Clarke tells a revealing anecdote about Ford's input into the script and vision of Scotland Yard: "'We'll have Michael Trubshawe as Gideon's assistant, I like the quirk of that officer's moustache on a three-stripe sergeant. And give him a long row of ribbons. This character had a fine war career, he won all of those various medals you British dish out'. Clarke replied: 'the ribbons are out, Jack, because Gideon is a plain clothes officer and that goes for his assistant too. The CID and the uniformed branch work separately, they don't mix'. 'They do in this picture. Mike Trubshawe wears uniform'. And he did. And nobody queried it. Accuracy is fine so long as it's not allowed to become a despoiler of entertainment".[31] Gideon's team consists of Trubshawe's Sergeant Golightly, Frank Lawton's amiable Sergeant Frank Liggot, and John Loder's Sergeant "Duke" Ponsford who with his rolling gait and

[29] McBride, *Searching for John Ford*, p. 424.
[30] Clarke, *This Is Where I Came In*, p. 194.
[31] Clarke, *This Is Where I Came In*, pp. 194–5.

bowler hat strongly recalls Victor McLaglen in his demob suit in *She Wore a Yellow Ribbon*. None of these characters are in the book and are inventions of Ford and Clarke. The casting of Anna Lee, a cavalry wife in *Fort Apache*, as Mrs. Kate Gideon simply deepens the cavalry analogy. In a classic Fordian scene Gideon and his team drop in at his home for lunch and promptly take over Kate's kitchen, breaking out the bottles of beer from the fridge.

Interestingly Hawkins, who had not worked with Ford before, writes that he "grew devoted to him because he was a perfect actor's director".[32] Typically Ford surrounded himself as far as possible with old friends and actors he had worked with before. His old friend Michael Killanin produced. He recruited Cyril Cusack, Maureen Potter, Donal Donnelly, Michael Trubshawe and Frank Lawton from the cast of *The Rising of the Moon* and John Loder from *Seas Beneath* and *How Green Was My Valley*. He reached even further back to *The Informer* to cast Grizelda Hervey. He gave a screen debut to his god-daughter Anna Massey, daughter of Raymond and born during the filming of *The Hurricane*. Anna Lee was cast in her first film for some years after Ford had helped to get her name removed from the Hollywood black list, on which she had been included by mistake, confused with an actress called Ann Lee.[33]

Ford applied his customary method to the filming. Clarke recalled: "I took on the assignment knowing that my script was sure to undergo drastic changes on the floor. Ford treated even a final screenplay as little more than a guide, yet from the beginning of our talks he seemed to be looking at his eventual screen and mentally taking note of its every detail".[34] He told Ken Adam: "If you think that I'm the sort of arty-crafty director who pokes the camera up the nostrils of the actors or between their legs, that's not me. I shoot a picture the way I see it, the way I feel the camera move. And if I don't like the script, I tear out the pages. If you understand that, I'm sure we'll get on fine".[35] Anna Massey, observing Ford at first hand, later wrote:

> Working with Ford was fascinating … He never did any cover unless absolutely necessary, and he never did more than one take. He edited as he

[32] Jack Hawkins, *Anything for a Quiet Life*, London: Coronet Books, 1975, p. 163.
[33] Anna Lee, *Anna Lee* (with Barbara Roisman Cooper), Jefferson, NC: McFarland and Company, 2007, p. 226.
[34] Clarke, *This Is Where I Came In*, p. 194.
[35] Frayling, *Ken Adam*, p. 77.

Figure 5.3 Michael Trubshawe, Grizelda Hervey, Jack Hawkins and Frank Lawton in *Gideon's Day/Gideon of Scotland Yard* (Columbia, 1958)

filmed. His manner was easy and congenial. He knew what he wanted and went about achieving it with a minimum of fuss. The crew were in awe of him. His directions to them and the actors were simple and precise. The shot would be set up with the crew and cast, and then the actors would retire while the lighting was worked on. When the actors returned, we rehearsed until Mr. Ford felt everyone was completely prepared before we started shooting.[36]

Much of the film is done in medium shot with scenes framed in windows, doorways, corridors and arches. Ford tracks unobtrusively on movement of characters and dollies in rapidly to show surprise. There are very few close-ups.

The film is narrated by Chief Inspector George Gideon, his face framed by a window as he looks out over London at night from his office in Scotland

[36] Anna Massey, *Telling Some Tales,* London: Hutchinson, 2006, pp. 66–7.

Yard. The first sequence establishes Gideon in context as a family man. He quarrels with his eldest daughter Sally (Anna Massey) over first use of the bathroom. He joins his longsuffering wife Kate and two younger children Jane and Ronnie for breakfast but before he can finish it he is called away by an urgent phone call, which will be the pattern of his day. First, he drops the two younger children off at school and Sally at the Royal Academy of Music, where he is given a ticket by eager beaver young constable Simon Farnaby-Green for jumping a red light. Several running themes are established in this opening sequence. There are Gideon's attempts to leave work in time for an evening concert at the Academy where Sally is playing the violin in Strauss's *Don Juan*—he fails to make it. There are a succession of exasperated encounters with the coltish Farnaby-Green, beautifully played by Andrew Ray. There are repeated requests from Kate to Gideon to bring home fresh salmon for supper—he eventually turns up late but with haddock. This continually confirms the all-consuming nature of his job.

Gideon's breakfast call was from "Birdy" Sparrow (Cyril Cusack), a cockney ex-convict now working as caretaker at St. Ethelburg's church. He has information that Sergeant Eric Kirby has been taking bribes to turn a blind eye to the selling of drugs in a local pub. Ford as a good Irishman usually detests informing. But in this case it is emphasized that "Birdy" only informs on cases involving drugs because his daughter died after being involved in drugs and prostitution; he wants to protect young people from going the same way. Gideon confronts Kirby (Derek Bond) who angrily denies taking bribes. But Gideon reveals that he has been having him followed and has enough evidence to suspend him. Gideon interrogates Kirby's wife about their income and lifestyle. Mrs. Kirby is played by Grizelda Hervey, who after her brief stay in Hollywood in the 1930s had returned to Britain, becoming a celebrated radio actress on the BBC, notable for playing hysterical and highly strung women. The role of Mrs. Kirby gives her plenty of scope as she lies desperately to protect her husband and eventually throws a glass of alcohol in Gideon's face. But Gideon has to return to break the news of Eric's death at the hands of a hit and run driver. Gideon suspects he has been murdered by a criminal gang from whom he was also taking bribes.

In the next case, an escaped psychiatric patient Arthur Sayer (Laurence Naismith), suspected of murdering a young girl in Manchester, is on his way to

London. He is welcomed by his old landlady Mrs. Saparelli (Marjorie Rhodes) but later murders her daughter Dolly. Ford handles the sex murder wordlessly, with great delicacy and without showing the actual deed. After Sayer arrives at the Saparellis', he stares fixedly at Dolly as she goes upstairs to wash her hair. Sitting in the kitchen with a cup of tea after Mrs. Saparelli has gone out, he slowly lifts his eyes to the ceiling and then deliberately makes his way upstairs. Ford then dissolves to a rapid dolly-in to Gideon's face as he receives the news of the murder on the phone. Sayer is spotted and captured by Farnaby-Green in a cinema washroom. In a moving scene, Gideon visits Mrs. Saparelli to tell her Sayer has been caught. She sits brokenly in the kitchen, surrounded by neighbors, replying to him mechanically.

Gideon investigates the latest of a series of payroll robberies. The tire tracks at the scene of the robbery match those at the scene of Kirby's death, establishing a link between Kirby and this gang. A drunken and tearful Mrs. Kirby turns up at Gideon's office to reveal that Kirby had been having an affair. They find a photograph of the girl Joanna Delafield (Dianne Foster) in Kirby's locker at the yard.

Gideon nips into a pub for a quick snack and is accosted by Mrs. Sparrow. In the book she is a cockney; Ford turns her into an Irishwoman to accommodate a typically ebullient performance from the irrepressible Maureen Potter who jumps all over Gideon, orders drinks ("A slug of gin if you please") and warns him that the razor boys are after Birdy for informing. All this is watched in silent disapproval by a typically Fordian group of elderly, stuffy English gentlemen.

Birdy is chased into the church by the razor boys Simmo and Feeney but is protected by the curate, Rev. Julian Small (Jack Watling) who floors the attackers with judo throws and hands them over to the police. Small has been the butt of local children who regarded him as "a sissy" and had refused to join the boys' club. He declined to tell them he had been a commando in the war, not wanting to glorify his wartime experiences which had led to his entering the church. But his defeat of the razor boys earns him the immediate respect of the youngsters who now file obediently into the boys' club.

Gideon calls on Joanna Delafield, who is the wife of painter Paul Delafield (Ronald Howard), the leader of the payroll gang. He tells her Kirby is dead, Ford using a rapid dolly-in to her face to capture her surprise. She feigns

innocence and ignorance. But armed with her photograph, the police ascertain that she has worked briefly at all the firms that have been robbed, evidently providing information to the gang. Gideon returns to arrest Joanna but is confronted by a gun-wielding Paul. Paul gets her to hold the gun while he packs for flight. In fact he escapes. Gideon tells her that Paul will hang for the murder of Kirby and terrifies her with a description of a hanging. This is not in the book and parallels the similar scene in *Up the River* when Spencer Tracy deters Humphrey Bogart from killing a crook by describing an execution. Gideon disarms Joanna and tells her Paul will have fled, abandoning her to the police.

Back in the office, it is evening and Gideon receives reports of a raid on the St. James' Safety Deposit by a gang of aristocratic amateurs, "the posh boys". Their leader Fitzhubert has ruthlessly gunned down the night watchman. Police surround the building, Fitzhubert's terrified accomplices surrender. Fitzhubert attempts to flee but is rugby-tackled and captured by Gideon. Gideon finally gets home, having missed the concert, to find Sally turning up with her new boyfriend—Farnaby-Green. A phone call summons Gideon to London Airport to identify Paul Delafield who has been apprehended. Farnaby-Green drives him in his own car but receives a ticket for jumping a red light. Gideon sits back in amused satisfaction.

Despite his obvious respect for the dedicated professionalism of the CID, Ford gets in regular satirical digs at the English, with a dear old vicar chuntering about Gothic architecture, the Assistant Commissioner supervising the installation of a moose head on the wall of his office, and cups of tea being regularly delivered to lubricate the action.

John Ford's Wars

War is a recurrent theme in Ford's work. For Ford war was at once a vehicle for serving your country and testing your manhood, for displaying the qualities of duty, sacrifice and comradeship. But it was also one of the agents for the destruction of the family, another of Ford's preoccupations. During the course of his career, he tackled the American Civil War (*The Horse Soldiers, How the West Was Won*), the British experience in World War One (*Black Watch, The Lost Patrol*), and the Irish War of Independence (*The Informer, The Plough and the Stars*). Ford's special feeling for the Navy will be explored in Chapter 7 but this chapter concentrates on Ford's treatment of America's foreign wars, World War One, World War Two, the Korean War and Vietnam.

Ford's World War One drama *Four Sons* was remarkable in two respects. Firstly, it was about the impact of war on a German family and secondly, it contained only one battlefield scene. It highlighted archetypal Fordian themes: the tragedy of family break-up, the pivotal role of the mother and the enriching nature of community.

Four Sons (1928), scripted by Philip Klein, was based on a *Saturday Evening Post* story, *Grandma Bernle Learns Her Letters*, by I. A. R. Wylie. Ford had read it and persuaded Fox to buy it for him. Of the finished film, he later told Peter Bogdanovich: "I like that picture very much".[1]

Not only was the film very personal to Ford, it marked an artistic turning point in his career. He was enormously influenced by F. W. Murnau's Expressionistic masterpiece *Sunrise* (1927), which he declared the greatest film yet made.[2] He was awe-struck by the lighting, the composition of the shots, the rhythm of the editing, the use of visual symbolism. Sailing to Europe to shoot

[1] Peter Bogdanovich, *John Ford,* Berkeley and Los Angeles: University of California Press, 1978, p. 49.
[2] Joseph McBride, *Searching for John Ford,* London: Faber and Faber, 2003, p. 158.

background footage for *Four Sons*, Ford took the opportunity to visit Murnau in Berlin. Dan Ford recalled:

> Murnau allowed John to examine artists' renderings and design sketches, and explained in depth the preproduction techniques of German expressionist cinema. Fascinated, John screened the films of the German Golden Age . . . *The Cabinet of Doctor Caligari*, Lang's *Destiny* and *Metropolis*, Murnau's own *Nosferatu* and *The Last Laugh*—films that used design and lighting techniques of the greatest sophistication to translate their stories to the screen in purely visual terms. John studied them scene by scene, making mental notes on their techniques, their slow deliberate rhythms. Many of the lessons he learned in Berlin would become a vital part of his own visual style.[3]

Ford consciously set out to create an "art film" and in *Four* Sons, ravishingly photographed by George Schneiderman and Charles G. Clarke, he succeeded. The Murnau influence can be seen everywhere, emphasized by Ford's use of the European village and city street sets on which Murnau had filmed *Sunrise*. Ford's extravagantly mustached village Postman directly resembles Emil Jannings' doorman in *The Last Laugh*, and the scenes of Joseph and Grandma bewildered by the busy, bustling city streets directly recalls the reactions of George O'Brien and Janet Gaynor to the big city in *Sunrise*.

Photoplay voted *Four Sons* the best film of the year and it became Ford's biggest box office success since his Western epic *The Iron Horse* (1924). *Variety* (February 15, 1928), noting the influence of *Sunrise*, was unstinting in its praise, calling *Four Sons*:

> a profoundly moving picture of family life in Germany during the war . . . As an artistic creation it is magnificent . . . In its favor are some of the finest and most touching passages of high sentiment ever shown on the screen . . . The film is an achievement in artless realism. There isn't a moment when it does not live and the whole production is a revel in beauty and significant details with camera shots that are arresting.

The importance of the film to Ford is evidenced by his suggestion to Fox in 1940 that it be remade. It was remade, updated to take place during the Munich crisis

[3] Dan Ford, *The Unquiet Man,* London: William Kimber, 1982, p. 42.

and the German occupation of the Sudetenland, but directed by Archie Mayo. Ford took on another saga of family disintegration, *How Green Was My Valley*.

Shot in the summer of 1927, *Four Sons* was released in early 1928 with a synchronized musical score and sound effects. The score mingled Schubert songs ("Russlein", "Song of Love"), German tunes ("Die Wacht am Rhein"), and American songs ("Over There", "When Johnny Comes Marching Home"), with Grandma having her own theme song *Little Mother*.

The film contains some silent screen acting of a high order, not least from Margaret Mann as Grandma Bernle. She had been plucked from the ranks of extras at the age of sixty by studio chief Winfield Sheehan and succeeded in giving a performance which the *New York Times* (February 14, 1928) pronounced excellent.

The film is largely set in the Bavarian village of Burgendorf introduced by the intertitle: "The Old World—A deeply contented village, people gentle and kind". Ford proceeds to establish what is his ideal community—a rural Catholic peasant community, strongly rooted in family and good neighborliness. In a long flowing tracking shot, Ford's camera follows the village Postman through the main street of the village as he cheerily encounters the schoolmaster, the burgomaster, the blacksmith and the local children. Meanwhile Mother Bernle does her washing at the river and taking it home places the linen in each of four drawers, marked with the names of her four sons, and as she does the image of the son is superimposed on the drawer: Franz the soldier, Joseph the farmer, Johann the blacksmith and Andreas the shepherd. The Postman delivers a letter for Joseph from a friend in America urging him to come out and join him.

The new garrison commandant, Major Von Stomm (Earle Foxe) arrives and is met at the station by his staff. Von Stomm provides the film's one jarring note. He is a caricatured Prussian officer, a sneering, strutting bully, complete with dueling scar and monocle, almost a pantomime villain. He gets his men to evict the schoolmaster from his table in the inn so the officers can occupy it. When a haywain passes and hay falls out onto Von Stomm, Joseph jumps down to clear it up and Von Stomm slaps his face. Later when a black cat crosses his path, he pulls out his saber and kills it.

It is Mother Bernle's birthday, the first of three around which the narrative is structured. She distributes honey cakes among the children. The four sons

gather for dinner, in Ford's classic and regularly used table shot, with the table end on to the camera and the characters seated on both sides. Joseph reads his letter and expresses the wish that he could go to America ("It's a great country, America. Everyone is equal.") Mother gives Joseph her savings to enable him to go. The villagers converge on the house to celebrate Mother Bernle's birthday. The burgomaster endeavors to read an address but is upstaged by the arrival of the innkeeper with a roast suckling pig. Everyone joins in the singing and dancing. The joyous affirmation of community feeling directly prefigures similar scenes in *How Green Was My Valley*.

Time passes and a letter arrives from Joseph in America, whose details we see in flashback: Joseph's arrival in New York, his getting a job in a delicatessen and a developing romance with Annabelle. The camera rocks back and forth with them on a swing. War is declared in 1914. The Prussian officers around the table drink a toast and then smash their glasses, a scene exactly duplicated in the British officers' mess in *Black Watch* when war is declared.

Franz and Johann in uniform reverently take leave of their mother and join their regiment. The outbreak of war is indicated by bells, banners, bouquets of flowers and the celebratory quaffing of beer and champagne. In a telling shot, Ford films the marching troops from over the crosses in the village cemetery, foreshadowing tragedy. It is a set-up he will repeat in *Wee Willie Winkie* and *What Price Glory*. The troop train departs with Franz and Johann saying they will be back in three months.

In America, Joseph now owns the delicatessen, has become an American citizen and is married to Annabelle. In a wonderfully naturalistic scene Annabelle baths the baby watched by an admiring Joseph and the Ice Man, played by Jack Pennick in the first of more than 40 appearances in Ford films. Mother Bernle is showing a photograph of her baby grandson to the other women who are in her kitchen making comforts for the troops. There is a telling shot of the shadow on the wall of the Postman holding a letter. He makes his way slowly and reluctantly with the letter behind his back until he reaches Mother Bernle's and sadly hands it over. It announces the deaths of Franz and Johann on the Russian front. Mother Bernle retreats silently to her bedroom and sits there, bathed in a shaft of light, the sorrowing mother grieving in private.

In the United States, the name of the delicatessen changes from German–American to Liberty Delicatessen, signifying America's entry into the war in

1917. Joseph, recalling in flashback the slap from Von Stomm, enlists and finds himself sitting next to the Ice Man, who is also joining up.

By now, Germany is starving. It is Mother Bernle's birthday again but in contrast with the sunlit cheerfulness of the earlier birthday, it is dark and rain-soaked. She joins the queue at a Red Cross soup kitchen. She is surrounded by the children and in place of the honey cakes she can no longer make, she divides up her soup ration between them. As she and Andreas sit down to supper, Von Stomm staggers in, denounces her as the mother of a traitor and orders Andreas to report to the barracks for military service. After his diatribe, she points to the two certificates on the wall testifying to the deaths of Franz and Johann in the army. Shamed, one of Von Stomm's aides returns and silently kisses her hand after the other officers leave. That night, Mother Bernle watches through barracks windows as Andreas' flowing locks are shorn by a grinning soldier. There is a moving station farewell as Mother Bernle struggles through a sea of departing soldiers to hand a basket of food to Andreas and to clasp his hand.

In the sole battlefield scene, captioned "November 9", with fog drifting over a cornfield at the front, a small group of American soldiers listen to a wounded German crying out "Mutterchen" (Little Mother). The Ice Man comments reflectively: "I guess those fellows have mothers too". Joseph crawls out across the field to give water to the injured soldier. It is Andreas, who says "thank you—Joseph" and dies in his arms. But there is no time to linger as the Americans advance.

Mother Bernle is washing her linen in the river when the bells ring to signal the end of the war. A one-legged man, a one-armed man and a blind man, apparently all veterans, are seen approaching the church to give thanks. Mother is expecting Andreas home but the Postman once again arrives with a letter announcing his death.

The soldiers now approach Von Stomm and tell him the regiment has mutinied and he has ten minutes to shoot himself before they do it. He changes into his best uniform, puts on his medals and screws his monocle into his eye. The grinning soldiers outside the door listen as a single shot is heard.

Joseph and the Ice Man return to the United States and find that Annabelle has developed the delicatessen into a chain of restaurants and the baby is now a sailor-suited little boy who asks: "Are you my old man?". In Burgendorf,

Mother Bernle sits alone at the dinner table, the ghostly figures of the four sons superimposed on the empty seats.

The Postman at last has some good news. He brings a letter from Joseph asking Mother Bernle to join him in America. The villagers all gather to celebrate her good news as they had before. In order to be admitted to the United States, Mother Bernle must be literate and has to learn her letters. She studies alongside the children in a schoolroom presided over by the now one-armed schoolmaster, another victim of the war. She passes the examination and departs by train.

It is once again her birthday and Joseph and Annabelle have prepared the birthday cake. But at Ellis Island, tired and confused Mother Bernle forgets her letters and is held overnight for re-examination. She wanders off into the city and is lost amid the bustle. The authorities alert Joseph and Annabelle who begin to search for her. A policeman (accompanied on the soundtrack by "The Wearing of the Green" to indicate his Irish origin) finds her sitting on the pavement. She is identified and taken to Joseph's house and when he and Annabelle return from their fruitless search, they find her asleep by the fire with her grandson in her arms, as a tenor sings "Little Mother" on the soundtrack.

It was an article of faith for Ford only to move the camera when necessary. He thought that too much unmotivated camera movement made the audience screen-conscious and distracted them from the storytelling. So he tracks only on movement of a train, tramcar, bus, or haywain, alongside marching troops or following the Postman through the village. He frames shots in doors and windows. He uses close-ups sparingly and tellingly, preferring on the whole to compose within the frame. In *Four Sons* the close-ups represent points of intense emotion, as when Mother Bernle is looking through the barracks window at Andreas getting his head shaved. There is a series of close-ups of the American soldiers as they hear the wounded German crying "Mutterchen". There are also multiple close-ups as the villagers gather to hear about Joseph's letter inviting Mother Bernle to America.

The great Ford biographers have not on the whole shared the admiration of the contemporary critics. Tag Gallagher found it "ponderous" and "overly studied".[4] Joseph McBride thought the film "something of an anomaly in Ford's

[4] Tag Gallagher, *John Ford: The Man and his Films*, Berkeley and Los Angeles; University of California Press, 1986, pp. 55–56.

career, the one time he tried to be someone else".[5] Scott Eyman said "On every technical level, *Four Sons* is a tour de force, but it lacks a certain emotional impact; we never really know the boys who get killed, while the villain, the German colonel played by Earle Foxe, does everything but twirl his moustachios ... *Four Sons* is a big, elaborate camera show, full of prestige and full of itself".[6] But Lindsay Anderson perceptively observed:

> *Four Sons* is a frankly sentimental story ... But there is genuine sentiment here as well as sentimentality, and charm as well as storytelling skill: the warmth of family affection and the tragedy of separation are truly felt and so unmistakably is Ford's reverence for the enduring mother-love of a simple woman. One is not surprised that this should be one of the films for which he had a special personal feeling. The Irish heart of Ford always softened at the thought of home, of family, and of a mother's self-sacrificing love—themes that are no less true for having been so often celebrated in platitude.[7]

I am with Anderson on this one.

It was another I. A. R. Wylie short story, *Gold Star Mother* that provided the basis for an indisputable masterpiece, *Pilgrimage* (1933). It was both a critical and box office success when first released. *Variety* (July 18, 1933) declared: "Pictorially the production is a treat of fine atmosphere and stunning photography. From its earliest sequence it carries the stamp of reality, both in background and in character drawing and to the end it holds the illusion of actuality". The *New York Times* (July 13, 1933) said: "This is a fable that could drip with maudlin tears in any one of a score of sentimental scenes. It is a triumph for Miss Crosman and for Mr. Ford that *Pilgrimage* achieves delicacy and tact where those commendable qualities seem beyond reach. From a technical standpoint the film is replete with expertly contrived bits. The feeling of misty mornings is in the opening farm scenes and the quaint rural manners of the Middle West are presented with charming accuracy". It brought an estimated $650,000 at the box office.[8]

[5] McBride, *Searching for John Ford*, p. 161.
[6] Scott Eyman, *Print the Legend: The Life and Times of John Ford*, New York: Simon and Schuster, 1999, p. 108.
[7] Lindsay Anderson, *About John Ford*, London: Plexus, 1981, p. 50.
[8] Gallagher, *John Ford*, p. 498.

Lost and forgotten for many years, not even mentioned by Ford in his interviews with Peter Bogdanovich, *Pilgrimage* was rediscovered and restored in the 1960s and proved a revelation to Ford scholars. Joseph McBride called it "one of Ford's greatest films."[9] J. A. Place declared it "one of Ford's early masterpieces".[10] William K. Everson, pronouncing it "almost unbearably moving and poignant", wrote:

> Not only is the film an outstanding tour-de-force showcase for Henrietta Crosman in the starring role (the finest character actress performance in any Ford film) ... but it is visually one of the most beautiful and evocative of all Ford films. Almost all of it—a simple farmer's shack in the middle of the wheat-field, a brook in the forest, a railroad station—is entirely studio constructed and shot, producing a kind of stylised realism that again recalls *Sunrise*.[11]

He is right in every particular. But it was a revelation too in another regard. Customarily seen as a director of stories about men, in *Pilgrimage* Ford is exploring the lives and emotions of women. As a man who always celebrated and idealized mothers, he is here dealing with a stubborn, possessive, embittered woman who is responsible for the death of her son. But in a narrative trajectory that would have appealed to Ford's deep-rooted Catholicism, it is a story of repentance, atonement and redemption. Henrietta Crosman (1861–1944), a celebrated *grand dame* of the American theater who made a dozen or so films in her seventies, gives one of the towering performances of 1930s cinema as Hannah Jessop. Adapted for the screen by Philip Klein and Barry Conners, it had the advantage of dialogue provided by Dudley Nichols.

From the outset it is beautifully photographed by George Schneiderman in the luminous style favored by Fox in those years, and superbly designed by William Darling. The film begins by establishing the rhythm of life on the Jessop farm in Three Cedars, Arkansas in a succession of sequences recalling American pastoral painting. In the pale light of early morning Jim Jessop (Norman Foster) trudges out to hoe the fields while his mother feeds the chickens. When they stop for a break, he dashes off through the fields for a

9 McBride, *Searching for John Ford*, p. 195.
10 J. A. Place, *The Non-Western Films of John Ford*, Secaucus: Citadel Press, 1979, p. 25.
11 William K. Everson, "Forgotten Ford", *Focus on Film* 6 (Spring 1971), p. 18.

tryst with Mary Saunders (Marion Nixon). They arrange to meet that night after his mother has gone to bed. At dinner, his mother, who disapproves of the relationship, reads a verse from the Bible: "Lust not after an evil woman". They quarrel but are later reconciled before they retire to bed. However Jim climbs out of the window, goes to the Saunders' shack, puts her drunken father to bed, and then they retreat to the barn where by implication they make love amidst the hay. Later with snow on the ground, Hannah and Jim saw logs. He tells her he loves Mary and wants to marry her. Hannah forbids it. Jim threatens to leave: "The land ain't everything to me". Hannah tells him it should be; his grandfather died protecting it from the Indians ("His blood is in the land that's growing the corn"). The family has always belonged to the land and the land to the family. Hannah confronts Mary telling her she would rather see Jim dead than married to her. When Jim insists on marrying her, Hannah declares grimly "If you love her, you can't love me". She promptly goes into town and

Figure 6.1 Henrietta Crosman, Norman Foster and Marian Nixon in *Pilgrimage* (Fox, 1933)

gets Jim drafted into the army. There is a last meeting between Jim and Mary at the railway station when she tells him she is pregnant. He wants to stay behind and marry her but is pulled onto the train by the other soldiers and borne away into the night.

The next scene is in the trenches in France. The bombardment begins and the trench caves in, burying Jim alive. Ford cuts from this to a violent storm engulfing the farm in Arkansas. Hannah wakes suddenly, crying "Jim" as if sensing his death; Ford used the same effect in *Mary of Scotland*. Dad Saunders arrives, begging for Hannah's help. Mary is about to give birth and a woman's assistance is needed. She reluctantly accompanies him but will have nothing to do with Mary or the child, who is christened Jimmy.

The Mayor Elmer Briggs (Francis Ford) arrives with a telegram notifying Hannah of Jim's death. She is knitting, looking down sternly and, asking her friend to make coffee for the Mayor, she gets up and goes into the next room, unwilling to show the emotion she is feeling. In this, she recalls the actions of Mother Bernle in *Four Sons*. Then there is a close-up of her hands piecing together a torn photograph of Jim which she had evidently previously ripped up but which the film hadn't shown.

Ten years later Hannah, now white-haired, is working the farm with hired hands and buying extra land to extend it. A small boy walks past the farm and Hannah's dog Susie runs to him. Hannah orders the dog back and holds on to him. The boy is Jimmy. The Mayor arrives with Miss Prescot to persuade her to join the pilgrimage to France of the Gold Star Mothers, mothers who have lost sons in the war and wish to visit their graves. She flatly refuses to go until Elmer taunts her with cowardice and she agrees. Being seen off at the station as the only Gold Star Mother in Three Cedars, she is approached by Mary and Jimmy who ask her to put a posy on Jim's grave. Silently she reaches out of the train window with a black gloved hand and takes it.

At the quayside in New York, the mothers have their Gold Stars pinned on. The mothers are Italian, Jewish, Irish, Scottish and German–American, to emphasize the multi-racial nature of the country. As they go aboard, a woman hands Hannah a potted geranium and asks her to put it on Jim's grave. Her own son died but his body was never found and she is ineligible to go. As the lines of marines salute and men in the crowd doff their hats, an onlooker comments of the ranks of mothers setting off for Europe: "The most eloquent speech this country ever made".

Hannah shares a cabin with Mrs. Rogers who weeps over a photograph of her son. Hannah admits she has no photograph of Jim. The sea voyage and the arrival in Paris allow Ford to inject some comedy into proceedings. Hannah strikes up a friendship with plain-speaking, pipe-smoking Carolina hillbilly Tally Hatfield (a scene-stealing performance by Lucille Laverne) and Hannah laughs for the first time in the film. They are amused at a fashion show and when Tally gets her hair permed. They are amused most of all when at a shooting booth they hit all the targets, then shoot at the champagne bottles which are the prizes, and finally at the pipe in the mouth of an attendant who Hannah thought was a waxwork.

That night in the hotel, Mrs. Rogers bursts into tears as a song "You Will Remember Me" is played on the piano. Tally comforts her, revealing she has lost all three sons in the war. Hannah stands up and says she cannot go to the cemetery tomorrow. They are all proud of their sons. Her son disgraced the family. "I don't belong here" and she walks out. "She sure must have loved that boy a heap" says Tally perceptively.

Wandering over a bridge she encounters a drunken young American contemplating suicide, Gary Worth (Maurice Murphy). She slaps his face and calls a taxi to take him back to his lodgings. There is an amusing altercation when the landlady does not hand over enough for the taxi fare. It involves all the neighbors and is finally resolved by payment of a tip.

Gary wakes up to find Hannah has stayed with him all night. She cooks him breakfast and he explains he is despondent because he is in love with a French girl, Suzanne, but his upper-crust mother forbids them to marry on account of a difference in class. His mother has come to France to take him home. Suzanne arrives and Gary takes her and Hannah for a drive into the countryside where they observe a joyous haymaking festival. Suzanne tells Gary she is pregnant and images of Jim and Mary are superimposed on the screen as Hannah recalls the similar situation ten years earlier. Hannah now intervenes. She calls on Mrs. Worth, talks of her own experience and tells her mothers must not cling to their sons. They must let them go. She must accept Suzanne or lose Gary. The two women embrace and Mrs. Worth is reconciled to the situation. Hannah now goes to the cemetery, the camera tracking her through the crosses. She falls on Jim's grave and begs forgiveness. Back in Three Cedars, she calls on Mary and Jimmy, asks for their forgiveness and embraces them both.

The film is full of deeply moving scenes expressive of memory and loss: the station parting of Jim and Mary, Hannah receiving news of Jim's death, departure of the Gold Star Mothers, Hannah's search through the forest of white crosses looking for Jim's grave. There is a notable little vignette when the Mothers gather at the Arc de Triomphe to place wreaths at the tomb of the unknown soldier. A French general begins a speech, a little old lady, oblivious of what is going on, hurries in and lays a small flower on the tomb and disappears. The general pauses, salutes and resumes his speech.

Along with his feeling for the destruction of families, Ford also highlights the plight of the outsider. Hannah has isolated herself by rejecting her son and her grandson. Her reconciliation with Mary and Jimmy restores the integrity of the family unit. She is also instrumental in reconciling Gary and his mother. The film is in no way condemnatory of the two pregnancies as the couples wish to marry and regularize their relationships. There is a scene in which Jimmy at school is taunted with being illegitimate, fights his tormentor and causes the teacher to intervene and denounce the cruelty of the other children. Scenes in which a child outsider is picked on by other children occur also in *Just Pals* and *How Green Was My Valley*.

As usual Ford deploys camera movement only to track characters in motion. He carefully frames shots in windows and doorways. But he makes far greater use than usual of close-ups, emphasizing the intensity of feeling between the characters. There are several close-ups of Hannah gazing lovingly or jealously or possessively at Jim. There is one of her fiercely rejecting a request to assist at childbirth before she changes her mind. There are lingering close-ups of Jim and Mary gazing yearningly at each other and a long one of Mary watching tearfully as Jim's train departs. Ford handles the relationship of the two pairs of lovers with sympathy and compassion, though the British actress Heather Angel, in her first Hollywood role, is miscast as Suzanne, sounding upper-class English rather than French. But it is Henrietta Crosman's film all the way as she radiates a ferocity of feeling and eventual humanization that is unforgettable.

Ford returned to the subject of war's effect on families in *The World Moves On* (1934). On the face of it, it looks like a project that would appeal both to Ford's love of family and his Catholicism, but he told Peter Bogdanovich:

> I'd like to forget that. I fought like hell against doing it. "What does this mean?" I'd say. "Does it amount to anything?" I pleaded and quit and

everything else, but I was under contract and finally I had to do it, and I did the best I could but I hated the damn thing. It was really a lousy picture—it didn't have anything to say—and there was no chance for any comedy. But what the hell, that was called "being under contract". You were getting paid big money and there was very little income tax, so you swallowed your pride and went out there and did it. There were a few awfully good things in it— the battle scenes—but I argued and fought, and that was how I got the reputation of being a tough guy—which I'm not.[12]

Almost all his objections are questionable. It definitely has something to say, as contemporary reviews noted. It is strongly anti-war. Ford did manage to inject comedy in the incongruous form of Stepin Fetchit whose amusing scenes as a French foreign legionnaire look like typical Ford improvisation. Also the battle scenes, which are impressive, were not directed by Ford but lifted from Raymond Bernard's great 1932 French World War One drama, *Les Croix de Bois (Wooden Crosses)*.

Perhaps taking their lead from Ford, the leading Fordian scholars have mainly dismissed it. McBride thought it "one of the dullest and most pointless films he ever made".[13] Eyman pronounced it "leaden".[14] Andrew Sarris called it "one of his worst movies . . . talky, preachy and pompous".[15] Lindsay Anderson, Ronald Davis and J. A. Place do not even mention it in their books on Ford. Tag Gallagher alone finds some merit in it, rightly declaring: "Midst talky nothings, magic moments occur" and he singles out the U-Boat sinking, "a vivaciously stylized dance, a glittering Prussian wedding, a romantic ship scene, the parade of life outside windows" and the Stepin Fetchit scenes.[16]

Even at the time critics had their reservations. The *New York Times* (June 30, 1934) said: "It is an ambitious undertaking, well composed and photographed, but it does seem as though the film would be all the better if it were shortened". But the review praised the performances of Madeleine Carroll ("charming and able") and Franchot Tone ("commendable") and the screenplay of Reginald Berkeley ("admirably worked out as an argument against war").

[12] Bogdanovich, *John Ford*, p. 59.
[13] McBride, *Searching for John Ford*, p. 178.
[14] Eyman, *Print the Legend*, p. 150.
[15] Andrew Sarris, *The John Ford Movie Mystery*, London: Secker and Warburg, 1976, p. 64.
[16] Gallagher, *John Ford*, p. 100.

Variety (July 3, 1934), also identifying the anti-war message, praised the war scenes while recognizing that they came from *Wooden Crosses*. But the review added:

> That this war passage is both the feature's strength and weakness is the paradox forged by the story. The first half hour is undeniably slow and to follow such war action is not easy. To do so John Ford has had his hands full and hasn't entirely succeeded. The picture's takeoff is inactive, the war sequence is like a cold shower and then the film seems to wind its way back to the original groove. The fault appears to lay at Ford's door either because of his disregard of tempo or a disinclination to cut.

Berkeley's script is a melange of elements lifted from other film successes: *Cavalcade* (a family saga covering the period from the 1890s to the 1920s), *Berkeley Square* (reincarnation romance) and *The Four Horsemen of the Apocalypse* (a family with different branches serving on different sides in World War One). These elements do not entirely cohere, and the film, with its enormous cast of characters from several generations seems to be taking on too much. Much of the film consists of often banal dialogue exchanges conducted in interiors, the kind of thing Ford instinctively shied away from and which he mainly films in neutral medium shot, but even with such intransigent material, Ford managed some enlivening touches. He characteristically framed shots in doors, windows and archways and he broke up the action with some audaciously rapid tracking shots, almost always to accompany characters on the move: along the colonnade of the Girard mansion during the ball, down the long banquet table at the Prussian wedding, along a line of soldiers in the trenches and following Richard and Mary through the streets and down the station platform as he returns to the front.

Ford also makes effective use of the visual symbolism. Large shadows on the wall in the dueling sequence anticipate the death of one of the duellists. Richard and Henri learn about the outbreak of war when they stop their taxi after a night on the town, open the door and champagne bottles fall out and smash on the pavement. The camera lingers on the broken bottles symbolic of the end of the pre-war champagne life. During the battle in the cemetery, Henri flings up his arms with a large cross behind him and in the symbolism of the crucifixion becomes the image of the suffering soldier. Mary watches Richard leaving through a window streaked with rain, conveying her grief at their parting (an

image he would reuse in *The Quiet Man*). The film opens with a close-up of a crucifix on the wall of the family room in the Girard mansion and closes on the same image at the end, to the strains of the hymn "Christ the Lord is Risen Today", an indication of the Christian faith running through the film as a theme.

The film begins in New Orleans in 1825 with the reading of the will of the cotton king Sebastian Girard. He calls for the setting up of a great family combine in partnership with his old friend, Gabriel Warburton of Manchester, England, to control cotton growing and manufacture. Sebastian's sons Richard, Carlos and John will run the American, French and Prussian branches of the business. A ball is held at the Girard mansion at which Mary (Madeleine Carroll), the beautiful young wife of Gabriel Warburton, is insulted by a guest making a suggestive remark about her virtue. Richard (Franchot Tone) slaps his face and challenges him to a duel. The duel takes place in the garden. The insulter is shot dead and Richard wounded in the hand. When she sees his wound and realizes he has sustained it in defense of her honor, she falls into his arms. They are in love but her marriage precludes anything further between them. Mary and Gabriel sail for England. There is a beautiful little scene of memory and loss on the ship. Mary, her scarf streaming out behind her in the breeze, gazes back at the American shore. Gabriel urges her to look the other way toward England and with one fleeting backward glance, she turns sadly away.

An intertitle reveals that four generations pass and the families of Girard and Warburton have grown rich and powerful. In 1914 they gather for a reunion at the Girard mansion in New Orleans: Sir John Warburton and his daughter Mary, the Prussian Girards now known as von Gerhardt since they were ennobled, and the French Girards. A new Richard Girard meets the new Mary Warburton. They have a feeling they have met before and she recognizes a love song he plays for her and which the original Richard played for the original Mary, setting up a reincarnation theme.

The families renew the vow they made in 1825 and which is recited by Richard: "We solemnly swear to safeguard the family, to deny ourselves for the family and in all circumstances to put the needs of the family first". Baron von Gerhardt invites them all to Germany for the wedding of his youngest son Fritz and Jeanne, sister of Henri, now head of the French Girards. He hints at

an understanding between his eldest son Erik and Mary Warburton. A lavish wedding is held in Germany, which Ford tries to liven up by interpolating a scene where an officious major domo lines up the chefs with military precision and marches them all into the banqueting hall carrying the wedding cake. It is clear now that Mary and Richard are falling in love but they quarrel when Erik makes a premature announcement of their engagement. From Mary's reaction Erik realizes she loves Richard and in gentlemanly fashion withdraws.

War is declared. Richard and Henri join the French Foreign Legion. Sir John Warburton and Richard's father Charles are killed when their transatlantic liner is torpedoed by a German U-Boat, commanded by Fritz von Gerhardt. A British destroyer sinks the U-Boat. In a very striking scene Ford shoots the panic inside the submarine as it gradually fills up with water and then the screen goes black and silent.

Mary takes over the Manchester factory and travels with general manager Manning to France to discuss arrangements with Richard. But Mary and Richard quarrel over her refusal to manufacture munitions. He returns to the front. There is now a lengthy sequence of ten days of graphic battle footage lifted from *Wooden Crosses*, with studio close shots of Richard, Henri and Stepin Fetchit's Dixie to personalize it.

On leave Richard returns to England, proposes to Mary and marries her. After a few days he has to return and she accompanies him to the railway station (with "Keep the Home Fires Burning" on the soundtrack). As she bids him a tearful farewell, he says she was right to refuse to make munitions. But the government requisition the factory to make munitions anyway.

In a second impressive sequence from *Wooden Crosses* the French fight the Germans in a cemetery at night. Henri is wounded and Richard is blown up. In a church service for the troops (also from *Wooden Crosses*), "Ave Maria" is sung. A studio-shot scene is added with the injured being tended by nuns in part of the church. A priest administers communion to Henri, who recites the Ave Maria before calling for Richard. Richard is in a hospital in Germany, from where the Gerhardts take him to their home to convalesce. The Germans are starving and Baron von Gerhardt says Germany is finished. Church bells ring to signal the armistice. Henri, recovering from his injuries, says: "We've won the war. But we've torn down everything that matters—faith, freedom, civilization." A parade of French soldiers is inserted from *Wooden Crosses* with

the ghostly figures of their dead marching through the sky above them. German troops, including Erik, straggle home, bedraggled and dirty. In a scene which echoes Griffith in its simplicity and poignancy, Erik enters the house. We hear the parents talking in German off screen. He goes to join them and we hear the excited voices of the family reunion, while Richard smilingly slips out not wanting to intrude on their privacy.

1925 and a title declares: "The post-war years. Ideals born in blood and sacrifice forgotten, money the new morality, power the new God". The family gather to celebrate the centenary of the compact. Richard announces that they have gained control of the world's cotton and makes a speech about wealth and power. Henri, now a priest, says it reminds him of someone who once said: "All this is yours if you will fall down and worship me" (the words of the Devil when tempting Jesus). Richard angrily replies: "All that old-fashioned nonsense means nothing in the machine age". Mary corrects him: "It means everything". The Wall Street crash of 1929 wipes out the family's fortune. As the family gather, there is talk of another war and Mary once again acts as the spokesman for peace. When in 1825, Gabriel Warburton had commented that there was a lot of money to be made from war, Mary had denounced war, having had her father killed at Waterloo and her brother maimed at the battle of New Orleans. The second Mary had refused to manufacture munitions. Now as Erik says countries are becoming drunk on nationalism and building up their armaments, Mary says "War is a disease. Homicidal mania on a grand scale". She asks them to think of the mothers, of whom she is about to become one. There is a powerful sequence now of the marching armies of Germany, Russia, France and Japan, the British fleet and American air force, plus shots of Hitler and Mussolini.

The family is ruined but Richard and Mary return to the old home in New Orleans, now run down and decrepit, to try and rebuild. "Everything has gone" says Richard. "Not everything" replies Mary and they look up to the crucifix on the wall. The Faith endures.

By 1941 when the United States entered the war, Ford was at the height of his powers and reputation, having received best director Oscars for *The Informer* and *The Grapes of Wrath* and being about to receive a third for *How Green Was My Valley*. But he had seen war coming and in 1939 began to plan for it. He recruited and trained a corps of film technicians, who were drilled by

ex-marine Jack Pennick, who became Ford's aide-de-camp for the duration of the war. Already a naval reservist, Ford reported for active duty on September 11, 1941. The Navy declined the services of his unit but Colonel "Wild Bill" Donovan took it on and it became the Field Photographic Branch of the Office of Strategic Service with Ford, promoted to the rank of commander, as its chief. His brief was to produce instructional films and make a documentary record of overseas combat operations. Ford began with 28 officers and 123 enlisted men divided into 15 film units.[17] He would oversee the shooting of films in the Pacific, North Africa, Burma, Yugoslavia and Normandy on D-Day. He even participated in one production as an actor. *Undercover* (1943) was the first training film produced for OSS agents on how to operate behind enemy lines. It explains the importance of cover stories, social knowledge, false papers, correct clothing, personal effects and attention to detail. It is mainly performed by mediocre actors, though Hungarian actor Victor Varconi, once a star of silent films, plays a Gestapo interrogator. Ford with his trademark pipe and tinted glasses makes a relaxed appearance as attorney J. P. Baldwin, interviewing, assessing and briefing potential agents.

Ford's most personal project was *The Battle of Midway* (1942) but he was also centrally involved in *December 7th* (1943). In 1944 he was temporarily taken off active service and ordered to Hollywood to film *They Were Expendable* (see Chapter 7). He finally left active service on September 29, 1945.

In 1942 American Naval Intelligence intercepted Japanese communications and learned that a large air and sea operation against the American outpost on Midway Island was planned. Admiral Chester W. Nimitz, commander in chief, US Pacific Fleet, asked that the Field Photo Unit film the combat. Ford immediately volunteered for the job and flew to Midway with a young navy photographer Jack Mackenzie Jr., who had worked with him filming the devastation at Pearl Harbor for *December 7th* and before the war had been a trainee cameraman at RKO studios. Ford accompanied his friend Commander E. M. "Massie" Hughes on a reconnaissance flight, photographing American planes in the air. When the Japanese attacked Midway, Ford was posted by Captain Cyril T. Simard, Commandant, US Naval Air Station, on the roof of the Eastern Bloc Powerhouse with orders to report on incoming Japanese

[17] McBride, *Searching for John Ford*, p. 345.

planes as well as photographing the action. Ford eventually spotted and reported seventy-six enemy planes. Wounded in the arm and temporarily concussed by shrapnel, Ford carried on filming until the Powerhouse was badly damaged and had to be evacuated. Ford sent Mackenzie off to photograph the defenders of the island with the instruction that he photograph faces. The Battle of Midway lasted from June 3–6, and represented the first reverse for the Japanese forces in the Pacific. Ford received the Purple Heart for his gallantry under fire.

Anxious to avoid his film falling into the hands of the naval censors, Ford flew to Washington with eight cans of 16mm color film. Summoning the editor Robert Parrish, he ran the footage and asked him if he could make a twenty-minute documentary out of it. Parrish asked him "Do you want a factual account for the record or do you want a propaganda film?" Ford replied: "It's for the mothers of America. It's to let them know that we're in a war and that we've been getting the shit kicked out of us for five months and now we're starting to hit back. Do you think we can make a movie that the mothers of America will be interested in?" Parrish thought he could. Ford told him to take the film to his mother's house in Hollywood and cut it there in secret. Ford called in Dudley Nichols, who had scripted so many of his films, and he, Parrish and Nichols viewed the footage and worked out a shape for the film. Nichols then went off and scripted a narrative. Without telling Nichols, Ford also called in James Kevin McGuinness, then working as a production executive at MGM, ran the footage and got him to write a narrative. Ford recruited sound effects man Phil Scott to the team and a rough cut was assembled. Ford then summoned four actors he had worked with recently: Donald Crisp and Irving Pichel from *How Green Was My Valley* and Henry Fonda and Jane Darwell from *The Grapes of Wrath*. Selecting lines from the two scripts and inventing his own ("This really happened", "A council of war was held"), Ford got the four actors to read lines in a twenty-minute recording session. Alfred Newman who had scored *Young Mr. Lincoln*, *Drums Along the Mohawk*, *The Grapes of Wrath* and *How Green Was My Valley* was enlisted to provide a score. Ford specified the tunes to be used ("Anchors Aweigh", "Red River Valley", "The Air Force Song" ("Off we go into the wild blue yonder"), "The Marines' Hymn", "Yankee Doodle Dandy", "Onward Christian Soldiers", "My Country 'Tis of Thee", "The Star Spangled Banner", "Over There") and he told Parrish to use only half the

music Newman supplied. Parrish put together the final version, leaving out Jane Darwell's motherly appeal to get the wounded to hospital which he thought corny. But Ford insisted it go back in. He also told him to measure precisely the coverage given to the various forces so as not to provoke jealousy and he produced a clip of Major James Roosevelt, the son of the President, which he wanted slipped into the funeral sequence.

The film was shown at the White House to an audience including the President and his wife and various members of the top brass. Parrish recalled: "The President talked throughout the screening until the silent close-up of his son appeared and saluted the burial … of the heroic dead of the Battle of Midway. From that moment to the end (2 mins. 21 sec.) the audience sat in complete silence. When the lights came up, Mrs. Roosevelt was crying. The President turned to Admiral Leahy and said 'I want every mother in America to see this picture.'" Five hundred prints were made by 20th Century-Fox and rushed to cinemas across the country. Parrish attended the opening of the film at Radio City Music Hall in New York and observed members of the audience in tears. The film was subsequently awarded the Oscar for best documentary short of 1942, an award it shared with the US Army's *Prelude to War* (directed by Frank Capra), the Russian *Moscow Strikes Back* and the Australian *Kokoda Front Line*. It never did get viewed by the naval censors.

The opening titles of the eighteen-minute film, crediting only the Navy ("photographed by the US Navy in color"), stresses the authenticity of the footage ("This is the actual photographic record of the Battle of Midway"). The score is "My Country 'Tis of Thee". The film falls into three sections: the prelude, the battle and the aftermath. The prelude begins with a lone patrol plane, a shot of Midway Island declared by narrator Donald Crisp to be "our outpost; your front yard" and then marching columns of marines with flags and "The Marines' Hymn" ("From the Halls of Montezuma to the Shores of Tripoli"). There is jokey footage of seabirds on the island—gulls and albatrosses—with Donald Crisp announcing that these are the natives of the island whom the Japanese commander Tojo has promised to liberate. Against a flaming sunset, American servicemen are silhouetted in black and one of them plays the accordion. It is Ford's signature tune "Red River Valley" played by Danny Borzage and plucked from the soundtrack to *The Grapes of Wrath*. The dawn patrol reports the approach of the Japanese battle fleet and the American officers hold a council

of war, to the strains of "Off We Go Into the Wild Blue Yonder". As the B-29s prepare to take off, there is a conversation on the soundtrack between Jane Darwell, the archetypal American mom, and Henry Fonda. She recognizes one of the young pilots as Bill Kinney from her hometown, Springfield, Ohio, and she explains that his father is a railroad engineer and we see shots of his mother, father and sister. This effect, which is repeated in *December 7th*, personalizes the servicemen and links them directly with home. As the plane takes off, Jane Darwell says: "Good luck. God bless you, son".

The second section begins as Japanese planes swoop out of the clouds. There is now the battle sequence intercutting American planes taking off, bombs dropping, anti-aircraft guns firing, with the image shaking as the camera is rocked by the impact of the bombs and clouds of debris are thrown up after a hit. The camera picks out the determined faces of the defenders of the island. At one point a tattered American flag is raised under enemy fire. "This really happened" stresses narrator Irving Pichel with "The Star Spangled Banner" on the soundtrack. The Japanese fleet is harassed by US planes. On the island, dense clouds of black smoke and sheets of flame arise from bombed buildings. Although in interviews later in life, Ford claimed to have filmed it all, much of the sea action was filmed by Lt. Kenneth Pier.

The aftermath begins as American planes return to base and smiling pilots emerge to the strains of "Anchors Aweigh", one of them identified as Jimmy Thatch, another holding up four fingers to indicate his tally of "kills". Narrator Pichel addresses the audience: "Men and women of America, here come your neighbors' sons home from their day's work". There is a shot of Japanese plane wreckage. The search for survivors begins. A rescued pilot is given his first cigarette. Pichel name checks officers involved in the rescue, "Massie" Hughes, Logan Ramsey, Frank Fessler. We see the faces of survivors. "Onward, Christian Soldiers" is played on the soundtrack. Jane Darwell pleads: "Get these boys to hospital. Please do. Quickly. Get them to clean cots and cool sheets. Get them doctors and medicines and nurses' soft hands. Get them to hospital. Hurry. Please." A bombed hospital is shown with a battered Red Cross amid the rubble as a reminder of Japanese contempt for the wounded. Divine service is held beside a bomb crater. The dead are laid out in a line beneath US flags. The troops fire a salute and stand to attention. As "My Country, 'Tis of Thee" is played the camera picks out among the mourners Captain Cyril T. Simard,

commandant of the Naval Air Station, Colonel Harold D. Shannon, commander of the 6th Marine Defense Battalion and Major James Roosevelt. They each salute the dead. PT boats head out to sea with flag-draped coffins on them. The film ends with a soldier scanning the horizon through binoculars, planes taking off and the American flag still flying. A coda added at the request of the President lists Japanese losses: 4 aircraft carriers, 28 battleships, cruisers and destroyers sunk or damaged, 300 aircraft destroyed. Each statistic is crossed through with red paint and a V for Victory painted at the end.

Some documentary historians such as William T. Murphy, head of the Motion Picture Division of the National Archives in Washington DC, have been intensely critical of *The Battle of Midway* for not giving a factual account of the action and outlining the chronology and scope of the battle. He writes:

> Like most crude propaganda, the film aims more at the heart than the mind, and like most military propaganda films, it conceals more than it shows. There is no broad perspective of the battle. Even the events focused upon do not make a statement from the particular to the general, but actually misrepresent the true nature of the fighting. The aerial attack on Midway Island itself was a small, insignificant part of the battle. The crucial confrontation was between planes and ships of both sides. No belligerent ships engaged each other directly except for submarine contact. Japanese losses were devastating. Moral superiority over the enemy seems to be the main source of victory, not tactics, not equipment, not armaments. The B17s, emphasized in the film, missed all of their targets and played an inconsequential role. *The Battle of Midway* substitutes moral and emotional feelings for information.[18]

At the time, however, the *New York Times* (September 15, 1942) pronounced the film "astounding" and said, "Everyone on the home front has a definite obligation to see *The Battle of Midway*".

But Ford used virtually all the usable battle footage he had and his intention was to create an impressionistic account for the folks at home. All the techniques he had mastered in fictional cinema were deployed: editing images together for impact, using music to underscore emotions, intercutting faces, earnest,

[18] William T. Murphy, "John Ford and the Wartime Documentary Film", *Film and History* 6 (February 1976), p. 3.

strained, smiling, above all youthful, into the action. But Fordian scholars have recognized what he was doing and have responded accordingly. Tag Gallagher, describing the film as a "symphony" in three movements, said: "Never was Ford to make a film more cinematically and formally perfect than *The Battle of Midway*".[19] Joseph McBride called it "Ford's most purely poetic film ... an extraordinarily vivid and eloquent meditation on war, one of the rare pieces of propaganda that is also a timeless work of art."[20] Scott Eyman wrote "Judged as a documentary, it's unusually impressionistic, judged as a John Ford film, it's one of his best, offering the rough essence of Ford's spirit and the way he perceived the valor of battle".[21] As Andrew Sarris put it, "Ford's *Battle of Midway* is ostensibly a documentary, but it is as personal a statement as any of his fiction films. He focuses here on the ordinary scale by which the most gallant heroes are measured. It is not the battle itself that intrigues Ford, but the weary faces of rescued fliers plucked out of the Pacific after days of privation."[22]

Ford undertook another duty in connection with the Battle of Midway. Footage had been taken of the thirty members of VT-8 squadron. But twenty-nine of them had been killed and all fifteen planes lost on the morning of June 4. The only survivor had been Ensign George Gay who had survived the shooting down of his plane and watched it all while clinging to a seat cushion in the sea. Donovan suggested that the footage be edited in a cinematic tribute and distributed to the bereaved families. So Ford created an eight-minute film, *Torpedo Squadron 8*, which was never shown publicly. The film began with a title which read:

On June 4, 1942, near Midway Island in the Pacific, many naval aviators and flight crews gave their lives to unflinchingly pursue and destroy a powerful Japanese invasion force of superior aircraft carrier strength. These men of Torpedo Squadron Eight are gone. The memory of their courage and determination will forever be an ideal for Navy flying men to follow. These men, pilots and flight crews, of the squadrons who participated in this action have written the most brilliant pages in the glowing history of our naval air forces.

[19] Gallagher, *John Ford*, pp. 206, 208.
[20] McBride, *Searching for John Ford*, pp. 361, 364.
[21] Eyman, *Print the Legend*, p. 261.
[22] Andrew Sarris, *The American Cinema*, New York: E. P. Dutton, 1968, p. 46. On *The Battle of Midway*, see also Mark Harris, *Five Came Back*, Edinburgh: Canongate, 2014, pp. 145–51, 172–3 and Robert Parrish, *Growing Up in Hollywood*, New York: Harcourt Brace Jovanovich, 1976, pp. 97–110.

The film begins with the men of the squadron lined up for a team photograph on the deck of the aircraft carrier *Hornet*. Then the film shows the planes taking off, a title *In Memoriam* follows and as a funeral bell tolls, shots of all thirty airmen in pairs and posed next to their planes with their full names on inserts follow. "Onward Christian Soldiers" is heard on the soundtrack. It ends with footage of a religious service, a seven gun salute and the last post. The words of Abraham Lincoln from the Gettysburg Address are flashed up: "That we here highly resolve that these dead shall not have died in vain" and as a single plane streaks into the sky and up to the heavens, "Nearer, My God, to Thee" is heard. Copies of the film were taken by personal emissaries from Ford to the families and none of the footage was incorporated in *The Battle of Midway*.[23]

Ford promised Gregg Toland, who had photographed *The Grapes of Wrath* and *The Long Voyage Home*, the chance to direct if he would enlist in the Field Photo Unit and help train the rookie cinematographers. Toland agreed and was sworn in as a lieutenant junior grade. One of the earliest commissions for the unit in January 1942 was for a factual account of the attack on Pearl Harbor. Ford gave the job of directing it to Toland and dispatched him to Hawaii with erstwhile 20th Century-Fox scriptwriter Samuel G. Engel as writer-producer. It was provisionally entitled *The Story of Pearl Harbor: an epic in American history*. After six weeks when no film arrived from Honolulu, Ford flew out to discover that instead of the half-hour newsreel-type production he expected, Toland was planning a ninety-minute feature, complete with Hollywood actors (Walter Huston, Harry Davenport, Dana Andrews, Paul Hurst, Lionel Royce and Philip Ahn) and dramatic reconstructions to be filmed at 20th Century-Fox's studio. The problem was that there was virtually no film of the actual attack, though graphic scenes of the aftermath with battleships burning and planes wrecked had been taken by Movietone newsreel cameraman Al Brick. Ford warned Toland to be careful and shot some scenes of the salvage operations before he was recalled to film Lt. Col. James Doolittle's B-25 bombers taking off for the first aerial attack on Tokyo. It was twelve months before Toland completed his film with a score provided by Alfred Newman and narration by Irving Pichel, who had narrated *How Green Was My Valley*.

[23] McBride, *Searching for John Ford*, p. 364.

But when the film was shown to the authorities they were horrified. Admiral Harold Stark, chief of naval operations at the time of the attack, complained that the film blamed the Navy for its lack of preparedness and Lowell Mellett, head of the Office of Government Records which oversaw official propaganda, was appalled by the xenophobic attack on the Japanese inhabitants of Hawaii which took up the first half of the film. This was in blatant opposition to the official approach which was to avoid direct racist attacks on the enemy. In view of these reactions, Secretary of War Henry Stimson ordered the film shelved. Toland was deeply depressed and asked Ford for an assignment far away from Washington. Ford sent him to set up the Field Photo office in Rio. Then in 1943 Ford was asked to produce a film on the war effort to be shown to industrial workers. He dug out the Toland film and asked Robert Parrish to edit it down to something that would avoid the strictures of the top brass. Parrish cut it from eighty-three minutes to thirty-four and it was retitled *December 7th*. It was shown to audiences of war workers.

The original feature length version survived in the vaults and remained unseen until it was issued on video cassette in 1991. It proved to be a rambling and broken-backed production full of patently faked action scenes and virulent anti-Japanese racism. It opens on December 6, 1941, with Uncle Sam (Walter Huston) dictating a letter about the glories of Hawaii as a holiday destination. He talks of a hundred years of development, rich crops of sugar cane and pineapples and the building of Honolulu as a modern American city, complete with handsome public buildings and luxury hotels, flourishing commercial companies and churches of all denominations. But Uncle Sam is questioned by his conscience, Mr. C (Harry Davenport), who points out that labor was needed to construct this economy and the majority of Hawaii's laborers are Japanese. There is a montage of Japanese faces, and a rapidly edited sequence of Japanese shop and business signs. Some 157,000 Japanese live in Hawaii, 37 percent of the entire population, Uncle Sam says, and they are clearly loyal. We see a Japanese spokesman proclaiming the loyalty of the Hawaiian Japanese to the United States. Japanese school children give the pledge of allegiance to the flag and sing "God Bless America". Japanese boy scouts salute. But Mr. C points out that Japanese children also go to 175 Japanese schools to learn Japanese language and culture. There is an incongruous shot of a Japanese class singing "Auld Lang Syne" in Japanese. They follow what Mr. C dubs "their so-called

religion—Shintoism". Scenes of Shinto worship are shown and a Japanese priest (Philip Ahn) explains that Shinto is based on worship of the Emperor and encourages racist and nationalist ideas. Mr. C points out that many retain dual American and Japanese citizenship. The Japanese Consulate, with its 250 vice-consuls, is a center for espionage. In a series of staged scenes, Japanese spies watch the movement of ships, photograph vital installations, listen to American servicemen discussing their duties in barbers' shops, taxis and dance halls. A grinning Japanese spy reports to the Consul and a German Heinemann (Lionel Royce) arrives to tell the Consul of the ships sunk by the Nazis as a result of information supplied by the Japanese. The impression is given that virtually the entire Japanese population of Hawaii is engaged in anti-American activity. Mr. C tells Uncle Sam that no official action was taken to suppress this activity so as not to offend the local Japanese population. When anyone suggested doing something about it, they were branded warmongers. But Uncle Sam insists that nothing untoward can happen in Hawaii as it is a classic "melting pot" of races, Korean, Chinese, Portuguese, Filipino, Hawaiian, Japanese. Uncle Sam then sleeps, with Japanese images and images of Hitler and Mussolini superimposed on his face.

The film then cuts to the Japanese attack. It is early Sunday morning on the island of Oahu. Preparations have been made to combat sabotage but none to deal with a frontal attack. At an open air mass, the chaplain urges the men to send cards and presents to their loved ones. Individual young faces are picked out in the ranks and "O, Come, All Ye Faithful" is heard on the soundtrack. Sailors play baseball on the dockside. While Japanese envoys in Washington were still talking peace with Secretary of State Cordell Hull, 750 Japanese planes were attacking Pearl Harbor. Lookout Private Joseph Lockhart (Robert Lowery) had reported planes approaching but was told they were probably returning American planes. Since no film of the attack had been taken, the attack itself was recreated in a twenty-minute sequence at the Fox studios by second unit directors Ray Kellogg and James C. Havens. The shots of the planes at Hickam Field being destroyed and the US battleships *Arizona*, *Oklahoma*, *California* and *Nevada* being sunk, involve the use of very obvious models. Narrator Irving Pichel quotes Roosevelt's words about the atrocity, pointing out that fifty Japanese planes were shot down. Authentic footage of the aftermath was used. A total of 2,343 officers and men were killed. We see the

bodies being laid out and a roll call of American casualties is heard with Dana Andrews identifying photographs of the fallen and their parents, carefully chosen to represent the multi-racial society of the United States: an Irish American from the Midwest, a Brooklyn Jew, an African American from North Carolina, a Hispanic from Albuquerque, a Californian, and when Pichel asks why they all speak with the same voice, he is told because they are all Americans. There is a distinctly Fordian funeral sequence, with wreaths, fluttering flags, lines of immaculately uniformed sailors and "My Country, 'Tis of Thee" on the soundtrack. General Tojo broadcasts to the Japanese people, listing the ships sunk but is contradicted by narrator Pichel who recounts the salvage and repair of many of the damaged ships. There is a positive and upbeat sequence of repair accompanied by news of the reinforcement of men, ships and supplies. The film emphasizes the preparations for defense now made. Martial law is declared, a civilian defense committee formed, children issued with gasmasks, air raid precautions taken. The Japanese rally round, to give blood, buy war bonds and join the armed forces. Japanese notices come down, their schools and temples are closed and their flags removed. No acts of sabotage are reported. "All those who take up the sword will perish with the sword", says the narrator.

The film ends with another allegorical scene. At Arlington National Cemetery, among the rows of crosses, a marine killed at Pearl Harbor (Dana Andrews) and a World War One veteran killed on the Marne (Paul Hurst) discuss the future. The World War One veteran is cynical, pointing out that after the last war, America abandoned Woodrow Wilson's blueprint for world peace and retreated into isolationism. The Marine says he is putting his faith in the Roosevelts, the Churchills, the Stalins and the Chiang Kai-Sheks, and a world of decency, faith, brotherhood and religion to be created by the United Nations. The film ends with a parade of thirty-two flags of the United Nations as a chorus sings "United Nations on the March". A plane creates a V for Victory sign in the sky.

James Kevin McGuinness, Ford's longtime friend and associate, having viewed the Toland film, advised Ford: "I'd crowd in every interesting foot of the salvage operations I could and finish off with a burst of glory when the battle wagons put to sea again ... As you said, the question of the Japs in Hawaii doesn't belong in this picture. You can't report it accurately ... I would, of

course, hold on to every foot of the emotional film—the church services, the burials etc. That's swell and very moving".[24] This is exactly what happened. The entire opening thirty-eight minutes and the anti-Japanese propaganda was cut. So too was the Arlington cemetery sequence. What remained was the raid, the aftermath, the church service, the funerals and personalized introduction to the casualties. Parrish turned it into a more distinctively Fordian work by emphasizing the elements characteristic of Ford's other work, though Ford had the decency to admit to Bogdanovich apropos *December 7th* "Gregg Toland directed that … I helped him along, I was there, but Gregg was in charge of it."[25] The edited version of *December 7th* won the Oscar for best short documentary in 1943. Although Ford regularly claimed the Oscars for *Battle of Midway* and *December 7th*, they were officially awarded to the Navy and 20th Century-Fox for *Midway* and the Navy and the Field Photo Unit for *December 7th*.[26]

Darryl F. Zanuck had begun Hollywood's production of military training films in 1940 and was commissioned as a reserve lieutenant colonel in the Army Signals Corps in January 1941. When conscription was introduced under the Selective Service Act in 1940, it became necessary to produce basic training films to be shown to new recruits at army reception centers. One of these films, *Sex Hygiene* (officially Training Film 8-154), dealt with the danger of venereal disease which in wartime resulted in as many casualties as active service. Zanuck asked Ford to direct it. The result was a half-hour film, shot at the 20th Century-Fox Studio, and completed by the summer of 1941. The film featured a group of young soldiers being shown a graphic illustrated lecture with charts, photographs and tables on the varieties of sexually transmitted disease, their symptoms and their treatment. This involved close-ups of infected penises. The soldiers are told that one in ten of the male population will suffer from syphilis and if not treated, it can result in insanity. The lecturer (Charles Trowbridge, a Ford stock company regular) advised regular condom use, but total abstinence as the best way to avoid disease.

[24] Eyman, *Print the Legend*, p. 267.
[25] Bogdanovich, *John Ford*, p. 136. On *December 7th* see Harris, *Five Came Back*, pp. 206–10; Simon Willmetts, *In Secrecy's Shadow: The OSS and CIA in Hollywood Cinema 1941–1979*, Edinburgh: Edinburgh University Press, 2016, pp. 46–51; Robert Parrish, *Hollywood Doesn't Live Here Anymore*, Boston: Little Brown, 1988, pp. 20–22.
[26] McBride, *Searching for John Ford*, p. 386.

Ford's camera picked out the faces of the soldiers in the audience as they listened to the lecture. Ford told Peter Bogdanovich: "It really *was* horrible; not being for general release, we could do anything—we had guys there with VD and everything else. I think it made its point and helped a lot of young kids. I looked at it and threw up".[27] It continued to be used by the armed forces well into the 1950s.

Ford returned to 20th Century-Fox and Zanuck for a wartime comedy. *When Willie Comes Marching Home* starring Dan Dailey and Corinne Calvet was filmed between June and August 1949 and released in February 1950. Ford told Bogdanovich: "I read the story and liked it. It was amusing".[28] But he told Bill Libby in 1964 that he considered *When Willie Comes Marching Home* "one of the funniest films ever made".[29] He told a student who asked why he didn't make more films like *Willie*: "I feel I'm essentially a comedy director, but they won't give me a comedy to do. When I direct a scene I always want to make the leading lady fall down on her derrière".[30]

Willie was not a personal project of Ford's in the sense that he had developed it himself with the writers. Zanuck handed him a script by Mary Loos and Richard Sale and he agreed to take it on, though he insisted that Mary Loos be present on set in case changes were needed. He managed to recruit some of his stock company for supporting roles (Mae Marsh, Jack Pennick, Harry Tenbrook, Hank Worden). But he did have some problems. He disliked the producer Fred Kohlmar and refused to attend meetings in his office. While he got on with Dan Dailey he did not want Corinne Calvet to play the French Resistance leader. They disagreed fundamentally about the interpretation of the part. Calvet wrote later that Zanuck had approved her interpretation of the role in her screen test:

> The undercurrent of emotion in the test was based on the girl falling in love with the American during his numerous attempts to escape, and her devotion was checked only by the knowledge of his imminent departure. When she learned that she had to dress as a bride in this final escape attempt, and to go

27 Bogdanovich, *John Ford*, p. 80.
28 Bogdanovich, *John Ford*, p. 87.
29 Gerald Peary, ed., *John Ford Interviews*, Jackson: University of Mississippi, 2001, p. 53.
30 Peary, *John Ford Interviews*, p. 67.

through a mock ceremony, she was being asked to pretend to be something she really wanted to be. Such an interpretation gave the part an added dimension. Ford wanted this whole emotional element eliminated. He wanted me to play a tough, emotionless guerrilla fighter. Once more I called Zanuck and told him my dilemma. After watching a rehearsal Zanuck put his arms around Ford's shoulder and walked away with him. The result of their long conference was a compromise between my interpretation and the one Ford wanted. As we proceeded Ford removed most of the sensitive lines from the script.[31]

The film was quite well received. The *New York Times* (February 18, 1950) thought it "highly humorous", the script "crackling and ingenious" and said "Mr. Ford's special talent for directing his actors' style and pace has done wonders for Mr. Dailey is here at the top of his comic form". *Variety* (January 5, 1950) praised the excellence of the script and the acting but said the major share of the credit goes to Ford: "Ford turns to comedy for the first time and demonstrates that a laugh-film can also be his forte. While the picture has plenty of old-fashioned slapstick, Ford has also brought in some Chaplinesque overtones of tragi-comedy". The film took $1,700,000 in domestic rentals, making it eighteenth in Fox's list of the biggest box office successes of the year.[32] Sy Gomberg's original screen story was Oscar-nominated.

Fordians have had mixed feelings about it. Lindsay Anderson thought it "amusing . . . capably done" and Andrew Sinclair said "the film amuses without engaging attention".[33] But Andrew Sarris dismissed it as "feeble and outdated",[34] Dan Ford does not mention it at all and McBride said "The problem with *Willie* is that it's not very funny".[35] This was partly because as Bogdanovich pointed out, the central passage of the film involving the war in occupied France is largely played straight. Ford replied: "Well that was my racket for a while, and there wasn't anything funny about it".[36] With its satire on American small town life, a theme similar to *Hail the Conquering Hero* (1944) and the presence of

[31] Corinne Calvet, *Has Corinne Been a Good Girl?*, New York: St. Martin's Press, 1983, p. 195.
[32] Gallagher, *John Ford*, p. 499.
[33] Anderson, *About John Ford*, p. 79; Andrew Sinclair, *John Ford*, London: George Allen and Unwin, 1979, p. 159.
[34] Sarris, *The John Ford Movie Mystery*, p. 129.
[35] McBride, *Searching for John Ford*, p. 491.
[36] Bogdanovich, *John Ford*, p. 88.

Sturges regular William Demarest in the cast it looks more like a Preston Sturges film than a John Ford film.

The film which is narrated by Bill Kluggs (Dan Dailey) falls into three sections. The first section opens with Bill Kluggs introducing the audience to his home town of Punxatawny, West Virginia. It is Sunday in December 1941 and the people make their way to church. "Shall We Gather at the River" is playing softly in the background. But unable to resist a dig at the Protestants, Ford repeats a gag from *Just Pals* in which a well-dressed woman fumbles in her purse for a coin to put in the collection plate and carefully removes change. Kluggs introduces the audience to his girlfriend, Marge Fettles (Colleen Townsend). Then he introduces himself enthusiastically playing the trombone in jazz band practice at the druggist's after church (J. Farrell MacDonald can be glimpsed in the background in the non-speaking role of the druggist). Rehearsal is interrupted by Charley Fettles, Marge's brother, rushing in with the news that the Japanese have attacked Pearl Harbor and America is at war.

Bill is the first to enlist and a great fuss is made with newspaper headlines, photographs, a speech by the Mayor, and a procession by the American Legion to see Bill off. He trains for the Army Air Force but fails. In a stunt flying sequence that echoes *Air Mail* and prefigures *The Wings of Eagles*, he flies his plane through a hangar and then crashes it, having sheered off the wings. He, however, triumphs in the shooting and becomes a valued instructor. He is transferred to a new base which happens to be in his home town of Punxatawney. The town puts on wild celebrations for the return of their first enlisted man and he is presented with an identity bracelet at an exciting gathering. Two soldiers in the hall (played by an uncredited Alan Hale Jr. and Arthur Walsh) laugh uproariously, thinking it is a joke and unable to understand the fuss. But as time passes and the war proceeds, with headlines announcing the Americans landing in North Africa and Sicily, Bill remains at the Punxatawney base as an instructor. He gradually becomes an embarrassment. His father, a World War One veteran, becomes irritated, his mother embarrassed. People stop talking to him, even dogs snap at his heels. He makes increasingly frantic demands to be sent overseas but each time is rewarded with a promotion and a good conduct medal in recognition of his value as an instructor. Then 1944 arrives and Charley Fettles, now a much decorated air force hero, returns from the Pacific. At celebrations to mark his return, Bill is snubbed by the citizens. Then when a

replacement gunner is needed at short notice, Bill is drafted into an aircrew and flies to France.

The second section of the film begins with the plane in thick fog, the crew ordered to bale out but Kluggs asleep, not hearing the order. When he wakes up, the plane is over France and he bales out just before it crashes. He is picked up by the Resistance and once they have established his identity as an American by putting questions to him about Dick Tracy, The Lone Ranger and the New York Yankees, they include him in their operation to photograph the installations of a new Nazi rocket site. They avoid capture by the Germans by hiding in a mausoleum. They decide that Bill must get the photographs to London and so they stage a wedding party to put the Germans off the scent and get Bill to the coast. The problem is that he has drunk so much wine at the wedding party that he is virtually incapable.

This leads to the third section which the *New York Times* called "one of the most side-splitting comedy sequences we have had in years". As Bill is transferred to a motor torpedo boat and then a plane and is conveyed to Army Headquarters in London he is continually fed alcohol as he is deemed to be sea-sick and air-sick. Completely exhausted he is called upon to recite his experience five times to different groups of the top brass before he passes out. He is accidentally committed to a psychopathic ward in a military hospital. He escapes, makes his way back to Punxatawney and finding his house empty and locked up, climbs in through a kitchen window and is knocked out by his father (William Demarest) who mistakes him for an intruder. He tries to explain to his parents and to Marge what has happened but nobody believes him until military policemen turn up at the house to escort him to Washington to receive a medal from the President for delivering the vital photographs of the Nazi secret weapon. The American Legion band escort him to the airfield playing *Yankee Doodle*; the officers of the base line up to salute him as the plane takes off; the commandant says he will recommend him for a good conduct medal.

It is a moderately amusing but essentially minor Ford opus. It gently satirizes small town war fever, sympathizing with the hapless Bill Kluggs, desperate to see action but repeatedly told he is doing a vital job at home. Significantly the real-life hero Charley Fettles seeks him out and does not share in the civilians' disparagement of him. That is Ford's position—soldiers obey orders. There is also gentle ribbing of the army hierarchy by an old navy man for the way Bill's

questioners, as they gradually move up the ranks in seniority, have to have his story repeated over and over again each time.

Ford had a longstanding connection with the play *What Price Glory* by Maxwell Anderson and Laurence Stallings. The play had been a smash hit when it opened on Broadway in 1924. As Kevin Brownlow put it in *The War, the West and the Wilderness*, audiences were amazed by "its blunt honesty, its raucous language and its unprecedented lack of respect".[37] It combined a truthful look at conditions for soldiers on the Western Front with the rivalry of Captain Flagg and Sergeant Quirt who booze, fight and chase women in a permanent competition of macho masculinity. Stallings knew what he was writing about as he had served with the Marines in France and lost a leg from injuries sustained in the fighting. The play ran initially for 299 performances. Fox bought the film rights and assigned Raoul Walsh to direct. Walsh cast Edmund Lowe as Quirt and intended originally to use Louis Wolheim who had starred in the play for Flagg. Victor McLaglen lobbied him for the role but Walsh thought him too English for the part. However, McLaglen, who had served in World War One, told Walsh "there were no soldiers in the world tougher than the men in my old Middlesex regiment. A soldier was a soldier all the world over".[38] After a screen test he got the role. The film with its spectacular battle scenes, its comic rivalry between Flagg and Quirt and the fact that lipreaders could tell the actors were using real profanities in their robust exchanges (McLaglen can distinctly be seen mouthing the words "son of a bitch" three times) became a critical and box office hit. It inspired no fewer than three sequels with the same leading characters. *The Cock-eyed World* (1929), based on an unpublished play by Anderson and Stallings, and directed by Walsh was another box office hit. The third film in the sequence, *Women of all Nations* (1931), also directed by Walsh, was in his words "a turkey".[39] Basically a recycling of *The Cock-eyed World* it was a critical and box office failure and after one more outing, *Hot Pepper* (1933), directed by John Blystone, the series was terminated. Lowe and McLaglen were teamed again not as Flagg and Quirt but as the same characters in all but name in *No More Women* (1934)

[37] Kevin Brownlow, *The War, the West and the Wilderness*, London: Secker and Warburg, 1979, p. 194.

[38] Victor McLaglen, *Express to Hollywood*, London: Jarrolds, 1934, p. 272.

[39] Raoul Walsh, *Each Man In His Time*, New York: Farrar, Straus and Giroux, 1974, p. 200.

and *Under Pressure* (1938). They were reunited in 1942 as McGinnis and Curtis in *Call in the Marines* to repeat their Flagg and Quirt rivalry for World War Two.

Ford, who was working at Fox in 1926, actually directed some of the battle scenes of *What Price Glory* with a second unit. In 1949 Ford put on an all-star production of the stage play to raise funds to build a clubhouse for paraplegic veterans. Ward Bond and Pat O'Brien played Flagg and Quirt and Maureen O'Hara, the French café entertainer Charmaine. Ford regulars Harry Carey Jr., George O'Brien, Wallace Ford and John Wayne played supporting roles with guest appearances by Gregory Peck, Forrest Tucker and Oliver Hardy. Luis Alberni who had played café owner Cognac Pete in the original stage version recreated his role. All the actors performed free.

Ford had another direct connection with *What Price Glory* in that he became a friend and collaborator of its co-author Laurence Stallings (1894–1968). His success with *What Price Glory* led MGM to sign Stallings as a screenwriter and he scripted another classic Great War film, *The Big Parade* (1925). He remained with MGM as a scriptwriter until the outbreak of World War Two when he was recalled to the service and ended up as a lieutenant colonel in the Army Air Force. Having lost a leg as a result of war wounds and developed a career as a screenwriter, his career ran curiously parallel to that of Frank Wead. Wead collaborated with Ford on two films and after the war, Stallings worked on three scripts for Ford, *3 Godfathers* (1948), *She Wore a Yellow Ribbon* (1949) and *The Sun Shines Bright* (1953), his final works for the screen.

In 1951 Paramount Pictures decided to produce a remake of *What Price Glory* and applied to Darryl F. Zanuck at Fox for the rights. Zanuck immediately decided that Fox would remake it but as a musical. He hired Phoebe and Henry Ephron to script it, specifying only that there should be a romantic subplot involving a young soldier and a village girl. The Ephrons scripted a romance between 22-year-old Private Lewisohn and 17-year-old convent schoolgirl Nicole Bouchard. This replaced the mawkish theme of "mother love" that the permanently homesick Lewisohn embodied in the original and which earned him the nickname "Mother's Boy" from his comrades. The Ephrons decided to run Walsh's original film before writing their own. Henry Ephron recorded: "We came out of the projection room limp and with the last line 'Wait for baby' still ringing in our ears. *What Price Glory* played almost as if it had been made

yesterday."[40] Zanuck turned to Ford to direct. But the Ephrons found him to be almost permanently angry. They discovered that he had wanted to cast Ward Bond, John Wayne and Maureen O'Hara in the leading roles but Zanuck insisted on James Cagney, Dan Dailey and Corinne Calvet. Calvet, after her difficulties with Ford on *When Willie Comes Marching Home*, did not want to do it but Zanuck assured her after talking to Ford, that he would treat her courteously. She recorded in her autobiography that Ford was not "cordial but he had accepted me".[41] Then Ford fell out with the Ephrons. They were walking round the French village set together when Phoebe innocently remarked that there were too many churches for a little village, Ford snapped back "Don't you think there are a lot of synagogues in a Jewish village". Concluding that he was anti-Semitic they walked off the set. But this was a typical Ford reaction to any word of criticism—the sarcastic flare-up. The Ephrons heard from someone in the studio that "Ford barely looked at the script. If he had seen the Raoul Walsh film, he was obviously determined to make his own version".[42]

They were certainly right about that. Walsh saw the play as an anti-war text, writing in his autobiography:

> Its message was that war is not only futile but a dirty, bungled mess. There was no glory for the men in the rifle pits and the trenches. They had to launch or repel an attack against the enemy because the generals and the Congress said it was their duty. I would film it in that way.[43]

Kevin Brownlow believes that the pacifist sentiments, often found in Malcolm Stuart Boylan's intertitles, are negated by the comradeship of Flagg and Quirt.

> Two titles spoken by McLaglen sum up the schizophrenic nature of the film. Following the exciting night battle, McLaglen addresses his troops: "They sent me babies to baptize in blood. You've gone through it"—and McLaglen smiles his approval—"and as one soldier to another, I'm as proud of you as America should be". The final shot shows Flagg and the wounded Quirt in

[40] Henry Ephron, *We Thought We Could Do Anything*, New York: W. W. Norton and Co., 1977, pp. 119–120.
[41] Calvet, *Has Corinne Been a Good Girl?*, p. 214.
[42] Ephron, *We Thought We Could Do Anything*, pp. 119–120.
[43] Walsh, *Each Man In His Time*, p. 186.

close-up, marching to battle again with an eager comradeship. Quirt claps on a steel helmet and grabs a rifle with its bayonet ready fixed. That gesture and the power of emotion behind the shot, sinks all the pacifism in the picture.[44]

Another piece of evidence suggests that the anti-war message did not necessarily get home. Walsh records: "The War Department applauded the film, claiming that it was responsible for a substantial increase in Marine Corps enlistments."[45] The fact that *The Cock-eyed World* which contained no anti-war message and concentrated squarely on the adventures of Flagg and Quirt, was also a box office hit suggests that it was these characters that most appealed to the audience.

It is the Flagg–Quirt characters that most appealed to Ford. In a way they prefigure Donovan and Gilhooley in *Donovan's Reef*. Ford was no pacifist. He believed in the military and in service. Perhaps the key to his attitude to the film, especially after his experiences in World War Two and in Korea, is to be found in Flagg's final line as he departs from the front: "There's something about the profession of arms, some kind of religion connected with it you can't shake". So at various points Ford softens the anti-war emphasis of the original. This is most notable in the "What price glory" speech. In the original Lieutenant Moore has a complete nervous breakdown, refuses to take his men back out to fight, crying "What price glory" before collapsing unconscious. In Ford's version Lieutenant Aldrich—who regards Flagg as a loud-mouthed tyrant—is wounded and, pumped full of morphine, questions Flagg's right to order men to their deaths and urges him out to make the supreme sacrifice ending with "What price glory". But later when the men are ordered back into the line, Aldrich staggers to his feet, heading up the steps on his crutches before collapsing. Ford also introduced a characteristic opening not in the 1926 version. As the marines straggle back, exhausted and dirty, they see a smart French Army unit lined up for inspection. Flagg orders his men to form up into a smart column marching in time. It is clear that Flagg believes war should be left to the professionals, as he says to Charmaine: "I'm sick of war. It's alright with thirty men in the hills who know their job but now so many little boys". He is most concerned with the slaughter of raw recruits, hence his

despairing cry "Little boys" as he leads his men in attack on an enemy-held railway station.

Despite his failure to get his preferred stars, Ford characteristically inserted members of the stock company into the supporting cast (Jack Pennick, Dan Borzage, Bill Henry, Mickey Simpson, Fred Libby) plus several cast members from *When Willie Comes Marching Home* (William Demarest, Ann Codee, Luis Alberni, Peter Ortiz). Also in a nice gesture he cast Barry Norton, who had played "Mother's Boy" Lewisohn in 1926, as the village priest. In a typical private joke he cast two Irishmen from the cast of *The Quiet Man* (Charles Fitzsimons and Sean McClory) as pukka British officers.

But Ford had problems with the idea of the film as a musical. It begins as if intending to develop into a musical with Corinne Calvet as Charmaine singing "*Oui, Oui, Marie*" in the café and later in an embarrassingly glutinous sequence Nicole (Marisa Pavan) crooning "My Love, My Life" to Lewisohn (Robert Wagner). But as Ford later recalled: "There wasn't one catchy tune in the whole score ... A quarter of the way through I got disgusted with it".[46] As if to make up for the deletion of the songs, Ford included rousing renditions of World War One favorites "Tipperary", "Pack Up Your Troubles" and "There's a Long, Long Trail A-Winding" after British troops take over the café. Alfred Newman's score included "Battle Hymn of the Republic", "The Marines' Hymn" and "Over There". When Zanuck saw Ford's final cut, he wondered what had happened to the songs and Ford retorted "If you want music, you put it in" and stalked out. Zanuck simply accepted what he had been presented with. However, with a domestic gross of $2 million, it turned out to be Fox's tenth most profitable of the year though it did less well overseas. Reviews were mixed. The *New York Times* (August 23, 1952) called it "a swift moving but not especially distinguished offering ... an entertainment that is hardly an improvement on the original." *Variety* (July 30, 1952) thought it "overlong" and said "there's nothing distinguished enough about the presentation to rate a class audience." The *Saturday Review* (August 23, 1952) perceptively complained that it could not make its mind up whether it was a musical or a straight drama. It also suffered from comparison with *The Quiet Man* which was released simultaneously and swiftly became a critical and box office success.

[46] McBride, *Searching for John Ford*, p. 493.

Fordians on the whole dislike the film. McBride complains that the "listless staging of the badly misconceived 1952 film version and Joe MacDonald's gaudy Technicolor photography of phony-looking sets of a French village reflect the director's utter disdain for the project".[47] The French village was Fox's standing French village which had featured in *The Song of Bernadette* and *When Willie Comes Marching Home*. Eyman said "the script lacked the bawdy vitality of the original play and silent film, and, in any case, after his experiences in World War II, Ford could not commit to the original's ambivalence about the military".[48] John Baxter concluded: "it remains an unlikable film, amusing, tightly directed but unsatisfactory for reasons that tell us a lot about Ford and his attitudes ... The film dramatizes what a fine technician Ford is, but underlines that, in his work, involvement is everything".[49] Gallagher said: "Although all Ford's movies of the early fifties are eccentric, *What Price Glory* is the weirdest of the lot ... The concentration on the frightening process by which individuals coalesce into a fighting organism deprives the picture of deep peaks and valleys of contour. Despite the contrasts between love and war ... the modal variation is insufficient to relieve a certain erosion in interest".[50] J. A. Place concluded "It is a film that takes its generic theme too lightly for a serious picture and takes its comedy too casually for a satisfying comedy. Add to this a static and dull visual style and *What Price Glory* is a likable (because the two leading characters are likable) but neither moving nor complete film".[51]

In Ford's hands *What Price Glory* becomes a celebration of the Marines, in particular their brawling, boozing and womanizing. It is far from being "a strong critique" of this model of masculinity as Sue Matheson alleges.[52] Andrew Sarris nails it precisely when he writes "the originally pacifistic *What Price Glory* is transformed by Ford into a nostalgic celebration of military camaraderie with the once-raucous Charmaine emerging from the dim shadows as an idealization of the Chivalric Code".[53]

[47] McBride, *Searching for John Ford*, p. 492–3.
[48] Eyman, *Print the Legend*, p. 412.
[49] John Baxter, *The Cinema of John Ford*, London: Zwemmer, 1971, p. 139.
[50] Gallagher, *John Ford*, p. 274.
[51] Place, *The Non-Western Films of John Ford*, p. 96.
[52] Sue Matheson, *The Westerns and War Films of John Ford*, Lanham, MD: Rowman and Littlefield, 2016, p. 139.
[53] Sarris, *The American Cinema*, p. 48.

Figure 6.2 James Cagney, Corinne Calvet and Dan Dailey in *What Price Glory* (20th Century-Fox, 1952)

Dispensing with the amatory episodes of Flagg and Quirt in Peking and the Philippines and the knockabout comedy of the "other ranks", Kiper and Lipinsky, which featured in the 1926 version, Ford's film begins in France in 1918 with a narrator telling us that the Marines were the first American troops to arrive, having seen service in China, the Philippines and San Domingo. Flagg's unit, Company L, Third Battalion, 5th Regiment of Marines, return from the front line to the village of Bar-le-Duc and immediately occupy Cognac Pete's café, drinking and singing. In a typical piece of Ford knockabout, a soldier tries to play "The Marine's Hymn" on the upright piano and is constantly barged into by Jack Pennick. Pete's daughter Charmaine sings "*Oui, Oui, Marie*" to the delight of the soldiers. Upstairs, Flagg takes a bath in a wooden tub, preparing to go on leave. Charmaine, who is evidently Flagg's girlfriend, asks him to take her to Paris too and to marry her. But he tells her he has to attend a high-level meeting and anyway is already married. He produces a postcard of stage star Lillian Russell who, he explains, is his wife.

Replacement troops arrive for his unit, some as young as seventeen. Flagg expresses his disgust: "They're always sending me babies". But his old rival and sparring partner Sergeant Quirt turns up. Corporal Kiper (William Demarest) carefully removes all the breakables before admitting Quirt to Flagg's office. Ritualistically they put chalk marks on the floor and then fight each other until Flagg knocks Quirt out. He sends for his subalterns and introduces Quirt, telling them he is the best man in the army when sober and worse than Flagg when drunk ("He's worse than I am and you know I don't allow anyone to be that bad"). So if he is sober, he is to be left in charge of the unit; if drunk, he is to be reduced to the ranks. Flagg then takes off at high speed in the sidecar of a motorcycle outfit ridden by Kiper, in a repeat of a sequence from 1926. Quirt now drills the new recruits in a typical Ford scene. When the regulars gather to mock the efforts of the youngsters, Quirt orders them to line up and march off laughing in unison. One remaining soldier sitting laughing on the bridge is ordered to stand up and turn right, causing him to fall into the water. Flagg returns from leave in a repeat of the high-speed motorcycle ride, which this time ends with him tipped out onto the manure heap. Still drunk, he is sobered up by Jack Pennick, repeatedly slapping him across the face with a wet cloth. Pete arrives to complain that Charmaine has been compromised by one of Flagg's men. He wants a wedding and financial compensation. When Flagg discovers the guilty man is Quirt, he pays the money and orders a wedding to be arranged. There is a large family gathering to meet Quirt, with family members playing "Three Cheers for the Red, White and Blue". Charmaine appears in the wedding outfit looking radiant, the very image of the chivalric ideal mentioned by Andrew Sarris. Both Flagg and Quirt stare at her entranced. But the wedding is interrupted by the arrival of General Coakley (James Gleason), a brisk, no-nonsense commander who orders Flagg and company back to the front line with specific instructions to capture a German officer who may have knowledge of the enemy's plans. As the unit prepares to move out, Quirt paternalistically picks out the two youngest soldiers, puts them on a charge and has them confined to the brig. Several of the soldiers kneel to receive a blessing from the village priest. In a field of long grass, Flagg suddenly stands up, blows his whistle and orders his men to attack an enemy-held railway station. As the young soldiers are shot down, he shouts despairingly "Little boys" and furiously hurls grenades at the German position. Later in a

dugout, he attends to the needs of the wounded. He dispatches Lieutenant Moore to capture the required German officer. But Moore and his men fail to reappear. In an advance position, Flagg and Lewisohn watch for their return. Lewisohn confirms his desire to marry Nicole, the French girl he has been romancing. Flagg says he has almost married twenty-five times but was saving himself, "from what?" he muses. Flagg and Quirt now set out to capture the required officer, each admitting that he wishes to marry Charmaine as they crawl across the blasted landscape of no-man's land. They capture a farmhouse and with it a German colonel, but he is killed as they try and take him back to their lines and Quirt is injured and ordered to hospital. Lewisohn brings in a captured German lieutenant but is then blown up and dies in Flagg's arms. The men are ordered back into action to take the railway station. Back in Bar-le-Duc, the British troops have moved in and inhabit Cognac Pete's. Quirt, having discharged himself from hospital and borrowed a major's greatcoat, returns to find Charmaine has been "entertaining" a British officer Captain Wickham, who considerately bows out. Flagg returns and proposes to Charmaine. Quirt appears to claim her hand. They both get steadily drunk and decide to cut cards for her. Flagg bluffs Quirt into throwing in his hand and in an excess of drunken triumphalism dances round the café firing his gun and shrieking "I've bluffed him". Corporal Kiper arrives to tell him that the unit is ordered to the front. Flagg at first refuses to go but then pulls himself together and joins his men. He tells Kiper that he has been holding his discharge papers, which Kiper has been awaiting, for a year, wanting to keep him on. He hands them over but Kiper pockets them and joins the column, echoing the actions of Captain and Mrs. Collingwood at the end of *Fort Apache*. Quirt bids Charmaine farewell and dashes after the unit, shouting "Wait for baby" and taking his place beside Flagg as they march out.

It is clear to see that the relationship of Flagg and Quirt is what interested Ford. He seems to have had little interest in the romantic subplot of Lewisohn and Nicole. Their love scenes are fundamentally false and Hollywood-conventional. Flagg's grief at Lewisohn's death, weeping and shoulders heaving with his back to camera, appears stagy and unconvincing and Flagg's breaking the news of Lewisohn's death to Nicole is curiously flat.

Although Zanuck went along with Ford's version at the time, he later concluded that it had been a failure, saying: "Our picture was a flop because it

was neither fish nor fowl. It was not the powerful *What Price Glory* of World War I that everyone loved and remembered—it was certainly not good comedy".[54]

Anxious to do his bit to support American forces in the Korean War, Ford volunteered his services to make a documentary film. Republic Pictures agreed to distribute it and Ford arrived at the start of January 1951 just as the Chinese Army invaded and pushed back the United Nations forces. Ford was accompanied by his former naval aide Mark Armistead, and two Field Photo cameramen from World War Two, Charles Bohuy and Robert Rhea. Ford spent four weeks filming the 7th Fleet and First Marine Division and the result was a fifty-minute film *This is Korea!* shot in Trucolor and released on August 10, 1951. The narration was provided by James Warner Bellah, author of the cavalry trilogy filmed by Ford, with input from his regular scriptwriter Frank Nugent. They received no screen credit nor did the narrators Irving Pichel and John Ireland. Having completed the film Captain John Ford was awarded the Air Medal and officially retired from the Navy, being raised by President Truman to the rank of Rear Admiral. So the film credits read "supervised by Rear-Admiral John Ford (retd.)".

The film does not concern itself with strategy, dates or statistics but concentrates on giving the ordinary soldier's point of view. So the soldiers seem to be continually advancing or retreating aimlessly and experiencing dreadful conditions, wet, cold, freezing, icy winds, snow, as they footslog wearily along roughly made roads or climb hill after hill ("always another hill"). The frozen conditions are compared to Valley Forge.

The film opens with an idealized image of a peaceful agrarian society, a country of lakes and villages and happy peasants living contented lives "until the ruthless Red hand of Communism reached out to snatch it". The faces of children are heavily featured in this introduction and provide a linking image repeated regularly throughout the film. Children are seen skating on a frozen lake. They are seen starving "until we fed them". They are seen receiving candy from American soldiers and being shown how to eat it. The marines are shown sharing their rations with children. The protection of these children is thus being advanced as one of the causes of American involvement in the war.

[54] Mel Gussow, *Don't Say Yes Until I Finish Talking*, London: W. H. Allen, 1971, p. 162.

After the first shots of Korean children, narrator Irving Pichel, addressing the audience directly as he had when narrating *The Battle of Midway*, says "And here come your kids" as the marines march in "in the year of grace 1950". Their appearances are regularly accompanied as in *Midway* by "The Marines' Hymn". They reach the rest camp at Christmas and there is the classic Fordian scene of a church service, candles being lit on the altar, marines singing "O Little Town of Bethlehem". The troops form up into the chow line ("first hot meal in two months"). They receive mail from home with cards and presents ("Did you remember?"). Decorations for gallantry are awarded. Replacements arrive from the United States to take the place of the fallen. The camera pans along the line as the narrator, echoing a similar sentiment in *Midway*, declares: "young faces, American faces—New York, Georgia, Texas, Idaho, Maine, California—your sons with a pride in the corps and a will to do it". There is a flashback to the first arrival in Korea of the marines with a job to do ("a hard job, a tough job, a dirty job"). There follows a fearsome display of weaponry in action: Pershing tanks, bazookas, mortars, grenades, automatic rifles, machine guns, recoil-less rifles plus napalm and rockets delivered from navy planes strafing the enemy lines.

Then just as in *Midway* there is Ford's concern for the wounded. The wounded walk or are carried or are driven in ambulance jeeps to a field station for bandaging, pain-killing injections and blood transfusions. Pichel addresses the audience: "Aren't you glad you gave a pint of blood last week—or did you? But you will now, won't you?" They are flown to a hospital ship anchored off shore "with clean sheets, food and the best medical care". "Eternal Father, Strong to Save" is on the soundtrack.

In Seoul we see South Korean recruits being trained and aerial shots of streams of refugees, apparently without end, fleeing "from the Red scourge". Refugees are inoculated against typhus and smallpox; orphaned children are deposited with Catholic nuns.

After these humanitarian scenes there follows a chilling sequence of destruction. Phosphorous grenades and flamethrowers are directed at dug-in Communist forces. "Fry 'em, burn 'em, cook 'em" urges narrator John Ireland with unusual savagery.

Plans are made in Tokyo and Pearl Harbor to support the land forces with fire-power and we are given glimpses of the top brass, General Douglas MacArthur, seen in silhouette, entering his headquarters in Tokyo and in Pearl

Harbor, Admiral Arthur Radford, commander-in-chief, Pacific Fleet and Vice-Admiral Turner Joy, commander, Naval Forces, Far East making their dispositions. Planes take off from aircraft carriers on combat missions; USS *Missouri* shells the beach. Bombs and napalm are dropped on "dug-in Commies". The Americans abandon a forward base, burning the buildings, before advancing again in a different direction. "What is it all about?" asks Irving Pichel, "You tell us. Ask any of those guys what they are fighting for, and they can't put it into words. Maybe it's just pure cussedness or pride in the Marine Corps. A job to do—and duty". There is a forest of white crosses and a voice whispers from them "Remember me" and as the marines march out, a louder voice from the ranks repeats "Remember me". Once again a Korean child is seen and the narrator concludes "This is everyone's fight that life, liberty and the pursuit of happiness must not vanish from the earth".

Although there are glimpses of senior officers, including General Lewis "Chesty" Puller, who is seen ordering "Put some fire down on those people" and who shared a tent with and became a close friend of Ford, they are not the principal focus of the film. Ford described it as "simply a narrative glorifying American fighting men on land, sea and air".[55] It notably lacks the optimism of *The Battle of Midway* and while the familiar Fordian elements (the church service, the concern for the wounded, the crosses) are there, the overall mood is one of melancholy.

The film received some respectful reviews. For example, the *New York Times* (August 20, 1951) declared *This is Korea!* "well worth the price of admission ... impact beyond words is given to the intrepid work of the First Marine Division and the Seventh fleet (with a bow to the Army) ... this record is both a tribute to and a sobering reminder of the bravery of free men". *Variety* (August 22, 1951), however, dismissed it as "little more than well-edited newsreel clips with dramatic effect heightened by Trucolor ... one has the impression that one has seen it all before".

The film was a box office failure. When Peter Bogdanovich told Ford that he thought the film "very grim", Ford replied: "Well, that's the way it was ... there was nothing glorious about it. It was not the last of the chivalrous wars".[56] The grimness

[55] McBride, *Searching for John Ford*, p. 507.
[56] Bogdanovich, *John Ford*, p. 90.

may explain why exhibitors reported audience members, chiefly women, walking out. But the war itself was deemed by the public to be "costly, messy and protracted".[57] An ironic footnote is that narrators Irving Pichel and John Ireland who had delivered the strongly anti-Communist narrative were blacklisted as Communist sympathizers shortly after completing the film.

In 1968 Ford was hired by the United States Information Agency (USIA) to act as executive producer on a documentary explaining and justifying the US intervention in Vietnam. It was felt that his reputation would boost the impact of the film's message. Although Ford's private view of the war was "I haven't the slightest idea what we're doing there", he had a personal investment in it—his grandson Dan was serving there—and he had never failed to heed his country's call in time of war.[58] In the event the film did his own reputation little good. *Vietnam! Vietnam!*, a fifty-eight-minute feature, was completed in 1968 and only released in 1971 by which time it was already out of date, having been overtaken by events. It received only a limited release and wags dubbed it, in reference to one of Ford's best known films, *Drums Along the Mekong*.

The film was directed by Sherman Beck, a World War Two Army Signals Corps veteran who had been making films for USIA since 1949. Beck filmed for nine weeks in Vietnam, with Ford visiting during the last couple of weeks to inspect and advise. Beck returned with eleven hours of film. Ford supervised the editing and worked on the narration with journalist Tom Duggan. The narration was spoken by Charlton Heston. It turned out to be the most expensive production in USIA history.

The film was in two parts. Part I—*The People and the War*—strongly resembled *This is Korea!* It bore the indelible stamp of Ford's world view. The opening images illustrated the life of the simple and contented peasant people with a deep religious faith and love of the family—the ideal Fordian society. There are recurring images of smiling children, symbols of the innocence being menaced by the Viet-Cong; there is concern for the injured, both American and Vietnamese, and there is evidence of the enemy's savagery. A shot of a one-legged boy hobbling over the fields introduces a section on enemy atrocities—horrific scenes of burned villages, slaughtered villagers and

[57] Steven Casey, *Selling the Korean War*, Oxford: Oxford University Press, 2008, p. 367.
[58] McBride, *Searching for John Ford*, p. 690.

mass graves, followed by funeral processions, weeping people and children being fitted with artificial limbs. These images are contrasted with victory parades in North Vietnam where destruction is celebrated as liberation.

President Kennedy's New Year message to the South Vietnamese promises support and the film stresses the Allied effort of the United States, Australia, New Zealand, Malaysia, Korea, Thailand and the Philippines. The film demonstrates the care taken to avoid civilian casualties with scenes of villages being evacuated before Allied military advances and children being helped into helicopters by GIs.

American military operations are deemed successful but casualties are the price of victory—40,000 Americans killed in Vietnam in the 1960s and 1,000 missing. Flag-draped coffins are loaded onto planes. The wives of the missing appeal to the North Vietnamese for news and returned American prisoners give testimony about their cruel treatment. These scenes are intercut with images of American prisoners being paraded through jeering North Vietnamese crowds.

Part II—*Vietnam: the Debate*—intercuts speeches by the proponents of the war (President Dwight Eisenhower, President Lyndon Johnson, Secretary of State Dean Rusk, Governor Nelson Rockefeller, Governor Ronald Reagan, Vietnamese President Nguyen Van Thieu) and its opponents (Senator William Fulbright, Senator Eugene McCarthy, Senator Ernest Gruening, Dr. Benjamin Spock). US soldiers in wheelchairs talk about the war being "a just war" and a Hungarian refugee anti-Communist denounces anti-war activists. President Richard Nixon explains that his term of office has been dominated by the search for an end to the war. But the film makes its sympathies clear by intercutting rowdy anti-war demonstrators chanting "Hell no, we won't go" with heroic shots of South Vietnamese soldiers marching and singing patriotic songs to defend their homeland. Although the war dragged on into the 1970s, opposition to it mounted and the documentary had no effect on public opinion, being finally taken out of circulation in 1975. By then American troops had been withdrawn from Vietnam following a peace treaty in 1973, and in 1975, two years after Ford died, Saigon fell to the North Vietnamese who reunited the country under Communist rule.

The last film Ford ever directed was a documentary tribute to Lt. General Lewis "Chesty" Puller, the retired Marine commander, who had become a

friend of Ford in Korea. Entitled *Chesty: Tribute to a Legend* it was shot between 1968 and 1970 and introduced and narrated by John Wayne. It interspersed war footage with scenes of the ailing Puller, who had suffered several strokes, reminiscing with Ford about his career. "Chesty" is defined as the kind of hero Ford and Wayne admire, stressing his love of the Marine Corps and the American people and above all his concern for the well-being of his men. Characteristically Fordian is the march past of cadets from Puller's *alma mater* the Virginia Military Institute, a sequence which recalls *The Horse Soldiers,* and "Chesty's" visits to the graves of Confederate heroes Stonewall Jackson and Robert E. Lee. The score was also classic Ford, consisting of "Red River Valley", "Lorena", "The Marines' Hymn", "The Bonnie Blue Flag" and "Carry Me Back to Old Virginy". The film ran for an hour but no distributor for it could be found before Puller died in 1971. So it was cut to twenty-eight minutes and eventually released on home video. *Variety* described it as "a sentimental right wing military fantasy".[59]

[59] McBride, *Searching for John Ford*, pp. 697–700; Scott Eyman, *Print the Legend*, p. 538.

John Ford's Navy

Born in Cape Elizabeth, Maine, Ford was brought up within the sight and sound of the sea. He developed a life-long love of the sea and told Lindsay Anderson in 1950 that he would like to have been a tugboat captain.[1] During summer vacations he worked as a deckhand on a variety of vessels. Toward the end of his high school career he applied to join the Annapolis Naval Academy but failed the entrance examination. Called up in 1917 for the armed forces, he applied to be an aerial cameraman but was rejected because of his bad eyesight. He was still seeking to have the rejection overturned when the war ended and in consequence he never saw action. He would later claim to have been an ordinary seaman in World War One but there is no evidence to support this story. This early failure may well have fueled his later burning desire to gain advancement in the Navy.

In 1934 he purchased a 110 foot ketch, the *Faith*. Having it extensively overhauled and improved, he renamed it the *Araner* after the islands from where his mother's family hailed. A handsome and stylish white-painted boat with a crew of six, it became Ford's alternate home. Although it was used for family holidays with his wife and children, it became predominantly his masculine domain. He would take off on the *Araner* after finishing a film to relax and recharge his batteries. But he also held intensive script conferences aboard when working on a personal film project. It became the base for his all-male coterie, ironically named The Young Men's Purity, Total Abstinence and Yacht Association (later renamed The Emerald Bay Yacht Club) where his closest associates would meet to play cards and drink, usually to excess: directors Emmett Flynn, Frank Borzage and Tay Garnett; writers Gene Markey, Liam O'Flaherty and Dudley Nichols; his agent Harry Wurtzel; and actors

[1] Lindsay Anderson, *About John Ford*, London: Plexus, 1981, p. 25.

Preston Foster, Frank Morgan, J. Farrell MacDonald, Grant Withers, Henry Fonda, John Wayne and Ward Bond—a group with a preponderance of hard-drinking Irish Americans. There would also be fishing and carousing trips along the Mexican coast.

At the same time as he bought the yacht, Ford enlisted in the Naval Reserve and was commissioned as a lieutenant commander. Dan Ford explained the appeal of the role:

> As a product of Hollywood, John had a romantic, idealized notion of what the navy was all about—it was like being in a yacht club, with fancy white uniforms and Sunday brunches on the officers' club lawn. But it also meant respectability, for in those years before the technocrats took over the military, a commission, and particularly a naval one, gave a man status as a gentleman. Determined to make his career in the naval reserve as successful as his career in motion pictures, John attacked his new job with enthusiasm. He bought every uniform the navy had ... John didn't miss a chance to win favor or influence. He presented an expensive oil painting of the *USS. Constitution* to the Officers' mess at the US Naval and Marine Corps Armory in Los Angeles. He cultivated his commanding officer, Captain Claude Mayo, taking him to Catalina on the *Araner* and showering him with theater tickets and studio passes.[2]

His reserve status became active once America entered World War Two and Ford formed the Field Photographic Unit to make documentary films, instructional films and reconnaissance films for the OSS. Entering the war as a commander, he ended it as a captain and on his retirement from the Navy in 1951 was raised to the rank of Rear Admiral. President Nixon made him a full Admiral on the occasion of the American Film Institute Life Achievement Award in 1973.

Ford would lovingly explore the world of "men without women" in a series of eight films, evoking the courage, comradeship and service of sailors. But interestingly in many of the films he chose to concentrate on neglected and unsung branches of the service: Q-ships (*Seas Beneath*), the "splinter fleet" (*Submarine Patrol*), the merchant marine (*The Long Voyage Home*), PT boats (*They Were Expendable*) and cargo ships supplying the fleet (*Mister Roberts*).

[2] Dan Ford, *The Unquiet Man*, London: William Kimber, 1982, p. 76.

After he himself had seen service under fire and had lost comrades, many of them very young, his films achieved an even greater sense of emotional commitment to the Navy than they had had before.

The Blue Eagle (1926) survives only in a truncated version, compiled from three different negatives and missing a chunk of the action from the middle of the film. It was a studio assignment, part-naval drama, part-social problem film, scripted by L. G. Rigby from Gerald Beaumont's novel *The Lord's Referee*. But it featured a range of favorite Ford themes: the Navy (it is dedicated to "the unsung heroes of the Navy—of steadfast service and unconquerable courage"), male bonding, the Irish American community, and family break-up.

It opens in 1917 with the US fleet on convoy duty. In the stokehold stokers George Darcy (George O'Brien) and Big Tim Ryan (William Russell), who on shore are leaders of rival ward gangs, Darcy's Terriers and Ryan's Rats, work side by side, having suspended their hostility for the duration of the war. Despite this, they quarrel and come to blows. Chaplain Father Joe O'Reagan (Robert Edeson) arranges a boxing match between the two. The fight is interrupted by the approach of an enemy ship. Footage of the engagement between the ships and the sinking of the enemy ship is lost. Ryan carries an injured stoker, Joseph Rohan, out of the burning stokehold but he dies and is buried at sea.

After the war, they return to their Irish American community where tension between Darcy and Ryan resumes as they are both in love with the same girl, Rose Kelly (Janet Gaynor), daughter of a police sergeant. George discovers that his brother Limpy has become a drug addict. He agrees to fight his addiction as George appeals to the memory of their dead mother, her portrait on the wall with flowers beneath it, a familiar Ford visual trope. Father O'Reagan, now a parish priest, is called to the deathbed of a dying drug-addicted mother. She entrusts her child to the priest's care.

Father Joe determines to eradicate the drug pushers. Meanwhile the police raid a drug den and Limpy, fleeing from the police, takes refuge on the submarine used by the drug smugglers. George and the police pursue and watch horrified as the submarine dives, leaving Limpy on deck to drown. The police continue to pursue the drug pushers and in one of the raids, Dizzy, a former henchman of Tim, now a policeman, is shot dead. Father Joe enlists

George and Tim to combat the drug menace. They agree following the deaths of Limpy and Dizzy. They extract from a terrified addict the location of the submarine. George and Tim and their respective gangs sail to Rock Island. George swims out to the submarine, plants a dynamite charge and blows it up. Father Joe arranges another boxing match between George and Tim to finally resolve their rivalry. After a furious fight in an empty gym, George wins and Rose turns up to declare her love for him. Father Joe matches Tim with Mrs. Rohan, widow of the stoker he tried to save, and they adopt the dead drug addict's orphaned child. The film ends with them all marching as veterans into the new headquarters of the American Legion.

Along with the drama, Ford inserts some characteristic comic vignettes. At a dance, George and Tim vie with each other to get a dance with Rose and there is a free-for-all as the men dash for the refreshments counter. Similarly amusing is the scene where the rival gang gather to beat up George but when he emerges carrying the baby, they crowd round and instruct him how to hold the child.

The film is intensely homoerotic, highlighting in particular O'Brien's magnificent body. It opens with scenes in the stokehold with sweaty, half-naked stokers powering the ship. George and Tim strip to the waist to fight on the deck. George strips to swim out to the submarine. He is stripped and wearing the skimpiest of shorts in the final boxing match. As George O'Brien's biographer David W. Menefee, records:

> Many of the viewers at this time, notably in *Variety* and the *New York Times*, observed the frequent displays of his biceps and chest in his films. George also posed for a number of photographic portraits that were taken of him in the 1920s that flaunted his muscularity in a manner befitting a Rodin statue. He was posed artistically in the nude, throwing a discus, aiming a bow and arrow, and in full-figure with strategically positioned fig leaves attached to his anatomy. These images, though shocking in their time, were widely circulated in postcards and in various magazines … His popularity was partly caused by the circulation of these beefcake nude portraits.[3]

[3] David W. Menefee, *George O'Brien: A Man's Man in Hollywood*, Albany: Bear Manor Media, 2009, pp. 72–3.

But O'Brien was also a capable actor, his most notable performance being in the role of the murderous husband in Murnau's masterpiece *Sunrise* (1927).

O'Brien had made his breakthrough to stardom in Ford's Western epic *The Iron Horse* (1924) and subsequently starred for Ford in *The Fighting Heart* (1925), *Thank You* (1925) (both titles now lost), *3 Bad Men* (1926), *The Blue Eagle* (1926), *Salute* (1929) and *Seas Beneath* (1931). Ford and O'Brien became close friends and went together on a tour of the Far East in 1931. Ford went on one of his benders in Manila and after he resisted all pleas from O'Brien to sober up, O'Brien abandoned him and carried on the tour alone. Regarding O'Brien's behavior as a betrayal, he cast him out, ending their friendship. He would not recall him for seventeen years, when he cast him in *Fort Apache* (1948) and *She Wore a Yellow Ribbon* (1949). O'Brien wrote in his diary:

> I had known him for nearly 10 years ... yet after four months in which I was with him every second of every day, I think I knew less about him than ever before. He was the most private man I ever met, and even though I loved him, I guess the truth is that I never really understood him.[4]

Limpy was played by Ford's nephew Philip Ford, the son of Francis, whom he strongly resembled. Janet Gaynor's role as the girl loved by both George and Tim was essentially peripheral with the main focus being on the rivalry and eventual alliance of two Irish American he-men, George and Tim.

Salute (1929), which McBride calls "piffle" and William K. Everson dismisses as "pointless", is a mixture of documentary and conventional romantic drama.[5] Adapted by John Stone from a story by Tristram Tupper, it has dialogue by James Kevin McGuinness. The dialogue is stilted and banal, the photography (Joseph H. August) is uneven, generally failing to match the location shooting, and the studio scenes, and some of the acting is bad, notably Helen Chandler. George O'Brien, the ostensible star, plays what is in effect a supporting role. Nevertheless it was the top Fox moneymaker of 1929 and elicited some enthusiastic reviews. The *New York Times* (October 5, 1929) called it "a genuinely well thought out yarn" with "the most stirring football game that has been filmed" and praised Ford for showing "a happy faculty for interesting detail, a

[4] Menefee, *George O'Brien*, p. 127.
[5] Joseph McBride, *Searching for John Ford*, London: Faber and Faber, 2003, p. 170; William K. Everson, "Forgotten Ford", *Focus on Film* 6 (Spring 1971), p. 17.

keen imagination and a good sense of humor". *Variety* (August 15, 1929) said: "It's football, but more important there's laughs and plenty of them".

Basically it is a full-hearted celebration of the United States Naval Academy at Annapolis where much of the film was shot in the spring of 1929. Ford explained how this came about:

> The superintendent of Annapolis was from the same island I'm from in Maine—Peak's Island—he and my father were great pals; so we went back there to shoot and they let us do whatever we wanted, turned everything over to us. We put up lights and shot the actual Commencement Ball; after the Ball, we did our close-ups. The Admirals' daughters were all in the picture—you know, ten bucks a day—and we had a lot of fun.[6]

It is a hymn to service and tradition, structured by the Academy's rituals— the taking of the oath, formation (the morning parade), drilling, the commencement ball, last post. It is full of marching and singing, "Anchors Aweigh" being played and sung repeatedly. Interestingly the upper classmen parade to the strains of "Dixie", foreshadowing the finale of *Rio Grande* twenty years later.

The film opens at the grand home of Rear Admiral Randall where there is a farewell party for his grandson Paul (William Janney). The service tradition is heavily stressed. When Randall's son and daughter-in-law died, the two grandfathers took over responsibility for raising each of their two children. General Somers brought up the eldest son John (George O'Brien) and sent him to West Point. Admiral Randall took charge of the younger, Paul (William Janney), and is sending him to Annapolis. Paul is urged by his grandfather to uphold the family tradition, embodied in a series of portraits of serving officers.

Arriving at Annapolis, Paul arranges to room with the brash but likable Albert Edward Price, the same character played by the same actor (Frank Albertson) who will appear in *Men Without Women*. Nancy Wayne (Helen Chandler), daughter of an invalided officer, teaches the new recruits to sing "Anchors Aweigh". Paul is bullied by senior classmen, who believe wrongly that he has reported them to the officer of the watch for "hazing" Price (pushing a custard pie in his face). He decides to leave and goes AWOL but he encounters

6 Peter Bogdanovich, *John Ford*, Berkeley and Los Angeles: University of California Press, 1978, pp. 50–51.

Nancy who gives him a speech about tradition and duty, persuading him to go back. He is reconciled with the senior classmen who apologize for their behavior. At the ball, John turns up and takes over Nancy from Paul. The finale of the film is provided by the annual Army versus Navy football game. John is the star of the Army team and the Navy is fielding a weak team. It is the Navy coach's last game. The Navy are losing when the coach puts in Paul who scores an equalizer, securing an honorable draw. There is extensive long shot footage of the game, with the actors featuring in close shots. An uncredited Lee Tracy plays a fast-talking radio commentator who describes the progress of the game in inserted close-ups. John, who had advocated a philosophy of taking what you want and holding on to it, now admits he needed taking down a peg and surrenders Nancy to Paul.

Much of the film has an improvisational feel about it, notably the sequence of the new recruits being drilled by what sounds suspiciously like a real drillmaster and the ball in which an increasingly exasperated Ward Bond tries and fails to get a dance. Important supporting roles as senior classmen are played by Ward Bond and Marion "Duke" Morrison, the future John Wayne, neither of them actors at this time. Ford explained:

> We brought the entire USC football team back there with us; Ward Bond and Wayne were on it—they were both perfectly natural, so when I needed a couple of fellows to speak some lines, I picked them out and they ended up with parts.[7]

For the football scenes twenty-five members of the USC Trojans football team were recruited by "Duke" Morrison, a former Trojan who had been working as a prop man for Ford since 1927. Ford was so taken with the self-confident behavior and photogenic ugliness of Ward Bond that he cast him and Morrison as the senior classmen who harass the new recruits at dinner, "haze" Price, and participate in the ball and the football match.

Similarly the appearance of Stepin Fetchit as the shuffling, sleepy-eyed, slow-talking, head-scratching "Darky" Smokescreen in a succession of what are essentially comic monologues, also has an improvisational feel. He insists on going to Annapolis to look after Paul ("I's your mammy"), turns up in the

7 Bogdanovich, *John Ford*, p. 51.

Admiral's dress uniform and ends up looking after the Annapolis mascot, a goat. Ford evidently loved the character portrayed by Stepin Fetchit, using him again in *The World Moves On, Judge Priest, Steamboat Round the Bend* and *The Sun Shines Bright*. In 1946 Ford created a role for Stepin Fetchit in *My Darling Clementine* but Darryl F. Zanuck vetoed his casting, saying there would be strong criticism from African Americans. As McBride puts it, "the increasingly militant National Association for the Advancement of Colored People had warned Zanuck and other Hollywood executives that Stepin Fetchit embodied what was considered an offensive and unacceptable racial stereotype".[8] The fact that Stepin Fetchit was also a Catholic may have further endeared him to Ford. But after Ford's *The Sun Shines Bright* in 1953, Stepin Fetchit did not make another film until the all-black comedy *Amazing Grace* in 1974. Latterly there has been an attempt to rehabilitate the actor. Joseph McBride in particular believes that Ford and Stepin Fetchit were satirizing racial stereotyping, ridiculing and subverting the conventions of American racism.[9] But how many in the audience recognized this? Andrew Sarris admits: "Even this Ford enthusiast must testify that he winces when Stepin Fetchit enacts the mock-castration of his race. The guilt and shame are almost too much to bear".[10]

Men Without Women (1930) derived its title but nothing else from a 1929 Ernest Hemingway collection of short stories purchased by Fox. The original story *Submarine* was devised by Ford himself and James Kevin McGuinness. Released in two versions, silent and sound, it now exists only in an awkward hybrid with intertitles but also musical soundtrack, sound effects and snatches of dialogue. The film inaugurated the long and profitable partnership with Dudley Nichols. Nichols was Irish American, a Navy veteran from World War One, an activist in the Screen Writers Guild. Nichols explained to Lindsay Anderson in 1953 how his partnership with Ford came about. Winfield Sheehan, head of production at Fox, talked him into coming to Hollywood:

> I knew nothing about film and told him so. My love was the theater. I had seen one film I remembered and liked, Ford's *The Iron Horse*. So I arrived

8 McBride, *Searching for John Ford*, p. 434.
9 McBride, *Searching for John Ford*, p. 171. See also Joseph McBride, "Stepin Fetchit Talks Back" in Brian Henderson and Ann Martin, eds., *Film Quarterly: Forty Years—A Selection*, Berkeley: University of California Press, 1999, pp. 420–29.
10 Andrew Sarris, *The John Ford Movie Mystery*, London: Secker and Warburg, 1976, p. 59.

here rather tentatively and experimentally, intending to leave if I found it dissatisfying. Fortunately Sheehan assigned me to work with Ford. I like him. I am part Irish and we got on. I told him I had not the faintest idea how to write a filmscript. I had been in the Navy during World War 1, overseas two years, and we decided on a submarine story. I told him I could write a play, not a script. In his humorous way he asked if I could write a play in fifty or sixty scenes. Sure. So I did. It was never a script. Then I went on the sets and watched him break it down into filmscript as he shot. I went to rushes, cutting rooms etcetera and began to grasp what it was all about. But I must say I was baffled for many months by the instinctive way Ford could see everything through a camera—and I could not . . . Working with Ford closely I fell in love with cinema. What I found was an exciting new way to tell a story; new to me, old to Ford.[11]

Ford used the film to make technical advances in the process of film-making. Nichols recalled:

They believed long dolly shots could not be made with the sound camera. He did it—one long shot down a whole street, with men carrying microphones on fishpoles overhead. And there were many astonishing pictorial things in it. I remember when I started the "script", I told Ford I would imagine and write scenes which could not be photographed. "You write it" he said, "and I'll get it on film". Well, he did. Even put the camera in a glass box and took it on a dive on the submarine. It is old hat now. Not then.[12]

It was filmed partly on Catalina Island with full Navy cooperation, particularly in the rescue scenes. Ford's success was recognized by reviewers. *Film Spectator* (February 15, 1930) called it a "truly great motion picture. It shatters all our highly respected screen traditions". The *Bioscope* (March 12, 1930) called it "a stirring story of everyday heroism and a fine tribute to the men of any naval service, besides having strong dramatic interest". The film bore the credit "staged by Andrew Bennison" which probably means that he rehearsed the actors. Ford retained fond memories of the film, telling Peter Bogdanovich:

That was the first submarine picture ever made actually using a real sub. It was a very effective picture—for those days; these guys are trapped in a submarine and eventually rescued, but one man has to stay behind . . . The

[11] Anderson, *About John Ford*, pp. 237–8.
[12] Anderson, *About John Ford*, p. 238.

submarine leaves from Shanghai, and we had a lot of Chinese atmosphere—the longest bar in the world and so on. I think it was the first picture Dudley Nichols and I did together. From then on, we worked together as much as possible, and I worked very closely with him. He had never written a script before, but he was very good, and he had the same idea I had about paucity of dialogue.[13]

Nearly forty years on he could still recall some of the comic business in the film:

The picture was full of humor despite the tragedy of it. There was one Blue Jacket we had who'd bought a big Chinese vase—and all through the picture he keeps talking about how he's going to bring it back to his Mom. We had a scene in which the rickshaw went over backwards on him—he did a back tumble—and still had hold of the vase. Even when he goes through the escape hatch, he's still carrying this thing, meaning to bring it back to his mother.[14]

He is more or less correct. The character "Dutch" Winkler does have a Chinese vase, survives the rickshaw accident and several times afterwards when he almost drops the vase. But he succumbs to chlorine gas on the sub, entrusting to a shipmate the vase with a note to his mother.

The first twenty minutes of the film has the crew of submarine S-13 on leave in Shanghai. They bustle into "the longest bar in the world", which is full of boozing sailors and smiling Chinese prostitutes. Innocent young Pollock seeks to buy dirty postcards but womanizer Joe Cobb offers to fix him up with a prostitute. He eventually backs out and Cobb strolls off with two girls on his arm. Costello (J. Farrell MacDonald) thinks there is a goldfish in his drink until he realizes it is a reflection from a nearby goldfish bowl. An exotic dancer contrives to kick the mocking "Lug" Kaufman (Warren Hymer) on the chin. They all get steadily more and more drunk and start singing "The Monkeys Have No Tails in Zamboanga". Ford's camera sweeps up and down the bar in tracking and dolly shots pausing to capture individual comic vignettes. In the officers' section, a British officer, Commander Weymouth, thinks he recognizes one of the American sailors, Burke (Kenneth MacKenna) as Quartermain,

13 Bogdanovich, *John Ford*, pp. 51–2.
14 Bogdanovich, *John Ford*, p. 52.

captain of a British destroyer in the late war. He was carrying England's greatest Field Marshal on a secret mission (presumably a reference to Lord Kitchener sunk aboard HMS *Hampshire* in 1916). His ship was torpedoed and sunk by the Germans because the sailing plans had been betrayed to the enemy. Everyone including Quartermain was believed to have been lost. A court of enquiry had to consider whether Quartermain was a traitor or whether he had inadvertently passed the information to his lover, Lady Patricia, and she had innocently given it to the enemy. They decided that Quartermain had been a traitor. Weymouth is now determined to discover if Quartermain survived and is now serving in the American Navy. The submarine crew are summoned back to the boat. Propositioned en route by a Chinese prostitute, they sing "She's Only a Bird in a Gilded Cage" and have water tipped over them. They stagger back on board, being searched by military policemen for drink. Kaufman hides a bottle under his uniform but one of the policemen lays a truncheon across his stomach, breaking the bottle (an incident repeated in *Submarine Patrol* and *The Horse Soldiers*). Ensign Albert Edward Price (Frank Albertson, last seen in the same role in *Salute*) reports for duty aboard the submarine.

S-13 sails but during a storm it crashes into another ship and sinks. Thirteen men are trapped. Price has to take command as Captain Carson was on deck with others of the crew and they were washed overboard. As Jenkins tries to get a message out by radio, lights flash on and off, tension rises and tempers fray. Oxygen runs low and the men fight over the remaining water supply. "If we've got to go, let's die like men" demands Price. Pollock develops religious mania and tries to blow up the submarine. Price shoots him dead and then cracks up. Burke takes command. Chlorine gas begins to seep into the cabin and they move into the torpedo hatch. Cobb repents of his womanizing and infidelity to his wife and dies from the gas. So does Winkler, having written a note to his mother and entrusted it to Price. Jenkins makes contact with a British ship which steams to the rescue. The drama inside the sub is intercut with documentary scenes of the rescue ship arriving and sending down divers. The divers clear the torpedo hatch and the men are shot out one by one. One man must remain behind to operate the mechanism. Price insists on staying as acting commander. Burke reveals that he is indeed Quartermain. He had not been a traitor but is haunted by guilt and wants to redeem himself. He begs

him not to tell Weymouth and then knocks him out and propels him to the surface. On the deck of the British ship, Price tells Weymouth that Burke came from his home town and he has known him all his life. All the sailors doff their caps, the camera pans up to a bugler playing the last post and the flag is lowered to half-mast.

Interestingly the characters sketchily prefigure the similar but more fully developed types in *The Lost Patrol*: the womanizer, the gentleman ranker, the old sweat, the religious maniac, the green kid. The situation (crew trapped in submarine and requiring one to stay behind when others are rescued) later featured in the German film *Morgenrot* (*Dawn*) (1933) and the British film *Morning Departure* (1950). For Ford, the appeal was the values of the service, sacrifice and comradeship.

The effectiveness of the sound version is confirmed by contemporary reviews. The *New York Times* (February 1, 1930) called it "an absorbing pictorial study in which suitable comedy relief comes to the rescue of incisive dramatic interludes. The characters are wonderfully real, whether they are the high-strung nervous men, the sullen specimens or those who keep their heads and think of others as well as themselves. The voices as well as a variety of sounds, including the gurgling water as the sailors go to and fro in the sunken submersible, are mighty effective. The audibility of these sequences makes them far more impressive than they would be in a silent film, for in the old-fashioned form of screen story the natures of the men would never be developed as they are in this production". *Variety* (February 5, 1931) agreed: "Story and characters are built up with uncanny shrewdness ... the punch of the acting is the surprise comedy bits of a number of minor characters. It is those touches and the grim comedy of the lines that lift the picture out of melodrama to an illusion of reality."

Seas Beneath (1931), also scripted by Dudley Nichols from a story by Commander James Parker Jr., is a prequel to *Men Without Women*, containing several of the characters from the earlier film: "Lug" Kaufman (Warren Hymer), Joe Cobb (Walter McGrail), Winkler (Harry Tenbrook) and Mike Costello (played now by Walter C. "Judge" Kelly rather than J. Farrell MacDonald). It has a "staged by" credit, again to William Collier Sr., who was also playing crew member "Mugs" O'Flaherty and with whom Ford had got on well enough in *Up the River*. Largely shot on location at Catalina Island and at sea, the film

combines a semi-documentary account of the work of Q-ships in World War One with the rather stale melodrama of upright American officers being vamped by female German spies. Ford recalled the film to Peter Bogdanovich:

> That was a war story about a Q ship—some good stuff in it—but at the last moment, the head of the studio put a girl who'd never acted before in as the lead because he thought she spoke a few words of German—which she didn't ... She just couldn't act. But we did the actual refuelling at sea. That stuff was good and so was the battle stuff, but the story was bad; it was just a lot of hard work, and you couldn't do anything with that girl. Then later they cut the hell out of it.[15]

Ford was wrong about the girl Marion Lessing not speaking German. She was German and played female leads in German-language versions of Fox films. But he was right in saying she was a very bad actress. On the other hand George O'Brien as Commander Bob Kingsley, captain of the Q-ship, gives a thoroughly naturalistic performance. The location shooting gives the film a vigor and freshness which is consistently engaging; the camera descending with the submerging U-Boat, the camera inside the stricken U-Boat as it fills with water, the refueling of the U-Boat from a fishing boat while at sea, the various drills aboard the Q-ship, the sea battles and sinking of the burning fishing boat. Further authenticity is provided by the Germans speaking German with subtitles translating their words. Throughout, the Germans and Americans behave with mutual respect toward each other.

The Q-ship is a merchant ship with hidden guns whose object is to lure German U-Boats to the surface and destroy them. The ship's log gives details of its mission. It is to search for and destroy U-172, a particularly dangerous German submarine that has been preying on Allied shipping. Kingsley the commander welcomes his new crew, many raw recruits, but two are old hands, Cobb and Costello (who had served with his father). He explains the purpose of the mission, demonstrates the use of the guns and rehearses a panic drill with the crew abandoning ship to lure the U-Boat to the surface. It requires one crewman rather reluctantly to disguise as a woman after he had shamefacedly confessed he once played the lead in *Bertha the Sewing Machine Girl*. Ford characteristically includes a comic episode in which, after Costello

[15] Bogdanovich, *John Ford*, pp. 53–4.

laments the passing of old-style seamen and tells how he once leaped from the mast to rescue a drowning comrade, he is challenged to repeat the feat. He starts to climb but the rope breaks and he falls into the sea. Young Ensign Cabot dives from the top of the mast into the sea to rescue him. Kaufman, sent to get brandy to revive Costello, drinks it himself.

When the ship docks in the Canary Islands for a period of leave, the exotic vamp Lolita in a very heavy-handed sequence seduces Cabot, giving him drugged wine and searching his documents for information on his ship. By the time he recovers, his ship has sailed. But he spots Lolita handing over information to German officers and being paid off. The Germans sail on a fishing boat to rendezvous with U-172 for refueling. Cabot swims out to the boat, boards it secretly and at the rendezvous sets fire to the fuel and is shot dead. The Germans put his body in a lifejacket and float it off, standing and saluting as it drifts away. It is picked up by the Q-ship and the picture dissolves to a written report of his burial at sea. The European print, however, contained a scene cut from the American version and its loss may account for Ford's disgruntlement at Fox's treatment of the film. In this scene the body of Cabot is found floating at sea. It is retrieved and carried along the deck, a young crewman tearfully singing a song of farewell. Kingsley pronounces the final prayer and the body is buried at sea. The final shot in the sequence is the placid sea surface, gilded by the setting sun and with the melancholy notes of the last post sounding from the side of the ship. It is quintessential Ford, at once underlining the ideas of service, sacrifice and community.

While on the Canary Islands, Kingsley had dallied with Anna Maria Von Stueben (Marion Lessing), posing as a Danish tourist but in fact the sister of the commander of U-172. She had been visiting her brother on the fishing boat but later it sinks, irreparably damaged by the fire started by Cabot, and she and the crew put off in a lifeboat and are picked up by Kingsley. In a seriously over-acted sequence, she tries to seduce Kingsley from his duty: "I am an American officer in command of an American ship" he replies and orders her locked up. U-172 fires at the Q-ship and then surfaces for the kill. The Q-ship guns are brought into action and an American submarine shadowing the ship is alerted and sinks the U-Boat. The captain of U-172 and some of the crew, scramble on deck, shake hands and salute the German flag as the water engulfs the stricken boat. They are later picked up by the Americans and marched off

to a detention camp in an Allied port. Kingsley wants to marry Anna Maria but she says she cannot desert her people, it would not be sporting. But she will come back to him when the war is over. There would not be another maritime film from Ford until 1938.

Seas Beneath was less well received than *Men Without Women*. The *New York Times* (January 31, 1931) said: "It is not a picture to be taken very seriously, so far as war activities are concerned, for no mystery ship could ever have survived long in such circumstances. All its action is theatric in the extreme, without much thought being given to the necessary conduct aboard such craft … yet it is endowed with competent acting, excellent photography and some compelling scenes of submarines and ships". *Variety* (February 4, 1931) thought that the film was too long, was slowed down by the love interest and that the tension was diluted by comedy "so there's actually no wallop anywhere".

Submarine Patrol (1938) was Ford's first naval film since 1931. It has generally had a poor press from Ford scholars—"routine" (Andrew Sinclair), "dire" (Scott Eyman), "potboiler" (Sue Matheson; Joseph McBride).[16] This contrasts markedly with the rousing reception it received at the time of its release. Frank Nugent in the *New York Times* (November 19, 1938) wrote:

Mr. Ford has made a few cinematic flivvers this year. He needed a good script and it's grand to see the way he has pitched into this one, hammering it into a straight narrative line, cramming it with action, lacing it with rousing comedy and managing betimes to give his engineer a sweet word or two with the captain's daughter. That is why adventure films should be filmed. We have no qualms about calling this the best of its type this year.

The *Motion Picture Herald* (November 5, 1938) agreed:

The story of the boat, the dangers it survives, the manner of its victories and the effect of all this upon its crew make thrilling entertainment … John Ford, whose direction of pictures with martial aspect, is high among the reliable factors of film production, does his usual fine job with the mainly masculine cast involved here. He keeps things moving steadily, the comic as well as the serious, and he is at his best in his handling of the climax wherein

[16] Andrew Sinclair, *John Ford*, London: George Allen and Unwin, 1979, p. 76; Scott Eyman, *Print the Legend: The Life and Times of John Ford*, New York: Simon and Schuster, 1999, p. 88; Sue Matheson, *The Westerns and War Films of John Ford*, Lanham, MD: Rowman and Littlefield, 2016, p. 81; McBride, *Searching for John Ford*, p. 266.

the boat sets out with a volunteer crew, duly warned, to find and destroy an enemy submarine in a densely mined recess. This episode is among the best of its kind ever filmed.

Submarine Patrol should be grouped together with *Men Without Women* and *Seas Beneath*, much of which both in outline and in detail it reworks. Ford emphasizes this similarity by casting J. Farrell MacDonald (Chief Bosun's Mate Mike Quincannon) and Warren Hymer (Rocky Haggerty) in roles similar to the ones they played in the earlier films. He also found roles for stock company regulars Ward Bond (as crew member Olaf Swanson), John Carradine (as McAllison, the puritanical first mate of the freighter) and Jack Pennick (as gunnery officer McPeck). The great difference between *Submarine Patrol* and *Seas Beneath* is that where the latter was largely shot on location using real ships, the former was shot almost entirely in the studio, using models. It may be this that explains the different responses of critics then and now. *Seas Beneath* is characterized by freshness and realism. By comparison present-day critics find the studio-shot *Submarine Patrol* essentially phony and artificial. This would not have been the reaction of contemporary critics who had been raised on a diet of studio-shot projects. Ford evidently enjoyed the experience of making *Submarine Patrol*, telling Peter Bogdanovich:

> Having been a Blue Jacket—though I wasn't in the submarine fleet—I had a lot of sympathy for them, I knew what they went through. The head of the fleet was an old pal of mine and he helped me on it. I had a lot of fun with that picture and, of course, all the comedy in it wasn't in the script; we put it in as we went along.[17]

War films had been generally unpopular with audiences in the 1930s. A 1938 Mass Observation survey in Britain found them almost the least popular cinematic genre with audiences of both genders and all classes.[18] After a handful of powerful anti-war films in the early Thirties (*All Quiet on the Western Front* in the United States, *Westfront 1918* in Germany and *Les Croix de Bois* in France), America retreated into isolationism, the wartime allies disarmed, and policies of appeasement toward dictators were adopted in order to prevent

[17] Bogdanovich, *John Ford*, p. 69.
[18] Jeffrey Richards and Dorothy Sheridan, eds., *Mass-Observation at the Movies*, London: Routledge and Kegan Paul, 1987, pp. 32–41.

a new war at any cost. Flag-waving "death or glory" Great War dramas went out of fashion. But by 1938 the newspapers were full once more of war scares and European crisis and there was conflict in both Spain and China. Some studios began to turn again to World War One stories with a message of preparedness.

Submarine Patrol was based on a novel *The Splinter Fleet* by Ray Milholland, adapted for the screen by Rian James, Darrell Ware and Jack Yellen. It paid tribute to the small, cramped plywood subchasers whose contribution to the war effort had gone largely unrecognized, which is why the *Motion Picture Herald* said it was "a deal more fresh than most film material emanating from The Great War". It emphasized the values dear to Ford—service, duty, tradition, comradeship. But the structuring themes of the narrative were familiar and well-worn involving as they do a disgraced officer redeeming his honor, a new commanding officer licking an undisciplined and inexperienced crew into shape, and a frivolous playboy knuckling down and learning to be a serious and committed team member.

The action takes place in 1917 and centers on subchaser SC-599 and opens in Brooklyn Navy Yard with Perry Townsend III (Richard Greene), handsome and arrogant playboy millionaire, arriving in his sleek roadster, almost knocking down Sergeant Joe Duffy and demanding to be taken to see the Admiral. Admiral Maitland, an old family friend, assigns him as chief engineer to SC-599. Appalled to find his new craft a dirty, crowded subchaser, he returns to the Admiral and demands a transfer. Maitland firmly tells him that now he is in the Navy, his connections mean nothing, and he will do the duty to which he has been assigned. The film traces the process by which he is cured of his high-handed assumption of privilege and masters his job, becoming a full and integrated member of the crew. He is further humanized by falling in love with Susan (Nancy Kelly), daughter of freighter captain Leeds (George Bancroft), who, knowing what sailors are, forbids their liaison and twice knocks Perry out as he presses on with his courtship. Finally he is convinced of Perry's good intentions by the arrival of a special license and a naval chaplain. But before the wedding can take place, SC-599 is ordered to Malta for a refit and Susan will have to wait for him.

The officer seeking redemption is Lt. John C. Drake (Preston Foster). Court-martialled for causing a destroyer to run aground—an action which blighted

his career, though there were unexplained extenuating circumstances—Drake is given command of 599 with its crew of raw recruits and ordered to get it ready for sea. He at once orders them into proper uniforms, to use the correct forms of address, to clean up the deck and put the guns in order. He is assisted in his task by hard-drinking, two-fisted Irishman Chief Bosun's Mate Quincannon, who had served with his father. Drake is ordered to sea to escort a convoy to the Mediterranean. They encounter and sink a German U-Boat. The scenes inside the U-Boat are taken from *Seas Beneath* and had already been reused in *The World Moves On*. They arrive in Brindisi where Drake is given a special mission to destroy a dangerous enemy submarine "Old man 26", protected by a minefield. He asks for volunteers and the entire crew volunteer. There is a tense sequence when Quincannon and a detachment of men in a rowing boat steer 599 through the minefield. There is an exchange of gunfire and the German submarine and its base are destroyed. Drake has redeemed himself and the crew he has welded together and trained up has proved itself under fire. Back in Brindisi Drake receives a commendation and the crew get shore leave, only to be recalled to sail to Malta for a refit.

Ford fills the crew with characters and clearly enjoyed devising comic business and managing the interaction between them. There is a bespectacled zoology student Rutherford Davis Pratt (known as "the professor") who is trying to complete a BA and keeps his specimens, including white mice, in the galley. There is dumb Brooklyn cabby Rocky Haggerty with a nice line in malapropisms. He describes Perry as "rich as creosote" and calls the captain's binoculars "vernaculars". There is a diminutive mournful Jew, Irving Goldberg. But much of the comedy revolves around Slim Summerville as the lugubrious cook "Spuds", whose real name is Ellsworth Fitchett, and who is illegally running a restaurant ashore while serving on 599. He throws garbage overboard into the wind and it is blown back at him. His bout of seasickness is made worse by Quincannon extolling the virtues of salt pork. Trying to smuggle a bottle of whiskey aboard under his uniform he has it broken when a sentinel lays his truncheon across his stomach (a repeat of an incident in *Men Without Women*). He tries unsuccessfully to avoid volunteering for the dangerous mission. There is also a lovely cameo from Henry Armetta as a lachrymose, lopsided Italian waiter fussily but kindly doing all he can to facilitate a romantic encounter between Perry and Susan in a Brindisi hotel.

Ford reworks the opening sequence of *Men Without Women* with the crew going ashore, packing into a crowded bar, singing "The Monkeys Have No Tails in Zamboanga" and trying in vain to get coins out of a fruit machine until Sergeant Duffy strolls up and effortlessly empties it of its contents, an episode Ford repeats in *Donovan's Reef*.

These are amidst the comic knockabout quintessential Ford moments. As they sail out of New York past the Statue of Liberty in a convoy of little ships, Ford tracks along the faces of the crew as they gaze back wistfully to shore, knowing that some of them may never return, an effect he repeats in *The Long Voyage Home*. Then when the German U-Boat is sunk, one of the recruits says "Don't we cheer or nothing" and is firmly told by "Guns" McPeck "No". Ford then cuts from group to group of the crew and finally the captain as they stand and salute an honored foe, and "Anchors Aweigh" plays softly on the soundtrack.

The Long Voyage Home is Ford's first indisputable maritime masterpiece. It was also an all-out bid to create high art. His aim was to film four one-act plays by the Nobel Prize-winning playwright Eugene O'Neill—*The Moon of the Caribbees* (1917), *Bound East for Cardiff* (1914), *In the Zone* (1917) and *The Long Voyage Home* (1917). Although they had been conceived separately, they had been produced together on stage in New York in 1929 under the title *The Long Voyage Home*. Zanuck was not interested in doing it at Fox but Ford's contract allowed him to make one film a year outside of Fox. So he and Merian C. Cooper formed a production company, Argosy Pictures, and took the project to independent producer Walter Wanger who was releasing through United Artists. Ford's previous production for Wanger had been *Stagecoach* (1939), a blockbusting critical and box office success. So Wanger willingly took it on for release by his grandly named Masterpiece Films. Ford enlisted Dudley Nichols. For six weeks they discussed and developed the script. Ford recalled:

> After these conferences, Dudley locked himself up sixteen hours a day for twenty days and turned out the first draft. Then we took a week and knocked it apart, and then another month to put it back together again. The final script was changed very little during shooting.[19]

[19] Matthew Bernstein, *Walter Wanger: Hollywood Independent*, Minneapolis: University of Minnesota Press, 2000, p. 164.

The result was a script in which Nichols brilliantly interwove the characters and events of the one-act plays to provide a continuous narrative. The action was updated from World War One to World War Two. O'Neill's dialogue was pared back to the minimum necessary to delineate character and to tell the story. In one characteristic change, Smitty the alcoholic with a secret is transformed into a British Royal Navy officer, cashiered for drunkenness and in need of redemption, an exact analog of the characters Burke, Cabot and Brown in *Men Without Women, Seas Beneath* and *The Lost Patrol*. The crew detecting at once the difference in class nickname him "The Duke". In the play Smitty is not killed as he is in the film, simply humiliated by the discovery of his secret. Ford asked Victor McLaglen to play Driscoll but was only offering half of what McLaglen was receiving per film. McLaglen turned him down and they remained estranged until Ford recalled him for *Fort Apache* (1948).[20] Thomas Mitchell was cast instead and Ford surrounded him with many of his stock company. Lacking an actress to play the cockney prostitute Freda in the final sequence, he mused aloud that he was looking for a young Una O'Connor. Someone suggested a young stage actress Mildred Natwick who had never made a film. She was cast in her first screen role and later recalled of Ford: "He told me everything to do … it was like marvelous coaching … He just made me so comfortable and so easy, that it was a wonderful way to do one's first movie".[21] She would subsequently appear for Ford in *3 Godfathers* (1948), *She Wore a Yellow Ribbon* (1949) and *The Quiet Man* (1952).

Gregg Toland, who had photographed *The Grapes of Wrath*, was hired as cinematographer and shot the film in his distinctive deep-focus, high-contrast, razor-sharp black and white, achieving exactly the effect Ford wanted and uniquely earning him a screen credit alongside Ford's in the opening titles. In its use of Expressionist lighting (shadows, spotlights, screen darkening) and poetic symbolism it looks back to *The Informer*, Ford's previous essay in art film. As usual, Ford framed shots in doorways, archways and windows. Joseph McBride called it "one of the most avant garde films ever made in Hollywood". It was shot over thirty-seven days at the Goldwyn Studio, coming in ahead of schedule and at $682,495, only $6,000 over budget. Much of the

[20] Eyman, *Print the Legend*, p. 228.
[21] Eyman, *Print the Legend*, p. 228.

action took place aboard James Basevi's stylized ship set, with the sea and the clouds back projected. There were a few days' exterior shooting at Wilmington Harbor, California. But this approach to filming conveyed an appropriate feel of claustrophobia to the narrative. In post-production, Wanger with Ford's agreement added prefatory and concluding titles written by Gene Fowler. He promoted it as high art, commissioning ten canvases from contemporary American painters of scenes and characters from the film and had them exhibited around the country to coincide with the film's release. O'Neill was delighted with the film, congratulating Ford on "a grand deeply moving and beautiful piece of work. It is a great picture and I hope you are as proud of it as I am".[22] It was universally hailed as a work of art. Typically the *Hollywood Reporter* (October 8, 1940) called it "about as high an art of motion pictures as one could find". It received seven Oscar nominations (best picture, best screenplay, best music, best photography, best editing, best visual effects, and best sound). It won in none of the categories. But Ford, not nominated as best director, won the best director Oscar that year for *The Grapes of Wrath*. Ford won the New York Film Critics Award as best director for *Grapes* and *Long Voyage Home* jointly. But despite all the critical praise, it was a box office failure, grossing only $580,129, a net loss of $224,336.[23]

Gene Fowler's introductory title sets the scene:

> With their hates and their desires, men are changing the face of the earth. But they cannot change the sea. Men who live on the sea never change. They live apart in a lonely world, moving from one rusty tramp steamer to another, forging the life-lines of nations.

This is the world Ford brilliantly evokes. The crew of the *Glencairn*, exiles all (a mixture of English, Scottish, Irish, Swedish, American, Norwegian), dropouts, misfits, drifters, cling together under the leadership of Aloysius "Drisc" Driscoll (Thomas Mitchell). They booze, fight, chase women, convincing themselves that they are enjoying life and will eventually leave the sea but they are deluding themselves. Only one crewman, the taciturn, philosophical, pipe-smoking Donkeyman (Arthur Shields) has accepted his fate. He never goes ashore ("I'm through with the land and the land is through with me"), does not drink, signs

[22] McBride, *Searching for John Ford*, p. 318.
[23] Bernstein, *Walter Wanger*, p. 440.

Figure 7.1 The crew of the *Glencairn* in *The Long Voyage Home* (United Artists, 1940)

on again immediately at the end of each voyage and waits for the others to drift back, as he knows they will. The voyage of the *Glencairn* from the Caribbean to London via New York, in wartime, gradually reveals the futility and emptiness of their lives.

The film opens with a long shot of the *Glencairn* as a black silhouette on a dark, oily sea. Drums are beating rhythmically and sounds of native chanting reach the ship. The crew appear on deck, bronzed, sweating, fanning themselves, pacing up and down silently and restlessly and looking longingly toward the shore. Close-ups of crew members Ole, Yank, Smitty, Davis, and Narvy are intercut with shots of sultry native women writhing suggestively and languidly against palm trees. On board, Cocky (Barry Fitzgerald), the pugnacious, inquisitive ship's steward, is listening at the porthole of the Captain's cabin and hears him tell the mate that a native policeman has been hurt in a brawl ashore with a seaman. He is going to check the crew to see if anyone is missing. Cocky warns them and they hurry to their bunks. The Captain (Wilfrid Lawson) and the First Mate (Cyril McLaglen) investigate and find that Driscoll is missing. But he turns up beaming to say he has been asleep in the focs'l. When the

Captain has gone, he reveals he has been ashore arranging for a boatload of women to come out with baskets of fruit, concealing in them bottles of rum. The women arrive and the Captain allows them aboard. The Captain, brusque and stern but fair-minded and concerned for the men, has just learned that they are to pick up a cargo of explosives in New York, so he is giving the men something to relax them. The drink flows freely, the dancing becomes more abandoned, one of the women propositions Smitty and slaps his face when he rejects her. Then a fight breaks out and there is soon a free for all. Burly brawler Yank (Ward Bond) alternates between roughly kissing the women and slugging his fellow crew members. Driscoll, shaking his head wearily, joins in. Then in the melee someone is stabbed. The Captain appears, stops the fight, examines the injury—it is not serious, and throws the women off the ship. The men shamble sheepishly off. Quietly the Donkeyman picks up and folds his stool. As the chanting from the island continues, the screen goes black. The opening vividly establishes the milieu and the characters.

In New York Cocky discovers that explosives are being loaded on the *Glencairn*. The men gather, muttering about quitting. The Captain addresses them, saying "If the cargo doesn't get there, it'll be missed. We won't". Smitty (Ian Hunter), determined not to return to England, slips ashore, although all leave has been canceled. In a series of long shots he runs between banks of packing cases on the dockside, but is pursued by military policemen and after a scuffle captured and returned to the ship. Ford uses a similar set up for a chase in *Gideon of Scotland Yard*. In the focs'l Drisc comes in, Axel is playing "Blow the Man Down" on his flute, while Smitty sits on his bunk staring blankly. Drisc tells Axel to shut up and turns out the light, leaving the focs'l in darkness but for Smitty's face. As the ship sails, the camera pans along the faces of the crew gazing back at the land. A major storm blows up, superbly staged, with the camera at deck level washed over by the sea. Trying to secure the anchor, Yank is injured. In a very fine sequence in the focs'l, Yank dies. As he is dying, Drisc tenderly gives him water and a cigarette. They reminisce until he expires and Drisc buries his head in the bunk weeping. The camera holds on this tableau until Axel arrives with pain-killing medicines from the Captain, too late. Yank is buried at sea, the howling wind drowning out the prayer being recited by the Captain over the body. Drisc is left alone on deck, walks up and down and gazes out to sea, as the screen darkens.

As the *Glencairn* enters the war zone in the fog, nerves are taut among the crew. Cocky reads about spies transmitting information to the Germans in code and suspicion falls on Smitty. He is seen on the bridge checking the route and in the Captain's cabin apparently consulting his code books—in fact searching for alcohol. Axel thinks he has seen him signaling from the porthole over his bunk. Smitty is seized and bound and gagged and his belongings searched. A packet of letters is found. Drisc reads them out loud and they reveal that Smitty is Thomas Fenwick, cashiered alcoholic naval officer and they are loving and concerned letters from his wife, refusing to tell the children that he is dead as he has requested. There are close-ups of the crewmen listening and of an agonized Smitty struggling against the gag. As they realize what the letters mean, the men gradually disperse and Smitty is released. Drisc orders everyone out. Smitty goes up on deck. "All well, Smitty?" calls Ole who has been on the deck during the interrogation; "All well, Ole" replies Smitty. Next day, the sailors are lounging on deck when the sound of planes is heard. We never see them but the Nazi planes dive on the ship, dropping bombs and spraying the deck and the bridge with machine gun bullets. Smitty, his self-respect restored, briefly takes command and issues orders but he is shot down as he seeks to launch the lifeboat. A tarpaulin blows over him as he falls. Ford then adds a patriotic tribute, superimposing the White Ensign on the tarpaulin and with *Rule Britannia* playing softly on the soundtrack. He has redeemed himself and honor is restored. When the ship arrives in London, there is a high angle shot of the dockside with a black-clad weeping woman, Smitty's widow, and two children being escorted by the Captain to a waiting Rolls-Royce with a liveried chauffeur after collecting Smitty's belongings. The two children look up at the ship as the crew silently watch from the deck. Ford now establishes that it is wartime: banks of sandbags, gasmasks, the blackout, a service club, sandwich boards announcing the Nazi invasion of Norway. Despite this, his studio-created Limehouse of cobbled streets, seedy drinking dives, blind street musician, and dark corners resembles the Germanic London of *The Threepenny Opera* rather than the real thing.

The voyage over, the crew sign off and collect their pay. They set out on a spree but first they want to ensure that Ole fulfills his plan to return home to Sweden. Axel sews Ole's money into the lining of his jacket. They visit a pub and then the shipping office to buy Ole's ticket. They are denied entry

to a servicemen's club, and wander off disconsolately causing Drisc to cry despairingly "Blackout! Blackout! Is there no more light in the world?" But they are picked up by an ingratiating tout (J. M. Kerrigan playing a cockney version of the role he took in *The Informer*). He lures them to Joe's place.

They start drinking and are soon singing. A trio of blowsy prostitutes are introduced and they are quickly dancing with them. They are lured into a backroom and Ole prepares to leave for his ship. But pathetic cockney prostitute Freda, clearly hating what she has to do, is sent by Joe and the tout to feed Ole a drugged drink. He passes out and a gang of sailors appear to shanghai him aboard the *Amindra*, "a starvation tub" they had passed on their way into town and which is short of hands. When the crew reappear in the bar and Ole is gone, they think he has left for his ship. They stagger off, pausing only for Drisc to knock out Joe, who had cheated him out of his money on a previous visit. They bump into the tout who is carrying Ole's parrot and they realize something is wrong. They surround him and force him to reveal what happened to Ole. They storm aboard the *Amindra* and after a fight amidst oil drums, rescue Ole and carry him aboard his ship for Sweden. Drisc returns to shout drunken defiance at the ship's crew but is knocked out. The *Amindra* sails with Drisc aboard. When Axel returns to look for Drisc, he sees the ship pulling away. Next morning, in the bleak light with scraps of paper blowing about the dock, the hung-over crew drift back to the *Glencairn*, Cocky escorted by two policemen, to be received by the Donkeyman. Asking where Driscoll is, Axel tells him "Drisc gone on *Amindra*". The Donkeyman drops the newspaper he had been reading over the side, its headline reads "*Amindra* Torpedoed. All hands lost." The epilogue reads: "Men like Ole come and go, the Driscolls live and die, the Smittys and the Yanks leave their memories but for the others the long voyage never ends."

For Ford, the greatest tragedies in life are either not belonging and having no home, or losing your home and your sense of belonging. "Home" is the central theme of *The Long Voyage Home*. It is the plan of gentle innocent Swedish giant Ole (John Wayne at his most self-effacing), to leave the sea and return to the family farm in Sweden and settle down with his mother and brother. Three times he has tried and failed to fulfill this plan. The others laugh at him but the protective Swede Axel Swanson (wonderfully played by John Qualen) who fusses over Ole like a mother hen, leaps to his defense and

Figure 7.2 Barry Fitzgerald, John Wayne and John Qualen in *The Long Voyage Home* (United Artists, 1940)

expresses what they all must feel: "You don't make a fool of Ole. He go home. You got no home. I got no home. But Ole—he got a home". The crew ensure that Ole does get home. All this, including the Axel–Ole relationship, has been added to the narrative. In the play it is Ole and not Driscoll who is shanghaied aboard the *Amindra*. So Ole never got home.

Linked to the idea of "Home" is the idea of memory. At the beginning of the voyage as Smitty broods alone he is asked by the Donkeyman "What is bothering you, Smitty" and is told "Memories". "Best thing to do with memories is forget them" says the Donkeyman. Then he says "You ought to be going home". It is the Donkeyman who says "Smitty's gone home" after his death. But as becomes clear Smitty is haunted by guilt over the failure of his Navy career and the disgrace he has brought on his family. Dying Yank recalls with Drisc the bars and dance halls, the women and the fights in Buenos Aires, Singapore, Sydney and Cape Town, in one of which it emerges he accidentally killed a man. Asked to name a relation or someone dear to him, he can only think of a barmaid in Cardiff who once loaned him money. His last word to Ole is to tell

him to go home. When in the pub, Paddy sings "When Irish Eyes Are Smiling" and everyone joins in, Cocky weeps, as the song reminds him of home. As early as *Straight Shooting* (1917) Ford includes a scene where in a Western bunkhouse, a cowboy plays "Home Sweet Home" on an upright piano and several cowboys mop their eyes with handkerchiefs. Behind all these scenes lies the nostalgia and the pain of dreams and memories, hope unfulfilled, contentment lost, and the paramount idea of home and belonging.

Richard Hageman's score makes much use of popular tunes. "Blow the Man Down" is played behind the credits and sung several times during the film. "When Irish Eyes Are Smiling", "Tipperary" and "Shenandoah" are also sung or played. "Rule Britannia" accompanies Smitty's death. Ford, impressed by Britain's stand against Nazism, moderated his anti-Englishry sufficiently to include a visual and aural tribute to the fallen Englishman. Nevertheless he cannot resist casting Lionel Pape, his regular pompous Englishman, as the agent delivering the explosives to the *Glencairn* and wittering on about the crew doing their bit and being heroes until impatiently cut short by the Captain.

In 1942 W. L. White's *They Were Expendable* was an instant best-seller. It was an account of the exploits of Torpedo Boat Squadron number 3 in the Philippines in the early days of the war. In the end all the boats and most of the men were lost. But White compiled the story from interviews with four of the surviving officers, including the commander, Lt. John Bulkeley and his executive officer Lt. Robert B. Kelly. It was a story of courage and sacrifice which captured the imagination of the public. MGM purchased it for filming and studio executive James Kevin McGuinness convinced the bosses that the only director who could do justice to the story was John Ford. Ford was reluctant to leave his work with the Field Photo Unit to return to Hollywood. But MGM commissioned a script from Frank "Spig" Wead. Lt. Commander Frank "Spig" Wead had been a naval flier who was paralyzed in an accident in 1927 but began a career as a screenwriter, specializing in service pictures and working with many of the leading Hollywood directors, among them Frank Capra (*Dirigible*), Howard Hawks (*Ceiling Zero*), Victor Fleming (*Test Pilot*) and Michael Curtiz (*Dive Bomber*). He co-wrote *Air Mail* for John Ford and they became friends, so much so that Ford later directed a biopic on Wead, *Wings of Eagles* (1957) with John Wayne playing the lead. After Wead completed the script, MGM had it polished by Sidney Franklin and continued to press

Ford to direct it. Ford's reluctance was overcome when he actually met Bulkeley, who was running a fleet of PT boats patrolling the French coast during the D-Day invasion. They became friends and Ford was greatly impressed with his modesty (he claimed not to have deserved the Congressional Medal of Honor he was awarded) and his attitude to a possible film. Suspicious of the flag-waving heroics of Hollywood war films, he refused to advise on the filming or to attend the shooting. Ford decided to do the film and to make it as accurate as possible. Lindsay Anderson, perhaps the film's most passionate admirer, said: "its deeply personal inspiration, crystallizing so many of Ford's most intimate convictions and aspirations, gives it a uniquely revealing, uniquely affective power."[24] Ford had been wounded under fire and had lost thirteen of his Field Photo Unit colleagues. Just as filming began he would hear of the deaths in action of the sons of two close friends. It is small wonder then that the whole film has an elegiac feel to it but also an accuracy that caused Bulkeley to pronounce it "very authentic".[25]

In 1944 Ford was still under exclusive contract to 20th Century-Fox and had to agree to make a film for them within six months of his discharge from the Navy in order to obtain permission to work for MGM. Ford had wanted Gregg Toland to photograph the film but Samuel Goldwyn refused to release him and Ford chose Joseph H. August, a Field Photo Unit veteran and the cinematographer on *Seas Beneath*, *The Informer*, *The Whole Town's Talking*, *Mary of Scotland* and *The Plough and the Stars*. James C. Havens was engaged as second unit director to film the battle scenes. To stress the authenticity Ford insisted that the leading production talents be credited with their military ranks: John Ford, Captain USNR; Joseph H. August, Lt. Commander USNR; James C. Havens, Captain, USMCR and Frank Wead, Commander USN (Retired). It is a measure of Wead's importance to the project that his name appeared alongside Ford's in the credits. Thanks were offered in the credits to the Army, Navy, Coast Guard and OSS for their "splendid cooperation". Ford told Peter Bogdanovich: "What was in my mind was doing it exactly as it had happened".[26]

[24] Anderson, *About John Ford*, p. 101.
[25] McBride, *Searching for John Ford*, p. 403.
[26] Bogdanovich, *John Ford*, p. 82.

The real-life characters in *They Were Expendable* were given new names: Lt. John Bulkeley became Lt. "Brick" Brickley, Lt. Robert B. Kelly became Lt. Rusty Ryan, Admiral Rockwell became Admiral Blackwell and General Sharp became General Martin. Boatbuilder "Dad" Cleland became "Dad" Knowland. Lt. Beulah Greenwalt Walcher, called Nurse Peggy in the book, became Lt. Sandy Davys in the film. She later sued MGM for implying in the film that she had sex with Rusty. She was awarded $290,000 for "invasion of privacy". Kelly sued for being portrayed as difficult to get along with and was awarded $3,000. Bulkeley thought the characterization of Kelly/Ryan to be accurate.

MGM, having tried and failed to secure the services of Robert Taylor, cast John Wayne as Rusty Ryan and Ford called up members of the old stock company (Ward Bond, Jack Pennick, Harry Tenbrook, Russell Simpson). But the most remarkable piece of casting was Robert Montgomery as Brickley in his first film since 1941. Montgomery who starred in over sixty films was one of MGM's busiest stars in the 1930s. He was one of those debonair American gentleman actors, like Franchot Tone and William Powell, who could play both American and British roles. He was an accomplished light comedian but took his share of dramatic roles. He told Lindsay Anderson in 1980 that of all his films, only three or four gave him any sense of achievement.[27] These may have included films in which he was cast against type, as a gangster in *Earl of Chicago* and as a psychopath in *Night Must Fall* and *Rage in Heaven*. But they must surely also have included *They Were Expendable*, the one film he is likely to be associated with today. He was perfect casting. He had served as Bulkeley's executive officer on PT boats in the South-West Pacific in 1943 and was later operations officer of a destroyer squadron on D-Day. Bulkeley noted that Montgomery not only resembled him physically but that he had accurately reproduced his mannerisms and mode of speech. It was, he concluded, "a good performance".[28] Montgomery was unstinting in his praise of Ford, calling him "a genius" and telling Anderson "Anything that's good about *They Were Expendable*, in the script, the performance, the editing, the camerawork, was Ford's achievement".[29]

[27] Anderson, *About John Ford*, p. 226.
[28] McBride, *Searching for John Ford*, p. 406.
[29] Anderson, *About John Ford*, p. 226.

Montgomery confirmed that Ford deployed his usual method. Sometimes they would rehearse a scene; sometimes go for a single take. Brickley's farewell to his men when he has been detailed to join the army on Bataan was done in one take. Ford also changed the script "all the time". He had Frank Wead on the set and although they had already reworked the script prior to the shooting, Ford continued to make changes, as Montgomery explained:

> Sometimes he'd expand a few lines into a page of dialogue. And sometimes he'd take pages of dialogue and reduce them to a few lines. That scene with the young submarine commander from whom Wayne and I extort torpedoes. There were pages of dialogue there in the script. When the poor boy arrived on the set, all prepared, Ford just handed him a sheet of paper with about four lines he'd scribbled on it. That was his part. He nearly collapsed.[30]

This is the scene in which Wayne and Montgomery blackmail the submariner by threatening to tell the crew he played the lead in *Tess of the D'Urbervilles* at the Academy. This reproduces a piece of business from *Seas Beneath* when a seaman is blackmailed about his thespian past. Ford also improvised the funeral service for Larsen and Mahan, with Wayne reciting Robert Louis Stevenson's *Requiem*.

Location shooting for the film began in early February 1945 around Key Biscayne, Florida, using 6 PT Boats borrowed from the Navy and disguising the Coast Guard station as the naval base of Cavite. There was tension between Ford and Wayne, inspired in part by Ford's anger that despite repeated promises to do so, Wayne had not served in the war, his studio getting regular deferments for him to make morale-boosting war propaganda. By contrast many of Wayne's box office rivals joined up and served: James Stewart, William Holden, Glenn Ford, Clark Gable, Tyrone Power, Henry Fonda, Ronald Reagan, Douglas Fairbanks Jr., Robert Montgomery, and Sterling Hayden. The absence of so many box office rivals undoubtedly boosted Wayne's star status. At the start of shooting, Ford shouted at Wayne in front of everyone: "Duke—can't you manage a salute that at least looks as though you've been in the service".[31] Wayne walked off the set and Montgomery took Ford aside and told him never to speak to anyone like that again. This made Ford weep and he

[30] Anderson, *About John Ford*, pp. 226–7.
[31] Anderson, *About John Ford*, p. 226.

eventually apologized to Wayne. Shooting continued at the MGM studio back in Hollywood but toward the end of May Ford fell from a camera platform, fracturing his right shinbone. He insisted that Montgomery should take over the direction but after a week he returned to shoot the final scene of Brickley and Ryan departing for Australia. Filming was completed in early June but MGM did not release the film until late December 1945.

To the astonishment of Lindsay Anderson, who regarded it as a transcendent masterpiece, "a heroic poem",[32] Ford told him: "I just can't believe that film's any good". When pressed he complained that he had been ordered to do it and had been pulled out of the front line to do so. He said that he wanted the film very lightly scored, using only a few songs like "Marcheta" and "Red River Valley", because "the picture was shot as a documentary you know".[33] MGM had imposed a full symphonic score by the in-house composer Herbert Stothart. But Anderson quite reasonably pointed out that Stothart's score used many of the hymns, folk tunes and popular songs that figured in other Ford films. *Expendable's* score features "Battle Hymn of the Republic", "Battle Cry of Freedom", "My Country, 'Tis of Thee", "Anchors Aweigh", "From the Halls of Montezuma", "Eternal Father, Strong to Save", "Red River Valley", "Marcheta", "The Monkeys Have No Tails in Zamboanga" (a feature of all Ford's naval pictures). Ford also complained that the studio had cut the bits he liked best. They included a scene in a shell-hole with a priest (played by Wallace Ford) talking to a boy who says he is an atheist and a bitter farewell speech by Brickley to his men.

Ford used his $300,000 fee for directing the film to acquire land and build the Field Photo Farm as a clubhouse and retirement community for the veterans of his photographic unit (180 of them). It functioned with ritual formality and revolved around regular annual events: Memorial Day on which uniforms were worn, the flag raised and *America* sung and which commemorated the thirteen members of the unit who had died; Founder's Day, held on Ford's birthday; St Patrick's Day; and Christmas parties for families. It was a bid to preserve the wartime spirit of comradeship. The Farm lasted until 1966 when the land was sold and the chapel was moved to the Motion Picture Home. Dan Ford recalled:

[32] Anderson, *About John Ford*, p. 108.
[33] Anderson, *About John Ford*, p. 21.

It had a feeling of family about it that was very special ... In a very real way my grandfather recreated the world of his pictures at the Farm; the gatherings had the same sense of community that his films had. Everyone that was close to him, whether they were veterans of his unit or actors from his troupe, became involved with the Farm. It was a cult, a true community, and one of the most unique institutions ever created in Hollywood.[34]

This was all part of the profound change that came over Ford during the war. As Dan Ford recalled:

Before the war, the military had been an avocation, something John had played at for his amusement and used as a way of gaining social status. Now it became the centerpiece of his life. He now became a remote, paternal figure who presided over his aides and ruled his stock company in an almost military manner. The military shaded his personal style ... At work he started wearing his fatigues and his navy baseball cap with the captain's eagle perched proudly on it. He kept a closet full of uniforms; perfectly tailored and carefully maintained, they stood in marked contrast to the casual work clothes he usually wore. John gleefully donned them at every opportunity ... He joined every veterans' organization that would have him ... He was constantly maneuvering to get more medals, decorations and awards.[35]

This had a direct effect on his work. In the ten years between 1931 and 1941 he made only one film centrally concerned with the war (*Submarine Patrol*, 1938). Between 1945 and 1955 he made 9 dealing with war and the military. *They Were Expendable* was his first feature film to deal with World War Two. It was also the first time he was making a film about a personal friend.

Ford's style remained simple and economical. He only tracked the camera to accompany the characters in motion. He framed images by doorways, windows and corridors. But unusually he included far more close-ups than was his custom and they were not just of the stars but of supporting actors and even bit part players, as if to say that they were all equal in the struggle and they deserved to have their emotions registered. There were also recurrent shots of lines of men watching their comrades depart, sometimes never to return. It reinforces the pervading sense of loss.

[34] Dan Ford, *The Unquiet Man*, p. 208.
[35] Dan Ford, *The Unquiet Man*, pp. 206–7.

The film opens and closes with quotations by General Douglas MacArthur. The introduction says:

> Today the guns are silent. A great tragedy has ended. A great victory has been won ... I speak for the thousands of silent lips, forever stilled among the jungles and in the deep waters of the Pacific which marked the way.
>
> Douglas MacArthur, General of the Army

Then up comes a title: "Manila Bay—in the year of Our Lord Nineteen Hundred and Forty-One."

A line of motor torpedo boats scythes through the waters of the Bay and there are close shots of Robert Montgomery and John Wayne as Lt. Brickley and Lt. Ryan in command of their craft. The boats come into their berths and the scene dissolves to a tracking shot as Admiral Blackwell, accompanied by his staff, Brick and Rusty, marches past rows of sailors, drawn up for inspection. As he gets into his car, the Admiral says that they maneuvered beautifully but in wartime he prefers something more substantial. Rusty angrily declares his intention of seeking a transfer to destroyers as there is no future in PT boats. The differences in character are immediately established: Brickley calm and accepting of authority, Ryan impatient and impulsive.

That night there is a dance at the Services Club where the sense of community is established. The ensigns are dancing and continually tapping the shoulders of their colleagues to take over their partners, exactly like the naval cadets in *Salute*. The other ranks gathered round the piano are singing the inevitable "The Monkeys Have No Tails in Zamboanga". Silence is called for and Chief Bosun's Mate "Boats" (not Boots as some filmographies have it) Mulcahy (Ward Bond) declares that Doc Charlie (Jack Pennick) is retiring and they all want to wish him well.

> I'm not gonna make a speech. I just got something to say. Tomorrow our old pal Doc here is going out, being paid off after thirty years. I know most of you kids have got a long way to go before you find out what thirty years in the Navy means. It means service, tough and good, it means serving your country in peace and in war.

There is a succession of close-ups of young sailors as they drink a toast to Doc, their ages measured in the type of drink that is ordered: beer, sarsaparilla and for the youngest, milk. The twin themes of service and community are thus

established. A dissident note is struck by Rusty who is completing his request for a transfer to destroyers. Brick asks him: "What are you aiming for? Building a reputation or playing for the team". Brick clearly stands for the team as opposed to selfish individualism.

The club manager enters, accompanied by two soldiers. The soldiers go from table to table speaking to the officers sitting there who immediately get up and leave. He then takes over the microphone to announce that the Japanese have bombed Pearl Harbor and all personnel are ordered to report to their units. Rusty tears up his transfer request and follows Brick out. As they leave, a tearful Philippine singer stands up with the band to sing "My Country, 'Tis of Thee".

Brick reports to the office of Admiral Blackwell for orders but is sent word that the PT boats will run messages. Obviously disappointed, Brick walks out slowly and down a shadowy corridor. Ford holds the camera on him until he disappears. As Lindsay Anderson discerned, this is all part of "the masterly construction of the final version, the slow cumulative rhythm so different from the dynamic pacing of a conventional Hollywood war picture ... The editing of *They Were Expendable* is as delicate and as firm throughout as the shooting. Close-ups, affectionate or noble, are held at leisure; long shots are sustained long after their narrative role has been performed".[36]

Japanese planes attack and PT boats sail out to fire at them in the first of the vigorous, lively and well-staged combat sequences, directed by James C. Havens. When the raid is over, the PT boats return to base to find it a smoking ruin. An unknown woman in close-up weeps on the dockside. Brickley goes to see the Admiral who in a classic Fordian scene sits him down and tells him "Listen, son, you and I are professionals. If the manager says sacrifice, we lay down a bunt and let somebody else hit the home run. It's our job to lay down that sacrifice. That's what we were trained for and that's what we'll do". They are to continue to run messages from a new base in Sisiman Cove on Bataan. Brick reports this to his staff and shrugs "Theirs not to reason why. Theirs but to do". "And die" Rusty adds bitterly. He leaves savagely kicking a can. After he has gone, Brick kicks the same can.

However when a Japanese cruiser is reported to be on its way to attack the base, the Admiral orders the PT boats to sink it. Rusty, suffering from blood

[36] Anderson, *About John Ford*, p. 108.

poisoning from an infected wound picked up in the first attack, is replaced as commander of the second boat and ordered to hospital in Corregidor. Lt. Shorty Long and his boat go instead. Ford holds his camera on the line of men not going on the mission as they watch the PT boats leave. There is a night attack on the cruiser. Boat 31 is blown up and the crew believed lost but later Lt. Long and some of the crew who have survived make their way back to base. Brick sinks the cruiser. The downbeat return is without glory, under a dull morning sky and with a body carried ashore under the flag.

On Corregidor, the impatient Ryan is stripped of his trousers by the no-nonsense nurses and tended to by Lt. Sandy Davys (Donna Reed). Later during an air raid with lights flickering on and off, an exhausted doctor performs an operation eventually by the light of a hand-held torch, with close-ups of faces watching the operation. After the operation is over, there is a long shot of three nurses, cigarettes drooping from their lips, walking slowly and wearily down a long, darkened corridor. The whole sequence is powerful and evocative of duty done under pressure.

Figure 7.3 Jack Pennick, John Wayne, Robert Montgomery and Ward Bond in *They Were Expendable* (MGM, 1945)

There is a brief episode of release from the tension and weariness at the nurses' dance. In semi-darkness on a veranda nurses dance with servicemen to the strains of "Marcheta". Sandy Davys is dancing with Captain "Ohio" Carter when Rusty who had earlier refused to attend turns up. He and Sandy dance in silhouette. There is a long close-up of their faces side by side as they sit on a hammock talking of home (hers: Iowa, his: New York State) and compare the gunflashes in the hills to fireflies. "Every night they come a little closer". Then Brick turns up with orders. Sandy is left alone sitting facing the camera holding Rusty's cap as behind her Brick and Rusty pace up and down discussing the orders *sotto voce*. The look on her face tells us that she knows that they are about to be parted again by the war. It is one of the succession of scenes in which the camera captures unspoken expressions of pain and loss. A series of noticeboards now announce attacks, raids, losses, and deaths. Intercut are scenes of men straggling back to base, tired and drained.

In another graceful and gentle interlude, Sandy comes to dinner with the PT Boat officers. In a typical Ford table shot, she is seated at the head of the table with officers on each side: Long, Gardner, Aiken and Cross along with Brick and Rusty. An unseen trio led by Mulcahy sing "Dear Old Girl" (an effect repeated when the Sons of the Pioneers serenade Maureen O'Hara at dinner in *Rio Grande*). The officers all behave toward Sandy with courtesy and dignity, appreciating a civilized interlude of female company amid all the strain and urgency of war. After dinner, they gradually depart, until Sandy and Rusty are left alone.

The officers go to visit the gravely injured Lt. Andy Andrews (Paul Langton) in hospital. They put on a show of cheerfulness and optimism. When they have gone, Andy asks Brick to wait, tells him he appreciates the act they have put on but knows he is dying and gives him letters for his mother and wife. Outside silhouetted in a darkened corridor the officers wait. Brick joins them silently and they leave together, another of those long shots held beyond their narrative purpose.

The boats are ordered to evacuate "Key Army Personnel". Before they do, Rusty manages to get a few words with Sandy before the phones are cut off. Surplus crews are being sent to join a Naval Battalion. Just before they leave, two young sailors scamper into the cemetery, kneel and genuflect in front of the graves of shipmates Brant and Tomkins, and then dash off. Brick addresses

the men being left behind telling them it has been a privilege to serve with them. He'd like to be able to tell them he is going for help but it wouldn't be true. "You older men, take care of the kids". He begins another sentence "Maybe" but will not give them false hope; instead he just says "God bless you". They form up and march off to the strains of "Battle Hymn of the Republic".

The evacuation is seen in long shot. A woman, a child and a nursemaid are helped from a launch onto a long jetty and then alone comes General MacArthur (Robert Barrat), identified by his trademark pipe, stick and dark glasses. He is sensed as an iconic presence. Ford accords him the apotheosizing low-angle close shot he reserves for heroes, such as Abraham Lincoln in *The Prisoner of Shark Island*. "Battle Hymn of the Republic" rings out on the soundtrack. There are a succession of close-ups of sailors awed and admiring. A young sailor asks MacArthur to autograph his cap. Mulcahy throws up his hands in despair. But the General does it, uttering his only words of dialogue: "Why certainly". They land the General and his family at Mindanao and Admiral Blackwell orders Brick to place himself and his men under the orders of General Martin (Jack Holt). The crew are carrying out repairs on a damaged

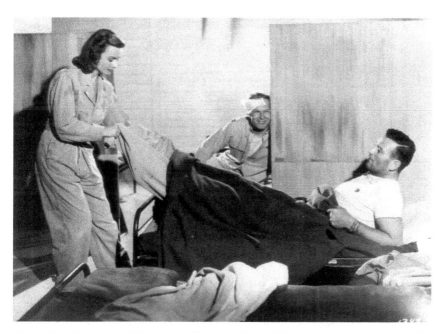

Figure 7.4 Donna Reed, Louis Jean Heydt and John Wayne in *They Were Expendable* (MGM, 1945)

boat when Ensign Gardner (Marshall Thompson) rushes from group to group telling the men they have been awarded the Silver Star for their contribution to the war so far. But they receive the news with indifference. They are not interested in decorations only in completing the job.

Rusty's boat runs aground and sturdy old boat builder "Dad" Knowland (Russell Simpson) takes care of repairs. Ryan and Brickley obtain torpedoes by blackmailing a young submarine commander. General Martin orders the boats to delay a Japanese cruiser which is approaching. There is another vigorous battle scene. Rusty's boat is disabled, runs aground and is blown up by Japanese planes. "Squarehead" Larsen and "Slug" Mahan are killed. Rusty has their bodies taken to a nearby church. The priest is away, tending the wounded in hospitals. Rusty and his crew with two altar boys stand round the coffins, draped with the flag. Then in a funeral scene improvised by Ford and not in the script, Ryan says of the dead sailors: "They were just a couple of bluejackets who did their job and did it well." He then recites Robert Louis Stevenson's *Requiem*:

> Under the wide and starry sky
> Dig the grave and let me lie.
> Glad did I live and gladly die,
> And I laid me down with a will.
> This be the verse you grave for me:
> "Here he lies where he longed to be;
> Home is the sailor, home from the sea,
> And the hunter home from the hill."

One of the sailors plays the last post on a harmonica. Wayne was to recite this poem again at the funeral for Harry Carey staged by Ford at the Field Photo Farm in 1947. This is an example of how Ford's films and his life increasingly overlapped.

After this informal service, Rusty stalks out, opens a closed bar and gets a drink. Others come in and silently line the bar drinking. They switch on the radio. "Marcheta" is playing and Wayne's face registers the memory of what the tune means—his dance with Sandy. It is interrupted by news of the surrender of Bataan with 36,000 American prisoners. The men at the bar listen in silence in a succession of haunted close-ups. Then Wayne throws down money on the bar and stalks out.

General Martin now orders the base evacuated. "Dad" Knowland will not leave. In a superb scene of quiet defiance, he sits on the steps of his shack, jug of whiskey at his side, rifle over his knees, as "Red River Valley" plays on the soundtrack. He says he has worked for forty years to build up his business and they won't get him without a fight. We know he will die fighting and that his spirit is that of the pioneers of the American frontier.

Ryan rejoins Brick and finds that he is handing over the last surviving PT boat to the army for duties. A man dashes aboard to retrieve the tattered battle flag before it goes. Brick, Ryan and the crew pull out and march off. General Martin arrives in his jeep and orders Brick and Ryan to Australia. The worth of the PT boats has been proved and they are to return to the USA to build a fleet of them. They tell the men and put Mulcahy in charge. He asks to shake Brick and Ryan's hands, addressing them by their nicknames and then the men march off to the strains of "You're In The Army Now". In a long-held shot Brick and Ryan watch them go as they disappear down the road.

Brick and Rusty arrive at the airfield to find a crowd of officers waiting to be evacuated. One plane arrives. Brick and Rusty are priority passengers, but ensigns Cross and Gardner have not turned up. "Ohio" Carter and Major Morton take their places. The two ensigns arrive and their replacements have to give up their seats which they do resignedly, leaving letters to be sent to their wives. Rusty wants to give up his place to Carter but Brick restrains him saying "Who are you working for? Yourself?" Then adopting the same tone to Gardner as the Admiral had taken to Brick he explains why they are on the plane: "Look, son, we're going to do a job and that job is to get ready to come back". Brick puts his arm round Rusty as they take off. The officers left behind watch the plane leave and then drift away. General Martin also left behind, his face in shadow, drives off. Led by Mulcahy, the PT crew struggle along the beach. There is a succession of close-ups as they gaze up at the departing plane. MacArthur's pronouncement "We Will Return" is flashed up and "Battle Hymn of the Republic" played.

The film cost $2.9 million to make and grossed a respectable $4.1 million worldwide.[37] It was generally well received by the critics. Bosley Crowther in the *New York Times* (December 21, 1945) recognized the personal commitment lying behind the film:

[37] Eyman, *Print the Legend*, p. 283.

> Quite clearly, the making of this picture was a labor of understanding and love on the part of the men who produced it, from John Ford, the director, on down. Most of those who worked on it were active or recent Navy personnel... complete authenticity and Navy "savvy" are notable throughout. The most thrilling and electrifying passages in the film are those which show the torpedo-boat action ... But the drama and essence of the story are most movingly refined in those scenes which compose the pattern of bravery and pathos implicit in the tale. Mr. Ford and apparently his scriptwriter, Frank Wead, have a deep and true regard for men who stick to their business for no other purpose than to do their jobs. To hold on with dignity and courage, to improvise when resources fail and to face the inevitable without flinching—those are the things which they have shown us how men do.

He also praised the acting, in particular that of Montgomery ("a fine and laconic officer"), Wayne ("magnificently robust") and Donna Reed ("extraordinarily touching"). The film duly found its way onto the *New York Times* Ten Best Films list for 1945. It was nominated for Oscars for best special effects and best sound recording but did not win. James Agee wrote in *The Nation* (January 19, 1946): "The whole thing is so beautifully directed and photographed ... that I thoroughly enjoyed and admired it. Visually, and in detail, and in nearly everything he does with people, it is John Ford's finest movie".

Dan Ford said that filming *They Were Expendable* was the "culmination of four years of the most intense personal experience".[38] It is in consequence one of Ford's most profound statements on memory, loss and war. Filmed in the last months of the war and actually released only when the war was over, it is already a recollection of things past, the outbreak and early months of the war. Like his other naval films, it deals with an unfashionable and initially disregarded branch of the service which has to prove its value under fire. It is notably not triumphalist. It does not depict or comment on the Japanese unlike much wartime propaganda. The enemy consists of planes and ships which have to be destroyed. The themes running through the script which bind it together are the recurrent emphasis on service, comradeship, sacrifice, teamwork, professionalism and obedience to orders. This is the doctrine

[38] Dan Ford, *The Unquiet Man*, p. 199.

enunciated by Brick and which Rusty has to learn. The Navy men are not interested in receiving medals or boasting about their victories. They are most profoundly moved by the death of comrades, as seen in the visit to the dying "Andy" Andrews and the improvised funeral service for Larsen and Mahan. Even more powerful are the partings made in the certain knowledge of prison camps or death—when the surplus crews are sent to reinforce the Naval Battalion, when Rusty and Brick have to leave the rest of the crew behind, when "Dad" Knowland prepares to defend his boatyard to the end and when the last plane flies out, leaving many officers, including the General, behind. They know and the audience know what is likely to be their fate. It is a film suffused simultaneously with both pride and grief, pride in a job done and grief for the price paid.

Mister Roberts had been an enormous Broadway hit. Based on the 1946 novel by Thomas Heggen, it had been adapted for the stage by Heggen and Joshua Logan and directed by Logan. It told of life on a cargo ship in the backwaters of the Pacific at the tail end of the war. Both Heggen and Logan had envisaged Henry Fonda in the title role and he left Hollywood to play it, chalking up 1,670 performances over three years. It was the greatest stage performance of his career. Inevitably the film rights were acquired by Hollywood. Warner Bros bought it and the intention was for Joshua Logan to direct the film version. Logan had been cutting and reshaping the play for the screen, substituting "less censorable but equally effective language" for the sailors' profanities.[39] But Leland Hayward, who had produced the stage version and was to produce the film version, persuaded Logan that John Ford would be a more appropriate director, reminding Logan that he had not directed a film for 17 years. Ford had a proven track record with naval dramas and more importantly had all the necessary contacts to secure full cooperation from the Navy. Ford agreed to do it but Warners wanted either William Holden or Marlon Brando to play the lead, as Fonda had not made a film since he had starred in *Fort Apache* in 1948. But Ford refused to do it unless Fonda got the part and Warner Bros capitulated. Fonda who had believed that he was too old at forty-nine to be playing the role of a 26-year-old was delighted to get the

[39] Joshua Logan, *Movie Stars, Real People and Me*, New York: Delacorte Press, 1978, p. 239.

chance to immortalize the character and to work with Ford, for whom he had given some of his finest film performances. Ford duly secured the use of naval personnel, vessels and bases. But he began the process of turning *Mister Roberts* into a Ford film. Having begun working on a screen adaptation with playwright John Patrick, he soon sent for Frank Nugent to complete a shooting script and began devising comic business for the large cast. He also filled the supporting roles with his stock company, among them Ward Bond, Pat Wayne, Ken Curtis, Harry Carey Jr., Harry Tenbrook and Jack Pennick. Fellow Irish American James Cagney was cast as the Captain of the cargo ship *Reluctant* and having failed to secure Spencer Tracy to play the ship's surgeon Doc, Ford was able to coax William Powell out of retirement to take the role. A relative newcomer, Jack Lemmon, who had previously made only three films, was cast as Ensign Pulver. He recalled that Ford took to him immediately and began making up bits of business for him, as when trying to show off to visiting nurses, he samples the dishwater in mistake for soup and urges the chief to put in more salt, an incident borrowed from *They Were Expendable*. He would add new lines and built up Ward Bond's part of CPO Dowdy.

The film was scheduled for a 45-day shoot first on location on Midway Island and at the Kaneohe Marine Corps Air Station in Hawaii and later at the Warner Bros studio in Hollywood. The location shooting lasted from September 1 to October 8, 1954. But from early on tensions simmered. The ultra-right-wing Ward Bond, a stalwart with John Wayne of the Motion Picture Alliance for the Preservation of American Ideals, regarded the liberal Henry Fonda as a dangerous "pinko". Fonda became increasingly unhappy at the way Ford was altering the play. He had wanted a straightforward screen transcription of the stage play. As he said later, he disliked Frank Nugent's shooting script:

> Josh (Logan) and Tom Heggen had written an excellent play, and very subtly, the dialogue had been changed around. Not a helluva lot but enough to lose the laugh and the nuances of frustration and pain.[40]

Logan hated Nugent's new dialogue calling it "shocking" and "shop worn ... bad, bad, bad".[41] According to Harry Carey who was playing seaman Stefanowski there was another problem. "Ford rehearsed a scene until the pace was right

40 Henry Fonda, *My Life*, (with Howard Teichmann), London: Book Club Associates, 1982, p. 231.
41 Logan, *Movie Stars, Real People and Me*, p. 243.

and everyone was comfortable with what they were doing, and then he shot it, nearly always in one take. Henry always wanted a lot more rehearsal."[42] Eventually a crisis meeting was held between Fonda, Ford and Hayward at which Fonda voiced his criticisms. Denouncing him as a traitor, Ford punched Fonda. They were separated and sometime later a tearful Ford apologized. But it put an end to their relationship. Henceforward after every take Ford would sarcastically ask Fonda if it met with his approval. Ford and Fonda would never work together again. They did not even speak for ten years but a reconciliation was eventually effected and they can be seen reminiscing together in the 1971 documentary *The American West of John Ford*. More seriously Ford began drinking which he normally avoided during shooting. It got so bad he had to be hospitalized in Hawaii to dry out. In his autobiography James Cagney makes no mention of any of this. He says he liked his part and enjoyed the filming and particularly working with Powell and Lemmon. Conspicuously he makes no mention of Fonda or the problems on the film.[43] According to Scott Eyman, Powell found the whole experience so traumatic he never made another film.[44]

They returned to Hollywood for the interiors starting on October 12 but after four days shooting Ford collapsed with an inflamed gall bladder and was hospitalized for an emergency operation. He could not return to the film. So Mervyn LeRoy, who was directing *Strange Lady in Town* for Warner Bros, was brought in to complete the film. LeRoy recalled:

> The original play, as I had seen it in New York and read it the night before, was far superior to the script Ford had been using. So I called the actors together and said we were throwing out the screenplay and going back to the Broadway play. Leland Hayward and Jack Warner went along with me.[45]

LeRoy also claimed that Ford had turned Doc into a drunk and he made him sober, as in the play. He finally said that he had directed 90 percent of the film but magnanimously allowed Ford a joint directing credit. That is clearly nonsense. The exteriors such as the nurses' visit and the "liberty" scenes are self-evidently by Ford, having all his liveliness, spontaneity and invention. LeRoy's interiors were, as Tag Gallagher puts it, "long, sparsely edited, talky and

[42] Harry Carey Jr., *Company of Heroes*, Metuchen, NJ: Scarecrow Press, 1994, p. 145.
[43] James Cagney, *Cagney by Cagney*, London: New English Library, 1976, pp. 132–5.
[44] Eyman, *Print the Legend*, p. 440.
[45] Mervyn LeRoy, *Take One*, London: W. H. Allen, 1974, pp. 195–6.

static-lack visual interest and resemble a filmed play, as Fonda wished".[46] Ford said: "A lot of that forced comedy inside the ship wasn't mine".[47] This must include the whiskey-making and laundry explosion scenes which Ford had wished to cut but LeRoy filmed.[48] However, the writing and acting are strong enough to allow them to work when interspersed with Ford's exteriors.

But when LeRoy left the project, it needed further work to mesh the different sections together and Joshua Logan was called in to film some brief linking passages, redub some scenes and to reshoot Pulver's final confrontation with the Captain and the explosion in the laundry. Logan and Hayward cut some of Ford's slapstick scenes but Jack Warner liked them and put them back, among them the scene of a drunken sailor riding a motorbike off the pier into the sea. For his efforts, Logan received a joint screenplay credit with Nugent. However, Logan and Fonda ended up hating the film and considering it inferior to the play.

The public reaction was entirely different. For all its troubled gestation, it was a critical and box office success. The critics liked it. Typically, A. H. Weiler in the *New York Times* (July 15, 1959) called the film "strikingly superior entertainment … hilarious … wonderfully sentimental and touchingly perceptive about its civilian–seamen caught in the backwash of a war they neither saw nor fully comprehended … loaded to the gunwales with screamingly funny scenes which, in several instances, are visual improvements on the play … one of the season's greatest pleasures". *Variety* (May 25, 1955) declaring it perfectly cast, pronounced it "an outstanding payoff in screen entertainment" that even improved on the stage version.

It was also a huge box office hit, grossing $9.9 million worldwide against a cost of $2.3 million.[49] It was second only to *Cinerama Holiday* as the year's top release at the North American box office. It received three Oscar nominations, including best picture and won one, best supporting actor for Jack Lemmon. Neither Ford nor LeRoy was nominated as best director. Ironically Joshua Logan was nominated best director for *Picnic* and James Cagney, best actor for *Love Me or Leave Me*; neither of them won. The Writers' Guild of America gave

[46] Tag Gallagher, *John Ford: The Man and his Films,* Berkeley and Los Angeles: University of California Press, 1986, p. 346.
[47] Bogdanovich, *John Ford*, p. 142.
[48] Gallagher, *John Ford*, p. 348.
[49] Eyman, *Print the Legend,* p. 440.

Nugent and Logan the award for best-written American comedy of 1955 and the film was included in the *New York Times* annual "ten best films" list.

Like Ford's previous films, *Mister Roberts* deals with a forgotten branch of the Navy, the cargo ships delivering supplies to the combat fleet in the Pacific. The ship is the *Reluctant*, known to the men as the *Bucket*. The film centers on the battle of wills between the commanding officer Captain Morton, a petty tyrant with a chip on his shoulder, an ex-waiter and merchant marine captain who is determined to get on in the Navy, and his executive officer, Lt. Doug Roberts, whom he despises as an ex-college boy from a privileged background but whom he needs to keep the men working. Roberts regularly takes the side of the crew when faced with the Captain's unreasonable enforcement of pettifogging regulations. But his principal concern is to see active service. He regularly requests transfer to combat duty and the Captain regularly rejects his requests.

The film opens with Roberts gazing wistfully at a line of battleships on the horizon heading for combat and determining to put in another transfer request. Then in an echo of the opening of *The Long Voyage Home* Ford establishes the atmosphere of heat, boredom and tension as the crew are tormented by the smell of the island and the fact that they have had no "liberty" (shore leave) for a year. A disembodied voice on the tannoy regularly intones mechanical orders, adding to the monotony. There is a flurry of activity when crewman Insignia, assigned to polishing the telescopes and binoculars, discovers that nurses are moving into a newly built hospital on the island and he can see them taking showers. The frustrated crew fight each other to get control of the binoculars until broken up by Roberts and Chief Petty Officer Dowdy. Dowdy advises Roberts that the men must have liberty or discipline will break down. Roberts agrees to get it. He goes onshore and bribes the portmaster with a bottle of whiskey to send the ship to a liberty port. Roberts is accompanied onshore by Ensign Frank Thurlowe Pulver, the idle, boastful, lecherous but likable laundry and morale officer who wants to chat up the nurses. He invites Lt. Ann Girard (Betsy Palmer) to visit him on the ship. But getting back he discovers that Roberts has disposed of the whiskey he was intending to use as part of his seduction routine. So to help him out Doc and Roberts concoct some imitation whiskey from pure alcohol, Coca-Cola and hair lotion. Clashes between Roberts and the Captain continue. The

Captain forbids fresh fruit to be offloaded with supplies but Roberts offloads it nonetheless. The Captain orders the men to keep their shirts on despite the stifling heat in the hold; Roberts gives permission for their removal. Lt. Girard comes aboard but brings the other nurses with her and Pulver tries to show off to them, demonstrating the use of the telescope and—to the fury of the men—revealing their view of the nurses' quarters which Girard promises to block.

The ship sails to Port Elysium in the Limbo Islands, natives swarm aboard but are ordered off by the Captain who decrees "no liberty". Roberts storms in to the Captain and strikes a bargain with him. If the Captain grants the men liberty, he will cease putting in transfer requests and cease countermanding the Captain's orders. Leave is granted. Later in a characteristically rumbustious sequence the crew return, noisy, drunk or comatose, escorted by shore patrolmen, sporting black eyes and souvenirs, including parasols, garlands and a goat. The ship is placed off limits and the shore patrol officer (Martin Milner, doing a vocal impersonation of Stepin Fetchit) explains that the crew invaded the Colonel's testimonial party, hospitalized thirty-eight army men in a brawl, broke into the French Governor's residence, believing it to be a house of ill-fame, and threw all the furniture out of the window. Next day the ship is ordered to leave the island and innocent youthful Bookser (Pat Wayne) arrives, following a romantic rendezvous on the beach, just in time to jump aboard the vessel as it pulls away.

Roberts now fulfills his bargain with the Captain and is increasingly snubbed by the men, who think he is after promotion and no longer standing up for them. VE Day is announced and Pulver celebrates by setting off a giant firecracker in the laundry and flooding the passageway with soapsuds. Roberts finally loses his temper and throws overboard the prized potted palm that the Captain received for holding the record for delivering toilet paper and toothpaste to the Navy. The Captain sounds a general alarm, realizes who has done it and fiercely denounces Roberts for breaking the bargain. The crew thus learn over the tannoy what Roberts had to do to get them their liberty and their attitude toward him changes. Soon after his transfer arrives and as he is packing, Doc reveals that the men forged the Captain's signature on a transfer request to secure the move. The men turn up with a special presentation, an imitation decoration with a brass palm tree on it, marked "for action against the enemy above and beyond the call of duty". Sometime later Pulver, now

27

cargo officer, receives two letters; one from Roberts with a tribute to the men, encouragement to Pulver to be worthy of them, and an account of going into action, and the other announcing Roberts' death, killed when a kamikaze pilot hit the ward room. Suddenly Pulver straightens up, goes up on the bridge and throws overboard the replacement potted palm the Captain has acquired. He then goes in for a row with the Captain about why he has banned the night's movie and the Captain wearily realizes he has been saddled with another Roberts.

The themes of the film are pure Ford as he evokes the enclosed world of the cargo ship: the comradeship, the service, the horseplay, the bond between officer and men. "I love those guys" confesses Roberts, "I think they're the greatest guys on this earth". Also there is a job to be done. Doc tells Doug that for all his hankering for the battlefront, he is doing a necessary job for the war effort as cargo officer for he is the man who keeps the ship going and supplying the fleet. The men work hard out of respect and affection for Doug, bonded by their dislike of the Captain and also by their shared participation in the liberty which highlights drinking, fighting and womanizing as the source of their bonding. It is after the liberty that Roberts believes they have truly become a crew.

There are excellent performances from the stars. As A. H. Weiler put it in the *New York Times* (July 15, 1955) Fonda "does not simply give the role a professional reading. It now appears as though he *is* Mr. Roberts. It evolves as a beautifully lean and sensitive characterization, full of dignity and power". The *Monthly Film Bulletin* (November 1955) pronounced Cagney, who contrives to be loathsome and funny at the same time, "outstanding" in his "portrayal of the oafish Captain (the stunted figure, piggy eyes and clipped speech are beautifully right for the part)". They are perfectly complemented by William Powell's wise, sympathetic and philosophical Doc and Jack Lemmon's idle, boastful lecher. Although Ford only directed half of it, it is a film which can accurately be described as Fordian.

The Wings of Eagles (1957) is the film in which Ford's artistic vision and his personal life directly overlapped. It originated in a request from the Navy to MGM for a film that would promote the idea of naval aviation. In 1953 MGM commissioned a screenplay from Frank Fenton and William Whister Haines which dramatized the life of the aviator and screenwriter Commander Frank

"Spig" Wead (1895–1947). In due course the film was offered to Ford. As Ford told Peter Bogdanovich:

> I didn't want to do the picture because Spig was a great pal of mine. But I didn't want anyone *else* to make it. I knew him first when he was deck officer, black shoe, with the *Mississippi*—before he went in for flying. I was out of the Navy then and I used to go out and see him and some of the other officers. Spig was always interested in writing and I helped him a bit, encouraged him. We did a couple of pictures together. He died in my arms ... The title was lousy—I screamed at that. I wanted to call it The *Spig Wead Story*, but they said "Spig" is a funny name, and people are going to wonder who's Spig Wead.[50]

With John Wayne and Maureen O'Hara cast as Spig Wead and his wife Minnie, Ford surrounded them with members of his stock company. His son-in-law Ken Curtis played Wead's best friend John Dale Price and Ward Bond played film director John Dodge, a thinly disguised version of Ford himself. In keeping with his latter-day habit of recalling stars he had worked with early in his career, Edmund Lowe (*Born Reckless*) returned to play Admiral Moffett and there were small parts for Jack Pennick, Dan Borzage, Willis Bouchey, Bill Henry, and Olive Carey (uncredited). He also cast former silent stars, May McAvoy (*Ben Hur*) as a nurse and Stuart Holmes (*The Prisoner of Zenda*) as an MGM producer. The film was shot between September 10 and October 4, 1956 with location work at the US Naval Air Station at Pensacola, Florida and aboard *USS Philippine Sea*. Unusually for Ford it went 8 days over schedule, testifying to the great care Ford was bestowing on this most personal of projects.

Contemporary reviewers saw *Wings of Eagles* as typical Ford. *Variety* (July 30, 1957) said it was "always an entertaining show with the thrills, action, heart and comedy that trademark nearly all of Ford's pictures". The *New York Times* (February 1, 1957) said it was "an affectionate tribute" to two of his dearest friends, the Navy and "Spig" Wead. The critics tended to agree that Wayne, although obviously too old at fifty for the role of the daredevil young naval cadet of the early scenes, turned in a mature, sensitive and sympathetic performance as the older crippled Spig.

[50] Bogdanovich, *John Ford*, p. 96.

Fordians have mixed feelings about the film. McBride argued "this is one in which the director's tendency to balance tragedy and comedy unquestionably works to a film's detriment" and complained about the "remarkably arch and witless dialogue".[51] Eyman thought it "an uneasy mixture of ... uninspired rough house in the manner of a silent comedy and ... intense domestic drama".[52] Lindsay Anderson thought that "too much of the drama ... is simplified and sentimentalised in an old-fashioned way, and too much of the writing is familiar Hollywood reach-me-down stuff".[53] But J. A. Place thought it "beautiful"[54] and Andrew Sarris called it one of "Ford's most profound achievements in his late period as film poet without portfolio".[55] I veer more toward these positive appraisals. Although it brought in $2,250,000 in domestic rentals it was regarded as disappointing by the standards of other Wayne vehicles.

The film is narrated by Ken Curtis as John Dale Price, Spig's best friend and now, as Admiral John Dale Price (retired), the film's technical adviser. Reflecting its origin in the Navy's request for a film on air power, the film is dedicated to "the men who brought Air Power to the United States Navy" and includes a scene of a Congressional hearing in which Senator Barton pours scorn on the prevailing pacifism of the inter-war years ("The world is gonna live together like one big happy family. There's going to be no more wars. The army and navy are going out of business") underlying the continuing need for military preparedness.

The film falls into three distinct sections. The first section emphasizes Spig's reckless, devil-may-care exploits as a naval cadet. Although he has never been up alone in a plane and has been specifically forbidden to do so, he takes off in order to show off to a visiting army pilot, Herbert Alan Hazard (Kenneth Tobey). They buzz Spig's crew and a train crossing a bridge and fly through a hangar before running out of fuel, wrecking the Admiral's tea party and crash landing in the swimming pool.

Spig graduates as a naval flier and over the next few years becomes a renowned airman. When the Army announces plans to fly round the world,

51 McBride, *Searching for John Ford*, p. 581.
52 Eyman, *Print the Legend*, p. 445.
53 Anderson, *About John Ford*, p. 160.
54 J. A. Place, *The Non-Western Films of John Ford*, Secaucus: Citadel Press, 1979, p. 136.
55 Sarris, *The John Ford Movie Mystery*, p. 155.

Navy aviators plan to race them and Spig is named captain of the team. Spig and the Navy men crash an Army dinner and polite chit-chat rapidly descends into an all-out punch-up involving use of a cake as a weapon. The police are sent for (marching in to the strains of "The Wearing of the Green"), the combatants flee through the kitchen and end up falling into a swimming pool. But the Navy round-the-world race is vetoed. They are ordered to get their publicity some other way. They enter the competition for and win the Schneider Trophy with Spig captaining the winning team. At the victory dinner, the Army team arrive and break up the event in a repeat of the earlier fracas. Ford insisted on the accuracy of these episodes:

> I tried to tell the story as truthfully as possible, and everything in the picture was true. The fight in the club—throwing the cake—actually happened; I can verify that as an eye witness—I ducked it. I thought it was very funny when they all fell into the pool; that actually happened—they ran like hell through the kitchen and landed in the pool. And the plane landing in the swimming pool—right in the middle of the Admiral's tea—that really happened.[56]

This may well be true but the stunt flying routines repeated similar stunts from *Air Mail*.

The hi-jinks come to an end when Spig falls down the stairs at home and breaks his neck, resulting in almost total paralysis. The second section of the film is devoted to his recuperation at the San Diego Naval hospital where, nursed devotedly by Chief Petty Officer "Jughead" Carson, he is bullied, cajoled and encouraged to regain some movement ("I'm gonna move that toe"). The slow painful process is enlivened by humor as various members of the medical staff seek to sneak whiskey into him. Eventually he transfers to a wheelchair and then crutches as he regains some movement. But he is retired from the Navy and, seeking gainful employment, turns his hand to writing. His stories are all turned down until John Dale Price recommends him to a Hollywood director who is planning a film on naval fliers and is seeking an authentic approach to the subject. Spig arrives in Hollywood and there follows the most obvious autobiographical passage as he meets director John Dodge. Ward

56 Bogdanovich, *John Ford*, p. 96.

Figure 7.5 John Wayne and Dan Dailey in *The Wings of Eagles* (MGM, 1957)

Bond gives an impersonation of Ford, having borrowed the director's hat, pipe and dark glasses and furnished the facsimile of Ford's office with his Oscars and photographs of Harry Carey and Tom Mix. Ford's secretary, nicknamed "Stonewall", is played by Dorothy Jordan, the wife of his old producing partner Merian C. Cooper. Ford is depicted as irascible but good-hearted, totally professional and anti-intellectual (he claims to have appeared in *The Odyssey* playing Robert E. Lee). When Spig asks what he should write about, Dodge/Ford authentically barks "People! Navy people!"

There is a preview of the film Wead wrote. But what we see is not *Air Mail*, the film Wead wrote for Ford, but *Hell Divers*, the film about naval flyers that he wrote for George Hill, the director who brought him out to Hollywood. There is a clip from the film with Wallace Beery and Clark Gable and in one of the many private jokes, the excited producer (Stuart Holmes) orders his minions to sign up "the kid with Wallace Beery". In a joke against himself, Dodge/Ford advises Spig against writing a stage play. He goes ahead anyway and the result, *Ceiling Zero*, is a hit. Wead becomes a successful screenwriter but when the Japanese bomb Pearl Harbor, he rejoins the Navy.

The third section of the film has Spig in a desk job, working tirelessly for the war effort. He devises the jeep carrier, ships which support and supply the big carriers when they are in action. This earns him a recall to active service. But he has a heart attack and, told that he does not have long to live, he asks to retire quietly. But as he is about to leave the ship for the last time, in a classic Fordian sequence, the band slowly play "Aloha" and senior officers line up to see him off. As he is being transferred in a bo'suns seat to another ship he says "So long", his voice breaking. Ford holds the long shot of his transfer until he vanishes, merging into the ship, symbol of the Navy that has been his life. In reality Wead returned to Hollywood and wrote four more scripts, one of them Ford's *They Were Expendable*, before his death in 1947.

Structuring the film and linking the three sections together are two parallel love stories: the troubled marriage of Spig and Minnie (Maureen O'Hara) and the devoted friendship of Spig and CPO Carson (Dan Dailey). Minnie is first seen pursuing Spig in a car as he takes off on his unauthorized joyride. The car crashes into the Admiral's tea table and she later falls over as she tries to slug Spig for his irresponsibility. Back home, she tells John Dale how much she hates the Navy because she is married to it. Their baby son "the Commodore" is taken ill and dies. But the parents grieve separately in a shot in which they are seen in different rooms. Later Spig fathers two daughters but when he is ordered to Washington, Minnie refuses to go with him, saying she has had seven different homes in seven years and can't go on. He chooses his career over the family and they lead separate lives. She takes the children to the cinema to see their father in the newsreel of the Schneider Trophy win. It is when he comes home for a reunion with the family that he falls and breaks his neck. He refuses to allow Minnie to nurse him, saying she would be better off on her own. But she still sends him red roses. Her place is taken by Carson who sees him through the painful and prolonged period of rehabilitation. Later when he is an established writer and "as rich as creosote" as Carson puts it, using Warren Hymer's line from *Submarine Patrol*, they meet in New York where Carson is now a taxi driver. Carson urges him to get back together with Minnie. Spig and Minnie meet and make plans to reunite, as Spig barely knows the children. "If it isn't a family, it is nothing" he says. But on the day he expects her to return, Pearl Harbor is bombed and he is back to the Navy. On board

ship, it is Carson who is looking after him again. When a kamikaze plane attacks his ship, Carson covers Spig with his own body and is wounded. When Spig visits him in sickbay, both men are embarrassed by the emotion involved in the moment. But when Spig collapses with his heart attack, it is "Jug" that he calls for. When Spig leaves for the last time, there is a telling close-up of Carson looking through a port hole and turning away in desolation.

The classic Ford themes are all here: the tragedy of family break-up; the all-male comradeship of the armed forces; the Navy as a way of life; the male bonding symbolized by ritualized boozing and fighting; the unspoken mutual love of comrades. There is no doubt that Spig and Minnie love one another. But their marital life is incompatible with his professional life in the Navy. The love is shown in a typical Fordian moment, simple, touching and effective. As he is packing his belongings before leaving the ship, he gazes fondly at photographs and in flashback we see idealized images of his wife and children, hints at a family life he might have had. The scenes of Minnie's descent into alcoholism were eliminated from the film in deference to her children but to the regret

Figure 7.6 John Wayne and Ward Bond (as John Ford) in *The Wings of Eagles* (MGM, 1957)

of Maureen O'Hara who found them important and satisfyingly dramatic. Fascinatingly the tension between marriage and service life and the primacy of male comradeship are recurrent themes in Wead's screen stories. What is also significant about the film, as his grandson Dan Ford points out, is that "Spig Wead's story was so much like John's that *The Wings of Eagles* stands as one of John's most autobiographical films".[57] But it was not a film that appealed to the wider public. It cost $2.6 million to produce but earned only $2.3 million in domestic rentals recording a loss of $804,000.[58]

Like Wead, Ford experienced the conflicting demands of family and work. Where flying was Wead's life, film-making was Ford's. He kept the two spheres of home and work strictly separate. Although in her only known interview, Mary Ford described her husband as "the greatest man that ever lived in every way" she confirmed that she was never invited onto his film sets, that he never discussed his work with her and she very rarely went on location with him. She spent her time doing charitable work.[59] Both Ford and Wead had distant and difficult relationships with their children. In Ford's case it ended with him cutting his son Patrick out of his will. Both men were absent from home for much of the war on active service. Both men were most comfortable in all-male environments. So it is in *The Wings of Eagles* that Ford's life and his art finally merge.

[57] Dan Ford, *The Unquiet Man*, p. 276.
[58] Scott Eyman, *John Wayne: The Life and Legend*, New York: Simon and Schuster, 2015, p. 189.
[59] Unpublished 1977 interview with Mary Ford by Anthony Slide and June Banker.

Conclusion

Ford always grumpily denied being the artist and poet that his admirers claimed. He insisted he was just a hard-working professional doing a job of work to feed his family. But in the *New York Times* (June 10, 1928) he set down some ideas about the art of motion pictures. He described Hollywood as "the great mental market place of the world". It attracted people from all over the world with a multiplicity of ideas because "written in the universal language of visual imagery, the pictures have made appeal to the creative impulses of almost all people and to almost every class of society. No man has been too high-brow to scorn the medium of motion pictures for his ideas, no man too humble to be denied the chance of success in the most modern medium of a world-old desire to tell a story". Films need not just visual appeal, but "vivid characters" and "just as in all art ... the simple story will always remain the most effective ... The pictures that people remember for years are not the spectacularly sensational films, but the heart-interest stories of plain people interpreting vital emotions". Hollywood represents "man's unceasing search for the something he can never find".

Ford was the epitome of the cinematic auteur. His entire body of work was bound together into an organic whole by the exploration of recurrent themes, the development of a distinctive directorial style and elements of autobiography. His films consistently articulate and embody his deep love of Ireland, his profound Catholic faith, the importance of family and community, his reverence for the military, the nature of male friendship, the values of service, sacrifice, loyalty, comradeship, and sympathy for outsiders, exiles, misfits and outcasts.

Index

Headings in italics are the titles of films (followed by the release date) or books/plays (followed by the author).

Borzage, Danny 27, 238, 255, 314
Borzage, Frank 27, 86, 267
Bouchey, Willis 29, 314
Boucicault, Dion 48, 49–50, 51
boxing matches 119, 142, 270
Brennan, Walter 11
Briskin, Sam 76
Britain
 film market 44, 126, 147
 imperialism 123–4, 125–7
 JF's dislike of the English 127, 132,
 139–40, 145, 155–6, 187–8, 293
British Board of Film Censors (BBFC)
 51–3, 74–5
Brophy, Edward 31, 208, 209
Bulkeley, Lt. John 5–6, 293, 294, 295
Burnett, W. R. 207–8
business, bits of 16, 21–3, 108, 276, 284,
 296, 308
Byrne, Donn 43, 54

Cagney, James 253, 309, 310
Calvet, Corinne 247–8, 253, 255
cameramen 34–5. *See also* August, Joseph
 H.; Clothier, William; Miller,
 Arthur; Schneiderman, George;
 Toland, Gregg
camera movement 36–7, 149, 215, 224,
 230, 232
Canutt, Yakima 149
Capra, Frank 207, 238
Cardiff, Jack 106–7
Carey, Harry 1–2, 15, 27, 28, 29, 304
Carey, Harry, Jr. 12, 22, 28, 29, 252, 308
Carey, Olive 28, 314
cargo ships 268, 311
Carradine, John 11, 29, 31
 Four Men and a Prayer (1938) 146
 The Hurricane (1937) 153, 157
 Mary of Scotland (1936) 189, 190
 Submarine Patrol (1938) 282
Carroll, Madeleine 231, 233
catchphrases 21–2
Catholicism
 The Fugitive (1947) 166, 172, 175
 importance to JF 12–13, 165–9
 Irish films 46, 49, 63, 78, 97–8, 104
 Mary of Scotland (1936) 177, 186–7,
 188

symbolism 167, 173
 The World Moves On (1934) 230, 235
cavalry 213
 cavalry trilogy 3, 17, 25, 37
Ceiling Zero (Wead) 317
censorship 51–3, 62, 74–5, 237
The Champ (1931) 204–5
Chandler, Helen 271, 272
characters, creation of 18, 19, 26, 33–4, 90,
 284
Charters, Spencer 29
Chesty: Tribute to a Legend (1976) 6, 264–5
Cheyenne Autumn (1964) 4, 20, 24, 28, 163,
 168
children 29–30
 perspective of 38, 116, 142
 portrayal of 163, 230, 260
Christ figures 166–7, 169–70. *See also*
 religion
Churchill, Berton 29, 144
cinematography 34–42, 65, 183, 197–8,
 275. *See also* superimposed shots
 camera movement 36–7, 149, 215, 224,
 230, 232
 close-ups 34, 36–7, 183, 200, 224, 230,
 298
 composition 35–42, 164, 189
 cutting 14–15, 35, 145, 208, 239, 240
 framing 38–40, 164, 191–2, 215, 230,
 232, 286
 low-angle shots 38, 78, 116, 178, 183,
 303
Civil War (American) 4, 7, 219
Clarke, Charles G. 220
Clarke, Donald Henderson 202
Clarke, T. E. B. 212, 213, 214
close-ups 34, 36–7, 183, 200, 224, 230,
 298
Clothier, William 34, 35, 164
The Cock-eyed World (1929) 251, 254
Collier, William, Sr. 15, 129, 278
Columbia 59, 208, 212
comedy 22–4, 247
 imperial epics 141–2
 Irish films 50, 57, 79, 83–4, 91, 102–3
 prison dramas 198–9
 underworld films 195–6, 202, 203, 207
 war films 248, 257–8, 270, 276, 279,
 284–5

CPSIA information can be obtained
at www.ICGtesting.com
Printed in the USA
LVHW051919160723
752506LV00003B/73